D1304210

SCHIRMER

Encyclopedia of *Art*

Ann Landi

SCHIRMER

Encyclopedia
of
Art

Ann Landi

VOLUME 3
K-P

SCHIRMER REFERENCE

GALE GROUP
™
THOMSON LEARNING

New York • Detroit • San Diego • San Francisco
Boston • New Haven, Conn. • Waterville, Maine
London • Munich

Schirmer Encyclopedia of Art

Schirmer Reference
1633 Broadway
New York, NY 10019

Gale Group
27500 Drake Road
Farmington Hills, MI 48331

Printed in the United States of America
10 9 8 7 6 5 4 3 2 1

Library of Congress Cataloging-in-Publication Data

Landi, Ann.
Schirmer encyclopedia of art / Ann Landi.
 p. cm.
 Includes bibliographical references and indexes.
 ISBN 0-02-865414-5 (set : hard : alk. paper) ISBN 0-02-865682-2 (v. 1)
ISBN 0-02-865683-0 (v. 2) ISBN 0-02-865684-9 (v. 3) ISBN 0-02-865685-7 (v. 4)
 1. Art—Encyclopedias. I. Title: Encyclopedia of art. II. Title.

 N31 .L3 2001
 703—dc21

2001040067

Front cover images (clockwise from upper right):
Girl in a Turban, painting by Jan Vermeer. Photograph © Francis G. Mayer/Corbis.
Actor in a Straw Hat, woodblock print by Gosotei Hirosada. Photograph © Asian Art &
 Archaeology, Inc./Corbis.
Figure, painting by Pablo Picasso. Photograph © Francis G. Mayer/Corbis; painting repro-
 duced courtesy of Estate of Pablo Picasso/Artists Rights Society (ARS), New York.
Venus Freyus, statue in the Museo della Civiltà Romana, Rome, Italy. Photograph ©
 Archivo Iconografico, S.A./Corbis.

Contents

VOLUME 2

D

E

VOLUME 3

VOLUME 4

W–Z

KAHLO, FRIDA

Mexican, 1907–1954

Magdalena Carmen Frida Kahlo y Calderòn—often known simply as Frida—is Mexico's most famous female artist. Since the 1970s, when LATIN AMERICAN ART began drawing serious international attention, Kahlo has been widely recognized and imitated. She was the daughter of Matilde Calderòn y Gonzàlez, a Catholic mestiza (a woman of mixed European and American Indian ancestry) and the photographer Guillermo Kahlo, a Jew of German-Austro-Hungarian descent. Kahlo was born in Coyoacán, just outside Mexico City, on July 6, 1907. Indicative of her penchant for drama and creativity in all aspects of her life and art, however, she claimed as her birth date July 7, 1910, the year the Mexican Revolution (1910–1920) broke out.

Kahlo gained importance not only as a major female artist but also as a bridge linking the Mexican muralist tradition, history painting*, FOLK ART, genre painting*, and the modern preoccupation with self. In fact, self-portraiture became her principal mode of expression, enabling her to deal with the physical and emotional pain she suffered throughout her life. Kahlo made the first of these paintings in 1926, while convalescing after a bus in which she was riding was hit by a streetcar in 1925. Her plans at the time to attend medical school were derailed by her injuries, which included a broken pelvic bone and damage to her spinal column and right leg, which eventually was amputated.

history painting a picture that depicts an important historical occasion

genre painting painting that focuses on everyday subjects

In spite of Kahlo's pain and suffering, however, her life, like her paintings, was also lively and colorful. In 1922, as the Mexican mural movement was beginning, Kahlo met its most famous practitioner, Diego RIVERA, who was painting a mural at her school. She married him in 1928, thus beginning a loving, tempestuous relationship in which the couple separated, divorced, remarried, and endured many affairs on both sides. Among Kahlo's most famous lovers was the Communist leader Leon Trotsky (1879–1940), who was assassinated in her native Coyoacán in 1940.

As a painter, Kahlo was mostly self-taught. Although her paintings seem to portray a world of fantasy and dreams, she did not consider herself a Surrealist. She insisted that what she was painting was real, once writing, "The only thing that I know is that I paint because I need to, and I paint always

whatever passes through my head, without any other consideration." As though by explanation, in *Self-Portrait with the Portrait of Dr. Farill* (1951), she sits in a wheelchair before a portrait she is painting, brushes in one hand dripping blood-paint and a heart in the other hand as her palette.

Kahlo's strong will, flamboyance, and talent, as well as her political audacity in supporting Communism, are all factors in her present-day popularity. *Self-Portrait with Monkey* (1938) clearly shows Kahlo's magnetism: the artist, with her heavy eyebrows characteristically knit together, her faint mustache, and her hair pulled up and entwined in a red ribbon that coils down around her neck, is embraced by a monkey whose expression and penetrating eyes mirror hers. One of the monkey's dark hands hangs around her neck, seeming to extend the coil of her braided hair and suggesting the hand of death. Kahlo appears against a backdrop of forest leaves. In her gold-trimmed dress and robe, like the bright, primary-colored clothes she wore in life, Kahlo is an exotic figure in the woods, perhaps even a modern-day incarnation of Mexico's famed Virgin of Guadalupe. —BARBARA M. MACADAM

(*See also* SURREALISM.)

KANDINSKY, WASSILY

Russian, 1866–1944

One of the great pioneers in the development of ABSTRACT ART, Wassily Kandinsky was born in Moscow, the son of a prosperous tea merchant. His parents divorced when he was a teenager, and he was educated largely by his aunt. He would later credit her teaching for his love of music, a major source of inspiration to him, and for his interest in Russian folktales.

Early Influences

Between 1886 and 1892, Kandinsky studied law and economics at the University of Moscow, but his interests also included art and anthropology. In 1889, he published an essay about tribal relics he had studied during an expedition to a remote area of Finland. The brightly colored peasant houses he encountered on a trip to northern Russia, which he viewed as pictures that could be walked into, would have a lasting impact on his painting.

By 1896, after declining the offer of a professorship and working briefly as an art director in a printing plant, Kandinsky turned to art full-time. A painting he saw at an exhibition of French paintings in Moscow in 1895, one in the *Haystack* series (1890–1891) of the Impressionist painter Claude MONET, made a deep impression on him. "I had the feeling that here the subject of the picture was in a sense the painting itself," he later wrote. "I wondered if one couldn't go much further along the same route."

Years in Munich

Kandinsky moved to Munich, then one of the great artistic centers of Europe, to study at a private art school run by the noted teacher Anton Azbe. Four years later, he began taking classes at the Munich Academy, where he met the Swiss painter Paul KLEE, who would remain a close friend for the rest of his life. Older and more experienced than the other students, Kandinsky be-

came a leader among his contemporaries. Klee said Kandinsky's "exceptionally handsome, open face inspired a certain deep confidence" in the other students. Kandinsky was also noted for being extremely methodical in his working habits. According to Klee, the older artist mixed the colors on his palette with "a kind of scholarliness," and Kandinsky himself joked that he was so neat he could paint in evening dress.

In 1901, Kandinsky became one of the founders of Phalanx, a group of artists who came together to jointly exhibit their works. The following year, he was elected president of the society and organized a total of eleven exhibitions. Through Phalanx and its art school, where he also taught, he met Gabriele Münter (1877–1962), a talented young painter who became his mistress and close associate until the outbreak of World War I (1914–1918). In 1904, Kandinsky obtained a legal separation from his wife, a Russian cousin whom he had married in 1892.

In the first decade of the twentieth century, Kandinsky was heavily influenced by ART NOUVEAU and IMPRESSIONISM. As the art historian H. H. Arnason has noted, however, all of his paintings were "characterized by a feeling for color and many for a fairytale quality of narrative, reminiscent of his early interest in Russian folktales and mythology." In *Blue Mountain, No. 84* (1909), Kandinsky combines the pointillism* of Georges SEURAT and the heavy outlines and bold color of Paul GAUGUIN with his own magical vision of horses and riders cantering across the foreground.

Turns to the Abstract and the Spiritual

Sometime during 1909, Kandinsky experienced a revelation that was to change both the course of his own art and the history of modern painting. He described how he made the breakthrough to complete abstraction:

> Twilight was falling; I had just come home with my box of paints under my arm after painting a study from nature. I was still dreamily absorbed in the work I had been doing when, suddenly, my eyes fell upon an indescribably beautiful picture that radiated an inner glow. I was startled momentarily and quickly went up to this ominous painting in which I could see nothing but shapes and colors, and the content of which was incomprehensible to me. The answer to the riddle came immediately: it was one of my own paintings leaning on its side against a wall. The next day, by daylight, I tried to recapture the impression the picture had given me the evening before. . . . Now I knew for certain that . . . subject matter was detrimental for my paintings.

In 1909, several years after the dissolution of Phalanx, Kandinsky joined with other artists in forming the *Neue Künstler Vereinigung* (New Artists' Association). In 1911, he published a book, *Concerning the Spiritual in Art,* that contained the ideas that had preoccupied him since his student days. Many of his views were influenced by his deeply spiritual nature and by his interest in Theosophy, a mystical religion then popular among many writers and artists, such as the Irish poet William Butler Yeats (1865–1939) and the Dutch artist Piet MONDRIAN. Even some of his closest friends were perplexed by the developments in Kandinsky's painting. He resigned from the New Artists' Association to form yet another society, *Der Blaue Reiter* (The Blue Rider; named after one of Kandinsky's paintings).

From 1910 to 1914, Kandinsky became absorbed in creating wholly abstract art. He called some of his works "compositions," in which he seems to have arranged geometric shapes, figures, and lines. Other works he called

Theosophy

Theosophy is a mystical philosophy that holds that God is all-knowing and all-good and that evil exists only because of man's insistence on material rewards. Although that belief had been around since ancient Buddhism and Brahmanism, it experienced a resurgence during the nineteenth and early twentieth centuries. Among the proponents of Theosophy were the Swedish scientist and philosopher Emanuel Swedenborg (1688–1772) and Madame Blavatsky (1831–1891), a Russian-born mystic and magician who founded the Theosophical Society in 1875. Blavatsky claimed to have received her teachings from Oriental religious gurus and to have reached a higher level of existence than that of other mortals.

The appeal of Theosophy for artists such as the Dutch painter Piet MONDRIAN and the Russian painter Wassily Kandinsky lay in its conviction that the universe is essentially spiritual in nature and that a deep harmony lies underneath the apparent chaos of the world. Through the "spiritual vibrations" of color, Kandinsky hoped his paintings would touch the viewer's soul.

*pointillism a technique in which dots of complementary colors are applied to a canvas; the result is a unified image

"improvisations"; these show seemingly little control over the colors and lines set down by his brush. As in SYMBOLISM, Kandinsky's work shows a strong interest in the relationship between color and sound. He was a talented cellist and pianist who counted the avant-garde* composer Arnold Schoenberg (1874–1951) among his friends.

Returns to Moscow

The years before World War I marked a period of intense activity and growing fame for Kandinsky, who showed his work in major European cities and at the 1913 Armory Show in New York City (*see* sidebar, DUCHAMP). When war broke out in 1914, Kandinsky was forced to leave Munich and return to Moscow because he had remained a Russian citizen during all of his years in Germany. He left Gabriele Münter behind and in 1917 married a much younger Russian woman, Nina Andreevskaya.

Like many advanced artists of his day, Kandinsky was sympathetic to the aims of the Russian Revolution of 1917, which led to the overthrow of Czar Nicholas II (1868–1918; ruled 1894–1917). He enjoyed many honors and responsibilities under the new government, but by 1921 he had become disillusioned with the growing trend toward making fine art subordinate to industrial design and government propaganda.

Lasting Impact

Kandinsky returned to Germany and in 1922 accepted a teaching post at the newly created BAUHAUS school in Weimar. In his years at the school, where

Wassily Kandinsky. *Composition 4.*
1911. Oil on canvas. THE ART ARCHIVE/
KUNSTSAMMLUNG NORSHEIN WEST/HARPER COLLINS
PUBLISHERS

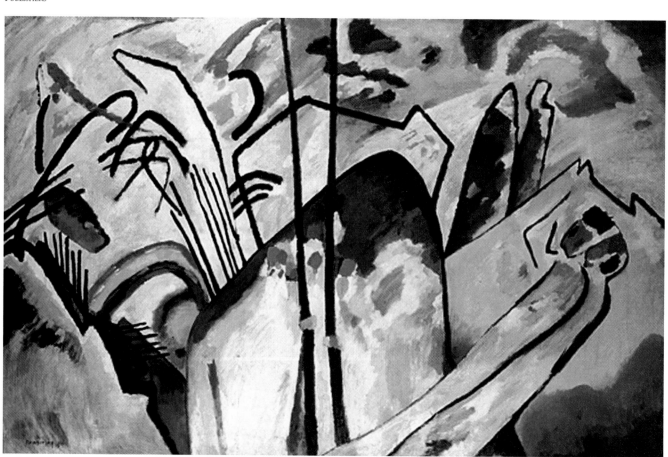

he remained until 1933, he taught analytical drawing and the elements of line and color. He also published a summary of his theories, called *Point and Line to Plane* (1926). Kandinsky's own paintings during this time gradually became more geometric, incorporating circles, triangles, and wavy lines. His fame spread to the United States, with an exhibition in New York at the Société Anonyme. In 1926, in honor of his sixtieth birthday, an exhibition of his works toured Germany.

With the rise of the Nazi Party, the Bauhaus was forced to close its doors in 1933. Kandinsky decided it was time to change his own life as well and moved to the Parisian suburb of Neuilly-sur-Seine, where he remained for the rest of his life. In his last period, he introduced a new element of fantasy, perhaps inspired by the growing Surrealist movement. A deeply respected figure in the Parisian art world and elsewhere, Kandinsky continued to have a lasting impact on younger artists, both through his work and his writings, long after his death at age seventy-eight.

(*See also* EXPRESSIONISM; SURREALISM.)

KATZ, ALEX

American, born 1927

Although often grouped with the Pop artists, Alex Katz can be categorized as more of a contemporary Realist. His large-scale paintings are generally free of the ironies and playfulness of such artists as Andy WARHOL and Claes Oldenburg (born 1929). His works borrow from some of the same sources—advertising and movies—but the cropping and indirect angles used in his compositions also recall such Impressionist painters as Edgar DEGAS.

The son of Russian immigrants, Katz became serious about art as a teenager. He studied at the Cooper Union School in New York City, and in the early years of his career supported himself working as a teacher and a frame maker. Like many of his generation, Katz struggled against the overwhelming presence of ABSTRACT EXPRESSIONISM in New York. He found a way of his own, however, in REALISM. By the mid-1950s, he was producing cut-paper collages* of just one or two figures in outdoor settings.

*collage a method of picture making in which pieces of photographs, torn paper, news clippings, and other objects are assembled on a flat surface

Later, Katz took his subjects from the world around him: art-world personalities; fashionable people at play; innumerable portraits of his wife, Ada; and large, haunting landscapes and cityscapes. Although Katz was never a purely abstract painter, works like *The Red Coat* (1982) show that he was working toward a pared-down style at the same time as the Minimalist artists. In its flat colors and crisp shapes, the painting also owes a debt to the French painter Henri MATISSE. Although Katz's paintings appear to be spontaneous and quickly painted, for many he actually did numerous studies before painting and also used a video camera to capture gestures and break them down into individual still frames.

(*See also* IMPRESSIONISM; MINIMALISM; POP ART.)

KAUFFMANN, ANGELICA

Swiss, 1741–1807

The daughter of an artist, the Swiss-born painter Angelica Kauffmann traveled around Switzerland and Italy with her father from an early age. Eventually, she settled in Rome, where she became a member of the Academy of San Luca in 1765. As a woman, however, she was excluded from figure-drawing classes; it was considered improper for a female student to work from nude models. Nevertheless, she became one of the most successful female painters in the history of art.

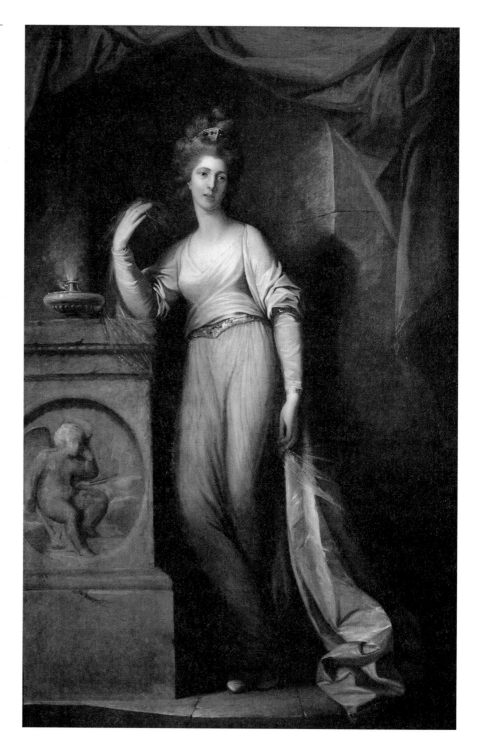

Angelica Kauffmann. *The Winter's Tale by William Shakespeare with Elizabeth Hartley as Hermione.* *Garrick Club, London, England* THE ART ARCHIVE

In 1766, Kauffmann moved to London and became one of the leading figures of the Neoclassical movement in England. She was a founding member of the Royal Academy, Great Britain's official art school, and became a close friend of its president, Sir Joshua REYNOLDS. A woman of great personal charm, Kauffmann counted many of the leading artists and intellectuals among her friends, including the sculptor Antonio CANOVA and the German writer Johann Goethe (1749–1832).

Kauffmann's early career was as a fashionable portraitist, and she was sought by clients all over Europe. Later, she turned to mythological and historical scenes. Her painting *Pliny the Younger and His Mother at Misenum* shows the young Roman orator and statesman taking notes, while in the background a volcano erupts. The figures' garments, the architecture, and the dramatic gestures are all in the Neoclassical tradition, but compared with the work of an artist like Jacques-Louis DAVID, a contemporary in France, Kauffmann's figures and lighting are softer and her feeling for space less assured.

Kauffmann also did decorative work for the architect Robert Adam, through whom she met her second husband, Antonio Zucchi (died 1795), also a painter. Although she aspired to paint grand themes from Homer (active eighth century) and Shakespeare (1564–1616), she was much more admired for "ladylike" works that nevertheless have great charm. After 1781, she settled in Rome and became the center of a famous social circle while continuing her successful career.

(***See also*** NEOCLASSICAL ART.)

KEI SCHOOL

The Kei school of artists introduced a dramatic and realistic style of sculpture during Japan's Kamakura period (1192–1333), a time when Buddhism flourished and sculptors were commissioned to create works on divine subjects. The lineage of the school began with Raijo (1044–1119), a disciple of the famous sculptor Jocho (died 1057), who created the Amida Buddha sculpture at Phoenix Hall, a private retreat that became a temple. However, it was Kokei (c. 1151–1200), Raijo's son, who organized and founded the Kei school.

The Kei school worked on many restoration projects funded by the Kamakura's new military rulers. In 1190, a few years after the Kamakura leader Minamoto Yoritomo (1147–1199) had begun to gain power, the school was commissioned to create works for Todaiji temple, a Buddhist complex (dating to 743) in the city of Nara, Japan. For the temple's Great South Gate, the Kei school's most renowned artists, Unkei (c. 1148–1223) and Kaikei (active 1183–1236), produced two famous wooden sculptures, "Pair of Guardian Kings" (1203). The figures, which stand twenty-seven feet high, are dramatically posed—their drapery blowing in the wind and fierce expressions on their faces, as if ready to defend.

After the project at Todaiji was complete, Unkei moved the Kei school to Kyoto, where it prospered under the leadership of his son, Tankei (c. 1173–1256). The next generation of Kei sculptors continued to work in a realistic style, best illustrated by *The Priest Kuya* by Kosho (died 1237). The sculpture is an imagined portrait of the faithful Kuya, shown in mid-step, holding a staff

and hitting a drum that hangs from his neck. The artist depicted six Amida Buddhas (religious figures) coming out of the priest's mouth, symbolizing the Buddhist chant that Kuya preached in his travels. Adding to the realism, the figure's eyes are inlaid with crystal, a characteristic of the Kei school.

The sculpture of the Kamakura period was widely considered to be among the best and most well-defined in the history of Japanese art. The era's Kei artists created a powerful sculptural form, ideally suited to their spiritual subjects. —KRISTIN BENGTSON

(*See also* BUDDHIST ART; JAPANESE ART.)

KIENHOLZ, EDWARD

American, 1927–1994

Sometimes grouped with the Pop artists of the 1960s, Edward Kienholz defies being categorized. He was one of the most brilliant social commentators in the United States, creating morbid and shocking "environments" that have never lost their power to disturb.

Kienholz was born in Fairfield, Washington, the son of farmers. He learned carpentry and plumbing, but he was largely self-taught as an artist. After moving to Los Angeles in 1953, he began making abstract wooden reliefs* and helped run several avant-garde* galleries. Within ten years, he was creating life-size tableaux, or scenes, such as *The Beanery* (1965), a replica of a seedy, run-down bar that viewers could actually enter to mingle with the "customers." The customers included a pair of furniture movers, an elderly woman in a mink stole, an overweight businessman, and a tired waitress—all with clocks in place of faces. "A bar is a sad place," Kienholz once remarked, "a place full of strangers who are killing time, postponing the idea that they're going to die." Although *The Beanery* is a far more gruesome vision of alienation, it echoes the sense of loneliness and estrangement that imbues many of the works of Kienholz's contemporary Edward HOPPER.

Even more provocative than *The Beanery* is *The State Hospital,* created in 1966. Kienholz, who had worked for a time in a mental institution, shows a pair of waxy emaciated bodies, each tied to a filthy mattress; both are curled in the same pose. The figure in the bottom bunk is the patient. The figure on the upper mattress is the patient's mirror image; he is surrounded by the kind of "speech balloon" seen in comic strips. The message seems to be that even when dreaming, there is no escape from this harrowing reality.

In other works, Kienholz's brand of social satire is more political. His *Portable War Memorial* (1968), a protest against U.S. involvement in the Vietnam War (1959–1975), features the famous bronze soldiers from the monument commemorating the raising of the American flag over the Japanese-controlled island of Iwo Jima during World War II (1939–1945). Kienholz's version, however, has the soldiers planting the flag on a suburban patio table. Later works, often made in collaboration with his wife, Nancy Reddin Kienholz, commented on the evils of Nazism.

Kienholz's funeral in 1994 was as theatrical as his art. As bagpipes played, his embalmed body, wedged into the front seat of his 1940 Packard, was dri-

*relief sculptural figures or decorations that project from a flat background

*avant-garde literally, the "advanced guard"; a term describing innovators or innovation in a particular field

ven into a large hole near his home in Hope, Idaho. As critic Robert Hughes noted, it was "the most Egyptian funeral ever held in the American West."

(*See also* POP ART.)

KINETIC ART

The term "Kinetic art" was derived from the Greek word for movement, *kinesis.* The earliest attempts at making artworks that incorporate motion date to the early twentieth century. In 1909, Italian Futurists first proposed an art based on "dynamism." Artists such as Umberto BOCCIONI made sculptures that implied motion, but they remained earthbound and static. A few years later, Naum GABO, a Russian Constructivist, made an electrically driven, vibrating sculpture, which was soon followed by Hungarian Constructivist Lázló Moholy-Nagy's (1895–1946) "light-space modulators," motor-driven machines with reflective parts that cast light onto surrounding surfaces. By 1934, the American-born sculptor Alexander CALDER had invented his mobiles, sculptures that suggest biomorphic* shapes and that move by responding to air currents.

*biomorphic an abstract art form based on shapes found in the natural world rather than on geometric patterns

The heyday of Kinetic art began in the mid-1950s in Europe and lasted through the 1970s, by which time it had spread to the United States. The exhibit "Le Mouvement," at the Denise René Gallery in Paris in 1955, showed art in motion by Alexander Calder, Marcel DUCHAMP, the Swiss-born painter and sculptor Jean Tinguely (1925–1991), and the Belgian sculptor and former member of the CoBrA group Pol Bury (born 1922).

Tinguely later became well known for his *Homage to New York* (1960), an elaborate construction made of an old piano and motors found around the American city. The installation was supposed to self-destruct but, instead, it caused a minor fire in the sculpture garden of New York's Museum of Modern Art; firefighters called to the scene helped destroy the piece. Twenty years later, with companion and fellow artist Niki de Saint Phalle (born 1930), Tinguely completed a more permanent monument: a fountain, outside Paris's Pompidou Centre, that features mechanical birds and beasts spouting jets of water.

Bury, whose works had also been featured in the seminal 1955 show in Paris, abandoned painting for Kinetic sculpture in 1953. Within a few years, he was creating motor-driven sculptures—witty assemblages* that have extremely slow-moving parts. Another Paris-based sculptor, Nicholas Schoffer (1912–1992), was one of the first to make use of computer technology to incorporate movement in his works. He used computer programs to make sculptures rotate on their bases and project colored lights in response to a viewer's presence.

*assemblage a type of sculpture in which a group of objects is put together to form a work of art

In the United States, George Rickey (born 1907) became the foremost advocate of Kinetic art. Like others in what one observer dubbed the "movement movement," Rickey began as a painter, turning to mobiles in the late 1940s. By the mid-1950s, he was experimenting with glass and stainless steel. His favorite shapes were long slender rods and cubic or rectangular planes, made of gleaming, burnished metal; his sculptures were usually sited out of doors, where they respond to wind and weather. At their best, his works have a sense of fragility and weightlessness; the light that reflects from the polished steel adds to the kinetic effect of his sculptures.

(*See also* CONSTRUCTIVISM; FUTURISM; LIGHT SCULPTURE.)

KIRCHNER, ERNST LUDWIG

German, 1880–1938

One of the leaders of German EXPRESSIONISM, Ernst Ludwig Kirchner was nervous and highly imaginative from childhood on. His father was a distinguished chemist, and the family moved a lot in Kirchner's youth, finally settling in the city of Chemnitz, located in the province of Saxony in eastern Germany. Later remembering his high-strung nature, he wrote, "In youth dreams prevailed, often faces at night when I was a boy. . . . The nocturnal dreams continued into daytime life, fear of many people."

By the age of eighteen, he had decided to become an artist, but his family opposed his ambitions and Kirchner agreed to go to architecture school in nearby Dresden. He studied there between 1901 and 1905, with only a brief time out to take courses in painting in Munich. Soon before graduation, he and a group of fellow artists founded *Die Brücke* (The Bridge). Like the other members of the group, which eventually included the much older painter Emil NOLDE, Kirchner was deeply influenced by POSTIMPRESSIONISM, FAUVISM, and the works of Edvard MUNCH. The climate was ripe for change, because Dresden galleries were beginning to show works by Vincent VAN GOGH and other Postimpressionists.

Nonetheless, Kirchner, like most artists, did not win immediate recognition. He lived in extreme poverty, sharing a former butcher's shop for a studio and earning money by painting stove tiles. Many of his paintings from these early years were figure compositions, especially portraits and nudes with erotic overtones. Kirchner's forms are typically jagged, his colors jarring. For example, acid yellows are combined with violet and blue shadows.

The artist discovered a receptive audience for his work after moving to Berlin in 1911. He began to part ways with the members of Die Brücke but found other comrades among the artists of *Der Blaue Reiter* (The Blue Rider),

Ernst Kirchner. *Street, Dresden. 1908. Oil on canvas. Museum of Modern Art, New York City* THE ART ARCHIVE/DAGLI ORTI

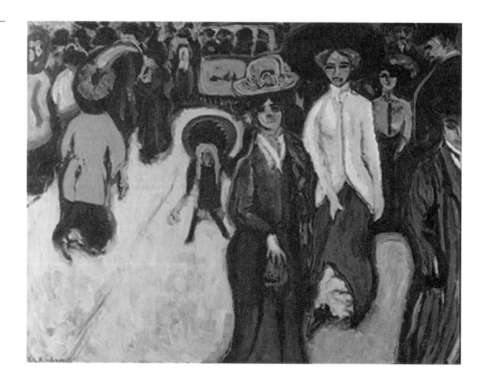

especially Franz MARC. One of Kirchner's paintings was selected for exhibition at the groundbreaking 1913 Armory Show in New York City (*see* sidebar, DUCHAMP) and in a period of four months during 1913–1914, he had three one-man exhibitions in Germany. Kirchner's most celebrated paintings of the period were a series of street scenes, such as *Street, Dresden* (1908), which capture the glare and tension of city life. Perhaps his childhood memories resurface in paintings such as this one: the little girl near the center seems lost and rootless among the bustle of large adult figures.

Drafted into the German army during World War I (1914–1918), Kirchner was soon discharged as unfit for service. He was hospitalized in 1916 and wrote of his distress: "I always have the impression of a bloody carnival. How is it all to end? One feels that crisis is in the air and that everything is mixed up."

In 1917, Kirchner was partially paralyzed after being hit by a car in Berlin; he became dependent on pain-killing drugs for the next four years. He settled in Switzerland, and during his recovery, his artistic style underwent a profound change. He turned to painting mountain landscapes and peasant scenes; the new work showed a measure of serenity missing from his earlier paintings. "Art is a good means to declare one's love to people, without inconveniencing them," he wrote. By this time, Kirchner's paintings and prints were becoming known to a wider audience, and young artists sought him out for advice.

Kirchner visited Germany several times during the 1920s, making extended visits to Berlin, Frankfurt, and Dresden. In the latter part of the decade, he painted less directly from nature and began to experiment with CUBISM, abandoning the rather unfortunate results in 1930. Just as Kirchner began to enjoy a larger reputation in Germany and elsewhere, his health started to deteriorate. As the Nazi regime rose to power during the early 1930s, his finances also began to suffer. The inclusion of his work in the Degenerate Art exhibition of 1937 (*see* sidebar, NOLDE) caused him further anguish. In June 1938, Kirchner committed suicide by shooting himself through the heart.

KLEE, PAUL

Swiss-born German, 1879–1940

One of the most inventive and fanciful artists of the twentieth century, Paul Klee was also a gifted teacher, writer, and musician. His many paintings, drawings, and prints have some of the same freshness and spontaneity as children's art. Klee once wrote, "I want to be as newborn, to be almost primitive."

Early Years and Etchings

Klee was born in Switzerland to a German father and a Swiss mother, both trained musicians. He is often considered Swiss, although he remained a German citizen throughout his life. From an early age, Klee showed a strong talent for music. He learned the violin at age seven, and at ten he was playing in the Bern, Switzerland, municipal orchestra.

By his teens, however, Klee was determined to be an artist and went to study at a private art school in Munich in 1898. Two years later, he enrolled at the Munich Academy. From his school years until the end of World War I (1914–1918), he kept diaries that record his struggle to find himself as an artist.

His works at this time, influenced by the art of the Belgian painter James EN-SOR and the English illustrator Aubrey Beardsley (1872–1898), show promise but little originality.

In the winter of 1899–1900, when he was twenty, Klee met his future wife, a pianist he had met at musical evenings spent with friends in Munich. After completing his studies, the artist returned to Bern, where he earned a living as a regular member of the orchestra. In 1906, he rejoined his wife in Munich and had his first show of etchings*. Their precise, linear technique suggests the influence of Late GOTHIC ART, and they show a fondness for bizarre situations and grotesque figures. In works such as *Two Gentlemen Bowing to One Another, Each Supposing the Other to Be in a Higher Position (Invention 6)* (1903), Klee established the importance that titles would have in his works; they became key to understanding his often baffling subjects.

*etching a method of printmaking in which a design is made on a plate using acid and wax

Travels and Influences

Klee traveled widely in the years before World War I and probably saw works by the French painters Henri MATISSE and Paul CÉZANNE and by the Dutch painter Vincent VAN GOGH. More important to his career, however, was meeting the Expressionist painters of the group *Der Blaue Reiter* (The Blue Rider). Among them were the German painter Franz MARC and the Russian painters Alexey von JAWLENSKY and Wassily KANDINSKY. Kandinsky would become one of his closest friends.

In 1914, a visit to Tunisia in North Africa made a profound impression on Klee. Like other artists before him, he was moved by the brilliance of the sunshine, the clarity of the atmosphere, and the intense colors of this exotic region. "Color possesses me," he wrote in his diaries. "Color and I are one—I am a painter." *The Niesen* (1915), a free interpretation of a Swiss landscape painted a year after his journey, combines glowing tones and an almost Cubist feel for composition with elements of childlike fantasy in the moon and stars at the top of the picture.

World War I Years

Between 1916 and 1918, Klee served in the German army. Unlike his painter friends August Macke (1887–1914) and Franz Marc, both of whom were killed in combat, Klee saw no action. Instead, he worked as a clerk and painted airplanes. Klee viewed the brutality of war with a certain detachment, writing, "I have carried this war within me for some time, and that is why it no longer concerns me internally."

During the war, Klee's reputation began to grow, with an exhibition at a Berlin gallery and the publication of a volume of reproductions. After he returned to Munich, he was rejected for a teaching post on the grounds that his work was "playful in character and lacking firm commitment to structure and composition." A retrospective exhibition a year later, however, was a huge success and led to an invitation to teach at the BAUHAUS school in Weimar, Germany, which was fast becoming the leading school of art and architecture in Europe.

From Bauhaus to Düsseldorf

Klee left Munich for Weimar in 1921 and remained at the Bauhaus for the next ten years. Like other teachers, Klee was required to offer expertise in

more than one subject and found himself giving classes in glass painting, bookbinding, and weaving. He proved an inspired and popular teacher (on his fiftieth birthday, in 1929, one of his former students, Anni Albers, hired an airplane to drop bouquets of flowers over his house). In the most important publication to come out of his Bauhaus experience, the *Pedagogical Sketchbook* (1925), Klee analyzes his own process of creation. Like the Dutch painter Piet MONDRIAN and Kandinsky, with whom he was close during the Bauhaus years, Klee had deeply mystical feelings about the spiritual aspects of the natural world.

Housing as it did some of the major artists and architects of the twentieth century, the Bauhaus was a pressure cooker of forceful personalities. Klee managed to remain aloof from the feuds and factions that arose, earning the nickname Bauhaus Buddha. The quarrels became increasingly tiresome, however, and he resigned his post in 1931 to teach at the Academy of Art in Düsseldorf, Germany.

Final Years and Works

With the Nazi Party's rise to power, Klee was dismissed from the Düsseldorf Academy a scant two years later and returned to Switzerland in 1933, settling permanently in Bern. In 1935, after an attack of measles, his health began to fail. Now that Klee was cut off from the German audience that had so greatly appreciated his style, his work began to change. His magical, sensitive line grew blunt and rough, and his sense of humor turned dark. His imagery, as in *Death and Fire* (1940), contains a sense of doom and despair. The

Paul Klee. *Cat and Bird.* *1928. Oil and ink on canvas mounted on wood.* ARTISTS RIGHTS SOCIETY

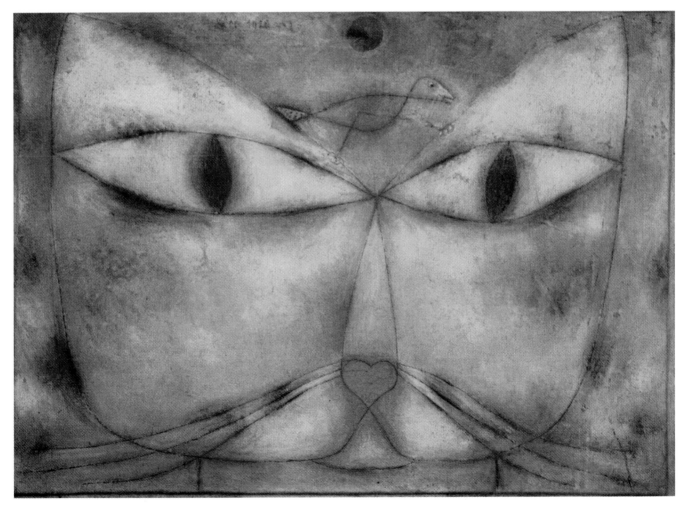

features of the ashen face depicted in this painting spell out the word *Tod* (German for "death").

At the time of his death in 1940, Klee left behind a huge body of work; his total output of prints, drawings, and paintings has been estimated at approximately nine thousand works. He worked on a small scale and rarely ventured into abstraction, shuttling freely from one inspiration to another. His art draws on virtually all of the major innovations of the late nineteenth and early twentieth centuries, tapping into a rich vein of fantasy. Figures, faces, landscapes, buildings, and still lifes were all transformed in his hands into moments of whimsy, magic, and mystery. On Klee's gravestone is written an extract from his diaries: "I cannot be grasped in this world, for I am as much at home with the dead as with those yet unborn—a little nearer to the heart of creation than is normal, but still too far away."

(**See also** ABSTRACT ART; CONSTRUCTIVISM; CUBISM; EXPRESSIONISM; SYMBOLISM.)

KLIMT, GUSTAV

Austrian, 1862–1918

One of the leading painters of the ART NOUVEAU movement, Gustav Klimt was the son of a goldsmith. A love of intricate patterns and lavish decoration, perhaps inspired by the jeweler's art, would surface in his work throughout his career.

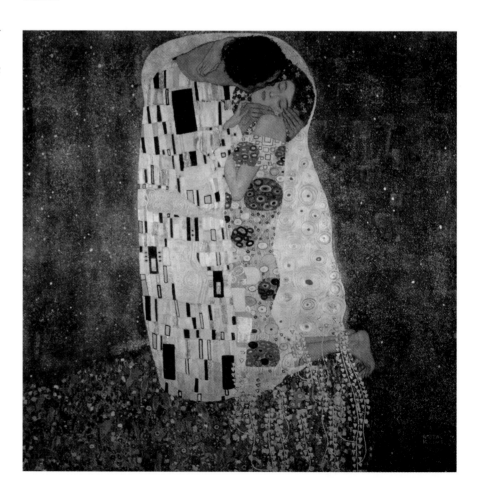

Gustav Klimt. *The Kiss. 1907–1908. Oil on canvas. Austrian Gallery, Vienna, Austria*
AUSTRIAN ARCHIVES/CORBIS

Secession Movements

The Vienna *Sezession* (Secession) was one of many similar movements that spread across Europe in the last decade of the nineteenth century. Artists of the time rebelled against the stifling powers of the art academies, which still taught classes using out-of-date techniques and tired formulas. The academies also monopolized exhibitions, deciding what kind of work could be shown to the public. That stranglehold on the visual arts led young painters, sculptors, and architects to form their own alternative groups. Recognizing the international thrust of modern art, the groups wanted to make their works known to a broader public and to exchange ideas through exhibitions and publications.

The first group to be founded was the Munich Secession in 1892, followed a year later by the Berlin Secession. The most famous, however, was the Vienna Secession, founded in 1897, of which Klimt became the first president. In its first seven years, the group held twenty-three exhibitions, supported by guided tours and free catalogues. The various secessions had a profound influence on modern art in the early twentieth century, providing a model for the rebellious avant-garde movements that would soon follow.

Klimt trained in a traditional academic curriculum and quickly became established as a mural painter in his native Vienna. In partnership with his brother Ernst, who was also a painter, Klimt landed an important commission around 1900 to create a series of paintings for the new Burgtheater in Vienna. Other prestigious projects followed, including the decorations for the Great Hall of Vienna University. Soon, however, his work brought him into conflict with the Austrian Ministry of Culture. Klimt was openly critical of what he saw as the decadence of Viennese society. In one work, he included nude men and women, old and young, overweight and terribly thin, surrounded by terrifying, mask-like faces with huge, staring eyes. After long and bitter arguments with the officials who commissioned the series, the artist gave up work on the paintings and returned his fee.

Like most artists in his native city, Klimt was a member of the Viennese Artists' Association. In the mid-1890s, dissatisfied with the conservative attitudes of the association, he joined a group of younger artists in setting up the *Sezession* (Secession), to which he was elected president. Their stated program was to "raise the flagging art of Austria to contemporary international standards." In time, even that group would prove too conservative for the ambitious Klimt, who withdrew from the *Sezession* to found an even more radical group.

In spite of his difficulties with fellow artists and official patrons, Klimt was considered the most important painter in Vienna in the early years of the twentieth century. After the official commissions stopped coming, he continued to be in great demand as a painter of portraits and symbolic scenes. He was especially sensitive to female beauty and did several striking likenesses of his mistress, Emilie Flöge, the owner of a fashionable dress shop.

Klimt's typical formula was to portray faces and bodies in a realistic style, although he often painted them in icy blues and grays. Backgrounds and clothing consisted of flat, highly decorative patterns, often reminiscent of Byzantine mosaics or Art Nouveau fabric designs. In one of his most celebrated paintings, *The Kiss* (1907–1908), of which Klimt made several versions, two lovers stand on a flower-covered bank, their bodies fused together inside luxuriously patterned golden robes. In a gesture that is both openly sexual and disturbingly

possessive, the man grasps the woman's face with both hands to kiss her up-turned cheek. With the exception of the faces and hands in the painting, the overall design is almost totally abstract.

The final decade of Klimt's life was far less stormy than the years of his early commissions. His stature as a painter led to his election as an honorary member of both the Academy of Fine Arts in Vienna and the Academy of Fine Arts in Munich, Germany. Although a younger generation of Expressionist painters began to rebel against his highly stylized work, Klimt had a deep impact on the work of two of his followers, the Austrian painters Oskar KOKOSCHKA and Egon SCHIELE. Klimt died suddenly in 1918, after suffering a stroke that led to paralysis of his right side and an infection of the lungs.

(*See also* BYZANTINE ART; EXPRESSIONISM.)

KOKOSCHKA, OSKAR

Austrian, 1886–1980

Oskar Kokoschka was one of the trio of great Viennese Expressionist painters that also included Gustav KLIMT and Egon SCHIELE. As a boy, Kokoschka was drawn to chemistry, but one of his teachers at the Vienna School of Arts and Crafts was so impressed by his drawings that he recommended the young artist for a scholarship. Kokoschka studied there from 1905 to 1909, at the same time painting fans and designing postcards for the *Wiener Werkstätte* (Vienna Workshops). Kokoschka also wrote two experimental plays, *Sphinx and Strawman* and *Murderer, the Women's Hope*.

Kokoschka's Portraits

Kokoschka soon began to make a name for himself as a painter with a series of psychological portraits. In these works, he claimed to lay bare the soul of his subjects. Using a scratchy, quivering line and patchy color, he sought to probe into his sitters' innermost torment, showing each at his most defenseless. The soul that was revealed, however, might have belonged more to the artist than to the subject, as the art historian H. H. Arnason has noted.

Kokoschka's 1909 portrait of the Austrian architect Adolf Loos (1870–1933), who was soon to become one of his biggest supporters, is typical of the psychological portraits. The figure seems insecurely placed against a dark, swirling background, and Loos's nervously joined hands echo the tension in his craggy face.

Effects of World War I

The Austrian establishment considered Kokoschka's paintings and dramas scandalous, and their violent subjects cost him his job at the Werkstätte. "This fellow's bones ought to be broken in his body!" the Austrian archduke Ferdinand commented. The artist's personal life was as tempestuous as his professional career. In 1911, Kokoschka began a passionate affair with Alma Mahler, widow of the Austrian composer Gustav Mahler (1860–1911). He immortalized their relationship in the large canvas *The Tempest* (also known as *The Bride of the Wind*) [1914], which shows two ravaged, half-naked figures tossed in a storm cloud of gray and violet brushstrokes.

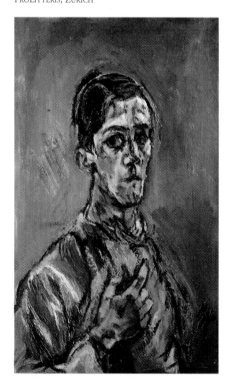

Oskar Kokoschka. *Self-Portrait. 1913. Oil on canvas. Museum of Modern Art, New York City* BURSTEIN COLLECTION/CORBIS © 2001 ARTISTS RIGHTS SOCIETY (ARS), NEW YORK/ PROLITTERIS, ZÜRICH

Kokoschka served as a lieutenant in the Austrian army during World War I (1914–1918), suffering injuries, including a punctured lung, in 1916. After being sent into combat a second time, he experienced a complete breakdown and settled in Dresden, Germany. His anguish seems to have been as much mental as physical. Still hurting from his breakup with Alma two years earlier, Kokoschka fashioned a life-size doll made in her image. He treated the effigy like a living companion, escorting it to dinner parties and to evenings at the opera.

After the war, Kokoschka's health and fortunes improved. In 1919, he was appointed professor at the Dresden Academy. The German composer Paul Hindemith (1895–1963) set Kokoschka's play, *Murderer, the Women's Hope,* to music in 1921. And a contract with the influential art dealer Paul Cassirer began to bring in money. After 1924, however, the restless artist abruptly resigned his teaching post and set off on a seven-year period of travel to Europe, Egypt, North Africa, Turkey, and Palestine. He turned from portraiture to landscape painting, developing a distinctive kind of townscape, portraying towns as if he were standing above them.

World War II and Later

Back in Vienna in the 1930s, Kokoschka came into conflict with the Nazi Party, which later declared his work "degenerate." When the Nazis came to power, hundreds of his paintings were removed from museums and confiscated (*see* sidebar, NOLDE). Uneasy with the political situation, he left Austria, settling in London in 1938. Although Kokoschka had gained an international reputation, his work was little known in England, and he spent the World War II years (1939–1945) in poverty. In 1939, Kokoschka was living in Cornwall, making watercolors of the local scenery, while his wife, whom he had met in Prague, ran a pastry shop to help make ends meet. In spite of all Kokoschka's difficulties, his work retained the freshness and freedom of his early years.

The post–World War II period brought a new round of acclaim for Kokoschka, who shared the honors with the late Austrian artists Klimt and Schiele in a major exhibition in Vienna. Other important shows followed in Bern, Switzerland, in 1947 and in Venice in 1952. From 1953 to 1963, Kokoschka founded and taught at the *Schule des Sehens* (School of Seeing) at the International Summer Academy for Visual Arts in Salzburg, Switzerland. He settled for the remaining years of his life at Villeneuve on Lake Geneva. Unaffected by newer trends in modern art, Kokoschka pursued his own distinctive vision to the end. He remained a highly respected figure until his death at age ninety-four.

(***See also*** EXPRESSIONISM.)

Wiener Werkstätte

When Austrian artists who were dissatisfied with the rules of the official academy broke away to form the *Sezession* (Secession), they also established an arts and crafts workshop known as the *Wiener Werkstätte* (Vienna Workshops). Founded in 1903, the Wiener Werkstätte bore certain similarities to the Arts and Crafts Movement, founded in the late 1800s, which preceded ART NOUVEAU in England.

Like its British counterpart, the Viennese workshop was composed of members who hoped to combine beauty and usefulness, producing objects that ranged from jewelry to complete room decorations. The goal was to bring aesthetic pleasure to a wider audience than the one that visited museums and galleries. However, high prices defeated that aim, and today objects produced at the Wiener Werkstätte command huge sums at auction. Nonetheless, the workshop survived for twenty years and offered employment to some promising artists, such as Oskar Kokoschka and Gustav KLIMT.

KOLLWITZ, KÄTHE

German, 1867–1945

Raised in an intensely religious family, the German graphic artist and sculptor Käthe Schmidt Kollwitz brought a spirituality to her mature sculptures and prints even after she abandoned any formal beliefs. A deeply empathetic person, Kollwitz was an eloquent advocate for the victims of social injustice, famine,

***engraver** one who makes prints by using a sharp instrument to render a pattern, design, or letters on a hard surface (usually wood, stone, or copper plate)

***etching** a method of printmaking in which a design is made on a plate using acid and wax

Käthe Kollwitz. *Death, Woman, and Child.* 1910. *Etching. Museum of Modern Art, New York City* GIFT OF MRS. THEODORE BOETTGER. COURTESY OF THE MUSEUM

and war. She began studying art at age thirteen with an engraver* who taught her PRINTMAKING. This training oriented her toward the graphic arts rather than painting.

As a student in Berlin and Munich, Kollwitz became interested in sociopolitical causes, especially feminism and Socialism. Her sympathies for the poor and downtrodden were reinforced after her marriage to Karl Kollwitz, a physician, in 1891. They lived in a poor section of northern Berlin, where her husband ran a clinic and Kollwitz saw firsthand the wretched conditions of the working classes.

Kollwitz had her first exhibition in 1893. The same year, she saw a play, *The Weavers,* by the German writer Gerhart Hauptmann (1862–1946) that inspired a series of six prints completed in 1897 and 1898. The play was based on a revolt of handloom weavers in Silesia (now part of Poland) in 1844 when their livelihood was threatened by the introduction of machines. Kollwitz's series, *Weavers' Revolt,* caused a scandal because of its radical subject matter and uncompromising support for the workers. Although the exhibition jury wanted to award her a gold medal, the government vetoed it. The series was so powerful, however, that it won awards when later shown in Dresden and London.

Another major cycle of prints, based on the sixteenth-century Peasants' War in Germany, was shown in 1908. Kollwitz was awarded a year's study in Italy thanks to the success of these works. Like the etchings* of the Spanish artist Francisco GOYA, *Losbruch,* from Kollwitz's series *The Peasants' War,* is a powerful and disturbing image. However, Kollwitz's true inspiration came from German GOTHIC ART, including the paintings and prints by such masters as

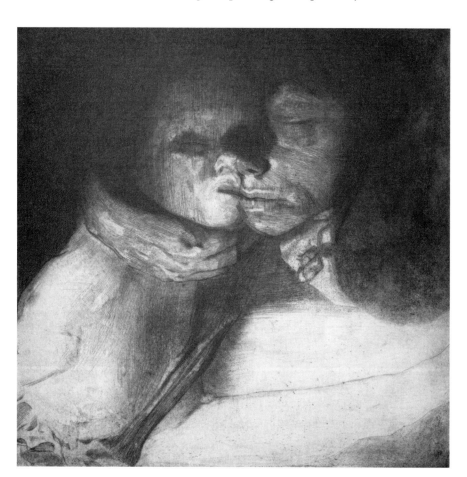

Matthias GRÜNEWALD and Albrecht DÜRER. Like these great artists, Kollwitz is able to convey a strong message through often starkly rendered images.

The years from 1910 until after the end of World War I (1914–1918) were relatively unproductive ones for Kollwitz. The younger of her two sons died in battle in Flanders (now part of northwestern Belgium) in 1914. In spite of Kollwitz's personal tragedy and her subsequent limited output, her reputation continued to grow. In 1919, she became the first woman to be elected to the Prussian Academy of Art in Berlin.

During her later career, Kollwitz turned toward more abstract themes, motherhood in particular. After the war, she also began to experiment with sculpture, beginning work on a granite memorial to her son and other fallen war volunteers. The war strengthened her leanings toward left-wing politics and pacifism, and she visited the Soviet Union in 1927. In 1933, after the Nazi Party rose to power, she was expelled from the Prussian Academy and publication of her prints was restricted. Nonetheless, Kollwitz completed a last great sequence of prints, *Death,* in 1936. Her lithograph* *Death Seizing a Woman* (1934) uses powerfully compact figures realized in snaking lines to convey a feeling of unspeakable terror.

*lithography the process of printing from a smooth, flat surface (such as a stone or metal plate)

Kollwitz's husband of nearly fifty years died in 1940, and her studio was destroyed in World War II (1939–1945) bombings. She spent the last year of her life as a guest of Prince Ernst-Heinrich of Saxony at his castle near Dresden. Her deeply pessimistic work, which reflected the difficult times through which she had lived, remains one of the high points of German EXPRESSIONISM. In 1922, she wrote, "I should like to exert influences in these times when human beings are so perplexed and in need of help."

(*See also* SOCIAL REALISM.)

KOREAN ART

Korea's distinct artistic tradition presents a fascinating synthesis of Korean religion, philosophy, and a turbulent political history. Korea's geographic location, a peninsula between China to the west and Japan to the east, encouraged active contact with both nations. Throughout history, Korean painting, ceramics, metalwork, and other decorative arts were strongly influenced by Chinese sources, and the arts of Korea, in turn, exerted a significant impact on the arts of Japan. Perhaps the most highly articulated expression of Korean aesthetics is Korea's rich ceramics history, ranging from refined, subtle celadon* to robust, dynamic stoneware* and porcelain*.

*celadon color in the range of green to blue; also refers to ceramics bearing such color

*stoneware a heavy, nonporous pottery made from impure clay that is fired at a high temperature

*porcelain a hard, usually translucent and white ceramic made from clay that is fired at a high temperature

The Three Kingdoms

Among the earliest surviving objects from Korea are comb-patterned, geometrically shaped ceramic storage vessels, dating from at least 3000 B.C. By 1000 B.C., Mongols introduced bronze technology to the region. Soon, bronze bells, mirrors, weapons, and other objects were produced, often for ceremonial purposes.

During the following period, known as the Three Kingdoms period (c. 57 B.C.–A.D. 668), the dynasties of Koguryo, Silla, and Paekche set the foundation for Korean art. Koguryo, the largest and most northerly kingdom, was

under Chinese rule until the fourth century, but continued to be a conduit for Chinese culture in the following centuries as well.

In the fourth century, BUDDHIST ART was brought from China to Koguryo, and it spurred production of religious statuary and paintings, and the construction of temples. Sculpture of the Three Kingdoms period shows the general influence of third-century Chinese dynasties, especially in its rendering of long, stylized drapery.

A particularly fine example of late sixth-century Buddhist sculpture is the gilt bronze Seated Maitreya, a national treasure housed in the Seoul National Museum of Art. Its overall balance and gentle facial expression convey the quiet meditative nature of Buddha. The seated Buddha's right leg is crossed over its left, and the right arm is gracefully raised to the face in a gesture of contemplation.

Throughout the Three Kingdoms period, Buddhist sculptures became more refined and increasingly reflected distinctly Korean attributes, particularly facial expressions. Beginning in the third century and continuing through the sixth century, Buddhism and its related arts were actively transmitted to Japan. Many Korean objects from this period were later found in Japan.

Silla Dynasty

The Silla monarch eventually unified the entire Korean peninsula, in a period known as the Unified Silla period (668–932). Much of what scholars know about Silla was learned from the excavation of the numerous tombs in the ancient capital, Kyongju. Among the striking objects uncovered were gold and jade burial crowns and gray-colored stoneware. Silla crowns, made of thin, rolled sheets of gold, often bear cascading jade pendants, which are comma-shaped. Tall stands, made of gray stoneware and bearing figures or incised with decorations, were also produced during the Silla period; these formed the basis for later Korean stoneware ceramics.

Buddhism continued to thrive during the Unified Silla period, and temples proliferated throughout the peninsula. The most important was the Sokkuram cave temple on Mount T'oham, near Kyongju. Constructed in the 750s, the Sokkuram temple was carved into the side of a granite mountain facing the East Sea. The temple contains a massive yet delicately carved stone Buddha. This Buddha, with a strongly volumetric form (it stands ten feet tall) and a benevolent expression, is similar in style to Indian prototypes, especially in its garments and hand gesture. The Sokkuram cave also contains relief* sculptures of Buddhist attendants and guardian figures.

Koryo Dynasty

The Silla monarchs eventually weakened and were succeeded by the Koryo dynasty (932–1392). Buddhism achieved the status of state religion, and it played an important role in unifying the country. Paintings of Buddhist deities and Buddhist themes, as well as illuminated texts, were produced, often stylistically mirroring their Chinese counterparts.

The Koryo period was renowned for its celadon ceramics, which appealed to the elegant tastes of the aristocracy. The blue-green color of celadon results from an addition of iron to the glaze, which is fired in a reduction, or oxygen-deprived, atmosphere. Because glazed ceramics technology had reached Korea

***relief** sculptural figures or decorations that project from a flat background

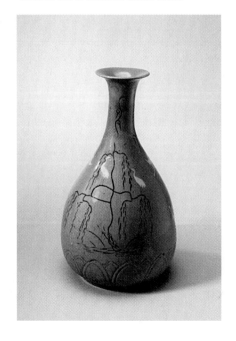

Inlaid pear-form bottle. *Koryo dynasty. Celadon ware.* CHRISTIE'S IMAGES/CORBIS

via China's Song (or Sung) dynasty (960–1279), Koryo celadons were influenced by Chinese celadons. But, by the twelfth century, the glaze and form of Koryo celadons became more refined than the Chinese ceramics. Vases, bowls, and beverage containers often took highly imaginative shapes like tortoises, melons, and bamboo shoots.

The *maebyong* or Prunus vase, with a small lip, wide shoulder, and narrower base, typified the perfection that Koryo patrons demanded. Elegant designs, abstract or pictorial, were often incised into the wet clay before firing.

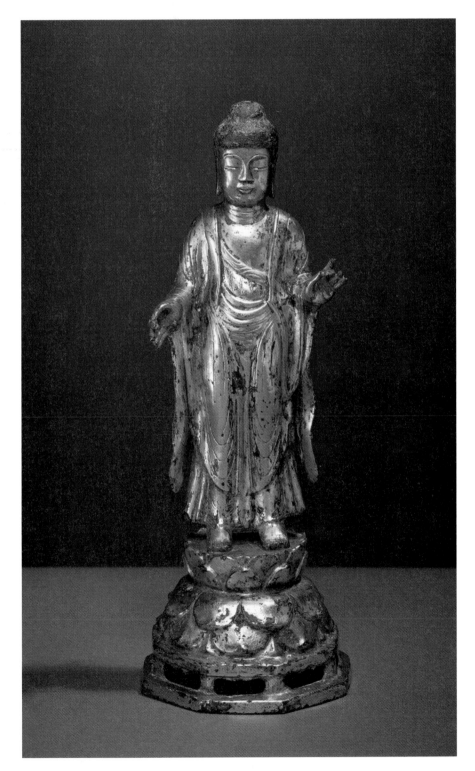

Buddha. *Eighth century. Gilt-bronze. Royal Ontario Museum, Toronto, Canada* COURTESY OF THE MUSEUM

Drawings of cranes and clouds (Taoist symbols of longevity), lotus blossoms (symbols of Buddhism), willow trees, grasses, grapevines, and plum blossoms were often placed within graceful borders and arabesque designs. Sometimes such incising was inlaid with white or brown slip*, an unusual technique for the time in East Asia. The great age of celadon was brought to a close by the turbulent Mongol invasions in 1231.

slip liquid clay, often used for ceramic surface decoration

Choson Dynasty

The Choson dynasty (1392–1910) saw a major upheaval in Korean government structure. Buddhism was supplanted by the new state orthodoxy, Neo-Confucianism, which emphasized social order and adherence to a strict code of behavior. While preference for celadon declined, two new styles of ceramics developed, *punch'ong* and white porcelain.

Punch'ong is stoneware decorated with white slip, using inscribing, stamping, or brush design techniques—or a combination of these techniques. Punch'ong was highly prized by the Japanese, and during Japanese warlord Hideyoshi Toyotomi's (1537–1598) military invasions of Korea, many Korean artisans, including potters, were forcibly taken to Japan. White porcelain, characterized by a modest, unostentatious expression, embodied Neo-Confucian codes prohibiting extravagance.

In the Choson dynasty, the variety of painterly styles increased dramatically. From this period onward, landscape painting enjoyed great popularity. Such paintings reveal an active interest in the natural world and people's relationship to it. With mountains covering about seventy percent of the Korean peninsula and since mountains were worshiped by early Korean shamans*, these natural landmarks figured prominently in painted scenes. Landscapes displaying Chinese themes were produced by Korean court artists such as An Kyon (active c. 1440–1470), who synthesized the monumental landscape techniques of the northern Chinese Sung with depictions of Korean scenery. These landscapes are often mounted on eight-fold screens. Yi Sang-jwa (active late 1400s–mid-1500s) was noted for a Confucian-style landscape, in which the scene is highly ordered. Yi's style was similar to the Chinese Ma-Xia tradition, of Southern Song painting style, in which the composition is intensified in one corner and natural forms are highly angular.

shaman a spiritual leader of shamanism, a belief system that focuses on the divine in the natural world

Many depictions of civil or military officials (*yangban*), farmers, and artisans were also painted during the Choson period. Amateur scholar-painters produced some of the best painting in this era. And although themes and techniques were similar to Chinese styles, Korean artists generally painted with brighter colors and in broader, bolder strokes. Several Korean paintings of the fifteenth and sixteenth centuries were later found in Japan, and it is likely that Japanese artists of the period were schooled in Korean techniques.

genre painting painting that focuses on everyday subjects

By the late eighteenth century, humorous genre paintings* proliferated. Caricatures by Kim Duk-Shin (1754–1822) and Shin Yun-bok (1758–after 1813) give the viewer a picture of everyday Korean life. "True-view" landscapes (*chin'gyong sansuhwa*) were also developed during the late Choson. These compositions feature a native Korean landscape rather than an imagined view. The foremost painter of the true-view was Chong Son (1676–1759). He often included poetic inscriptions about the profound qualities of the scenes he painted. Pictures of real scenes, like that of Mount Inwang in the western section of

Seoul, became popular. Such paintings reveal the late-Choson interest in distinctly Korean concerns. The tradition of true-view landscapes continued well into the nineteenth century.

Twentieth Century

During the Japanese occupation of Korea (1905–1945), the arts were generally in decline. The country remained in upheaval during and following the Korean War (1950–1953). But, beginning in the 1960s, art enjoyed a renewed strength and energy. Traditional Korean themes were reinterpreted and an international art flourished. Contemporary artists include Nam June Paik (born 1932), who became widely acclaimed for his revolutionary use of video to create striking art installations. —MEGHEN M. JONES

(*See also* CHINESE ART; JAPANESE ART.)

KORIN

Japanese, 1658–1716

Ogata Korin was one of the most influential members of the Rinpa school in Japan—in fact, the name Rinpa is derived from his name, meaning literally "school of [Ko]rin." He was born into a wealthy family in Kyoto that had made its money in the textile business. In the early years of the eighteenth century, however, the business went into decline, and Korin and his brother Kenzan, a ceramicist, began making a living by producing art for the increasingly wealthy merchant class.

In the family tradition, Korin began as a decorative artist, designing textiles, fans, and lacquerware, but he turned increasingly to painting. His roots in textile design are apparent in his two-dimensional work, however. When depicting traditional subjects, Korin's paintings rely on broad areas of bright colors, with forms arranged decoratively rather than naturalistically. This type of painting owes much to the work of Tawaraya Sotatsu (active 1600–1630s),

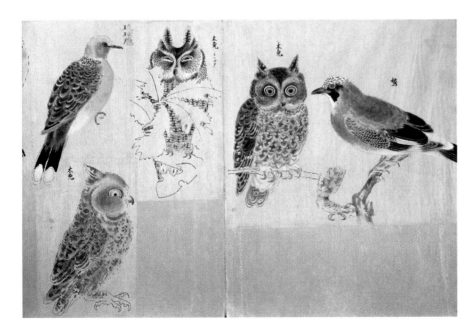

Korin. *Sketches of Birds.* BURSTEIN COLLECTION/CORBIS

who produced abstracted renditions of traditional subjects a century before Korin. Korin was fascinated by Sotatsu's work and revived many of his artistic practices, such as painting in layers of wet color on wet color (called *tarashikomi*), a technique that achieved a mottled, irregular effect.

Korin also reinvigorated the courtly subject matter of the Heian period (794–1185), seen as the golden age of Japan. In his reliance on classical literature for artistic content, Korin allied himself with the traditional center of Japanese culture, the imperial court in Kyoto, even though the real seat of power had shifted to Edo (present-day Tokyo). Perhaps not surprisingly, the school of painting and decorative arts that derived from his style flourished most notably in Kyoto, although there were artists using it throughout the country. The artists of the Rinpa School did not work together in any organized fashion, but their productions were linked by their reliance on Korin and Sotatsu's preference for traditional subjects rendered in a decorative style. —ELLEN ROBERTS

(*See also* JAPANESE ART.)

LAM, WILFREDO

Cuban, 1902–1982

The Surrealist paintings of Wilfredo Lam are rooted in the rich culture of his Cuban homeland. Born in Havana, his father was Chinese and his mother was of African, American Indian, and Spanish descent. Lam integrated his Cuban upbringing and the various elements of his heritage into his art, where they co-exist with the styles of the European art of his day. He also incorporated into his works the spiritual and artistic motifs* that he observed in his extensive travels.

After studying in Havana, Lam moved to Spain in 1923. In 1938, he relocated to Paris, where he became acquainted with André Breton (1896–1966), a founder and chief promoter of SURREALISM. Lam also became friends with Pablo PICASSO, whose studio he worked in.

In 1941, Lam returned to Cuba. There he was both an insider and an outsider. An intellectual who had trained abroad, he viewed his native African Cuban culture from the perspective of an interested observer. In 1943, he began work on *The Jungle.* "When I was painting it, the doors and windows of my studio were open and the passers-by could see it. They used to shout to each other: 'Don't look, it's the Devil!' And they were right," Lam said.

The Jungle, housed in New York's Museum of Modern Art, is among the richest examples of Lam's exuberant, inter-cultural explorations. Picasso's influence is also clear. In a forest of greens and blues, several abstract, masked figures are engaged in a ceremony. The composition is both exciting and frightening: a hand wields an enormous pair of scissors, the blood of ritual killings is on the ground, faces are both startled and bemused. The work is so evocative of a tribal ritual that the viewer may well believe that he or she can hear the incessant beating of drums.

The African masks and carvings that Lam painted fascinated his fellow artists, the European Modernists. He liked to explore the rituals and rhythms of Santeria, a Cuban religion that combines African tribal beliefs with Roman Catholicism. After visiting Haiti in 1946, Lam began incorporating aspects of voodooism in his works. Captivated by African and Caribbean island traditions, his figures combine human elements with aspects of animals and vegetation, creating all-new life forms.

*motif a favorite symbol or subject in an artist's work

Lam's work was first exhibited in New York City in 1943. Many spectators found his art shocking, with its strange and exotic subjects, rendered in an abstract form. Although he spent much of his time in Paris and New York City, and later lived in Italy, he remained one of Cuba's leading artists. Lam's works exerted a great influence on the northern European COBRA painters.
—BARBARA M. MACADAM

(*See also* LATIN AMERICAN ART.)

LATE GOTHIC ART

See NORTHERN RENAISSANCE ART.

LATIN AMERICAN ART

The art of Latin America includes the heritage of Mexico, Central America, and South America—regions that were first colonized by Europeans in the early sixteenth century. The long era that began with the initial contact between Europeans and Native Americans and ended in the early 1800s, when people throughout the Americas cast off the yoke of European domination, is called the colonial period.

Artists who worked during the colonial period took their cues from Europe. Although local traditions survived, sometimes secretly or in ways that were not immediately obvious, Latin American culture was strongly influenced by European BAROQUE ART, which reached its peak in the seventeenth and early eighteenth centuries. The Baroque held sway over the visual arts, as well as architecture and literature. Many twentieth-century Latin American artists looked back to the Baroque as the true source of their sensibility.

Colonial Art and Architecture

As in the architecture of Europe during the Renaissance (c. 1350–c. 1600), patrons of the arts in Latin America during the colonial period were members of the court or of the church hierarchy. Secular (nonreligious) architecture tended to express state authority, notably the authority of the courts of Spain and Portugal, the primary European colonizers of the region. The Spanish deliberately built their own structures on top of the ruins of pre-conquest civilizations—notably at the seats of the ancient Aztec and Incan Empires in Mexico, Peru, and Ecuador. The intention was to obliterate vestiges of the past and replace old symbols with the new symbols of Spanish dominance.

But aspects of Native American culture still made their way into the largely European-influenced church art and architecture. So, for example, the putti* in many colonial cathedrals have distinctly Native American faces. Part of this was deliberate: Catholic church leaders included familiar images and iconography* as part of their mission to attract Native American masses to church and convert them to Catholicism. The facade* of the Church of San Lorenzo in Potosí, Bolivia, built around 1728, expresses the architectural spirit of the age. This New World Baroque work features a Native American princess amid the

*putto (plural, putti) a cherub (small angel) rendered as a chubby male baby, often with wings; especially popular in Renaissance art

*iconography the symbols, signs, and images that are associated with a work of art, an artist, or a body of art

*facade the exterior face of a building, usually the front

vines and angels typical of Europe, as well as Peruvian guitars and symbols of the destroyed world of the ancient peoples.

The leading eighteenth-century Brazilian sculptor, Antonio Francisco Lisboa (1738–1814), known as Aleijadinho, was the son of a Portuguese architect and a black slave. In the prevailing European style of ROCOCO ART, he carved religious figures out of stone and wood. His major works were those at the Church of Saint Francis of Assisi, Ouro Prêeto, Brazil.

Throughout Latin America, city planning follows a standard pattern: a central plaza has a church at one end and a secular building at the other. Off the town squares, streets are set out at right angles. The *Zocalo,* the main square in Mexico City, for example, features a Baroque cathedral surrounded by eighteenth-century buildings, including the National Palace, which houses the president's offices.

Paintings During this time, painting followed traditional European genres: history painting*, genre painting*, still lifes, and portraiture. In eighteenth-century Mexico, however, artists began producing a new type of composition, the *casta* painting (*casta* means "caste" or "class"). These paintings were intended to reinforce socioeconomic class standings even though Latin America was becoming increasingly diverse: "pure" races—Spanish, black, and native—were intermixing, producing a variety of mestizos (those of mixed heritage). The Spanish authorities wished to assert that the society was, nevertheless, ordered. They also wanted to impose on it their own hierarchy. Thus the casta painting was born.

Casta paintings, of which there were sixteen accepted types, each depicted a couple and their children. The families are shown in settings that were perceived to be typical of each couple's heritage. A pure-blooded male and female and their privileged offspring were shown in elegant dress, often surrounded by European wares as well as the bounty of the New World—chocolate, tobacco, maize (corn), potatoes, tomatoes, and pineapples, which had been unknown in Europe. But the mixed-race men and women and their children were illustrated in worn clothing and in shabby settings; they were given animalistic labels, such as "wolf" (the child of a black man and a Native American woman) and "coyote" (the child of a Native American father and a Mestizo mother).

Among Mexico's accomplished casta painters were Juan Rodríguez Juárez (1675–1728) and Luis Berrueco (active eighteenth century). But the paintings were also produced in other Latin American countries, providing historians with a classification system for the region's colonial society.

Latin American arts remained on the periphery of the European tradition until the 1800s. The Napoleonic Wars (1799–1815), which included a French invasion of the Iberian Peninsula, caused Europe's once mighty Catholic powers to look inward. Thus distracted by battles at home, Spain and Portugal gradually lost control of their New World colonies.

Independence

Beginning in the first half of the 1800s, Latin America was consumed by the disintegration of the Spanish and Portuguese empires, civil wars, and the founding of new, independent nations. The violent upheavals of the period were not favorable to the arts. Once set free from the mother countries, the Spanish- and Portuguese-speaking nations of the Western Hemisphere found

***history painting** a picture that depicts an important historical occasion

***genre painting** painting that focuses on everyday subjects

themselves in a position to define their art for themselves. Yet, the European influence remained pervasive and the nineteenth century proved to be a transitional time for the arts, as it was in government and politics.

Continued interaction with Europe led to Baroque being eclipsed by the rise of NEOCLASSICAL ART. History paintings proliferated. For example, in the 1830s, Venezuelan artist Juan Lovera (1776–1841) created a famous depiction, titled *El 5 de Julio de 1811,* of the proclamation of his country's independence in 1811. Characteristic of the time, Lovera painted in the Neoclassical style of the great French master Jacques-Louis DAVID.

Portraiture became popular in Argentina. There Carlos Enrique Pelligrini (1800–1875) painted figures like the tyrannical Argentine dictator Juan Manuel de Rosas (1793–1877), who unified, but later fled, the country. Artists such as Argentine Juan Léon Palliere (1823–1887) and Uruguayan Juan Manuel Blanes (1830–1901) celebrated national heroes and tyrants, cowboys (*gauchos*) and the *pampas* (plains), as well as a new breed of hearty settlers.

In Mexico and Brazil, the major art academies established by the Europeans continued to produce artists trained in the European manner. In Mexico City, the Spanish had established the San Carlos Academy in 1785, ensuring the dominance of European art until the Mexican Revolution began in 1910. In Rio de Janeiro, Brazil, the Portuguese had founded the Royal Academy, where French painters were hired to teach Neoclassical principles to students. Imitative and academic artists continued to produce paintings in the style of Paris throughout the 1800s. Portraits of women standing beside pot-bellied stoves—considered an exotic element in tropical Brazil—are typical of this approach.

Throughout Latin America, a great number of landscapes, local scenes, and genre paintings (or *costumbrismo*) were produced, as part of the legacy of the casta paintings. Folk traditions persisted, particularly in the form of ex-voto (votive) paintings and sculptures—small works on tin, depicting miracles and expressing gratitude to saints. Native Americans became popular subjects and were portrayed alternately as noble savages or with classical European faces. The latter was the case in *The Discovery of Pulque* (1869), a historical scene, executed in the tradition of Neoclassicism, by José Obregón. Mexican landscape painter José María Velasco (1840–1912), who created large-scale landscapes in the eighteenth-century Italian style, portrayed the history and geography of Mexico.

naive art fresh, childlike painting characteristically employing bright colors and strong, rhythmic designs; usually the work of untrained artists

Popular art in Mexico also included semi-academic painting and naive* portraiture. The most famous of the portraitists, Hermenegildo Bustos (1832–1907), made distinctive close-ups that were also insightful renderings. At the same time, the caricature and the print thrived. José Guadalupe POSADA was highly influential in this field, printing and distributing broadsides (large pieces of paper, printed on both sides), featuring his skeletons (*calaveras*). The printed images parodied high society and politicians while championing the rights of the poor. Julio Ruelas (1870–1907), a Mexican illustrator and symbolist, was fascinated by the work of Albrecht DÜRER, Hieronymus BOSCH, and Pieter BRUEGHEL.

Modernism

Following Latin America's revolutionary period, the establishment of order and the emergence of a middle class set the stage for an artistic revival. The

modernismo (modernism) movement (1880–1920) struggled to redefine artistic principles and recover the ground that was lost during the anarchic 1800s. However, as Latin American artists sought to produce their own reality on their own terms, imitation of European styles continued.

Two seemingly divergent impulses manifested themselves in the artwork of the late nineteenth and the early twentieth centuries: the desire to catch up with European modern art trends and a determination to express or comment on Latin American society. The works by the avant-garde* were characterized by social undercurrents. In Mexico, muralism and *Estridentismo,* a movement rooted in FUTURISM and Communist ideology, blended European techniques with local content. In Argentina, *Ultraísmo* freely mixed SURREALISM, CONSTRUCTIVISM, and EXPRESSIONISM. The complex style was exemplified by the work of Xul Solar (1888–1963).

Variety within Avant-Garde Movement By the 1920s, the avant-garde abandoned modernismo, which came to be regarded as nostalgic and insufficiently local. In Brazil, the turning point came in 1922 with São Paulo's "Week of Modern Art." The event, with its nationalist overtones, signaled the beginning of a new era for Brazilian art. Painter Tarsila do AMARAL and her husband, poet and theorist Oswald de Andrade (1890–1954), championed Brazil's modern movement. Personally acquainted with such European artists as Pablo PICASSO, Amaral combined elements of FOLK ART, CUBISM, and Surrealism in her works, but her subjects were decidedly Brazilian; its villages, Baroque churches, and coffee plantations. In 1925, Andrade coined the term *Pau-Brasil* (Brazilwood) to describe his wife's groundbreaking works. Similar movements took hold in other Latin American countries.

***avant-garde** literally, the "advanced guard"; a term describing innovators or innovation in a particular field

José Guadalupe Posada. *El Jarabe en Ultratumba. Engraving. Boeckmann Center for Iberian and Latin American Studies, UCLA, Los Angeles, California* COURTESY OF THE CENTER

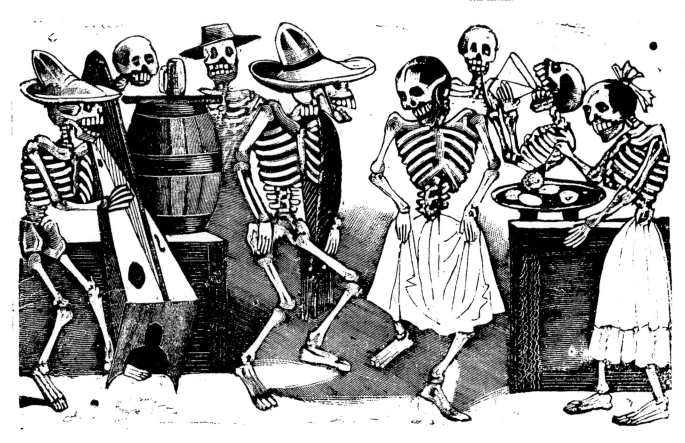

Roberto Matta. *The Bachelors, Twenty Years After.* 1943. *Philadelphia Museum of Art, Pennsylvania* PHILADELPHIA MUSEUM OF ART/CORBIS

***motif** a favorite symbol or subject in an artist's work

***collage** a method of picture making in which pieces of photographs, torn paper, news clippings, and other objects are assembled on a flat surface

Uruguayan painter Pedro FIGARI made a highly idiosyncratic blend of European POSTIMPRESSIONISM, religious and folk traditions, and native landscape. Also in Uruguay, painter Joaquin TORRES GARCÍA drew from Europe as well as from Mayan and AZTEC ART traditions, Russian Constructivism, and folk art to arrive at his "universal constructivism." He sought to combine the stylistic movements of Latin America, Europe, and North America with industrialization, social movements, myth, and ancient Amerindian traditions. A highly influential Latin American Modernist, Torres García's work continues to resonate into the twenty-first century.

In Argentina, Emilio Pettoruti (1892–1971) emerged as a pioneer of Latin American Cubism. Trained in Italy and France, in works such as *Farfalla Calma* (1962), the internationally known artist seemed to flaunt the influence of Picasso and Juan GRIS. More overtly political and directly affected by social injustice, the Argentine Antonio Berni (1905–1981) also took symbols and motifs* from Picasso and Gris, but he incorporated them into surreal, biting caricatures employing elements of collage*, as seen in his 1975 work *Ramona Adolescente.* Berni believed all art and artists were political.

In Mexico, the avant-garde was led by muralists Diego RIVERA, José Clemente OROZCO, and David SIQUEIROS. Attuned to international politics, responding to the Mexican Revolution (1910–1920), trained in the art of the Renaissance fresco-makers, these artists were also aware of Futurism and Cubism, and of native traditions and symbols. Their monumental works received international acclaim.

Surrealism gained strength in Latin America in the late 1920s. Prominent Surrealists included the Chilean-born Roberto MATTA, Cuban Wilfredo LAM, and Remedios VARO as well as the Austrian painter Wolfgang Paalen (1905–1959), who was active in Mexico City; and the English-born Leonora Carrington (born 1917), who also worked in Mexico, where she was inspired by the rich mythology. Surrealism enabled the Mexicans Rufino TAMAYO and

Frida KAHLO to express historical, political, and personal views through allegorical symbols and dream imagery. Surrealism persisted as an art form offering escape from an often-irrational political environment.

Developments after 1950

In the 1950s, ABSTRACT ART came to the fore. Latin American artists drew their inspiration from Piet MONDRIAN, the Constructivists, the Cubists, and from their own Torres-García. But they also added the geometric traditions of Incan and MAYAN ART. The most celebrated example of the region's abstractions were the works of Argentine Julio Le Parc (born 1928), whose abstract works are based on scientific principles and often require the viewer's participation. He was a leading proponent of Latin America's KINETIC ART.

Brazil's art maintained a more minimalist profile than that of the rest of Latin America. Brazilian artists drew inspiration from architects, such as Le Corbusier (Charles-Édouard Jeanneret; 1887–1965). In the early twenty-first century,

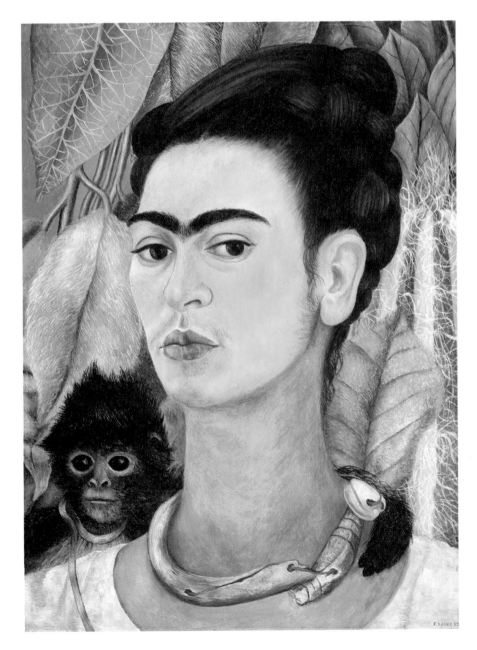

Frida Kahlo. *Self-Portrait with Monkey.* *1938. Oil on masonite. Albright-Knox Art Gallery, Buffalo, New York* BEQUEST OF A. CONGER GOODYEAR. COURTESY OF THE MUSEUM

Brazilian conceptual artists and sculptors continued to experiment with form and structures. For example, Cildo Miereles created an installation that required viewers to walk through a candle-lit room filled with talcum powder. But he also used "micromedia," such as his 1969–1970 wood carving, *Southern Cross* (measuring nine cubic millimeters), which symbolized "a region that does not exist on official maps," a region that was never divided by new arrivals (Europeans).

After the 1970s, Latin American artists became concerned with keeping up with international avant-garde movements. They struggled to not be perceived as provincial, but, at the same time, they held to their rich cultures. Established artists who showed this diversity of styles included POP ART sculptor Marisol (born 1930). Born Marisol Escobar in Paris to well-to-do Venezuelan parents, her witty style and passion for social commentary are evident in life-size figure arrangements such as *Women and Dog* (1964) and *The Funeral* (1966). The Colombian Fernando BOTERO continued to startle and entertain the world with his massive balloon-like sculptures and satiric paintings of politicians and townspeople.

Performance artists throughout the region engaged in an art form that focused on the body and nudity. For the Argentine Guillermo Kuitca (born 1961), the map became a metaphor for locating oneself. Kuitca painted charts and blueprints of real and imagined rooms and landscapes—such as libraries and concert halls, cemeteries and street plans. In the early twenty-first century, Latin American artworks spoke to racial oppression, feminist and political issues, the subjugation of women, and to freedom. —BARBARA M. MACADAM

(**See also** CONCEPTUAL ART; INCAN ART.)

LA TOUR, GEORGES DE

French, 1593–1652

An important painter of the early seventeenth century, Georges de La Tour enjoyed a successful career in his own day but was largely forgotten until the twentieth century. Little is known of his life, but at some point he fell under the influence of CARAVAGGIO, either through travels in Italy or by becoming acquainted with the works of the master's followers. By 1618, La Tour had settled in the village of Lunéville in his native province of Lorraine, France. The Duke of Lorraine was one of his patrons. In 1639, La Tour was listed with the title "painter to the king."

La Tour's early works were day-lit scenes, usually portraying peasants or cardsharps—such as *The Fortune Teller* or *The Hurdy-Gurdy Player*. The paintings from his mature period show nighttime scenes, usually illuminated by a single candle and often depicting religious scenes. In these works, La Tour's figures are generally reduced to simple yet monumental forms, half submerged in shadow. *The Penitent Magdalen* (1640–1644) depicts Mary Magdalene at the moment of her conversion to Christianity. Jesus Christ's most famous female follower is shown as a young peasant, a skull in her lap, seated before a mirror. The skull and candle are symbols of the fleeting nature of life on earth; the mirror is a warning against vanity.

In La Tour's hands, the scene in *The Penitent Magdalen* has a feeling of utter stillness and intimacy. The candlelight falls smoothly over the highly finished forms, drawing the viewer into the moment. Where Caravaggio used dra-

Georges de La Tour. *The Fortune Teller.* *c. 1632–1635. Oil on canvas. Metropolitan Museum of Art, New York City* FRANCIS G. MAYER/CORBIS

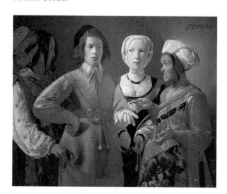

matic lighting to spotlight events that were often violent, La Tour used the flame of a single candle to heighten moments of solitude and quiet tenderness. This is also evident in *The Lamentation over St. Sebastian* (1630s).

Because his studio turned out highly accomplished copies of many of his paintings, art historians had trouble determining which were actually the original work of La Tour. His son Etienne was also a talented painter, and certain works signed "de la Tour," such as *The Education of the Virgin,* were assigned to his hand.

(*See also* BAROQUE ART.)

LAWRENCE, JACOB

American, 1917–2000

One of the foremost chroniclers of African American life in the twentieth century, Jacob Lawrence was born in Atlantic City, New Jersey. He grew up in Harlem, New York, during the severe economic downturn of the Great Depression (1929–1939). Trained as a painter at the Harlem Art Workshop, the artist's development was profoundly influenced by his experiences living in the nation's most well-known black community. There he came into contact with many great African American scholars and intellectuals, including Alain Locke (1886–1954) and Langston Hughes (1902–1967).

Among Lawrence's early accomplishments were series of paintings on great black leaders such as Toussaint-Louverture (c. 1743–1803), the freed slave who led a rebellion in Haiti; American abolitionist and writer Frederick Douglass (1817–1895); and Underground Railroad operator Harriet Tubman (c. 1820–1913).

In 1940, Lawrence began work on what became his most acclaimed series—the sixty paintings on *The Migration of the Negro* (1940–1941). The works illustrate the massive migration of blacks from the rural South to the industrial North in the early decades of the twentieth century. The Great Migration was described by one historian as "the largest movement of black bodies since slavery. Seeking escape from the horrors of the post–Civil War (1861–1865) South, African Americans fled to northern cities, often to discover even worse conditions of unemployment and racism in urban centers such as Chicago, Boston, and New York."

Lawrence spent months researching the Great Migration. In simple, spare compositions, he documented the lives of black people—on southern farms as well as in prisons, city slums, and labor camps. At times, his visual language recalls the paper cutouts of Henri MATISSE. But Lawrence's subject matter is usually without a trace of the French artist's joyous abandon. Panel *Number 57* (1941), also titled "The female worker was one of the last groups to leave the South," shows a solitary woman, stirring a vat of swirling laundry. As critic Robert Hughes noted, Lawrence's images are without a "trace of the sentimentality that coats [Pablo] Picasso's Blue Period or the works of most American Social Realists."

In 1942, the year after Lawrence completed his *Migration* series, the paintings were exhibited in museums around the United States, in a tour organized by New York's Museum of Modern Art. His reputation as one of the nation's

Jacob Lawrence. *Tombstones. 1942. Gouache on paper. Whitney Museum of American Art, New York City* COURTESY OF THE ARTIST AND THE MUSEUM; PHOTOGRAPH BY GEOFFREY CLEMENTS

premier painters of SOCIAL REALISM was firmly established. The artist's later works tend to be more decorative and less concerned with social issues, but his powerful style and commitment to portraying the African American experience earned him international acclaim.

LAWRENCE, THOMAS

English, 1769–1830

The last of the great eighteenth-century portrait painters, Sir Thomas Lawrence was an admirer of Joshua REYNOLDS, whom he succeeded as Painter in Ordinary to the king of England in 1791. Three years later, Lawrence was elected to the prestigious Royal Academy, Britain's national association of artists.

Born in Bristol, England, Lawrence was largely self-taught, displaying an unusual artistic talent in his youth. His earliest triumph was a 1789 portrait of Queen Charlotte (wife of England's King George III), painted when the artist was only twenty years old. In 1815, Lawrence was knighted, and three years later he was sent to the Continent by royal decree to paint portraits of the European leaders responsible for the downfall of French Emperor Napoléon Bonaparte (1769–1821; ruled 1799–1814). After returning to England in 1820, Lawrence became president of the Royal Academy.

*Salon France's official art exhibition; established in 1667

In 1824, Lawrence exhibited his work at the Paris Salon*. His deft handling of paint won him the admiration of French artists. Much in demand for his portraiture, he took on numerous commissions, resulting in an unevenness to the overall body of his work. However, Lawrence's finest paintings bear comparison with those of Peter Paul RUBENS and TITIAN.

Among Lawrence's greatest works is the likeness of Julia, Lady Peel (1795–1859), the wife of the great English prime minister Sir Robert Peel (1788–1850). The painting was probably inspired by one of Rubens's portraits of his young second wife, Hélène Fourment. Renowned for his good looks and charm, Lawrence was also a man of impeccable taste, who assembled an outstanding collection of old master drawings, including works by MICHELANGELO and RAPHAEL.

LÉGER, FERNAND

French, 1881–1955

A major Cubist painter, Fernand Léger stood apart from the movement's central figures, Georges BRAQUE and Pablo PICASSO. Léger worked with brighter colors than his fellow artists, and his use of tubular (cylindrical) forms earned him the title "tubist." Like many artists of the early 1900s, Léger was fascinated by industry and its sleek machinery. But he was the only Cubist to include such forms in his iconography*.

*iconography the symbols, signs, and images that are associated with a work of art, an artist, or a body of art

Artist's Development

Born in Normandy, France, Léger studied at the local art school in Argentan between 1890 and 1896. When he announced that he intended to

become a painter, his widowed mother sent him to architectural school instead. She believed architecture to be a more serious, respectable profession. In 1900, Léger settled in Paris, where he studied privately with academic painters. He supported himself by working as an architectural draftsman and photo retoucher.

Léger's earliest paintings were done in an Impressionist style. But, after seeing an exhibition of works by Paul CÉZANNE in 1907, Léger's outlook soon changed. He moved into La Ruche (The Beehive), the famed artists' colony in Paris's Montmartre district. There he came into contact with some of the leading figures of the avant-garde*, including Robert DELAUNAY and Henri ROUSSEAU. In 1910, Léger's work began receiving attention. His paintings were shown with works by Braque and Picasso in exhibits staged by the influential art dealer Daniel-Henri Kahnweiler (1884–1979).

Three Nudes in the Forest (1909–1910), one of the major canvases from the early part of Léger's career, was probably inspired by Picasso's similarly titled *Nude in a Forest (Dryad)* of 1908. Unlike Picasso's work, which shows a solitary figure, the Léger painting is a frenzy of robot-like figures. One art historian commented that the artist seemed to try to "create an entire work of art out of the cylinders and cones." Unlike comparable works by the Italian Futurists, who sought to celebrate the optimism of the machine age, Léger's vision is a hellish scene of confusion, rendered in bleak colors. Nevertheless, the work helped solidify Léger's reputation. In 1913, Kahnweiler gave him a one-person show, and, a year later, the artist was invited to exhibit in Berlin.

World War I Influences Work

Léger's promising career was put on hold by the outbreak of World War I (1914–1918). Serving on the front line, he wrote that the war "was a complete revelation," bringing him into contact with people of various backgrounds and heightening his awareness of the fierce beauty of machines. Léger described being "dazzled" by the breech of a gun standing uncovered in the sunshine—"the magic of light on white metal." The artist's wartime experience brought an end to his earlier experiments with abstraction. "Once I had got my teeth into that sort of reality, I never let go of objects again," said Léger.

Fernand Léger. *Woman Holding a Vase.* *1927. Oil on canvas. Solomon R. Guggenheim Museum, New York City* FRANCIS G. MAYER/CORBIS © 2001 ARTISTS RIGHTS SOCIETY (ARS), NEW YORK/ADAGP, PARIS

Injured in 1916, Léger spent a year recovering. He then returned to painting, developing a distinctive style that characterized his work for the rest of his life. His 1921 oil painting, *Three Women (Le Grand Déjeuner),* is representative of his mature style. Similar to the monumental compositions of the French Neoclassical artists Jean-Auguste-Dominique INGRES and Jacques-Louis DAVID, Léger painted large, full-bodied figures. But his painting is decidedly modern: the nude figures are as sleek and impersonal as machines; the fragmented, burnished forms recall his earlier experiments with CUBISM; and the bold use of color and pattern in the background suggest his careful study of compositions by Henri MATISSE.

Artistic Experiments and Acclaim

In the 1920s, Léger collaborated with architect Le Corbusier (Charles-Édouard Jeanneret; 1887–1965) on a publication defending the machine aesthetic. The artist also began designing sets for dance and film. In 1923, he worked with photographer Man RAY on the experimental film *Ballet mécanique*

(The Mechanical Ballet) [1924]. The movie has no plot; it is simply a series of everyday objects, set in motion. Its original, ultramodern soundtrack was written by American composer George Antheil (1900–1959), who scored the music for piano, player pianos, bass drums, xylophones, electric bells, siren, and airplane propellers.

As he gained international acclaim, Léger traveled widely. After the Germans invaded France in 1940, he settled in the United States. As World War II (1939–1945) raged in Europe, Léger taught at Yale University (Connecticut) and Mills College (California). He also befriended a progressive Catholic priest who commissioned him to design a mosaic for a church in France's Haute-Savoie region after the war.

Léger's painting became flatter and bolder, showing figures and objects outlined in a strong, black line. His works from the 1940s and 1950s focus on several basic themes: cyclists, divers, outings in the country, and construction crews at work. For the rest of his career, Léger devoted himself to large-scale figure compositions, such as *The Great Parade* (1954), a celebration of his fascination with acrobats and other circus performers. He also produced decorative art, including stained-glass windows, tapestries, and ceramic sculptures. In 1952, he painted two large abstract murals for walls of the General Assembly Hall at the United Nations headquarters in New York City.

Legacy

Léger's work was a reaction to and reflection of many of the mainstream currents in modern art—FAUVISM, Cubism, SURREALISM, and FUTURISM, among others. Yet he remained a distinctive and independent talent. As art critic John Golding noted, Léger's originality lay in his "ability to adapt the ideas and . . . visual discoveries of others to his own ends."

LEONARDO DA VINCI

Italian, 1452–1519

The High Renaissance (early 1490s to c. 1527) in Italy produced several extraordinarily talented artists, but none had the wide range of interests and depth of talent of Leonardo da Vinci. The list of his pursuits is a long one: painting, sculpture, architecture, engineering, astronomy, aviation, botany, mathematics, zoology, geography, and more. A keen observer of the world around him, Leonardo left a sizable and detailed record of his many experiments, inventions, and ideas. Five hundred years after his death, he remains the widest-ranging genius in the history of Western art.

Leonardo was the illegitimate son of a notary and a rural woman. Little is known of his early life, but he is presumed to have lived with his father's family in the Tuscan hill town of Vinci. His long and fruitful career, most of it spent in Florence and Milan, began with an apprenticeship (c. 1467–1477) in the workshop of Andrea del VERROCCHIO.

Leonardo's First Florentine Period

By 1466, when he was only fourteen, Leonardo had moved from Vinci to Florence, where he would have been exposed to early RENAISSANCE ART. As

the pupil of a leading artist of the day (Verrocchio), Leonardo was probably expected to learn metalworking, how to grind and mix colors, how to draw studies of drapery, and the basics of perspective* (*see also* sidebar, BRUNELLESCHI).

Historians believe that Leonardo painted an angel and, perhaps, part of the landscape in Verrocchio's *Baptism of Christ* (c. 1474–1475). Reportedly, Verrocchio was so impressed with his apprentice's work that he gave up painting. In 1472, Leonardo was registered in Florence's painter's guild. His first major independent work was an Annunciation*, but he also painted Madonnas and a small, elegant portrait of a young noblewoman named Ginevra de' Benci, housed in the National Gallery in Washington, D.C.

Like many of Leonardo's projects, his *Adoration of the Magi,* begun in 1481, was left unfinished. Commissioned for the monastery of San Donato in Scopeto, Italy, Leonardo made many drawings and studies for the painting. These preliminary works show the development of his mature style. In the studies, amazed onlookers at the birth of Jesus Christ form a confusion of heads and hands. The figures are not firmly outlined in the manner of contemporary Florentine painters such as Sandro BOTTICELLI. Instead, they seem to emerge from the murky background in soft shadings of dark and light. To achieve this effect, the artist used chiaroscuro*, a technique he employed in later works and one that was also used by CARAVAGGIO and REMBRANDT to create high drama in their paintings.

Leonardo in Milan

Around 1482, Leonardo traveled to Milan in northern Italy. For the next sixteen years, he worked in the court of Ludovico Sforza (1452–1508), one of the most powerful princes of fifteenth-century Europe. The nobleman regarded Leonardo as more than merely an artist in residence, however. He devised elaborate entertainments, which sometimes included fireworks of his own invention. When the plague killed many of Milan's citizens, Leonardo turned his attention to town planning, devising improved sanitary systems. During these years, he wrote most of *Trattura della pittura* (Treatise on Painting; published 1651) and filled many notebooks with the theories and sketches showing his wide-ranging curiosity.

Unlike other learned men of his day, Leonardo was not content to rely on the wisdom and observation of ancient (Greek and Roman) authorities. Although his notes reveal many references to classical* culture, he was more interested in investigating the world firsthand to satisfy his great hunger for knowledge. To understand human anatomy, he dissected more than thirty corpses. He was one of the first to examine how a baby grows in its mother's womb. Leonardo also studied the laws of physics that govern ocean waves and wind currents. And he observed and analyzed the flight of insects and birds, studies that helped him design a flying machine on paper. Historians have suggested that Leonardo made these studies in an effort to gain greater respectability for art. According to German historian E. H. Gombrich, by grounding art in science, Leonardo "could transform his beloved . . . painting from a humble craft into an honored and gentlemanly pursuit."

During the first few years of Leonardo's stay in Milan, he painted *The Virgin of the Rocks* (c. 1485). The artist shows the Madonna in a craggy setting, her right hand extended to support the shoulder of the infant John the

***perspective** a painting technique in which three-dimensional objects and figures depicted on a flat surface appear in correct proportion and relation

***Annunciation** in Christian art, a scene in which the angel Gabriel tells the Virgin Mary that she will give birth to the Christ child

***chiaroscuro** (Italian for "clear" and "obscure, dark") a subtle modeling from light to dark to create three-dimensional effects

***classical** pertaining to Greek or Roman culture

Leonardo da Vinci. *Anatomical Study.*
c. 1510. Drawing. Royal Library, Windsor Castle, England BETTMANN/CORBIS

Leonardo da Vinci. *The Virgin of the Rocks.* c. 1485. Oil on wood panel transferred to canvas. Louvre, Paris, France THE ART ARCHIVE/DAGLI ORTI

sfumato (Italian for "vanished in smoke") subtle shading of figures from light to dark, giving a hazy impression

***Passion** In Christian art, scenes depicting Jesus Christ in the events between the Last Supper and the Crucifixion

Baptist. Her left hand hovers above that of an angel, who sits just behind the Christ child and points toward the saint. As in Leonardo's study for the *Adoration of the Magi,* the figures are subtly modeled in shades of light and dark. A fine haze, or *sfumato**, lends the work a dreamy atmosphere, contributing to its mystery. Historians do not know what the relationship is among these four figures, or what their gestures mean. But many viewers have felt they were in the presence of a highly sacred event.

The Last Supper

Around 1495, Leonardo began the High Renaissance masterpiece of *The Last Supper* (c. 1495–1498). The painting was commissioned for a wall of the refectory at the monastery of Santa Maria delle Grazie, Milan. Upon viewing Leonardo's painting of this episode from the Passion*, the monks at Santa Maria delle Grazie must have felt the supper took place in a room not very different from their own dining hall.

Leonardo portrayed the moment when Jesus Christ said to his followers, "One of you will betray me." The twelve apostles, arranged in four groups of three, respond to this news with reactions of disbelief, astonishment, and shock. The traitor Judas does not sit in isolation, as he does in earlier paintings of the same scene, but is portrayed as part of the group. He is a darkened figure, reaching for a piece of bread with one hand and clutching his bag of silver with the other. At the center, Jesus Christ sits calmly, arms outstretched, his head framed not by a halo, but by the arched window and serene landscape behind him.

Although *The Last Supper* shows a highly emotional moment, there is nothing chaotic about the composition. Even the room's perspective is deliberate. The central vanishing point of the scene is just above Jesus Christ's head. The three windows behind him represent the Christian Trinity (father, son, and holy spirit). Four wall hangings on each side of the painting echo the four groups of three apostles. Christ gestures toward a glass of wine and a piece of bread, the elements of the Christian ritual of the Eucharist (or Communion). The viewer's eye is drawn toward the central figure of Jesus Christ, but the play of hands among the apostles guides the viewer's eye along the length of the table to observe each figure in the scene.

Leonardo spent three years working on this wall mural, which is nearly twenty-nine feet long and about fifteen feet tall. According to one eyewitness account, the artist would climb onto scaffolding and spend days scrutinizing what he had already painted before adding another brushstroke. Nevertheless, the result is neither labored nor fussy. The ease, naturalism, balanced symmetry, and use of perspective make *The Last Supper* the first great figure painting of the High Renaissance.

To create *The Last Supper*, Leonardo experimented with a new technique, called *tempera grassa* (Italian for "oily tempera"). In this method, the artist applied paint, made of egg and linseed oil, to dry plaster. But in traditional fresco* technique, the paint is applied to wet plaster, allowing it to bind with the sur-

***fresco** (Italian for "fresh") a method of painting in which powdered pigments mixed with water are applied directly to wet plaster

Leonardo da Vinci. *The Last Supper.* *c. 1495–1498. Fresco. Santa Maria delle Grazie, Milan, Italy* GRANGER

Restoration of *The Last Supper*

Leonardo da Vinci's *The Last Supper* (c. 1495–1498) began to deteriorate almost as soon as it was painted. In 1566, the art historian Giorgio VASARI said that all he could see on the wall of the rectory (dining room) at Santa Maria delle Grazie was a "blinding spot." To make matters worse, Leonardo's wall mural was neglected and abused over the following centuries.

In the 1600s, a door under the painting was made larger to permit easier access to the kitchens. But the remodeling cut off the bottom center of the mural, which included Jesus Christ's legs and feet. During the Napoleonic Wars (1799–1815), soldiers used the dining room as a stable, sometimes tossing bricks at the mural. During World War II (1939–1945), a bomb was dropped on the monastery, but *The Last Supper* was protected by sandbags, escaping complete destruction.

In 1978, the Italian government launched a major restoration. The venerable art restorer Pinin Brambilla Barcilon directed the painstaking work. Working inch by inch, Barcilon and his team removed centuries of grime and grit from the mural. The restored *Last Supper* was unveiled in 1999. About fifty percent of the painting and much of its original color had been recovered. Items that had never before been visible were revealed: rolls, finger bowls, a fish platter, and wineglasses.

To protect the fragile painting, visitors to the refectory are required to walk through air-filtration chambers that remove dust and other pollutants. Tickets to view *The Last Supper* have to be booked in advance and the number of visitors at any one time is limited.

face for greater durability (*see also* sidebar, GIOTTO). Regrettably, Leonardo's paints did not bind to the dry plaster, and within a few years of its completion, the painting began to flake.

Leonardo's Second Florentine Period

In 1499, the French gained control of Milan. Leonardo fled the city, traveling first to Mantua, and then to Venice. Eventually, he resettled in Florence, where he pursued his studies of anatomy. But in 1502, he entered the service of Cesare Borgia (c. 1476–1507) as a military engineer. By 1503, Leonardo was working on a mural for the council chamber of the Palazzo Vecchio, Florence's town hall. His subject was the 1440 Battle of Anghiari, in which Florence was victorious over the enemy army. He completed a full-size drawing (called a cartoon), and had just begun work on the painting when he returned to Milan. The drawing survived for more than a century, and had a tremendous impact on other artists, who were impressed by the savage but contained fury of Leonardo's armed men on horseback. Art historians' only knowledge of the work is from copies made by later artists, most notably Peter Paul RUBENS.

While still at work on the *Battle of Anghiari,* Leonardo completed his most famous portrait—and perhaps the most famous in Western art—the *Mona Lisa* (c. 1503–1505). Over the centuries, the painting exercised a magical spell, inspiring songs, poems, and parodies. The *Mona Lisa* is a portrait of Lisa del Giocondo (active 1500), the wife of a Florentine banker. She is sometimes called La Gioconda (the feminine form of Giocondo); "Mona" is a short form of Madonna, which is Italian for "my lady."

Many art historians tried to explain *Mona Lisa*'s profound hold on the imagination. The delicate *sfumato,* first seen in Leonardo's *Virgin of the Rocks,* was a source of wonder even in his own time. The effect, achieved through the application of thin layers of translucent paints (glazes), gives the portrait a luminous glow, adding to its mystery. Art historians also noted the composition's shifting viewpoints. The figure seems to be viewed at eye level, but the landscape in the background tilts slightly upward. Leonardo used several devices to

unify the two spaces in the picture: he repeated the shape of the subject in the triangular mountains (behind), echoed Mona Lisa's veil in the smoky background haze, continued the drape of her clothing in the arches of an aqueduct, and used a curving road to repeat the folds in her sleeve. The subject is in perfect harmony with her setting.

But it is Mona Lisa's enigmatic smile that inspired millions of viewers. The same *sfumato* that softens the atmosphere turns her gaze and mouth into a fascinating mystery. Her expression is open to the interpretation of the viewer; she may be smiling, she may be in a mood of deep reflection—or she may be amused by the viewer's curiosity. Mona Lisa maintains a secretive self-possession that defies easy explanation.

Later Years

In 1506, Leonardo returned to Milan to complete another version of *The Virgin of the Rocks* (1508). He also worked on a major equestrian monument for the city, but seems to have spent most of his time on scientific pursuits. He made hundreds of drawings and notes, which he hoped to compile into an encyclopedia. Most were never published in his lifetime. Often, the inventions that Leonardo designed on paper could not have been realized in his day; the means to do so—such as a steam or combustion engine—had not been developed yet.

In 1513, Leonardo traveled to Rome, where he found the visual arts were dominated by the genius of MICHELANGELO and RAPHAEL. In his fresco *The School of Athens* (1509–1511), Raphael included a likeness of Leonardo, who appears alongside other great thinkers.

In Rome, Leonardo worked on architectural and engineering projects for the Vatican, the papal headquarters. He also completed a painting of a young Saint John the Baptist (c. 1516). In 1517, the aging master accepted an invitation to France, where King Francis I (1494–1547; ruled 1515–1547) presented him with a chateau at Cloux. There Leonardo spent his last two years, pursuing his many interests, including designing buildings and gardens—showing a curiosity that seemed undiminished by age.

In addition to sublime paintings and drawings, Leonardo left a body of work that was of great importance to science. His notebooks foretold of a modern world, in which careful observation and experimentation would form the basis of theory. He also brought a new status to the role of the artist, establishing him as more than just a manual worker. Leonardo demonstrated that thought and theory could be just as important to the visual arts as they were to other branches of the humanities, such as mathematics or philosophy. His creativity and originality distinguish him as a true Renaissance genius, and reveal him as one of the great minds of all time.

(**See also** CHRISTIAN ICONOGRAPHY.)

LIGHT SCULPTURE

The use of light as a medium for making art was pioneered in the early twentieth century by two artists working on different continents and in entirely different contexts. In the United States, Wilfred Thomas (1889–1968) attempted to use light in order to create a form of abstract visual music. In 1919, he built

a machine he called the *Clavilux,* which used adjustable mirrors and glass slides to project shifting patterns of colored light onto a screen. Like an organist or pianist, the artist operated the Clavilux by pressing the keys on a keyboard. Thomas christened this new art form *Lumia,* and although it was not taken very seriously in his day, he optimistically wrote of his hope that it could "express the human longing for a greater reality."

About the same time, in Europe, Lázló Moholy-Nagy (1895–1946) was making substantial investigations into light and motion. The Hungarian-born artist taught at the BAUHAUS in the 1920s and became one of the most inventive advocates of CONSTRUCTIVISM. He was an engineer by temperament, if not by training, and, like others associated with the Russian-based movement, he believed that art should be integrated into society as a whole.

A brilliant educator and a restlessly experimental artist, Moholy-Nagy worked with collage*, photomontage*, film, PHOTOGRAPHY, and such innovative materials (for the time) as transparent plastics and reflective metals. As early as 1922, he made "light-space modulators," motor-driven machines that rank among the first examples of KINETIC ART. When set in motion, a machine's reflective parts cast light on its surrounding space.

***collage** a method of picture making in which pieces of photographs, torn paper, news clippings, and other objects are assembled on a flat surface

***photomontage** a composition made from parts of different photographs

Chryssa. *Gates to Broadway.* c. 1965– 1990. *Light sculpture.* GEOFFREY CLEMENTS/ CORBIS

The potential of light as an element in sculpture did not strike a widespread chord among artists until the late 1950s and 1960s, when a new cult of technology and investigations into the science of perception spurred a variety of experiments. Among American artists, the Greek-born sculptor Chryssa (born 1933) was credited as the first to use brilliant neon tubing in her work. Arriving in New York City in the mid-1950s, she was fascinated by the neon lights in Times Square, praising them as "poetic, extremely poetic." Taking a cue from commercial advertising as well as from the works of Jasper JOHNS and later Pop artists, she fabricated light sculptures out of neon, which she twisted into letters and typesetting symbols. Among Chryssa's most ambitious works is *Fragments of Gates of Times Square* (1980), a large sculpture shaped like a letter A, her symbol for America.

Several artists associated with MINIMALISM also became fascinated by the potential of commercial light sources. Among the most pared-down were works by Dan Flavin (1933–1996), who began combining light and sculptural constructions in 1961. Flavin's medium was the fluorescent tube commonly used in offices, stores, and industrial spaces. He eventually conceived of his spare light installations and the gallery space as a single entity, an almost meditative environment. According to critic Sam Hunter, Flavin's "fluorescent tubes, often radiating an austere white light but sometimes glowing with subtle color, created luminous zones of irradiation related to each other and to the overall room."

Robert Irwin (born 1928) also sought to transform the environment of the viewer. The California-based artist's first abstract canvases seemed to be an attempt to capture the white light around his home base of San Diego. Intrigued with manipulating light, in the 1960s, he worked with the semitransparent fabric used in set designs to create subtle, diffuse spaces that were described as "hypnotic." In later works, Irwin used both natural and fluorescent light in installations that viewers can enter and walk around, experiencing subtle changes in illumination.

Light has always been of major importance to artists, but its potential as a real medium, whether in the form of electrical brilliance or daylight, was not explored until the mid-twentieth century. Artists as diverse as Bruce NAUMAN and James Turrell (born 1943), a proponent of EARTH ART, sought to use light as a new and riveting medium. By the close of the twentieth century, the many possibilities of light seemed to be still in their infancy.

(*See also* POP ART.)

LIMBOURG BROTHERS

Flemish, active c. 1409–1416

The three Limbourg, or Limburg, brothers—Jean (sometimes written Jehanequin), Herman (Hermann), and Paul (Pol)—were leading painters of ILLUMINATED MANUSCRIPTS in their day. They were born in the Netherlands (in provinces that later became Belgium) and all died in 1416, probably victims of an epidemic. Although Paul was head of the workshop, their styles were so close that it is not possible to distinguish one brother's work from the others.

The Limbourg brothers' greatest works were two *Books of Hours*—prayer books used for private devotions and usually containing meditations for

different times of the day, week, or season. These were made for Jean de France (1340–1416), the Duke of Berry. He was the uncle of French King Charles VI (1368–1422; ruled 1380–1422) and one of the most generous art patrons of his day. The two manuscripts are known as *Les Très Riches Heures* (Very Rich Hours) and *Les Belles Heures* (Beautiful Hours). The *Belles Heures* was completed by another artist after the brothers died.

Typical of the works is the illumination (illustration) from *Très Riches Heures* for the month of May. The figures are dressed in the height of fashion. Their tapestry-like background shows a splendid palace in the distance. Although the artists have paid great attention to natural detail—illustrating animals, plants, and clothing right down to the richly brocaded borders and belts— the whole scene has a fairytale quality. The artists made no attempt to represent the figures in three dimensions or to give the scene perspective* (*see also* sidebar, BRUNELLESCHI). These innovations were not seen until the early fifteenth century in the RENAISSANCE ART of Florence. The Books of Hours crafted by the Limbourg brothers are among the greatest expressions of the INTERNATIONAL GOTHIC STYLE.

***perspective** a painting technique in which three-dimensional objects and figures depicted on a flat surface appear in correct proportion and relation

***avant-garde** literally, the "advanced guard"; a term describing innovators or innovation in a particular field

***classical** pertaining to Greek or Roman culture

Jacques Lipchitz. *Sailor with Guitar.* *1914. Philadelphia Museum of Art, Pennsylvania* PHILADELPHIA MUSEUM OF ART/CORBIS

LIPCHITZ, JACQUES

Lithuanian-born French, 1891–1973

The long career of sculptor Jacques Lipchitz was highlighted by his exploration of CUBISM. With Aleksandr ARCHIPENKO, Lipchitz was credited with best articulating Cubist expression in three-dimensional solid forms.

Born in Lithuania to a prosperous Jewish family, Lipchitz studied engineering before moving to Paris in 1909. Like other avant-garde* artists of the day, he was deeply interested in ancient and primitive art, especially the statues made by African tribesmen. Soon after arriving in Paris, Lipchitz forged friendships with some of the most adventurous artists of the day, including Pablo PICASSO, Henri MATISSE, Amedeo MODIGLIANI, and fellow Lithuanian Chaim SOUTINE.

By 1915, Lipchitz was creating Cubist constructions in stone, wood, and bronze. His *Man with a Guitar* (1915), made of limestone, takes a familiar Cubist theme and pushes it to the edge of abstraction. Without the title, the sculpture's subject might be indecipherable: the viewer can distinguish only the sound-hole of the guitar and the suggestion of the standing figure. In his autobiography, *My Life in Sculpture,* Lipchitz explained, "I was definitely building up and composing the idea of a human figure from abstract sculptural elements of line, plane, and volume; of mass contrasted with void completely realized in three dimensions."

In the 1920s, Lipchitz, like Archipenko, became increasingly concerned with exploiting the expressive potential of the open spaces in sculpture. Lipchitz's work gradually increased in scale, and he employed assistants to produce large bronze sculptures made from plaster models. After about 1930, he turned away from Cubism, rendering allegorical themes in abstract and even Surrealist forms. These works, based on classical* and biblical subjects, coincided with his deepening desire to express spirituality in his art. But the results were not always popular with critics, one of whom complained that Lipchitz's *Prometheus Strangling the Vulture* (1949) looked like "inflated shrubbery."

After the Germans marched into Paris in 1940 during World War II (1939–1945), Lipchitz fled to Toulouse, in southern France. A year later, he moved to the United States and settled in Hastings-on-Hudson, New York. Toward the end of his life, he carried out several large public commissions. A year before his death, Lipchitz's sculptures were celebrated with a major retrospective at the Metropolitan Museum of Art, New York City.

(*See also* ABSTRACT ART; SURREALISM.)

LIPPI, FILIPPINO

Italian, c. 1457–1504

The son and pupil of the quattrocento* painter Fra Filippo LIPPI, Filippino Lippi also studied in Florence with his father's student, Sandro BOTTICELLI. From Botticelli, he learned to create finely drawn figures. However, Filippo took this style further, adding a depth of emotion that was new to Italian art.

*quattrocento in Italian art, the fifteenth century

In 1484, Filippino was asked to complete the cycle of frescoes begun (c. 1424–1427) by MASACCIO in the Brancacci Chapel at Santa Maria del Carmine in Florence. He was so successful at imitating Masaccio's style that many art historians found it difficult to tell where one artist's hand left off and the other began.

Filippino created the largest painted tondo* of fifteenth-century Italy, the *Adoration* (mid-1480s). Although the elongated figures recall those in Botticelli's works, it is clear that Filippino had also studied the innovations of the young LEONARDO DA VINCI. This is especially evident in the portrayal of the mysterious, smoky landscape in the far distance of the painting.

*tondo a painting or sculpture in a circular shape; a sculptured medallion

Although he completed many commissions in Rome and Florence, Filippino's best-known work is probably the *Vision of St. Bernard* (c. 1480). It shows the Virgin Mary bringing strength to the ailing saint, as she delicately places her hand on the open book before him. In the upper right corner of the composition, monks look up in astonishment at the air through which Mary and her attending angels have descended. In the lower right, the painting's donor, a wealthy cloth merchant, views the scene with his hands folded in prayer.

It is likely that in painting *Vision of St. Bernard,* Filippino was influenced by the *Adoration of the Shepherds* (c. 1476), from the Portinari altarpiece by the Flemish painter Hugo van der GOES. That work was shown in Florence in 1483. Although Filippino and his contemporaries had certainly viewed smaller works by other Flemish masters, before the Goes altarpiece was displayed, they had never before seen the highly detailed realism that was popular in northern Europe.

(*See also* NORTHERN RENAISSANCE ART.)

LIPPI, FRA FILIPPO

Italian, c. 1406–1469

*quattrocento in Italian art, the fifteenth century

*fresco (Italian for "fresh") a method of painting in which powdered pigments mixed with water are applied directly to wet plaster

One of the great painters of the quattrocento*, Fra Filippo Lippi was known for his religious frescoes* (*see also* sidebar, GIOTTO) and canvases. Entrusted by a relative to a Carmelite monastery in Florence, Filippo Lippi was raised by

monks. He reportedly became inspired to paint by watching MASACCIO and MASOLINO DA PANICALE work on their frescoes for the Brancacci Chapel at Santa Maria del Carmine.

Fra Filippo's earliest dated works are both from 1437, a *Madonna and Child* painted for the city of Tarquinia, Italy, and a *Madonna and Child with Saints and Angels,* known as the Barbardori altarpiece. The three-dimensional forms, natural lighting, and realistic draperies show Masaccio's influence. However, Fra Filippo favored cluttered settings and an often fussy attention to detail. After about 1440, his works were increasingly filled with decorative elements: fluttering draperies, elaborate brocades, and detailed architecture and landscapes.

***tondo** a painting or sculpture in a circular shape; a sculptured medallion

Fra Filippo was especially famous for his tondos* of the Virgin and Child. With DOMENICO VENEZIANO, he was one of the developers of the *sacra conversazione* (Italian, "sacred conversation"), a single composition showing the Virgin and Child as well as church donors, saints, or angels. Usually, the figures appear to be speaking or gesturing to one another, as if in conversation.

Highly regarded in his day, Fra Filippo counted the Medici family (*see* sidebar, RENAISSANCE ART) among his patrons. However, the painter led a scandalous life. Customers complained that Fra Filippo did not fulfill commissions, and he often found himself in trouble with government authorities and the Church. At one point, he was tried and tortured. He became involved with a nun, fathering two children. Their son Filippino LIPPI was also a painter. In about 1461, the pope allowed Filippo to be released from his monastic vows, and he later marred Lucretia Buti, the former nun he had fallen in love with. Nevertheless, he continued to wear a monk's habit and sign his works "Fra [Brother] Filippo." He had the greatest influence on his pupil, Sandro BOTTICELLI. Four centuries later, Fra Filippo was a major inspiration to the PRE-RAPHAELITES.

LISSITZKY, EL

Russian, 1890–1941

A chief proponent of CONSTRUCTIVISM, El (Eleazar) Lissitzky was an influential painter and an innovator of typography and design. Like Marc CHAGALL, who was three years older, Lissitzky grew up in the small, predominately Jewish town of Vitebsk, in western Russia. He showed signs of artistic talent from an early age, but was rejected by the St. Petersburg Academy of Arts because of his religion.

In 1909, Lissitzky's family scraped together the money to send him to study architecture and engineering in Darmstadt, Germany. There he was introduced to the German version of ART NOUVEAU, known as *Jungendstil* (youthful style). In 1911 and 1912, he visited France and Italy. The mosaics in the Byzantine churches of Ravenna, Italy, made a lasting impression on him.

After fighting began in World War I (1914–1918), Lissitzky returned to Russia. Excused from military service due to poor health, he worked in an architect's office. In collaboration with Chagall, he produced a series of Yiddish (Jewish-language) picture books, which were heavily influenced by the traditional and popular prints called *lubok.* In 1918, Chagall became head of the art school in Vitebsk. A year later, he appointed Lissitzky professor of architecture

and applied arts. Also teaching at the school was Kazimir MALEVICH, who later quarreled with Chagall over administrative matters. Lissitzky, however, was profoundly inspired by Malevich's radical experiments with abstraction.

Begins Constructivist Works

Between 1919 and 1924, Lissitzky made a series of paintings he called *Prouns.* The title is an acronym for the Russian words meaning "project for the affirmation of the new." In these works, the artist took Malevich's flat rectangles and gave them the illusion of being three-dimensional. *Proun 99* (1924–1925) is one example from the series: a cube, cylinder, and netlike wedge seem to shift in space—they sometimes appear to be anchored and at other times appear to float in a void. The series has a strong sense of structure, with the individual paintings resembling plans for three-dimensional construction projects. Lissitzky described the series as "the interchange station between painting and architecture."

After Malevich left the Vitebsk art school in 1921, Lissitzky landed a teaching post in Moscow, where he was head of an architecture program. Like his Russian colleagues, Vladimir TATLIN, Aleksandr RODCHENKO, and Liubov POPOVA, Lissitzky became increasingly interested in "productivist art." Aligned with the ideology of Communism, these artists sought to use art for practical rather than purely aesthetic purposes. Their ideas formed the basis for the new Constructivist movement, which, for a time, dominated Soviet art.

Becomes Leader of Progressive Art Movement

Because of his time spent studying outside the Soviet Union, Lissitzky became an ambassador for Constructivism. In 1921, he set up a major exhibition of progressive art in Berlin; it was the first presentation of modern Soviet art in the West. When the show traveled to Amsterdam, the Netherlands, he made contact with members of de Stijl (*see* sidebar, MONDRIAN). He also became friends with the Hungarian experimental artist László Moholy-Nagy (1895–1946), who helped spread Constructivist ideas through his teachings at BAUHAUS. Through Kurt SCHWITTERS, Lissitzky became involved with a society devoted to promoting radical art. He later married Sophie Küppers, the widow of the group's first artistic director.

Turns Attention to Design and Typography

Lissitzky's reputation had peaked. But, at this time of great personal happiness, he fell ill from a lung infection and went to Switzerland to recuperate. His health continued to be fragile for the rest of his life. In 1925, he returned briefly to Moscow, then moved to Hanover, Germany, to live. Three years later, he returned to Russia, where he remained. By this time, Lissitzky had almost entirely abandoned painting to devote his energy to experimental typography. He was also in demand as a designer of exhibitions, in which large photographs and blown-up type figured prominently in the overall artistic concept.

Unlike many of his colleagues, Lissitzky continued to find favor with the Soviet government even after it turned repressive under Communist leader Joseph Stalin (1879–1953). Lissitzky was chosen to design the Soviet Union's pavilion for the 1939 World's Fair and his printing and lighting techniques soon exerted a powerful influence in Western Europe. Although plagued by ill

El Lissitzky. *Proun. Victoria and Albert Museum, London, England* THE ART ARCHIVE/EILEEN TWEEDY

health, he was always employed and remained untouched by Stalin's political purges. After a bout with tuberculosis, Lissitzky died in December 1941, a few months before Nazi Germany invaded Russia, during World War II (1939–1945).

LORENZETTI BROTHERS

Italian, active c. 1319–1348

Although they were leading painters in Siena, Italy, little is known of the lives of Ambrogio (c. 1290–1348) and Pietro (c. 1280–c. 1348) Lorenzetti. Their works, which feature weighty, solid figures, indicate that they were students of DUCCIO DI BUONINSEGNA. It is also apparent that they were influenced by GIOTTO. Although they worked independently, the brothers collaborated on a cycle of *The Life of Mary* (c. 1335) for the facade* of the public hospital of Siena. Both were probably victims of the Black Death, the bubonic plague that swept Italy in 1348, effectively ending the Sienese school of painting, whose stars also included Simone MARTINI.

Pietro achieved success for his large panel *The Birth of the Virgin* (1342), which was ahead of its time in its illusion of depth and perspective* (*see also* sidebar, BRUNELLSCHI). In his depiction of Saint Anne (the mother of the Virgin Mary), who rests wearily on her right arm while a midwife washes the newborn, he also introduces a new type of realism to a Christian scene. The in-

***facade** the exterior face of a building, usually the front

***perspective** a painting technique in which three-dimensional objects and figures depicted on a flat surface appear in correct proportion and relation

Ambrogio Lorenzetti. *Good Government Enthroned* (detail from fresco program). *1338–1339. Palazzo Pubblico, Siena, Italy*
THE ART ARCHIVE/DAGLI ORTI

clusion of domestic details, the fact that Joachim is depicted in the left panel awaiting the news of his wife's delivery, and the neighbor women who appear in the right panel to bring gifts combine to create a typical domestic scene that would take place in an upper-class Italian house of the 1300s.

Ambrogio was celebrated for his monumental fresco* (forty-six feet long) titled *The Allegory of Good Government: The Effects of Good Government in the City and the Country.* Painted between 1338 and 1339 for Siena's Palazzo Pubblico (town hall), it offers a unique picture of life in the flourishing banking center.

Good Government portrays typical Sienese buildings, as well as the style of dress, occupations, and amusements of the citizens. The scene is meant to illustrate how the Sienese people benefitted from wise and judicious government. The city-state* of Siena is shown at its most peaceful and orderly. Buildings and towers climb up the hillside toward a cathedral. The people attend to their daily business. One and all are protected by a zigzagging wall, interrupted by a gate—the Porta Romana, through which the Sienese pass in and out of their city.

Ambrogio's *Good Government* is rich in domestic details. Toward the left side of the fresco, the artist portrays the scenes of everyday life: a circle of women singing and dancing, workmen mending a faulty roof, a schoolmaster lecturing his pupils, and farmers taking their produce to market. On the right, well-dressed lords and ladies ride on horseback into the countryside, as laborers work the surrounding lands. Security, a winged allegorical figure, floats above the scene. She holds a scroll with an inscription declaring that peace is the order of the day—as long as she is in charge. And, should anyone be tempted to disobey her message, she shows the punishment they would receive: in her left hand there is a tiny figure swinging from the gallows.

In *Good Government,* the transition from medieval to RENAISSANCE ART can be seen. The shifting perspective and the inclusion of many tiny details ground the work in the Middle Ages (c. 500–c. 1500). But, for the first time since Greek and ROMAN ART, an artist rendered a vivid and inclusive panorama of his world and its inhabitants. *Good Government* is among the first secular images created since the beginning of the Christian era, during which almost all paintings had a religious meaning or were tied to church patronage. Ambrogio succeeded in showing viewers through the ages what life was like in Siena during the first half of the fourteenth century.

(*See also* GOTHIC ART; GREEK ART.)

LORRAIN, CLAUDE

French, 1600–1682

The painter born Claude Gellée is also known as Claude Lorrain or "Le Lorrain," after his birthplace in France. He is also called Claude, the single name a testament to the tremendous fame he enjoyed during his lifetime. He was among the most popular creators of the ideal landscape, a composition developed by Annibale CARRACCI early in the 1600s. In the ideal landscape, natural motifs* and architectural elements are a grand and highly formal

*fresco (Italian for "fresh") a method of painting in which powdered pigments mixed with water are applied directly to wet plaster

*city-state an independent, self-governed community that consists of a city and the territory that surrounds it

*motif a favorite symbol or subject in an artist's work

setting for small figures. In the hands of Nicolas POUSSIN and Claude, the ideal landscape became a setting for serious religious and mythological dramas.

Like Poussin, Claude spent most of his career in Rome. According to one account, he moved there when he was as young as twelve, becoming a pastry cook and, later, a painter's assistant. In his early twenties, he worked in Naples. The picturesque bay and coastline of the Italian city would figure in many of his paintings. In 1625, he returned to his native Lorraine and became the court painter to a nobleman. But by 1627, Claude had returned to Rome, where he remained for the rest of his life.

Claude brought to his works a deep feeling for the beauty of the Roman countryside, known as *la Campagna.* Drawings that he made on rural sojourns show an exceptional freshness, comparable to that seen in Chinese paintings. In his mature works, from about 1640 until his death, he created a hazy, atmospheric light that suggests early morning or late afternoon. These golden or silvery settings provide the backdrops for buildings or ruins from antiquity*. The small figures in the compositions seem afterthoughts in the great scheme of the natural world.

Claude's *Landscape with a Sacrifice to Apollo* shows figures in classical* dress, engaged in a ritual to the Greek sun god, Apollo. However, their actions seem far less important than the bending trees and sun-drenched vista in the background. Art historian E. H. Gombrich credited Claude with being the first to open "people's eyes to the sublime beauty of nature."

By the time he was thirty, Claude had become such a great success that other painters sometimes tried to pass off their paintings as his. To guard against forgeries, the artist began keeping a record of his works, titled *Liber Veritas* (Latin for "book of truth"). This unusual document contains drawings for almost all of his paintings made after 1635. Housed in the British Museum, the *Liber Veritas* is among the most complete catalogues of an artist's works and is a valuable resource for scholars.

Claude's poetic visions were highly influential, especially in England, where his works were eagerly collected and deeply appreciated by devoted gardeners. Wealthy Englishmen often modeled parts of their estates on Claude's paintings. English artists, such as J. M. W. TURNER, also found much to admire in Claude's dreamlike scenes of a lost golden age.

(***See also*** BAROQUE ART; CHINESE ART.)

LOTTO, LORENZO

Italian, c. 1480–1556

Lorenzo Lotto was one of the first major Venetian painters of the High Renaissance (early 1490s to c. 1527). Like his highly acclaimed contemporary, TITIAN, he trained in the studio of Giovanni Bellini (c. 1430–1516), but spent most of his mature career away from Venice. He worked in Rome, Bergamo (where he painted altarpieces), and possibly Tuscany, before returning to Venice in 1526.

Predominately a religious painter, Lotto's works are characterized by a mystical quality. In his *Annunciation* (c. 1520s), the Virgin Mary has been quietly

antiquity the period of history before the Middle Ages; Greek and Roman times

classical pertaining to Greek or Roman culture

Lorenzo Lotto. *Venus and Cupid.* *c. 1525. Oil on canvas. Metropolitan Museum of Art, New York City* GEOFFREY CLEMENTS/CORBIS

reading or praying when God and the archangel Gabriel rush in, startling a scrawny cat in the middle ground. The Virgin seems to be in a near-trance, while Gabriel wears a look of open-mouthed fear or awe. The painting's carefully rendered details, including a towel hanging from a hook and a gold candle stand, align the work closely with those of Flemish painters Jan van EYCK and Rogier van der WEYDEN. Indeed, Lotto's *Annunciation* seems more in keeping with northern European art than with the light-drenched tradition for which the Renaissance Venetians were famous.

During the latter twentieth century, art historians recognized Lotto for his fine dramatic portraits, such as *Lady as Lucretia* (1533). In this painting, it seems that the artist caught his subject off-guard, conveying her mood of brooding introspection and restlessness.

In spite of numerous commissions, Lotto was plagued by poverty much of his life. In 1554, suffering from partial blindness and mental instability, he went to live at the monastery at Loreto, central Italy. He died there two years later.

(*See also* BELLINI FAMILY; CHRISTIAN ICONOGRAPHY; RENAISSANCE ART.)

MAGRITTE, RENÉ

Belgian, 1898–1967

The son of a well-to-do manufacturer, René Magritte began his career as a commercial artist, drawing fashion advertisements and wallpaper designs. Between 1916 and 1918, he studied at the Academy of Fine Arts in Brussels, Belgium, and initially worked in a style heavily influenced by CUBISM and FUTURISM. Magritte's approach changed radically after he saw a reproduction of a painting by Giorgio de CHIRICO called *The Song of Love* (1914), and by 1925 he had emerged as an artist with a disturbingly original voice. For the rest of his life, his pictures would contain provocative juxtapositions of the bizarre and the ordinary, the charged and the commonplace.

Magritte was briefly a member of a loosely organized group of Surrealists in his native Belgium, and after moving to a Parisian suburb in 1927, he took active part in the Surrealist movement spearheaded by André Breton (1896–1966). Like many other artists, however, he eventually left the noisy politics of Breton's circle and returned to Brussels in 1930. Magritte lived a quiet bourgeois life, keeping regular hours and dressing in a suit to go to his studio.

Working in a polished realist style, Magritte developed a repertoire of startling and obsessive images: fish with human legs, bowler-hatted gentlemen dropping like raindrops from the sky, huge rocks that float in the air, and nighttime streets below cloud-flecked high-noon skies. He delighted in visual puns and paradoxes, and a favorite motif* was the painting within a painting, such as a landscape on an easel placed in front of an open window, exactly reproducing the scene outside. In one of his best-known works, *The Treachery (or Perfidy) of Images* (1928–1929), the artist painted a scrupulously realistic image of a pipe, and wrote in neat script below it: "Ceci n'est pas une pipe" (French for "This is not a pipe"). It is a puzzling notion at first, until one realizes that, of course, it is not a pipe, it is simply a painted replica of one.

*motif a favorite symbol or subject in an artist's work

Magritte's pictures often combine the banal with the fantastic. A single human eye stares up from the center of a slice of ham, or a locomotive bursts forth from a fireplace, which is depicted in *Time Transfixed* (1938). The train might have been inspired by the paintings of Chirico, but unlike the Italian artist, Magritte gives his scene greater visual punch by reducing the elements

René Magritte. *Perpetual Motion.* 1935.

of the picture to just a few carefully rendered objects in a spare setting. The train's cast shadow and the missing reflection of a candlestick on the right side of the mantle only add to the work's mystery.

Because of his distance from the world's major art centers, Magritte's work did not begin to receive the serious acclaim and critical notice it deserved until quite late in his life. His paintings were included in many Surrealist exhibitions, but it was not until Magritte was in his fifties that he gained an international reputation. Pop artists have acknowledged the influence of his humor and deft visual ironies, and his work has reached a wider audience through commercial advertising that imitates or reproduces his images.

(*See also* POP ART; SURREALISM.)

MAILLOL, ARISTIDE

French, 1861–1944

One of the pioneers of twentieth-century sculpture, Aristide Maillol began his career as a tapestry designer and painter exhibiting with the NABIS (Hebrew for "prophets"), a group of young avant-garde* painters known for decorative artwork. He made his first sculpture in 1895 but did not devote himself seriously to the art form until after 1900, when he was almost forty and a dangerous eye disease forced him to give up tapestry work. Maillol soon moved to clay modeling and bronze casting, developing a style that would change little over the course of his lifetime.

Maillol was a great admirer of the simplified strength of early Greek statues. With very few exceptions, he restricted his subject matter to the female nude—standing, sitting, or reclining. Unlike the great French sculptor Auguste RODIN, Maillol sought to strip his works of any literary meaning or dependence on architectural setting. His sculptures have none of the thrusting en-

*avant-garde literally, the "advanced guard"; a term describing innovators or innovation in a particular field

ergy of the older artist's work, but instead give off a timeless, static quality. Nonetheless, his nudes always contain a breath of life and a surface richness that come from close observation of the living model (often his wife).

One of Maillol's earliest sculptures, *Night* (1909), is typical of the massive, seated nudes that would become his trademark. Like classical Greek sculpture of the fifth century, the *Night* nude has a quality of composed and relaxed reserve. The smoothly burnished surfaces reinforce the sense of meditative calm, so unlike Rodin's love of animation and texture. Most of Maillol's commissions—which arrived steadily after 1910, when he was famous internationally—repeated just a few simple themes. When asked by a committee what form his monument to a French revolutionary hero would take, Maillol answered, "Eh! Une femme nue" (A naked woman, of course!).

In the 1920s, Maillol turned to book illustration. Some of his finest achievements are the woodcut illustrations for editions of poems by the great Roman poets Virgil (70–19 B.C.), Ovid (43 B.C.–A.D. 17), and Horace (65–8 B.C.). Many historians credit him with reviving the art of the illustrated book in Europe during this period. It is as a sculptor, however, that Maillol marks an important transition in the history of art, from the powerful figures of Rodin in the late nineteenth century to the dramatically pared-down forms of Constantin BRANCUSI and others in the twentieth.

(*See also* GREEK ART.)

MALEVICH, KAZIMIR

Russian, 1878–1935

Together with the Dutch artist Piet MONDRIAN, Kazimir Severinovich Malevich ranks as one of the most important pioneers of geometric ABSTRACT ART. Like Mondrian, Malevich had profound mystical leanings. He eventually came to believe that by abandoning the impulse to depict the natural world, he could break through to a deeper level of meaning.

As art historians have noted, the two dominant branches of abstract art in the twentieth century originated with the ABSTRACT EXPRESSIONISM of the Russian painter Wassily KANDINSKY and the geometric approach of Malevich. Each of these men held the deep spiritual conviction that their art was rooted in the traditions of Old Russia.

Early Influences and Works

Born in Kiev, Malevich came from an uncultured family, but he showed artistic leanings from an early age. He studied at the Kiev School of Art, supporting himself by working for a railway company, and then moved to Moscow in 1904 to continue his training. He became involved in underground politics, demonstrating the left-wing sympathies that would continue throughout his life.

Malevich's earliest works were Postimpressionist paintings on peasant themes, but he began to absorb the influence of contemporary French art after visiting the homes of two important Moscow collectors. His *Morning in the Country after Rain* (1911) shows the impact of CUBISM; it also bears a startling

resemblance to the works of the French painter Fernand LÉGER, although the two artists probably did not know each other.

Develops "Suprematist" Style

In 1913, Malevich designed the scenery and costumes for an avant-garde* opera, *Victory over the Sun,* and to this project he traced the origins of his own particular style of art. One of the backdrops for the opera was a totally abstract design of black on white. Malevich later wrote that "in the year 1913, in my desperate attempt to free art from the burden of the object, I took refuge in the square form and exhibited a picture which consisted of nothing more than a black square on a white field." Art historians believe that this was a drawing in pencil titled *Basic Suprematist Element.* The artist chose to call his style Suprematism, claiming it represented "the supremacy of pure feeling in creative art."

Malevich's first Suprematist compositions were not shown until December 1915. Completely and radically abstract, they marked a decisive break with pre-

***avant-garde** literally, the "advanced guard"; a term describing innovators or innovation in a particular field

Kazimir Malevich. *At the Harvest. 1909.*
ARCHIVO ICONOGRAFICO, S.A./CORBIS

vious painting. Malevich's creation of the black square on a plain white background served as an epiphany for him. Noted the art historian H. H. Arnason, "For the first time in the history of painting, he felt, it had been demonstrated that a painting could exist completely independent of any reflection or imitation of the external world—whether figure, landscape, or still life." Although the French painter Robert DELAUNAY and the Czech painter Frank Kupka (1871–1957) preceded him in the creation of abstract paintings, Malevich nonetheless can lay claim to having pushed abstraction to its most extreme geometric simplicity.

Over the next few years, the artist retreated from his self-imposed severity. He added more colors, tilted rectangles on one edge, and introduced the suggestion of a third dimension. These experiments, to Malevich, expressed different sensations inspired by the new worlds of aviation and modern technology. Thus, his Suprematist compositions were meant to capture, in his words, "the sensation of flight . . . the sensation of metallic sounds . . . the feeling of wireless telegraphy." After 1918, however, Malevich returned to his ideals with a series of paintings called *White on White*. In these, a tilted white square is placed on a white background, the only differences between them lying in the variation of the brushstrokes.

Turns to Teaching

After this point, Malevich seems to have realized that he could go no further and turned his energies to teaching and writing, as well as to drawings and models in which he explored the possibilities of three-dimensional form. Like most avant-garde artists in Russia, he supported the Bolsheviks (later to become the Communist Party), who overthrew the government of Czar Nicholas II (1868–1918; ruled 1894–1917) in the Russian Revolution of 1917. He believed the political upheaval was a logical outgrowth of what had already been accomplished in the artistic sphere.

In 1918, Malevich was invited by the noted painter Marc CHAGALL, then serving as district commissar for fine art, to teach at the Vitebsk School of Art in Vitebsk, Russia. The two soon had a falling out over theories and methods, however. Chagall returned from one of his frequent trips to Moscow one day to find that Malevich had replaced the sign that read "Free School" with one that said "Suprematist School." Chagall quit his post in disgust, and Malevich renamed the college "Unovis" (College of the New Art). By 1921, however, he was so unpopular with the local authorities that he and his followers were forced out of town.

Malevich moved to Petrograd (later St. Petersburg), where he taught at the Institute for Artistic Culture from 1922 until 1927. By the late 1920s, Malevich enjoyed a growing reputation, with exhibitions of his work in Italy, Poland, and Germany. His last moment of official recognition in his own country came in 1928, when he was given a retrospective exhibition at the Tretyakov Art Gallery in Moscow.

Later Works

Although Malevich had returned to a highly stylized form of figurative painting, his work was at odds with a repressive government and with the taste for Socialist Realism, the name given to the officially approved art under the Communist dictator Joseph Stalin (1879–1953; in power 1922–1953). Malevich

Socialist Realism

Socialist Realism is the name given to the officially approved art produced in Soviet Russia and other Communist countries under the dictatorship of Joseph Stalin (1879–1953). Suspicious of "experimental" and advanced artists such as Malevich, Stalin sought to exert iron control over artistic expression. Called Heroic Realism at the outset, *Socialist Realism* became the official term when Stalin issued his 1932 decree "On the Reconstruction of Literary and Art Organizations."

The style of Socialist Realism was never explicitly defined, but the approved art was realistic, often highly polished in presentation, and covered a set number of themes. The four main types of Socialist Realist paintings included domestic scenes, portraits, urban and industrial landscapes, and views of life on collective farms. In sculpture, heroic statues of military leaders or loyal workers and peasants prevailed. The titles of art produced under Stalin, such as *Industrial Worker* and *Collective Farm Girl,* give an inkling of the earnest and leaden nature of this art.

Like the Nazi Party of Germany, which condemned avant-garde art as "degenerate" (*see* sidebar, Nolde), the Soviets under Stalin wanted art that conveyed a particular political message to as wide an audience as possible. This led "approved" artists to look back to classical art and to nineteenth-century Realism for models. The rehashing of earlier sculpture and painting inevitably resulted in a certain blandness of style.

was arrested and jailed for a short time, but after his release he returned to painting and writing, often assigning earlier dates to his work to avoid further trouble. He remained a highly respected figure among adventurous artists of the day, and after his death from cancer in 1935, his body lay in state at the Leningrad Artists' Union in a coffin covered with Suprematist designs he had painted himself.

Even though his most memorable works were pared to the bare essentials, Malevich had a huge impact on the course of abstract art in central Europe. As Alfred H. Barr, the first director of New York's Museum of Modern Art, noted, "He stands at the heart of the movement which swept westward from Russia after the war and . . . transformed the architecture, furniture, typography and commercial art of Germany and much of the rest of Europe."

(*See also* CONSTRUCTIVISM; POSTIMPRESSIONISM.)

MANDALAS

*Sanskrit classical language of India

Mandalas are symbolic designs that represent the universe; they were originally associated with Esoteric (Tantric) Buddhism. In Sanskrit*, the word *mandala* means "sacred circle adorned and set apart." Most mandalas appear as flat symmetrical diagrams containing concentric circles and squares concentrated around a center point. Even though a mandala may appear in a two-dimensional form, it is meant to represent a three-dimensional palace that one mentally enters and moves through like a maze, encountering each palace deity in the journey through the mandala. Some mandalas contain many deities, symbols, and text, whereas others focus on one specific deity. Mandalas are found throughout Asia and have been made of different types of materials: paint, stone, sand, and even butter.

The deities and symbols depicted in mandalas represent the *secret* doctrines of Esoteric Buddhism. The explanation of a mandala and its source are passed on from teacher to student through a ritual. Mandala meditation is one of the

"three mysteries," three techniques used in Esoteric Buddhism to achieve enlightenment: hand gestures for the body (*mudra*); chanting of mystic syllables for speech (*mantras*); and visualization for the mind (*mandalas*). The mandala meditation is meant to unite an individual's mind with the mind of the Buddha, a practice that can lead to enlightenment.

The Tibetan Kalachakra sand mandala is one famous form of the mandala often produced outside Tibet. It represents a five-story palace of the deity Kalachakra and contains a total of 722 deities. Four monks create the mandala in colored sands from memory over a period of seven days. Once the mandala is finished, however, it is destroyed to reinforce the Buddhist idea of letting go of the self and material attachments. —KRISTIN BENGTSON

(*See also* BUDDHIST ART; TIBETAN ART.)

MANET, ÉDOUARD

French, 1832–1883

Often called the "father of modern art," Édouard Manet is associated with the Impressionists, although he never exhibited with the group of young painters who hailed him as their leader. He was a reluctant revolutionary, attacked by contemporary critics and always longing for the official honors that did not come his way until late in his brief life. Like Gustave COURBET, Manet was one of the first artists to look at modern life candidly. He rejected the stale models of academic painters, along with the detailed polish of their technique. Yet, Manet is a difficult painter to classify: he revered the art of the past but discovered a new way of portraying the world. No matter how radical his works, however, they often contain elements borrowed from such old masters as TITIAN, RAPHAEL, and Diego VELÁZQUEZ.

The son of a civil servant who disapproved of his artistic interests, Manet inherited a considerable fortune when his father died in 1862. From 1850 to 1856, he was a pupil of Thomas Couture, a painter of conventional portraits and historical scenes. Manet's own style, however, evolved largely from looking at pictures in the Louvre Museum in Paris and from visits to other museums in Europe.

Scandalizes Salon

Manet created a great scandal in 1863, when he was just thirty-one. His painting *Le Déjeuner sur l'herbe* (Luncheon on the Grass) was turned down by the official Salon*. This annual show was an important one for all French artists because it was their main chance to display their work. That year, the jury for the Salon was particularly finicky, and more than three thousand works by various artists were rejected. Because of the many resulting complaints, the king arranged for a separate section of the hall to show the "refused" works, known as the Salon des Refusés (*see* sidebar, IMPRESSIONISM).

Manet's painting was quite shocking to contemporary viewers. Critics were offended both by the subject and by the technique. Although the work was based on an engraving of one of Raphael's paintings, Manet's inclusion of a female nude side by side with two fully clothed men appalled the public. Neither did he idealize the naked figure nor model her after classical goddesses, as

***Salon** France's official art exhibition; established in 1667

was customary for artists of the day. Instead, he depicts a contemporary woman, gazing directly and coolly at the viewer.

Manet's technique in *Le Déjeuner* was considered equally scandalous. He used broad, flat areas of color with little modeling to suggest depth and shape. Compared with other works of the day, the figures look almost like cutouts against the lush backdrop of foliage. Ever since the Renaissance, painters had worked to create a "window" through which viewers gazed on a "lifelike" reality. In his work, Manet insists that the picture surface is a flat plane, on which he is free to combine whatever elements he likes. The notion of the "flat" canvas would have much influence on modern artists, from Paul CÉZANNE through Pablo PICASSO to present-day painters.

The work that Manet sent to the Salon two years later, in 1865, caused an even greater outrage. *Olympia* (painted in 1863) was based on Titian's *Venus of Urbino* (1538), but Manet substituted a prostitute for the model. Crowds lined up twenty feet deep; critics attacked the work for its frank sexuality and, again, for its bold technique. "The shadows are indicated by more or less large areas of blacking," wrote one reviewer. "The least beautiful woman in the world has bones, muscles, skin, and some sort of color. Here there is nothing."

The Reluctant Leader

***avant-garde** literally, the "advanced guard"; a term describing innovators or innovation in a particular field

From that time on, Manet found himself hailed as a leader of the avant-garde*. Younger painters—among them, Pierre-Auguste RENOIR, Claude MONET, and Cézanne—expressed open admiration for his work, although the older artist held himself somewhat aloof from the recently formed group of Impressionists. At the urging of his sister-in-law, the painter Berthe MORISOT, however, Manet began to accompany Monet and Renoir on painting trips along the Seine, the river that flows through Paris. As a result, his work became freer and brighter. Manet sketched constantly in the streets and cafés of Paris, and he painted subjects beloved by the Impressionists: boats along the riverbank, horse races, and scenes of people at the beach.

***lithography** the process of printing from a smooth, flat surface (such as a stone or metal plate)

Unlike his contemporaries, Manet did not shy away from portraying the political upheavals of his day. When Maximilian (1832–1867), the Austrian-born emperor of Mexico (1864–1867), was executed after the withdrawal of French forces from Mexico in 1867, Manet created paintings and lithographs* of the subject based on newspaper accounts. During the Franco-Prussian War of 1870–1871, when Paris was under siege, the artist recorded the clashes between Prussian troops and French citizens.

Final Years and Greatest Triumph

In the 1870s, Manet became ill with a disease that caused him great pain and fatigue. Nonetheless, his last work, the *Bar at the Folies-Bergère* (1882) is perhaps his greatest. Like many of the artist's paintings, the subject is mysterious. A young woman, whose back is reflected in a mirror at far right, seems to be talking to a customer. Some critics have suggested that, like the woman in *Olympia,* she is a prostitute, as much for sale as the liquor and oranges on the bar in front of her. Whatever the painting's real meaning, the artist has faithfully captured the flickering lights, the eager audience, and the sumptuous still life of the bar itself.

In the last two years of his life, Manet finally earned a few of the official honors he had craved throughout his career: a second-class medal at the Salon

Édouard Manet. *Olympia.* *1863. Oil on canvas. Musée d'Orsay, Paris* Francis G. Mayer/Corbis

and membership in the Legion of Honor. As more than one critic has pointed out, Manet's works seem to be more about the art of painting—the placement of pigment on a flat surface—than about their supposed "subjects." That freedom from literary, historical, or moralizing themes is what makes Manet one of the founders of the modern art movement.

(*See also* ACADEMIC ART; IMPRESSIONISM; RENAISSANCE ART.)

MANNERISM

Mannerism is the name scholars have given to the art produced in Europe from about 1525 to 1600, immediately after the High Renaissance (early 1490s to c. 1527). However, there really was no one coherent style of art produced during this period, and art historians disagree on how to define Mannerism.

The term is taken from the Italian word *maniera,* meaning "style" or "stylishness." It was popularized in the writings of sixteenth-century painter and biographer Giorgio VASARI, who used it as a term of praise. The artists he called Mannerists, in his view, shared a certain sophistication, grace, and poise.

In the seventeenth century, however, critics began to look back at those artists with a harsher eye. They saw in Mannerist art a falling-off from the

grandeur and harmony of the High Renaissance masters. "Mannerism" instead came to suggest a decadent style that exaggerated and plagiarized the greater works of such Italian Renaissance artists as LEONARDO DA VINCI, RAPHAEL, and MICHELANGELO.

Historical Background

The sixteenth century in Europe was a period of intense spiritual and political turmoil. The Protestant Reformation launched the first serious attack on the authority of the Catholic Church in more than a thousand years. German priest and scholar Martin Luther (1483–1546), who led the Protestant movement, believed that the truths contained in the Bible and direct communication with God led to salvation. The Catholic leadership instead held that its rituals and clergy were of greater importance. Protestantism spread rapidly in Germany, Scandinavia, and England, especially among political leaders who hoped for a greater degree of freedom from the Church.

Within a few decades, the Catholic Church started a reform movement of its own, known as the Counter-Reformation. Pope Paul III (1468–1549; pope 1534–1549) led this drive to cleanse the Church of corruption and worldliness. A new order of priests known as Jesuits* set stricter educational standards for the clergy and closely scrutinized its morals. The humanistic attitude of the High Renaissance thus gave way to a more dogmatic religious outlook and a harsher view of the world.

At the same time, Europe was rocked by political unrest, plague, and famine. After the armies of Charles V (1500–1558; ruled 1519–1556), the Holy Roman Emperor and king of Spain, sacked Rome in 1527, the city was no longer the artistic center of Europe. Many artists fled to other courts and countries. Italian painter ROSSO FIORENTINO went to France to decorate the palace of Francis I (1494–1547; ruled 1515–1547) at Fontainebleau, south of Paris. He was soon followed by Italian sculptor Benvenuto CELLINI and other leading artists of the day.

There was also a gradual change in the intellectual climate of European society. After Christopher Columbus (1451–1506) "discovered" the New World in 1492, the great explorers of the sixteenth century—Ferdinand Magellan (c. 1480–1521), Hernán Cortés (1485–1547), Francisco Pizarro (c. 1475–1541), Sir Francis Drake (c. 1540–1596), and others—brought back a wealth of artistic and natural wonders from their voyages. Old ways of thought inherited from ancient Greece and Rome—particularly those of Greek philosophers Plato (c. 428–c. 348 B.C.) and Aristotle (384–322 B.C.), which profoundly influenced Renaissance thinking—were brought into question. By 1650, a new body of learning based on science and rationalism would have a major impact on artists, writers, and scientists.

The Mannerist Style

Since "Mannerism" incorporates so many different styles of art, today the term applies more to the eighty or so years between the High Renaissance and BAROQUE ART than to any one kind of representation. Nonetheless, the artists who were active during this period, both in Italy and in other countries, do share certain characteristics. In painters as diverse as Rosso Fiorentino and EL GRECO, there is an emphasis on the distortion and elongation of the human

*Jesuit member of the Society of Jesus, an order of the Roman Catholic Church founded in the sixteenth century

body, and on the use of light for highly dramatic effects. Other qualities of Mannerist art include an artificial gracefulness, bizarre shifts in scale and perspective* (*see also* sidebar, BRUNELLESCHI), and vivid—sometimes harsh or shocking—colors. Paintings are crowded with figures, and their underlying meaning is often ambiguous.

Mannerist artists tended to reject the High Renaissance preoccupation with classical* art and learning. Instead their work emphasized "inner vision" and the free exploration of their imagination. Nor was the Mannerist artist much

***perspective** a painting technique in which three-dimensional objects and figures depicted on a flat surface appear in correct proportion and relation

***classical** pertaining to Greek or Roman culture

Parmigianino. *Madonna with the Long Neck. c. 1535. Oil on wood panel. Galleria degli Uffizi, Florence, Italy* THE ART ARCHIVE/ DAGLI ORTI

interested in studying human anatomy as Leonardo and Michelangelo had done. The artists of the mid- and late sixteenth century rejected naturalistic models, often looking instead to other works of art for inspiration.

For the most part, the great patrons of Renaissance art had been popes and high-ranking members of the Church. Mannerism, however, appealed to an elite, sophisticated audience of aristocrats with a taste for decorative display. The sculptor Benvenuto Cellini represented this new trend. "For him, to be an artist was no longer to be a respectable and sedate owner of a workshop," art historian E. H. Gombrich pointed out. "It was to be a 'virtuoso' for whose favor princes and cardinals should compete."

The religious divisions of the day took their toll on Mannerist art. CHRISTIAN ICONOGRAPHY still formed a large part of every artist's vocabulary, but its spiritual meaning often seemed strained or exaggerated to the point of caricature*. There is a world of difference between Raphael's *Madonna of the Meadows* (1505) and *Madonna with the Long Neck* (c. 1535) by Italian painter PARMIGIANINO. Raphael's Madonna shines with dignity and grace. Parmigianino's is overly elegant, puzzling, and almost empty of religious feeling.

In short, Mannerist artists responded—as all artists do—to the temper of their times. The sixteenth century was an unsettled period of change and conquest, warfare, and turmoil; its art reflects those stresses in its restless distortions and anxiously crowded canvases.

(*See also* RENAISSANCE ART.)

MANTEGNA, ANDREA

Italian, 1431–1506

Next to the Italian painter MASACCIO, Andrea Mantegna ranks as the most important painter of the Early Renaissance. Most of the major figures of this period, between about 1400 and 1475, were nourished by the intellectually and artistically stimulating atmosphere of the city of Florence. Wealthy patrons, an abundance of talent, and a competitive spirit produced an environment that led the city to be considered a "new Athens." Florence's achievements during this period drew comparisons with the ancient Greek capital at the height of its power, in the fifth century B.C.

Since the 1420s, Florentine artists had been introducing new concepts and methods when they visited northern Italy, specifically Venice and the neighboring city of Padua, where Mantegna grew up. Until Mantegna, however, virtually no painters or sculptors from this area had absorbed the influences to produce works that would rival the artists in Florence.

Early Influences and Works

The young Mantegna had a passion for archaeology and carefully studied both ancient ruins and classical* art. These influences can be seen in an early distinctive style that would change little over the years. Mantegna is especially known for his use of illusionist techniques, especially extreme foreshortening*. During his early years, he also showed a remarkably independent spirit. When he was only seventeen, he took his teacher, who was also his adoptive father,

caricature an image that is distorted or exaggerated for comic effect

classical pertaining to Greek or Roman culture

foreshorten to shorten or minimize an object in a painting so that it appears to be in the distance; gives the composition depth

to court and won a lawsuit that claimed the older painter was exploiting his pupils.

Mantegna's first major commission, undertaken in 1449, when he was still a teenager, was a series of frescoes* (*see also* sidebar, GIOTTO) illustrating the lives of Saint James and Saint Christopher for the Eremitani Church in Padua. The chapel that housed these paintings was almost totally destroyed by bombs in World War II (1939–1945), but black-and-white photographs of the paintings, as well as the sketches Mantegna made for the final works, attest to their strengths.

The fresco *St. James Led to His Execution* (c. 1455) is the most dramatic of the series, in part because it takes into account the viewer's position. The viewer looks up and into the scene in a way that must have seemed daring for its time. Mantegna's concern for the details that set the story in the Roman period extends to the huge triumphal arch, not a copy of a real one but very like those of the ancient republic. On the left, a saint stops to bless a paralyzed man, who will soon afterward get up and walk. Many of the details in the finished work seem to be based on actual costumes of Roman soldiers, which Mantegna probably duplicated after studying classical statues. It is interesting to note, however, that in his preparatory drawing, the artist, like others of the time, conceived many of the figures in the nude. Drawing the body without garments probably gave the artists a better sense of the actions and poses of figures.

Court Painter at Mantua

From about 1460 until the end of his life, Mantegna worked for Ludovico Gonzaga II (1447–1478), Marquis of Mantua, whose court attracted the leading humanists and artists of the day. Mantegna's frescoes of the Gonzaga family show group portraits, scenes from court life, and images from classical mythology. Some scenes include medallions* of the Roman emperors, clearly implying a link between this ruling family and the great leaders of the ancient world.

***fresco** (Italian for "fresh") a method of painting in which powdered pigments mixed with water are applied directly to wet plaster

***medallion** a large medal or tablet painted or carved with a portrait, scene, or pattern

Andrea Mantegna. Detail of the ceiling of the Camera degli Sposi. *1474. Fresco. Palazzo Ducale, Mantua, Italy* THE ART ARCHIVE/DAGLI ORTI

For the bedroom (the Camera degli Sposi; "Room of the Newlyweds") of the Gonzaga palace, Mantegna produced another astonishing feat of perspective* (*see also* sidebar, BRUNELLESCHI). The tondo* on the ceiling is painted so that the ceiling appears to be open to the summer sky. Several court ladies, their faces reflecting a golden light, gaze downward on the viewer. A shimmering blue and violet peacock, the symbol of eternity, keeps watch over the house of Gonzaga. Three fat putti* are arranged around the dome, their figures dramatically foreshortened.

Later Works

Mantegna's greatest feat of foreshortening, however, and perhaps his most moving picture, is *The Dead Christ* (c. 1501). The Savior's body is seen feet first, and the Crucifixion wounds on his hands and feet are vividly displayed. The artist takes the viewer from the skillfully painted folds of drapery that cover the lower half of Christ's body to his naked chest and finally to the face, which seems to have found an exhausted peace after terrible suffering. The work is both a powerful statement of the painter's astonishing skill and a poignant statement about Christ's humanity and pain.

(*See also* CHRISTIAN ICONOGRAPHY; RENAISSANCE ART.)

MARC, FRANZ

German, 1880–1916

The son of a professional landscape painter, Franz Marc has become one of the most popular of the German Expressionist painters. Animals are a major theme in Marc's works, and he is known for his bold semi-abstract paintings of red and blue animals, especially horses.

Early Works and Influences

After studying languages and theology at Munich University, Marc turned to art courses at the Munich Academy, where he trained between 1900 and 1902. His early works were in a conservative, academic style, but two visits to Paris resulted in a radical change in his approach. During the first, in 1903, he discovered the Impressionists. In letters home, he proclaimed them to be "the only salvation for us artists." Soon after, however, he suffered a serious depression, which was temporarily relieved by a visit to Mount Athos in Greece. Marc was of a deeply spiritual disposition, and visits to the monasteries there seem to have brought him tranquility.

The death of his father, however, and his engagement to a young woman in 1907 provoked further crises. He escaped the latter by running off to Paris again the day before his wedding. This time, he discovered the Postimpressionist painters. Marc was especially impressed by the works of the French painter Paul GAUGUIN and the Dutch painter Vincent VAN GOGH. He wrote that his own "anxiety-ridden spirit found peace at last in these marvelous paintings."

Study of Animals

Between 1907 and 1910, Marc began an in-depth study of animals, which led to further changes in his style, especially an increased intensity of feeling.

He believed that animals were both more spiritual and more beautiful than humans. "The ungodly human beings who surrounded me did not arouse my true emotions, whereas the inherent feel for life in animals made all that was good in me come out," he wrote. He made repeated visits to the zoo in Berlin and earned part of his income by giving lessons in animal anatomy.

Meets Macke

Two events in 1910 had another profound impact on Marc's work. He met the German painter August Macke (1887–1914), who was seven years younger than Marc and was to become his closest friend. Macke introduced the older artist to an influential patron who offered Marc a monthly allowance. He also saw an exhibition of works by the French painter Henri MATISSE in Munich. Macke painted Cubist scenes in high-keyed color. He also began to form his own set of artistic rules, assigning emotional values to certain colors. In a famous letter to Macke, he wrote, "Blue is the main principle, astringent and spiritual. Yellow is the female principle, gentle, gay and spiritual. Red is matter, brutal and heavy and always the color to be opposed and overcome by the other two."

A year later, Marc embarked on the series of paintings that would make his reputation. *Blue Horses* (1911), now in the Walker Art Center, Minneapolis, is the great masterpiece of his early style. It shows three brilliant-blue horses, whose powerful, swelling forms nearly fill the canvas. The colors are so vivid that the background of reds, blues, and yellows is not really "background" at all but pushes forward into the horses' space; only the softened tones toward the center give the painting an illusion of depth. According to Marc's theories, the colors take on a life independent of the subjects they describe.

avant-garde literally, the "advanced guard"; a term describing innovators or innovation in a particular field

Joins Der Blaue Reiter

In 1911, Marc joined the Russian painter Wassily KANDINSKY and others in forming an avant-garde* group known as *Der Blaue Reiter* (The Blue Rider).

Franz Marc. *Stables.* *1913. Oil on canvas. Solomon R. Guggenheim Museum, New York City* BURSTEIN COLLECTION/CORBIS

He helped organize their first exhibition and persuaded a German publisher to release Kandinsky's fundamental text *Concerning the Spiritual in Art* (1911). A year later, Marc saw an exhibition of Futurist works in Berlin and, together with Macke, went to Paris to visit the French painter Robert DELAUNAY. These events helped push his own paintings toward total abstraction.

In one of his most celebrated paintings from this period, *Animal Destinies* (1913), Marc used the fragmented forms of panic-stricken animals to symbolize a world on the brink of destruction. He said of this work, "It is like a premonition of this war, terrible and gripping. I can hardly believe I painted it." By 1914, his work had lost almost all representational content, as in *Fighting Forms* (1914), where jagged, swirling color and whipping lines suggest two great birds, reduced to beaks and claws, in bloody conflict.

World War I

When war broke out in 1914, Marc volunteered for service almost immediately. The following month, his good friend Macke died in combat. Although he was unable to paint while in the army, Marc sent numerous letters and drawings home that show his disgust with the carnage around him. In March 1916, he was instantly killed at Verdun, France, when a shell splinter struck him in the head.

(*See also* ABSTRACT ART; CUBISM; EXPRESSIONISM; FUTURISM; IMPRESSIONISM; POSTIMPRESSIONISM.)

MARTINI, SIMONE

Italian, c. 1284–1344

Simone Martini was probably the most distinguished student of the Italian painter DUCCIO DI BUONINSEGNA of Siena, an important artistic center during the fourteenth century. Duccio, Martini, and others of the Siena school were leaders in the development of Italian GOTHIC ART. Martini is noted for his elegant interpretation of courtly life.

In 1315, like his teacher Duccio, Martini was commissioned to paint a portrait of the Virgin in Majesty, known in Italian as a *Maestà*. Like Duccio, Martini favored kneeling and standing figures for his forty-foot-wide fresco* (*see also* sidebar, GIOTTO), painted for the end wall of a meeting room in Siena's town hall. Martini, however, brought innovative touches to his grouping. Some of the figures look out at the viewer; the Virgin is firmly seated on her delicate, Gothic throne; and the artist brings to the scene a unified space by means of a large canopy supported by eight poles. Moreover, the space suggests depth, so that the saints and angels are not merely lined up close together but stand one in front of the other.

Martini's next major work, also a commission from the Republic of Siena, was a large equestrian portrait of the Sienese captain Guidoriccio da Fogliano to celebrate a great victory. The fresco, which shows Guidoriccio riding in solitary splendor across a vast sweep of landscape, is generally considered one of the first such portraits since Greek and Roman times. However, its attribution to Martini has been in doubt in recent years, and it is now thought to have been painted in about 1333 rather than in 1328, as once believed.

***fresco** (Italian for "fresh") a method of painting in which powdered pigments mixed with water are applied directly to wet plaster

The painting generally regarded as Martini's masterwork is *The Annunciation* (1333), an altarpiece for the Siena Cathedral. Martini painted the Annunciation* in collaboration with his brother-in-law Lippo Memmi (died 1357). The flamboyant frame, punctuated by scalloped arches and spiked pinnacles, reflects the artist's interest in French Gothic art. The work is a wonderful example of richly decorative elements. The subtly patterned angels' wings, the embroidered hems of the figures' garments, the marble floor, and Mary's delicately carved throne show why Martini was one of the main sources of inspiration for the INTERNATIONAL GOTHIC STYLE. The way Mary seems to shrink apprehensively from the angel Gabriel's eager approach—his fluttering plaid cloak shows he has just arrived—gives the scene a tension and impact absent from the work of many of Martini's contemporaries.

Martini went to France in about 1340 and spent the remaining years of his life in Avignon, where he continued to paint. Among his important works from this period are *The Road to Calvary* (c. 1340) and *Christ Returning to His Parents after Disputing with the Doctors* (1342).

(*See also* CHRISTIAN ICONOGRAPHY.)

MASACCIO

Italian, 1401–1428

Along with his friends DONATELLO, Leon Battista ALBERTI, and Filippo BRUNELLESCHI, Masaccio (born Tommaso di Giovanni di Simone Guidi) is considered one of the "founding fathers" of the Renaissance. Although Masaccio was only in his mid-twenties when he died, his art helped to create many of the fundamental conceptual and stylistic foundations of Western art.

Little is known of Masaccio's early life and training; in fact, nothing at all is known about him from the time of his birthdate until 1422. According to the famous sixteenth-century art historian Giorgio VASARI, the artist was called Masaccio, which can be translated as "Big Tom" or "Clumsy Tom," because he was so devoted to his art that he cared little about social conventions, how he dressed, or what he ate. The earliest work attributed to Masaccio is a triptych* in the Church of San Giovenale in Cascia di Reggello, believed to have been painted in 1422. The triptych features the Madonna enthroned, two angels in adoration, and saints. In contrast to such contemporaries as GENTILE DA FABRIANO, Masaccio looked back to GIOTTO for inspiration. He rejected richly ornamented scenes in favor of realistic, earthbound figures.

In his frescoes for the Brancacci Chapel of the Church of Santa Maria del Carmine in Florence, Masaccio continued to develop a style of sweeping, simple grandeur. *The Tribute Money* (c. 1425) is in the familiar style of "continuous narrative"—that is, the story unfolds across the surface of the painting. In the center, Christ tells Peter to a catch a fish, inside whose mouth he will find money for the tax collector. In the distance, on the far left, Peter takes the coin from the fish's mouth, and on the far right, he gives it to the tax collector. Masaccio's figures are all illuminated by the same light source, which happens to correspond to the actual window in the chapel, furthering the illusion of reality. And, as in Donatello's reliefs, Masaccio gives us a sense of the atmosphere and the gently changing tones of the landscape.

*Annunciation in Christian art, a scene in which the angel Gabriel tells the Virgin Mary that she will give birth to the Christ child

*triptych a work of art, usually a painting, that consists of three hinged panels; the subject matter is often religious in nature

Masaccio. *Holy Trinity.* c. 1428. Fresco. *Church of Santa Maria Novella, Florence, Italy* THE ART ARCHIVE/DAGLI ORTI

Masaccio painted another important late work titled *Holy Trinity* on the left wall of the Church of Santa Maria Novella in Florence around 1428. The fresco* shows that he has fully grasped the principles of Brunelleschi's new architecture and scientific perspective* (*see also* sidebar, BRUNELLESCHI). Masaccio places his figures in a barrel-vaulted chamber, which creates a deep space instead of a flattened background used by so many of his contemporaries. His figures are "clothed bodies," wearing lifelike draperies that fall in natural folds. The donors who commissioned the work are life-size, and are placed to either side of the slightly smaller four central figures (the Virgin and Saint John are shown beneath God and Jesus; the Holy Spirit, the third member of the Trinity, is represented as a white dove). This completes the illusion that the viewer is looking into a real scene. In the lowest panel is a skeleton, accompanied by the grim reminder (in Italian), "What you are, I once was; what I am, you will become."

In most of the works that have survived from Masaccio's brief career, the figures are monumental, but often subdued, conveying emotion in a few simple gestures or meaningful glances. In his fresco *The Expulsion from Paradise* (c. 1427), however, the artist shows his full command of the human body in motion. A grief-stricken Adam and Eve leave the heavenly gates— Eve covering herself in shame—as an angel brandishing a sword hovers over them.

Masaccio traveled to Rome in 1428 and died so suddenly that Vasari claims many suspected that he was poisoned. Many of his Florentine contemporaries were unaffected by the power of his discoveries in painting, but the great artists of later generations and the High Renaissance (early 1490s to c. 1527) would absorb his valuable insights.

(***See also*** RENAISSANCE ART.)

MASOLINO DA PANICALE

Italian, 1383–c. 1440–1447

At one time it was thought that Masolino da Panicale was the teacher of fellow Florentine painter MASACCIO. Now, however, it seems that he probably learned from the younger Masaccio. For one thing, Masolino did not enter the Florentine Guild until 1423, a year after Masaccio, and the rules of the guild decreed that no master could take pupils until he had registered and paid his dues.

Both artists worked on frescoes* (*see also* sidebar, GIOTTO) for the Brancacci Chapel of the Church of Santa Maria del Carmine in Florence. In these works, Masolino favors the simple, realistic, gravity-bound forms favored by the younger artist. After Masaccio's death, Masolino reverted to the more decorative style of his earlier career. This later work revealed an interest in elaborate costumes and narrative details characteristic of painters like GENTILE DA FABRIANO and other masters of the INTERNATIONAL GOTHIC STYLE.

***fresco** (Italian for "fresh") a method of painting in which powdered pigments mixed with water are applied directly to wet plaster

***perspective** a painting technique in which three-dimensional objects and figures depicted on a flat surface appear in correct proportion and relation

***fresco** (Italian for "fresh") a method of painting in which powdered pigments mixed with water are applied directly to wet plaster

MASTER OF FLÉMALLE

Flemish, c. 1378–1444

Art historians believe that the painter called the Master of Flémalle and the painter named Robert Campin were one and the same. Campin was the foremost painter in the small town of Tournai in southwest Belgium. Documents exist that have allowed historians to trace his career from 1406 until his death in 1444. Together with his contemporary Jan van EYCK, Campin ranks as one of the founders of the Netherlandish school of painting and as one of the most important artists of the Northern Renaissance.

As with van Eyck, little is known about Campin's training and early life. By 1415, however, he was sufficiently well known to have acquired many pupils. In 1423, Campin became head of the painters' guild in Tournai.

Entombment of Christ

Campin's earliest work is thought to be his *Entombment of Christ,* dated to between 1415 and 1420. The decorative gold background puts the painting in the same tradition as late medieval painting of the INTERNATIONAL GOTHIC STYLE. The composition, however, suggests that Campin must have been familiar with the work created by the Italian painter GIOTTO for the Arena Chapel in Padua. As in the Italian master's frescoes* from a century earlier, Mary's grieving face is pressed close to that of her dead son. The two figures in the forefront, seen from the back, also appear to be inspired by Giotto. Campin, however, portrays the folds of drapery that fall across the bodies of his kneeling figures more realistically than the earlier artist.

Another, greater influence was provided by the sculptures of the slightly older artist Claus SLUTER of the Netherlands. Campin's figures have a dramatic force (for instance, an angel at the far right of the scene wipes a tear from his face) and three-dimensional solidity that was probably influenced by Sluter's sculptures.

***fresco** (Italian for "fresh") a method of painting in which powdered pigments mixed with water are applied directly to wet plaster

Master of Flémalle. Mérode altarpiece **(open triptych).** *c. 1425–1428. Oil on wood. Metropolitan Museum of Art, New York City* FRANCIS G. MAYER/CORBIS

Master of . . .

In art history, the title "Master of . . ." is used to identify an artist whose name and, usually, biography are not known, but who is believed to have created certain works that seem to be in the same style and by the same hand. This usage is more common in the study of painting and works on paper than in the study of sculpture. The first art historians to use this type of naming scheme worked in Germany in the nineteenth century.

Often the choice of names was more poetic than descriptive, such as the Master of the Pearl of Brabant. Later, art historians chose to name the anonymous artist after his most famous work, the place for which it was made, or the collection to which it belonged. Thus, the Master of Moulins, a fifteenth-century French painter, is named after the triptych in Moulins Cathedral in France. The Master of the Playing Cards, a German engraver of the fifteenth century, is named for a set of cards he designed. And the Master of Flémalle is named for the German village of Flémalle, home to a monastery that originally housed a group of three panels now located in Frankfurt.

*triptych a work of art, usually a painting, that consists of three hinged panels; the subject matter is often religious in nature

*Annunciation in Christian art, a scene in which the angel Gabriel tells the Virgin Mary that she will give birth to the Christ child

The Mérode Altarpiece

Campin's most famous work is a triptych* called the Mérode altarpiece (c. 1425–1428), which is named for the nineteenth-century French family that owned the painting. The central panel shows the Annunciation*. Instead of taking place in some neutral or churchlike space—as artists of the International Gothic style would have painted it—Campin's version of the famous scene is set in a realistically rendered room. The angel Gabriel brings the news of Christ's birth to Mary inside the comfortable room of a middle-class house of the time. Mary is quietly reading, supported by a long bench, and surrounded by everyday furnishings.

Despite this high level of realism, Campin has placed in the room many objects with a symbolic Christian meaning. The lilies on the table are references to the Virgin's purity. The copper basin and towel may remind the viewer of Mary as the "vessel most clean" and the "well of living waters," as she is described in the Bible. They may also symbolize Christ's mission to cleanse the sins of the world.

Most intriguing of all of these details is the candle on the table, which has just been snuffed out so that a wisp of smoke rises from the wick. Why, on an apparently bright day, was it lighted at all, and what made the flame go out? Scholars have come up with several theories. It could represent "artificial" light, which has been overwhelmed by the presence of the Lord. Or, the flame may be a symbol of divine light, now extinguished to show that God has become man. As further evidence that this is a sacred space where a miraculous event is taking place, a tiny figure carrying a cross—perhaps Christ himself—is shown sliding down the rays of light from a round window to the left.

The symbolism continues in the panels to either side of the Annunciation. At the left, the rosebush, violets, and daisies around them—like the lilies on the table in the central panel—are also flowers associated with the Virgin. The right section of the triptych portrays the elderly carpenter Joseph, Mary's husband, making mousetraps. Some scholars believe that this activity underlines his role as a "trap" for the devil. In some readings of the Bible, Joseph's marriage to Mary was interpreted as a divine plan for fooling Satan into believing that Christ's father was not God, but a mortal human being.

Campin continues the tradition of symbolism used by other artists of the Middle Ages (c. 500–c. 1500), but he places his subjects firmly among buildings and objects familiar to him. Unlike many of the artists of the International Gothic style, he was not a court painter working for a wealthy nobleman, but a middle-class artist making pictures for well-to-do fellow citizens, such as the two donors of this altarpiece who are shown kneeling in the left panel, their hands clasped in prayer. He brings to every detail of the altarpiece—from the clutter on Joseph's workbench to the cascading robes of Mary and the angel Gabriel—a sharply observed realism.

For the first time in the history of art, there is a sense of looking *through* the surface of a picture into a world that is similar to the everyday. What keeps the work from being completely convincing is its odd perspective. The floors and furniture tilt sharply upward into space and there is no single, unifying viewpoint. The ceiling of Joseph's workshop, for instance, seems to be lower than the ceiling in the Annunciation scene. Whereas Italian artists at this time were discovering the laws that governed perspective* (*see also* sidebar, BRUNELLESCHI), their Flemish contemporaries were content to show space in this somewhat random way. They seemed less interested in science and more concerned with conveying the spiritual in the everyday.

(*See also* CHRISTIAN ICONOGRAPHY; NORTHERN RENAISSANCE ART.)

*perspective a painting technique in which three-dimensional objects and figures depicted on a flat surface appear in correct proportion and relation

MATISSE, HENRI

French, 1869–1954

The Spanish painter and sculptor Pablo PICASSO once referred to himself and Henri Matisse as the "North and South Pole" of art. Indeed, these two geniuses dominated the art world for much of the twentieth century. Some art historians do not consider Matisse to be as versatile or as inventive as Picasso. Most agree, however, that Matisse launched a revolution against academic nineteenth-century REALISM that was as historically significant as Picasso's reinvention of art through CUBISM. As the leader of FAUVISM, Matisse discovered how to make color and line—rather than subject matter—the chief carriers of expression in his paintings and drawings.

Early Years

Henri-Émile-Benoît Matisse was born in Picardy, a province of northern France. He was the son of a grain merchant. After studying law in Paris, he worked as a legal clerk in his hometown of Le Cateau-Cambrésis and attended early-morning drawing classes at the local art school. In 1890, while Matisse was recovering from appendicitis, his mother gave him a box of oil paints. He later recalled, "When I started to paint I felt transported into a kind of paradise."

His father objected to him becoming a painter, but in 1891 Matisse abandoned his job as a legal clerk to study art in Paris, where he was briefly a student of the academic painter Adolphe-William Bouguereau (1825–1905). In 1895, Matisse began studying under the French painter Gustave Moreau (1826–1898) at the prestigious School of Fine Arts.

Matisse's early works were mainly still lifes and landscapes painted in sober colors in a Realist manner. In the summer of 1896, while painting in Brittany

(a region of northwestern France), he adopted a lighter palette and began to work in an Impressionist style. Soon afterward, he acquired a work by the French painter Paul CÉZANNE, *Three Bathers* (1877), which taught him the importance of using color to control the composition and structure of his paintings. Matisse kept the painting until 1936, when he gave it to the Museum of the City of Paris. *Three Bathers,* he wrote, "sustained me spiritually in the critical moments of my career as an artist; I have drawn from it my faith and my perseverance."

Matisse's painting of a male model, *L'Homme Nu; "Le Serf"* (Nude Man; "The Slave") [1900] shows the young painter's debt to Cézanne. From studying the Postimpressionist master, Matisse learned to simplify and compose a figure out of patches of color. He structured a slightly later painting, *Carmelina* (1904), in a similar manner. This painting is especially notable for another reason: a mirror located in the background contains a partial self-portrait of the artist. With this work, Matisse established two themes that would become important throughout his career—the studio interior and the artist and his model.

Although he was receiving recognition for his work, Matisse did not earn a lot during his early career. In 1898, he married Amélie Parayre, a strong-willed woman whose milliner's shop supported the couple during the first years of their marriage. In 1900, because of their financial situation, Matisse joined a team of decorators who were working on the Grand Palais for the Exposition Universelle, a turn-of-the-century world's fair held in Paris. Matisse's job was to paint yards of laurel leaves in the interior.

First Triumphs and Fauvism

Between 1902 and 1905, Matisse began to exhibit on a regular basis, both at the Salon des Indépendants* and with the prominent French art dealer Ambroise Vollard (*see* sidebar, ROUAULT). He was also acquiring a reputation among his fellow painters, who nicknamed him "the doctor" for his red beard and serious temperament. During this period, Matisse was experimenting with the pointillism* technique developed by the French painter Georges SEURAT. An example is his painting *Luxe, Calme, et Volupté* (Richness, Calm, and Sensuality) [1905], which was inspired by a line from a poem by the French poet Charles Baudelaire (*see* sidebar, COURBET), but he interprets it through the pointillist technique of applying color with short, quick brushstrokes.

The year 1905 marked a turning point in Matisse's fortunes. He and his friends showed as a group at the Salon d'Automne*. The effect was immediate and electrifying: a critic pointed to a quattrocento* sculpture in the middle of the galleries and sneered, "Donatello au milieu des fauves!" (Donatello in the midst of the wild beasts!). Pleased at the uproar they caused and delighted with being called wild beasts, the young artists started the Fauvist movement, with Matisse as the ringleader and spokesman.

At the 1905 Salon d'Automne, Matisse showed *Luxe, Calme et Volupté,* along with other canvases with bold, uninhibited colors that shocked contemporary audiences. One of these, *The Open Window* (1905), established another theme—the open window—that would be important to the artist throughout his life. The canvas shows a portion of a room, its windows flung open wide to look out on a view of bobbing sailboats and a cloud-flecked sky. Matisse uses a broad, pointillist technique for the leafy view, while defining the interior through a few simple swatches of broken color.

Outside Influences

It was also during 1905 that Matisse was brought to the attention of several powerful collectors, including the American writer Gertrude Stein (1874–1946) and her brother Leo and the Russian millionaire Sergei Shchukin. The patronage of such important collectors freed Matisse from financial worries and also allowed him to travel extensively—to Germany, Morocco, Russia, and Spain.

Around 1906, Matisse, along with other artists, began to collect AFRICAN ART. He and his colleagues were impressed by the savage power of these works, which fell outside the conventions of the European tradition and presented entirely new ways of representing the human figure. An early example of Matisse's borrowing from so-called primitive art occurs in his *Blue Nude: Memory of Biskra* (1907). Biskra was an oasis in the North African desert that the artist had visited. The background foliage, exaggerations in the figure, and touches of brashly applied blue paint all show the influence of African sculpture.

Matisse is famous for having said that his aim was to create "an art of balance, of purity and serenity . . . something like a good armchair." His works created during this period do not entirely support that goal, however. Among them, in addition to *Blue Nude,* were *The Green Line (Madame Matisse)* (1905), with a green stripe running through his wife's face; the feverishly painted *Girl Reading* (c. 1900); and a series of sculptures with disturbingly grotesque shapes.

Teaches in Paris

Between 1907 and 1911, Matisse ran a successful art school in Paris, mainly attracting pupils from Scandinavia and Germany. In the years before World War I (1914–1918), he painted some of his most memorable and groundbreaking works. His huge canvas *Le Bonheur de Vivre* (The Joy of Life) [1905–1906], made a considerable impression on Picasso, whose *Les Demoiselles d'Avignon* (The Young Ladies of Avignon) [1907] was in part a response

Henri Matisse. *The Joy of Life.*
1905–1906. Oil on canvas. Barnes Foundation, Merion Station, Pennsylvania BARNES FOUNDATION/CORBIS

to its lush sensuality and freewheeling composition. As critics have noted, the painting makes reference to past art—to cave paintings; to *Feast of the Gods* by the Italian painters Giovanni Bellini of the BELLINI FAMILY and TITIAN (the painting was completed by Bellini in 1514 and reworked by Titian in 1529); and even to a composition by the French painter Jean-Auguste-Dominique INGRES. Although the sinuous lines also owe a debt to the ART NOUVEAU style popular in Matisse's day, this vision of a sunny pastoral scene in bright sweeps of color is very much the artist's own.

Cubism and World War I

With the emergence of Cubism as a major artistic force around 1910, Matisse found his position of leadership among younger painters challenged. His response to Picasso and to the French painter Georges BRAQUE was to reintroduce sober color and more structured composition to his work. "His studies of Cubism were extremely helpful," the art historian H. H. Arnason noted, "for they encouraged him to simplify his pictorial structures [and] to control his intuitively decorative tendency."

After the outbreak of World War I, Matisse volunteered for military service but was rejected as too old at age forty-four. Many of his greatest pictures, such as *Piano Lesson* (1916), seem to reflect the grim reality of wartime Paris. The starkly geometric composition, with its forbidding figure of a woman on a high chair in the upper right, is nonetheless animated by decorative touches: the curving shapes of the balcony and the music stand, the bright swatches of pink and peach, and the inclusion of one of Matisse's own sculptures in the lower left.

Moves to Southern France

Matisse remained in Paris until 1917, but the extreme cold proved difficult for him, and he retreated to the sunny climate of the Riviera coastal region of southeastern France. He was to spend much of his time there, on and off, for the rest of his life. In the 1920s, he returned to the bright color and sensual themes of *Le Bonheur de Vivre.* In part, he might have been inspired by the lusty nudes of the French Impressionist painter Pierre-Auguste RENOIR, then elderly and crippled with arthritis, whom he visited several times.

During this same period, Matisse returned to the theme of the open window, often with a still life or figure set before it. His pictures reflect the sunny radiance and rich colors of the region, and his use of color was well described by the critic John Berger, who wrote, "It is comparatively easy to achieve a certain unity in a picture by allowing one color to dominate, or by muting all the colors. Matisse did neither. He clashed his colors together like cymbals and the effect was like a lullaby."

International Celebrity

By the early 1930s, Matisse was an international celebrity, with a stream of articles and books devoted to his work. Although he was in his sixties, he set about renewing his art by reducing it to its fundamentals. A series of photographs shows how painstakingly he worked on his *Pink Nude* of 1935. At each stage of the painting's development, he progressively simplified forms and color to arrive at the triumphant flow of color and line against a spare, geometric backdrop.

Matisse and Sculpture

Throughout his career, Matisse turned to sculpture, claiming there was a "give and take" between that medium and his paintings. He started making works in three-dimensional form, he said, "to put order into my feelings and to find a style to suit me. When I found it in sculpture, it helped me in my painting."

Early in his career, Matisse studied with the French sculptor Antoine Bourdelle (1861–1929), a talented artist who had been a pupil of the great French sculptor Auguste RODIN. One of Matisse's earliest works in bronze, *The Serf* (1904), is similar to his painting *L'Homme Nu; "Le Serf"* (1900) in its rough, blocky contours. However, the uncertain posture of the figure, who seems unbalanced in his stance, also owes a debt to a Rodin sculpture called *Walking Man* (cast c. 1903).

In the years between 1905 and 1910, Matisse studied the human figure in a variety of poses and mediums. It was during this period that he became especially influenced by African art. This influence can be seen in sculptures, as well as in his painting. The twisting posture of the woman featured in *Reclining Nude* (1907) resembles *The Blue Nude* painted in the same year.

In a series of sculptured heads of a woman named Jeanette, made between 1910 and 1916, Matisse experimented with portraiture. The first two were made in the tradition of Rodin's late bronzes, but the later ones, with their exaggerated features and geometric shapes, decidedly belong to EXPRESSIONISM.

Matisse's most ambitious effort in sculpture, by far, was a series of four backs of a female nude, executed at intervals between 1909 and 1930. More than six feet tall, they have more in common with his paintings than any other of his three-dimensional efforts. Each is an upright, rectangular surface, with the rectangle acting almost like a canvas. The sculptures themselves are in high relief (projecting from a flat background) instead of modeled in the round. Stage by stage, they show the artist developing an ever more abstract vocabulary for the female nude. Although they date from an earlier period in his life, the *Backs* parallel Matisse's journey in painting as he moves further from the realistic and closer to the abstract.

Henri Matisse. *Back I.* c. 1909. Bronze. Tate Gallery, London, England THE ART ARCHIVE

Matisse's greatest project from this decade, however, was a large triptych*, *The Dance II* (1933), for the Barnes Foundation in Pennsylvania. He began the series while living in Nice, France, only to discover that the measurements sent to him were all wrong. He painted the composition again from scratch, but instead of sketching in figures, he cut out large sheets of painted paper and pinned them to the canvas. Once he had decided on the final arrangement of the large, nude dancers, he discarded the paper and filled in the outlines. Late in his life, this procedure would lead to the series of jubilant works made entirely of paper cutouts.

Final Years

Matisse spent the years of World War II (1939–1945) in the south of France. In contrast to Picasso, whose *Guernica* (1937) and other works from this time express grief and despair, Matisse countered the inhumanity of war with joyously decorative explosions of color. Following two major operations for stomach cancer in 1941, he was confined mostly to bed or to a wheelchair. One of his most stunning projects from the late 1940s was the interior of the Chapel of the Rosary at Vence, France, a village near Cannes. The work was a

***triptych** a work of art, usually a painting, that consists of three hinged panels; the subject matter is often religious in nature

gift of thanks to one of the nuns, who had nursed him through his convalescence. The STAINED GLASS windows, filled with floral motifs*, are a luminous testament to the powers of an artist then in his eighties.

Completely bedridden during his final years, Matisse embarked on a series of works made entirely of cut-paper shapes. "The paper cutout," he explained, "allows me to draw in color. It is a simplification for me. Instead of drawing the outline and putting the color inside it . . . , I draw straight into the color." These final works, including *The Snail* (1952), are among the most buoyant and abstract of his career and would prove a great inspiration to artists of COLOR FIELD PAINTING and to members of the Pattern and Decoration movement, started in 1976 by American artists Miriam Schapiro (born 1923) and Robert Zakanitch (born 1935). Indeed, the colors were so strong that Matisse's doctor advised the artist to wear dark glasses while he worked.

A great sculptor as well as a brilliant painter, Matisse had a powerful influence on the art of the twentieth century. His love of pure color and simplified shapes truly changed the course of art. "I have worked for years," he once said, "in order that people might say, 'It seems so easy to do!'"

(*See also* ACADEMIC ART; IMPRESSIONISM; POSTIMPRESSIONISM.)

MATTA, ROBERTO

Chilean-born French, born 1911

The Chilean-born artist Roberto Sebastien Antonio Matta Eschaurren, generally known simply as Matta, had one of the most enduring twentieth-century careers, nurtured mostly in France, Italy, and the United States. He is best known for his sophisticated and varied Surrealist paintings. Although strongly influenced by many important European Surrealists, notably Max ERNST and Yves Tanguy (1900–1955), his work remains his own.

Trained as an architect, Matta studied under the great Le Corbusier (Charles-Édouard Jeanneret; 1887–1965) in Paris in 1934–1935 and then switched his attention to painting. Traveling to Spain in 1936, he met the poet Federico García Lorca (1898–1936), who introduced him to the great Surrealist painter Salvador DALÍ. By 1937, he had joined the European Surrealist movement. Along with many of those artists, he fled World War II (1939–1945) in Europe for the safe shores of New York City.

Matta became one of the most active proponents of automatism*, a fundamental tool of the Surrealists, who used "automatic writing" and "automatic drawing" to produce streams of words or doodles from the unconscious mind. He called his earliest Surrealist paintings "psychological morphologies" or "inscapes." His 1939 painting *Prescience* is typical of his work from this period—islands of shapeless blobs floating in what seems to be a translucent gelatinous sea of watery yellows and pinks and greens, and much the product of dreams.

The period from about 1939 through 1948 was a fertile time for art in New York. Matta came into contact with the Dadaist Marcel DUCHAMP, whose highly regarded work *The Bride Stripped Bare by Her Bachelors, Even* (1915–1923) Matta parodied in 1943 as *The Bachelors, Twenty Years After*. He began making his signature works in 1944, fantasy landscapes that combined

abstraction, body parts, imaginary machine fragments, and numerical calculations. Threatening and frightening, these semi-industrial paintings are also exhilarating and fast-moving—like an abstract circus stimulating connections, disconnections, and reconnections. In many of the paintings, body parts, machinery, and words appear linked by electrical charges and bizarre contraptions.

Matta's works of the 1940s are some of his best and most exciting. He cut himself off from the Surrealist movement in 1948 and began including figures in his art, even creating images inspired by the novel *Don Quixote* (1605) by Miguel de Cervantes (1547–1616). His art also became more political and socially concerned. —BARBARA M. MACADAM

(*See also* DADA; LATIN AMERICAN ART; SURREALISM.)

MAYAN ART

Sometime between 15,000 and 10,000 B.C., the remote ancestors of native American Indians crossed the Bering Straits from northeastern Asia into Alaska, and began drifting southward through North America. They were migrant hunters who used spear throwers, weapons still used by the Inuit into the twenty-first century. As early as 10,000 B.C., the migrant peoples were using these weapons to kill mammoths in the valley of Mexico. Between about 6000 and 5000 B.C., after centuries of wandering, some nomadic groups eventually arrived in Middle America, or Mesoamerica (modern-day Mexico and Central America). They made settlements and began learning the basics of farming. Compared with the Neolithic (c. 8000–c. 3300 B.C.) cultures in the ancient Near East (present-day Egypt, Israel, Syria, Iraq, Iran, and Turkey), who were building houses and primitive towns in 7000 B.C., the early inhabitants of Middle America came to village living late—around 2000 B.C.

Mayan Civilization Develops

As early as 1500 B.C. the Maya had settled in the humid marshlands and dense rain forests of the broad isthmus that connects North and South America, a forbidding terrain that remained difficult to cross even into the twenty-first century. Like other cultures of Middle America, they were greatly influenced by the Olmec people, a mysterious civilization that occupied a territory along the coastline of the Gulf of Mexico between 1700 and 400 B.C. The Olmecs had already produced works and mastered techniques that would endure in this area for centuries. They built platforms for religious ceremonies, temple pyramids, and large stone sculptures. They also introduced a kind of glyphic (symbolic) writing and a way of marking the days and months using a ritual calendar.

By about A.D. 200, Mayan civilization reached its peak and had moved from village living to establishing complex cities that were home to thousands of people. The Maya also developed a writing system and advanced systems of agriculture, and exhibited a genius for mathematics and astronomy. By the time of their decline (about A.D. 900), they had also created a legacy of architecture and artwork, including sculpture and paintings, that provides insight into their often bloodthirsty civilization.

The Paintings of Bonampak

In 1946, archaeologists, led by local *chicle* farmers (chicle is a substance from trees used to make chewing gum), discovered a brightly colored series of paintings on the walls of three small temple rooms in the forest of Mexico's Chiapas state (near the Guatemalan border). The paintings from this site, called Bonampak from the Mayan words meaning "painted walls," were remarkable not only for their well-preserved condition but for their vivid portrayal of a raid and the sacrifice of captives that followed it.

In one scene, Mayan warriors, in magnificent dress, grab hold of a victim by the hair. In another, priests and performers assemble for a ceremonial dance. A large tableau over a doorway shows the ruler, or *halach uinic*, in the center, surrounded by members of the court, including priests in leopard-skin capes and a lady carrying a fan. On the steps below, a captive sprawls, either dead or exhausted, while others are tortured by having their fingernails removed.

Aside from the skillful drawing and exquisite colors, the Bonampak murals proved to be of great value in documenting the ceremonies and warlike pursuits of the Maya. No other work from this culture provided as vivid an idea of how people dressed or how and where great rituals took place. Many elements of the paintings mystified modern historians, but the works told much about the Maya love of ceremony and display.

A Pantheon of Gods

The chief crop of the Maya was maize, a type of corn, which provided the basis of their economy. So important was maize to the survival of the culture that the plant itself was worshiped as a god; it seemed to have been revered above all other gods in the Mayan pantheon. In the Mayan version of Creation—the story of how the earth and its people came into being—the earliest gods created manlike creatures, first from mud and later from wood. Both of these were eventually destroyed. Finally, the gods used dough made of maize and fashioned the first "true men."

Other gods worshiped by the Maya included Chac, the divinity of rain, thunder, wind, and lightning; Itzamna, the aged god of the sun; Ah Puch, the god of death; and Ixtab, goddess of suicide, considered a good deity since death by one's own hand guaranteed a place in the Mayan version of heaven. According to the Mayan religion, many of the various gods and goddesses were believed to operate on earth and in the underworld; some were believed responsible for both good and evil. Such variables made modern study of the religion difficult. The rain god, for example, sent life-giving waters, but it was also held responsible for hailstorms and the damp that rots crops. Other gods defied normal expectations: Ixchel, wife of Itzamna, was the goddess of weaving and of pregnancy, yet, according to Mayan beliefs, she was considered an evil deity.

An Obsession with Time

The great distinction of the Maya was an obsession with time. Priests and rulers alike devoted themselves to the problem of measuring its passage, and each day had its own omens and associations. According to the Mayan world view, history repeated itself in endlessly recurring cycles, and understanding those cycles allowed one to explain the present and predict the future. The gods, both good and evil, controlled the cyclical patterns, and the priests, who acted as their go-betweens, were in charge of the sacred time counts.

As in many other ancient civilizations, Mayan priests exercised immense power. It was to the priests that the average farmer looked for interpretation of

the future and negotiation with the gods when necessary, for it was the priests who could tell which particular combination of good and evil was at work at any given moment.

Strict Class Structure

At its height, Mayan society was made up of strictly divided classes. Strong political authority lay in the hands of the elite. Foremost among the rulers were the nobles, or *almehen,* who owned private lands and held the most important political offices. At the head of each city-state was the *halach uinic,* or "true man," who was supported by the products of his lands, which were worked by slaves. Below him were the numerous priests, who performed official functions; among these priests were *chilanes,* who were considered gifted in prophecy. The chilanes were so highly esteemed that their feet were not allowed to touch the ground and they were carried around on litters (couches supported by poles) or on the shoulders of servants.

Lesser chiefs, called *batabs,* lived in the communities surrounding ceremonial centers, where they controlled small groups of warriors and made sure that regular tributes (payments or taxes) were offered to the halach uinic. Slaves, most of them captured in raids, made up the lowest group. Just above them were farmers, and the laborers and artisans who, using only the simplest wood and stone tools, made the spectacular buildings, ornaments, sculptures, and other artworks that were considered by scholars to be the high points of Mayan civilization.

Mayan City Centers

During the period archaeologists labeled Classic Maya (A.D. 250–900), the Mayans built over forty ceremonial centers, which consisted of temples, palaces, houses for the Mayan nobles, and ball courts. The remains of these thriving cities were found at Palenque, Chichén Itzá, and Cozumel, Mexico, as well as Copán, Honduras, and Tikal, Guatemala.

In these sprawling centers, most structures had religious purposes, and the centers themselves appeared to have been used almost exclusively for sacred rites and pageants. Noble rulers and high priests lived within the center's limits, but the ordinary Maya lived near their fields and came in only to watch ceremonies or trade goods with other farmers. Unlike ancient cities in the Near East, Mayan centers were rarely surrounded by defensive walls, even though the Maya staged frequent raids on their neighbors—primarily to take captives for slaves or for human sacrifices to the gods.

The Treasure of Palenque The complex at Palenque is widely considered by historians to be the most stunning Mayan ceremonial center. Situated inland, near the base of the Yucatán Peninsula, Palenque was the hub of settlements in a region comprising most of present-day Tabasco and Chiapas, Mexico. The most important buildings on the site date from A.D. 500 to about 800, when the city was abandoned. It was the first of the great Mayan centers to be mysteriously deserted in what was an east-to-west pattern of extinction.

In its heyday, Palenque encompassed more than seventy-eight square miles, and consisted of the priest-ruler's palace, numerous temples, plazas, burial grounds, and a ball court. The temples, which had an array of hallways and

Courtyard of the palace at Palenque.
c. A.D. 500–800 THE ART ARCHIVE/DAGLI ORTI

***stucco** a kind of reinforced plaster that can be applied to exterior walls or buildings or molded for decoration

***relief** sculptural figures or decorations that project from a flat background

narrow below-ground stairways, served as fortresses when the city was under siege.

In the center of the complex of buildings at Palenque is the palace once occupied by the priest-ruler Lord Pacal. Set on a high platform, like the surrounding temples, it contains a maze of rooms and galleries arranged around interior courtyards. A square, four-story tower may have been used as an observatory or lookout station. Stucco* work adorned the pillars of the gallery and the inner courtyards. The remains of steam baths, perhaps used in religious rituals, were found in the southwestern patio, suggesting that priests once dwelled in the adjoining cellars.

Just north of the palace was a ceremonial ball court. Every great Mayan center included one or more of these sacred enclosures in which a game similar to soccer was played. Archaeologists learned that in this Mayan game, a rubber ball was used and contestants were allowed to strike it only with hips, thighs, or elbows—never with the hands or feet. Team members wore knee and arm guards as well as protective belts made of wood and leather. Reliefs* carved for the great ball courts suggest that the game's stakes could be high: some show the decapitation of a ballplayer.

Temple of the Inscriptions Palenque's Temple of the Inscriptions, built atop a sixty-five-foot-tall stepped pyramid, is fairly typical of temple architecture during the Classic period. At the top stood a structure called a "roof comb"—a rectangular extension built of stone, often with "windows" cut into the surface and decorated with painted stucco reliefs. The temple was approached by a long stairway, accessed from the front of the structure. The plaster-walled rooms inside the temple were so narrow that they must have been used by only a select few.

At Palenque, the floor of the temple is covered with large stone slabs. One slab, having a double row of holes and removable stone stoppers, led Mexican

archaeologists to an astonishing find in 1952. Upon raising the stone block, they discovered a vaulted staircase below. It descended into the rubble-packed interior of the temple's base. Once the debris was cleared, archaeologists found that the staircase changed direction halfway down, eventually leading to a room at about the same level as the base of the pyramid. Outside this room, the skeletal remains of six young men, probably all sacrifices, were discovered.

On removing the large triangular slab at the entrance of the previously hidden room, archaeologists came upon a vaulted chamber, some thirty feet long and twenty-three feet high. Along its walls were relief figures of nine richly dressed men, perhaps representing Mayan theology's Nine Lords of the Underworld. On the floor was a five-ton rectangular stone slab, covered with relief carvings of an earth monster and symbols of life and death.

Finally, beneath the room's tremendous slab, archaeologists found a large sarcophagus*. Inside was the skeleton of the priest-ruler, Lord Pacal, for whom the elaborate tomb had been built. His body had been rested on its back and adorned with a treasure trove of jade jewelry and ornaments. Over the face was a life-size mask made of pieces of jade and eyes fashioned from shell and obsidian*. The Maya valued jade in much the same way precious stones, such as diamonds, were regarded in later centuries: the material was highly prized, and used to fashion showy "ear plugs" and other jewelry.

From the archaeological evidence, it seemed clear that the elaborate temple had been built before the death of this ruler, who had come to power at age twelve and died in A.D. 683, when he was eighty. Many workers must have labored many years to build Lord Pacal's mighty funeral monument. Thus, the Temple of the Inscriptions deserved comparison with the great pyramids of ancient Egyptian civilization, which were built for the pharaohs while they were still alive and in power.

Sculpture of the Maya

Mayan artists made carved reliefs and some freestanding sculptures, showing images of the gods, religious rituals, animals, ornaments, and the blood sacrifices that were an important part of certain ceremonies. Although there are some differences in style from place to place, the sculptures at all the great Mayan centers shared certain features. Important people and gods were rendered wearing elaborate finery—masks, belts, feathered headdresses, and jewelry adorning the wrists, neck, and ankles. One famous jade plaque, known as the *Leiden Plate* (because it eventually was transported to Leiden, the Netherlands), carries a representation of a richly outfitted Mayan lord, trampling an enemy underfoot. The theme of the powerful conqueror is repeated many times in Mayan art, and it is the kind of image that is found among other fierce peoples, such as the early Egyptians and the Assyrians.

In keeping with some of their more gruesome rituals, Mayan art can be extremely brutal. The Maya often sought favor with their gods by making offerings of human blood. In one ritual, the faithful pierced their bodies, collected their blood on tree-bark paper, and left the offerings before images of deities. In another, a kneeling woman would perform a blood sacrifice by pulling a cord through her tongue. If such injurious rituals failed to bring about the desired result (such as a good crop or favorable weather), the Maya turned to human sacrifices. Artist renderings of images of the Mayan gods show that the

*sarcophagus (from the Latin, "consumer of flesh") a coffin that is usually made of stone

*obsidian black volcanic glass

Mask of Lord Pacal. Jade mosaic. *National Anthropological Museum, Mexico City* THE ART ARCHIVE/DAGLI ORTI

people regarded their deities as fearsome beings. Thus, the Maya were eager to appease them through elaborate and even deadly ceremonies.

Although freestanding sculpture was rare in Mayan art, outstanding examples were found at Chichén Itzá on Mexico's Yucatán Peninsula. Known as *chacmools,* these mysterious figures lie on their backs, looking sharply over one shoulder and with the hands grasping a plate. Scholars concluded that the plates had a ceremonial purpose: the heart of a sacrificial victim could be placed on them in offering to the gods.

Occasionally the Maya proved themselves capable of showing tenderness and even humor. A stone head and upper torso of the young maize god found at Copán originally looked down from a temple or other building. His peaceful, gentle expression probably served as a reminder that the deity most revered by the Maya was not a fearsome one. Another relief carving, a jade plaque from Guatemala, shows an almost comical conversation taking place between a Mayan lord and a seated dwarf.

***terra cotta** a brown-red clay used for sculpture, pottery, and architectural purposes

Among the most accomplished and compelling Mayan sculptures are terra-cotta* figurines found on Jaina, an island off the coast of Campeche, Mexico. The hollow sculptures were usually painted after the clay had baked. The Jaina figurines show the fantastic finery worn by Mayan lords and priests. The figure of a priest wears a robe painted blue, which must have been a sacred color to the Maya. A lady wears a headdress and necklace that make even the elaborate ornaments of the ancient Egyptians seem modest by comparison.

Decline of the Maya

In about A.D. 900, Mayan culture of the Classic period came to an end. One by one, the great cities were deserted—some, it seems, almost overnight.

Mayan chacmool idol. *Pre-Columbian stone sculpture. Chichén Itzá, Mexico* CORBIS-BETTMANN

Although scholars can provide no conclusive reason why the civilization collapsed, they suggest that the Maya fell victim to warfare or natural disaster, such as a plague or famine. Many Maya were killed or left the region; those who remained continued to worship at the great centers.

In about A.D. 1000, another group invaded the area of Chichén Itzá, bringing with them new ideas about architecture and new sculptural styles. Many of the buildings from the post-Classic period of Mayan culture (about A.D. 900 to the arrival of the Spanish in 1517) point to the influence of a native people known as the Toltec, whose center was at Tula, near present-day Mexico City, and who had traded with the Maya. But even their culture was in decline by the time the Europeans arrived. The conquest of Mexico by the Spaniards in the early 1500s decimated the native cultures there, including what remained of the Maya.

(*See also* AZTEC ART; LATIN AMERICAN ART.)

MESOAMERICAN ART

See AZTEC ART; LATIN AMERICAN ART; MAYAN ART.

MESOPOTAMIAN ART

See BABYLONIAN ART; SUMERIAN ART.

MICHELANGELO

Italian, 1475–1564

Undoubtedly the greatest sculptor of the High Renaissance (early 1490s to c. 1527) in Italy, Michelangelo was also a painter of astonishing skill and an architect. During his long and productive career, he worked for popes and princes. He created some of the most memorable images of the day, drawing on classical* mythology and Christian theology. Michelangelo was also known for his tempestuous personality and his tendency to fly into impatient rages. He was jealous of contemporaries such as RAPHAEL and openly disliked LEONARDO DA VINCI. He was also continually in dispute with his patrons.

*classical pertaining to Greek or Roman culture

In contrast to Leonardo, Michelangelo considered sculpture by far the superior art to painting, believing that "the nearer painting approaches sculpture the better it is," and that sculpture "is worse the nearer it approaches painting." He added, "Therefore it has always seemed to me that sculpture was a lantern to painting and that the difference between them is that between the sun and the moon." Michelangelo believed that the idea for an image was locked in stone or marble and that it was his job as an artist to discover it.

Early Life and Works

The son of an impoverished gentleman named Lodovico di Simone Buonarotti, Michelangelo was born in the tiny village of Caprese, forty miles

southeast of Florence. The family moved to Florence before young Michelangelo was a month old. From a young age, the boy had a strong desire to be an artist, an ambition that was opposed by his family. They believed that they were "above" what they considered to be merely mechanical labors. When Michelangelo reached thirteen, however, his father and uncles gave in to his pleas. They found him a place as a student-apprentice in the studio of Domenico GHIRLANDAIO. There, he absorbed the traditions and techniques of the quattrocento*. Michelangelo was probably an outstanding student; he was paid a salary, unlike other young apprentices, and he was released from his three-year contract after barely a year.

Michelangelo was invited to work in the house of Lorenzo de' Medici (1449–1492) of the powerful Medici family (see sidebar, RENAISSANCE ART). Medici, who was the duke of Florence, had gathered around him some of the best intellects of the day, from whom Michelangelo had the opportunity to learn. In the Medici gardens, Michelangelo studied works of ancient art, especially marble sculpture. On trips to the Church of Santa Croce and the Church of the Carmine, both in Florence, he was inspired by the frescoes* of the Florentine painters GIOTTO and MASACCIO. From these years, scholars generally date Michelangelo's first extant work, a marble relief* called *Madonna of the Stairs* (c. 1492). It is patterned after Greek grave markers, or *stele*. The sculpture shows the Virgin cradling the Christ child on her lap. It is the only work by the master in which no hint is given of the shapes of the human forms beneath their draperies.

Other works from these years, before Michalengelo had even turned twenty-five, include many realistic and dramatic sculptures. The high-relief sculpture of the *Battle of the Centaurs* (c. 1492) accurately portrays a violent scene from Greek mythology, capturing all of the action of the moment. The nearly seven-foot-high, freestanding *Bacchus* (1497) shows the completely nude Greek god of wine. His head is wreathed in vine leaves and grapes, and he seems to be visibly tipsy. The statue is most remarkable, however, for the way in which Michelangelo captures the quality of human flesh in marble, as if the statue were alive.

Among his most famous works of this period is the astonishing *Pietà* (Italian for "pity"; c. 1498–1500) from St. Peter's in Rome. In this work, Michelangelo creates a high level of realism and emotion in his portrayal of the Virgin Mary cradling her dead son, Jesus Christ, in her arms. Equal skill is shown in the recreation of the intricate draperies of Mary's heavy skirts and the sorrowful tenderness of her face as she gazes down at the dead Christ.

In the first years of the sixteenth century, Michelangelo sculpted the mighty *David* (1501–1504) out of a huge block of marble called the Giant, which other sculptors had not been able to use. Unlike earlier portrayals of the biblical hero, the artist created a totally—and proudly—nude David, celebrating his manhood. The statue of the boy hero, who slew the evil giant Goliath in the biblical story of David and Goliath, became a symbol of the strength and independence of the republic of Florence. *David* also symbolizes a powerful individualism and humanity raised to an unprecedented grandeur.

Commissions in Rome

In 1505, Pope Julius II (1443–1513; pope 1503–1513) called Michelangelo to Rome to carve a tomb for him. In his sixties when he engaged Michelan-

quattrocento in Italian art, the fifteenth century

fresco (Italian for "fresh") a method of painting in which powdered pigments mixed with water are applied directly to wet plaster

relief sculptural figures or decorations that project from a flat background

Michelangelo. *David. 1501–1504. Marble. Galleria dell'Accademia, Florence, Italy* SCALA/ART RESOURCE

gelo to decorate his burial monument, the pope selected a plan from among several preliminary drawings for a freestanding, four-sided edifice surrounded by various figures. After a year of immense labor, the pope ordered work on the tomb stopped because funds were diverted to the building of a new St. Peter's. The artist left in anger for Florence, where he resumed work on the monumental, but unfinished, painting *The Battle of Cascina* (c. 1542).

Within months, the pope summoned Michelangelo back to Rome to execute a colossal portrait statue in bronze. (It was later pushed from a piazza in Bologna, melted down, and cast into a cannon to use against papal forces.) The artist had just returned to Florence in the spring of 1508 when Julius again ordered him to Rome and gave him the commission to paint the ceiling of the Sistine Chapel, the pope's private church within the Vatican. A reluctant Michelangelo worked on the project for the next four years, insisting all the while that he was not a painter. He agreed to the project in the hopes that he would be allowed to resume work on the pope's tomb.

The Sistine Chapel

Work on the ceiling for the Sistine Chapel was an incredible undertaking for Michelangelo, who was not trained in the art of fresco. The job was further complicated by the enormity of the task: Michelangelo was asked to paint an area of fifty-eight hundred square feet that was seventy feet off the ground. He was also faced with the problem of creating realistic perspective* (*see also* sidebar, BRUNELLESCHI) while working around the vaulted ceilings and painting so high off the ground.

The original plan for the series of frescoes called for the twelve apostles in spandrels*, with the central part of the ceiling to be filled with ornaments and geometric designs. In Michelangelo's hands, the apostles gave way to a sweeping story of mankind that included more than three hundred figures. His theme was the creation, fall, and redemption of man.

On either side of the central band, prophets from the Old Testament alternate with sibyls, or female prophets, from Greek mythology. The ceiling's central bands feature scenes from the Book of Genesis. One central panel, the *Creation of Adam* (1511–1512) is particularly dramatic and shows God and Adam reaching for each other, but not quite touching. Adam is depicted as a heavy, earthbound figure, whereas God transcends Earth and is wrapped in billowing drapery. Their strong forms echo the defined muscular shapes found in Michelangelo's sculptures. Four corner spandrels are filled with more scenes from the Old Testament. Other spaces in the ceiling show the ancestry of Christ, with the end wall devoted to a vivid depiction of the Last Judgment.

For this project, Michelangelo made hundreds of preliminary drawings, many of which survive, and designed a special scaffolding to raise himself high above the ground. Over time, the figures grew in size and expressive depth, from the huddled, comparatively inert figures of the *Deluge* (1509) to the magnificent sibyl who turns in a sweeping movement to close her book as she starts to step down from an altar.

Later Years

During the papacies of Leo X (1513–1521) and Clement VII (1523–1534), Michelangelo's activities centered on St. Lorenzo, the Medici church in Florence.

*perspective a painting technique in which three-dimensional objects and figures depicted on a flat surface appear in correct proportion and relation

*spandrel the rectangular space between the right or left exterior of an arch and the surrounding framework

Michelangelo. *Creation of Adam,* **detail
from the Sistine Chapel ceiling.**
1511–1512. Fresco. Vatican, Rome, Italy
SCALA/ART RESOURCE

For fourteen years, the artist worked on tomb sculptures for Lorenzo the Magnificent, who had housed the boy genius as a teenager; Lorenzo's brother, Giuliano; and two younger members of the family. Figures representing day and night—dawn and twilight—flank the seated figures of the two brothers. Four tombs in all were planned, lining the walls of the chapel. However, the original scheme, which included statues of the Madonna and two saints, was never completed.

In 1527, the Sack of Rome signaled the end of the High Renaissance. Charles V, the Holy Roman Emperor (1500–1558; ruled 1519–1556), invaded the holy city, looting and burning palaces and slums alike, and taking the pope prisoner. By the time Michelangelo returned to Rome to work on the Sistine ceiling in 1534, more than twenty years after completing his paintings of the creation, fall, and redemption of man, his frescoes reveal a changed mood, reflecting the spiritual and political crises of the time. *The Last Judgment* (1534–1541) shows a wrathful God delivering judgment on huddled masses of fearful humanity.

In the last thirty years of his life, Michelangelo turned his attention to architecture. Commissions to reshape the Campidoglio, a group of palaces on

Julius II, The Warrior Pope

Born Giuliano della Rovere in 1443, the man who became Pope Julius II in 1503 was a fierce and violent military leader as well as the spiritual head of the Catholic Church. He was one in a series of popes who worked to transform Rome from a local market town into a city that would rival the great centers of Milan, Venice, and Florence. Their goal was to make Rome a site worthy of housing the church leaders. In addition to reforming many practical aspects of life in the Vatican, Julius, known as the warrior pontiff, drove foreign invaders out of all Italy and played an active part in military campaigns to recover the territories of Bologna and Perugia, which had once been under Rome's control. When Michelangelo began work on a statue of the pope to be placed in Bologna, the artist suggested putting a book in the pope's hand. Julius responded, "Put a sword there—I know nothing about reading."

Actually, Julius had a much greater interest in learning and the arts than the average military leader—or even the average pope. He expanded the Vatican library and began a collection of antique sculpture. He rebuilt whole sections of the city and replaced the old basilica of St. Peter's with a grand new structure, initially designed by the architect Bramante (1444–1514). Julius is probably best known, however, as the patron of Renaissance artists, including Michelangelo and RAPHAEL. His ferocious temper led to stormy quarrels with Michelangelo, who proved the pope's equal in displays of anger. In spite of their quarrels, the two admired each other greatly.

After Julius died in 1513, Michelangelo returned to work on the pope's tomb on five separate occasions. Regrettably, little of the magnificent project survives. Michelangelo finished only three figures for it: the famous *Moses*, who suggests both great wisdom and a capacity for terrifying wrath, and two "slaves" (*Dying Slave* and *Bound Slave*), perhaps meant to signify territories conquered by Julius.

top of the Capitoline Hill in Rome, and the exterior of St. Peter's gave him the chance to plan on a grand scale. Although built largely after his death, the dome of St. Peter's conveys a powerful, almost sculptural energy, thrusting upward from the main body of the cathedral.

Michelangelo's last sculpture, the *Pietà Rondanini* (1564), seems to find the artist exploring new forms and a new language. Scholars generally believe that the unfinished work, showing the limp body of Christ almost slipping from his mother's grasp, was intended for Michelangelo's own tomb. In this work, the eighty-nine-year-old genius continues his search to liberate stone figures that still pulse with life across the centuries.

MILLET, JEAN-FRANÇOIS

French, 1814–1875

Born into a prosperous farming family in the Normandy region of northwestern France, Jean-François Millet became the first artist to lend dignity and timelessness to themes of rural life. Little is known of his early life, but by 1837 he was studying in Paris. He was largely self-educated and became well read in classical* authors who celebrated pastoral themes, such as the Greek poet Theocritus (c. 310–250 B.C.) and the great Roman poet Virgil (70–19 B.C.). He also read the Scottish poet Robert Burns (1759–1796), whose verse was steeped in the country life.

***classical** pertaining to Greek or Roman culture

Millet's early works consisted of conventional portraits and mythological and genre* scenes. In 1848, the year revolution erupted throughout Europe, he began to create a kind of painting that would be championed by liberal critics because it was so far removed from the stiff NEOCLASSICAL ART approved

***genre painting** painting that focuses on everyday subjects

by official taste. *The Sower* (1850) became a classic symbol of the peasant at work. Rural people who lived off the land had been a popular theme in French art for many years. Typically, however, they were shown as sentimental and charming figures, their lives celebrated to conjure up a world of simplicity and innocence.

In Millet's classic painting *The Gleaners* (1857), a bold and simple composition, three women stoop to pick up blades of wheat. The painting has a clear social message: the women belong to the lowest level in peasant society, those who were given permission to pick up the few "leftovers" in the fields after the wealthy had harvested their crops. Thus, they are the rural equivalent of city beggars. For audiences of his day, Millet's monumental figures were powerful symbols of the lower classes in an age of social unrest and industrial change. As one contemporary critic noted, even Millet's application of paint contributes to the forcefulness of the scene in *The Gleaners*. The artist, he wrote, "trowels on top of his dishcloth of a canvas . . . vast masonries of colored paint so dry that no varnish could quench its thirst."

In all of his works, Millet generally conceals the faces of his subjects in shadow and sets them in unidentifiable landscapes. They belong to no particular region, therefore they take on a wider significance, becoming symbols of mankind's dependence on the land. They are self-absorbed and tinged with a certain seriousness and even melancholy. Ironically, the artist celebrated a way of life that was rapidly disappearing as men and women turned away from the land to work in factories and cities. His paintings never show the technological improvements that were rapidly changing French agriculture. Instead, he emphasizes tools like the hoe and the rake, which have served mankind since the beginning of time.

After 1849, Millet settled at Barbizon, the small village outside Paris where he and a group of landscape painters established the BARBIZON SCHOOL in the mid-nineteenth century. He became a close friend of the French painter

Jean-François Millet. *The Gleaners.* *1857. Oil on canvas. Louvre, Paris* THE ART ARCHIVE/DAGLI ORTI

Théodore ROUSSEAU, whose work would influence the pure landscapes of his later career. Millet's painting *The Angelus* (1859), showing peasants praying in the fields, became one of the most widely reproduced paintings of the nineteenth century and today remains a favorite sentimental image. A powerful draftsman, Millet worked with a simple, fluid line that manages to eliminate all that is unessential to his figures. He has often been compared to the French painter Georges SEURAT for the forceful economy of his drawings.

(*See also* REALISM.)

MINIMALISM

The movement known as Minimalism, also called Minimal art, emerged in the 1960s, largely as a response to the primacy of "action painting" of ABSTRACT EXPRESSIONISM, which dominated the American avant-garde* in the 1950s. Followers of the Minimalist aesthetic rejected the intuitive, spontaneous approach of action painters in favor of spare, stripped-down parts and surfaces as well as strict geometric arrangements.

While precedents for the movement can be found in European models, such as the works of Dutch painter Piet MONDRIAN and the Russian Constructivists, Minimalism flourished primarily in the United States and lacked the spiritual or political overtones of those artists. A major American influence on Minimalism was the COLOR FIELD PAINTING of Ad Reinhardt (1913–1967), who, during the 1950s, made monochromatic canvases in red, blue, or black. His approach was that of an uncompromising purist: the rectangles or squares in his paintings can only be perceived after careful observation. Reinhardt stated that his aim was to eliminate all references to the world outside his painting, so that the viewer's only experience was of the art itself.

Minimalism was primarily a movement among sculptors. Foremost among them was Tony Smith (1912–1980), whose work and pronouncements on art helped shape the group as a whole. Although he came of age at the same time as the Abstract Expressionists, he did not exhibit his sculpture until 1964. Composed of large and simple geometrical elements, Smith's works demand that the viewer walk around them to appreciate their full impact. Like the younger Minimalists, he had his work manufactured by outside sources, and the surfaces—usually weathered steel—have a rough, industrial quality, which contributes to the overall effect.

The sculptor Donald Judd (1928–1994) was a major theorist who took Smith's ideas a step further, eliminating virtually all references to other art or nature in the polished uniform surfaces of his boxy sculptures. Like Judd, Carl Andre (born 1935) made sculptures from identical geometric units, often simple bricks or steel plates, which he placed directly on the floor. Richard Serra (born 1939) also used industrial materials, but on a gigantic scale. His *Tilted Arc* (1981), a huge, curving slab of steel that intersected a plaza in New York City, generated prolonged and heated controversy as well as a full-blown court trial after it was removed in 1989.

The only woman among the Minimalist sculptors to achieve renown was Eva Hesse (1936–1970). A restless talent, she experimented with a number of unusual materials during her brief career. Using fiberglass, rubber tubing, and

***avant-garde** literally, the "advanced guard"; a term describing innovators or innovation in a particular field

Agnes Martin. *Untitled Number 1.* *1981. Gesso, paint, and pencil on canvas. Museum of Modern Art, New York City; gift of the American Art Foundation* COURTESY OF THE MUSEUM

fabric, she made works that provoked associations with the processes of birth, sex, and death.

Minimalist painters used many of the effects exploited by the movement's sculptors: repetition, geometry, and large formats. Canadian-born American artist Agnes Martin (born 1912) relied on a large-grid format to capture extremely subtle effects that recall the light and atmosphere of her adopted home of New Mexico. After the 1960s, American Robert Ryman (born 1930) dedicated himself to exploring the infinite variations of white on white. Limiting himself to paint, paper, canvas, and a few other materials, he created numerous works that, in various ways, celebrate the potential of restrained and straightforward objectives. Others who turned to extremely simplified geometric formats included Americans Robert Mangold (born 1937) and Dorothea Rockburne (born 1934), who called on mathematical theory to produce intricately folded and sumptuously colored works that reveal Minimalism's more sensuous side.

More than one art critic saw the aims of Minimalism as a restatement of a fundamentally puritanical strain in American art. But, by stripping away much of the grandiloquence that had followed the Abstract Expressionist movement, Minimalists used simple means to open up new and rich artistic territory.

(*See also* CONCEPTUAL ART; CONSTRUCTIVISM; HARD-EDGE PAINTING.)

MINOAN ART

See AEGEAN ART.

MIRÓ, JOAN

Spanish, 1893–1983

Born in Barcelona, the son of a well-to-do goldsmith, Joan Miró looked to the Catalan landscape of his youth as a source of imagery for his art. He enrolled in a commercial college in 1907 and later worked briefly as a clerk because of his family's disapproval of an artistic career. After an illness that plunged him into a deep depression, however, he was allowed to follow his talent and enrolled in an art school run by a liberal-minded painter named Francisco Galí.

Early Influences

When an exhibition of French painting opened in Barcelona, Miró fell under the spell of original works by the French painters Henri MATISSE, Paul CÉZANNE, and Claude MONET. Miró's first show, in 1918, sold few paintings, however, and the artist retreated to the family farm at Montroig, in rural Spain, to find a new direction.

A year later, Miró arrived in Paris and soon came under the influence of the Swiss painter Paul KLEE, whose work was just becoming known in the French capital. For many years afterward, Miró would spend winters in Paris and summers in Montroig. He began increasingly to draw on the powers of his imagination rather than working from nature. In 1924, he signed the first *Sur-*

Joan Miró. *Catalan Landscape.*
*1923–1924. Oil on canvas. Museum of
Modern Art, New York City* ARTISTS RIGHTS
SOCIETY/ADAGP, PARIS; COURTESY OF THE MUSEUM

realist Manifesto but always remained somewhat distant from the other members of the movement.

First Inventive Works

One of the first works to demonstrate Miró's rich powers for fantastic invention was *The Harlequin's Carnival* (1925). The small canvas features a boisterous group of bizarre creatures—one sporting blue-and-green wings pops out of a box; another has a disk for a face and a comb for a mouth. Miró's creatures stem from many sources in the natural world and from the works of other Surrealist painters, but nothing quite this unbridled and imaginative had been seen before in the history of art. The artist himself, who was extremely poor at the time, claimed these were hallucinations brought on by hunger.

In 1928, Miró traveled to Holland, where he painted the series *Dutch Interiors,* based on the works by such seventeenth-century masters as Jan STEEN. Miró's figures, however, are restated as fantastic and even comical motifs*. His works from the late 1920s moved toward a greater economy of means, reducing his compositions to a few simple images. In *Dog Barking at the Moon* (1926), for example, the pictorial elements are restricted to a cartoonlike hound, a crescent moon, and a steep ladder stretching high into the night sky. Ladders, for Miró, symbolized a bridge to another reality.

***motif** a favorite symbol or subject in an artist's work

Experimental Years

Miró's work was becoming more widely known in the 1930s, but the decade also marked a period of restless experimentation. In 1933, he made a series of

*collage a method of picture making in which pieces of photographs, torn paper, news clippings, and other objects are assembled on a flat surface

*biomorphic an abstract art form based on shapes found in the natural world rather than on geometric patterns

*gouache a painting medium in which watercolor is mixed with white pigment, giving a chalky finish; also known as body color

collages* combining realistic details torn from newspapers with painted biomorphic* shapes; a year later he did his first paintings on sandpaper. With the outbreak of the Spanish Civil War (1936–1939), Miró's work became more overtly political. Although not as forceful as *Guernica* (1937) by Pablo PICASSO, Miró's "protest" paintings such as *Still Life with Old Shoe* (1937) feature objects that hint at decay and death.

Miró spent the years of the Spanish Civil War in Paris but moved to the island of Majorca, Spain, after the Germans occupied France in 1940. At about this time, he began to garner considerable international acclaim, especially after a retrospective exhibition at the Museum of Modern Art in New York in 1941.

The artist's isolation in Majorca at this time led him to a more contemplative state of mind, and painting became a haven from the devastation taking place elsewhere. "I felt a deep need to escape," he later recalled. "I deliberately retreated into myself. Night, music and the stars now played a major role in suggesting my pictures." The result was a series of twenty-three small gouaches* he called *Constellations* (1941). These effervescent doodles, scattered across the picture's surface, were suggested to the artist by the migrations of birds and butterflies and by the patterns of stars in the night sky. Their evenly dispersed composition, in which no one element takes priority over another, made a profound impact on the young American Abstract Expressionists after the works were shown in New York in 1945.

Other Mediums

After the war, Miró began working on a much larger scale and turned to other mediums. He took up ceramics in 1944, executed several mural-size commissions, and made monumental sculptures cast in bronze. He was also a prolific printmaker and started making designs for STAINED GLASS when he was in his eighties. A modest and retiring man, Miró was the temperamental opposite of his younger contemporary, Picasso. Throughout his long life, he shunned the limelight and preferred to work in relative isolation in his native Spain.

(*See also* ABSTRACT EXPRESSIONISM; PRINTMAKING; SURREALISM.)

MODERN ARCHITECTURE

Modern architecture, ushered in by the CHICAGO SCHOOL, got under way after World War I (1914–1918). Architects departed from historical design to create a new vocabulary. By 1930, modern architecture was developing in two directions: the organic method, which integrated human-centered structures with their environment, was pioneered by Frank Lloyd Wright (1867–1959); and the International style, which relied on simple rectangular forms and often took on expansive proportions, was championed by the groundbreaking architects Le Corbusier (1887–1966) and Ludwig Mies van der Rohe (1886–1969). Although markedly different, the two paths emerged from similar origins.

Wright, who had worked in the Chicago architectural firm of Louis Sullivan (1856–1924), was influenced by ART NOUVEAU, which sought to blur the

distinction between the fine and applied arts. Corbusier was a student of the pioneering German industrial architect Peter Behrens (1868–1940), who had begun as a painter and craftsman in the Art Nouveau style, but had later rejected it. Mies van der Rohe was director (1930–1933) of the groundbreaking BAUHAUS school. Established in 1919 by architect Walter Gropius (1883–1969) in Weimar, Germany, Bauhaus combined the teaching of art, craftsmanship, and architecture. For Gropius, architecture was the ultimate form of art, and the buildings of the future would "embrace architecture and sculpture and painting in one unity." Thus, like the earlier Art Nouveau style, Bauhaus broke down the distinction between the fine and applied arts, although its output was highly streamlined and far more revolutionary.

In the 1960s, after the deaths of the towering figures of Wright, Corbusier, and Mies, modern architecture developed into Postmodernism and late-century design became wildly diverse. The original visions of individual architects exerted tremendous impact, and small experimental groups arose that attracted architects from various countries. Thus, it became impossible to pinpoint national styles of architecture.

Frank Lloyd Wright

In the early 1900s in the United States, the eccentric genius Frank Lloyd Wright established himself as arguably the twentieth century's greatest and most original architect. A student of Louis Sullivan, a leader of the influential Chicago School, Wright adopted Sullivan's mandate that "form follows function." With the goal of creating harmony between building and nature, he designed structures that seem to fit into the landscape.

Wright's famous houses, many of them located around Chicago (his home and studio were in neighboring Oak Park), are rendered in his signature "Prairie style." This style is characterized by long horizontal roofs with overhanging eaves; the flat expanses of roof are reminiscent of the prairie landscape of Illinois. Muted earth tones allow the houses to blend with their surroundings. Exemplified by the Robie House (Chicago, 1909), the interiors of Prairie-style dwellings have low ceilings, open floor plans, and continuous and overlapping wood elements. Wright designed everything, from the fixtures to the furniture—and he disapproved of inhabitants changing or moving them.

Among Wright's masterpieces is Fallingwater, or Kaufmann House (1936–1939), in Mill Run, Pennsylvania. In this home, he realized his ambition of creating a structure that works with nature. The house is built on a hillside over a waterfall; several large boulders help secure the house on the side of the hill. With rocks jutting into walls, Wright integrated the boulders into the design of the house. Fallingwater, made of sandstone to echo the rocky landscape, consists of levels, layered like trays, and extending over the waterfall. Inside, horizontal windows with natural-wood frames and stained-glass ceiling panels create a composite of art, nature, and light.

Although Wright is known for his houses, he also designed office buildings (including 1904's Larkin Building in Buffalo, New York, and 1939's Johnson Wax Company Administration Building in Racine, Wisconsin), hotels (1920's Imperial Hotel in Tokyo, demolished 1968), churches (including 1904's Unity Church in Oak Park, Illinois) and other public buildings. His Solomon R. Guggenheim Museum (1949) in New York City is spiraling, spare,

Frank Lloyd Wright. Kaufmann House (Fallingwater). *1936–1939. Mill Run, Pennsylvania* ART RESOURCE

and perennially futuristic-looking. Whimsically featured as a center of alien invasion in the 1997 film *Men in Black,* the Guggenheim is one of Wright's most well-known structures. Surprisingly, Wright never built in Europe.

Wright's intensely personal style acted with and reacted to Modernism's other strains, Holland's de Stijl group (*see* sidebar, MONDRIAN), and the Arts and Crafts movement, the late-1800s movement led by artist-poet William Morris (1834–1896) and art critic John Ruskin (1819–1900). Yet, Wright's vision and designs were wholly original and continued to exert influence into the twenty-first century.

The International Style

In 1932, an attempt was made to define and classify the trends that were emerging in modern architecture. That year, an exhibition called International Architecture was staged at New York City's Museum of Modern Art (MoMA). The event was sponsored jointly by MoMA Director Alfred H. Barr Jr., architecture historian Henry-Russell Hitchcock, and architect Philip Johnson (born 1926). Barr was credited with coining the term "International style" to describe the new architecture, which he considered the first new Western form since the thirteenth century.

The International style sought to break with tradition to create a look that reflected the ideals of a progressive, industrialized society. It generally rejected surface ornamentation, instead focusing on functionalism and geometric form. It also subscribed to the rational use of modern materials—notably, iron, steel, glass, and concrete. The resulting spare look was sometimes described as "ultramodern"—the height of Modernism. In highlighting the advancements, the 1932 exhibit celebrated the designs of Corbusier in particular.

Le Corbusier The revolutionary architect known as Le Corbusier was born Charles-Édouard Jeanneret and was of French-Swiss origin. In 1923, he

published his *Vers une architecture* (Toward a New Architecture), which comments on the problems of modern architecture. Translated into many languages, it gave a strong voice to a new generation. In 1926, he released his groundbreaking "Five Points of a New Architecture," which became the basis for the International style. His five points were: (1) a pillar can rise through the open space of a house; (2) a structure's walls or partitions are independent of its skeleton (i.e., non-bearing); (3) interior spaces should be free-flowing (and flow out of and into the outdoors); (4) a building's facade* can be a non-supporting "thin skin" (also called the "free facade" or "curtain wall"); and (5) living space can be extended to the roof.

***facade** the exterior face of a building, usually the front

Corbusier's highly original and influential designs linked the complexity of CUBISM with the unadorned aesthetic of the Bauhaus. The theme that ran through his work was the desire to create living spaces that reject the notion of separate indoor and outdoor spaces. His goal was to use modern techniques and materials to blend nature with his structures, which he called "machine[s] for living." Corbusier created private (single-family) homes as well as multi-storied urban residential complexes, designed around green spaces or incorporating other features (balconies, rooftop gardens, etc.) that allowed dwellers to interact with the outdoors. His buildings often feature horizontal banks of windows, which run across the entire length of walls.

Among his most famous houses is the Villa Savoye at Poissy, outside Paris. Completed in 1929, it is an almost square structure that is supported by thin columns called *pilotis.* The building features a glass-fronted curved garage that sits below an overhanging second story. The living spaces on the second floor open onto a terrace, which is protected from the elements by half walls. The interior of the structure is connected by a ramp that runs from level to level and from indoors to outdoors.

Corbusier's urban structures are exemplified by a later work, his *Unité de habitation* (French for "habitation unit"), an apartment community, begun in 1947 and completed in 1952 in Marseilles, France. The concrete structure, which sits on pilotis, takes up an entire city block and features duplex apartments, each with a two-story living room and two-story balcony. Midway up the building are two shopping "streets," which include retail space and restaurants. Recreation areas include a rooftop garden. An external fire escape was rendered as a spiraling cement sculpture. The huge building, a city unto itself, epitomizes Corbusier's ideas about urban planning.

The Unité de habitation also represents a mid-century development called Brutalism, which adhered to the idea that materials (in this case concrete) could be used in their raw form. At the opening ceremony for the apartments, the architect proclaimed that it seemed possible to consider concrete as "worthy of being exposed in its natural state"—not stuccoed or painted. Although some wall panels on the Marseilles edifice were painted in bright colors, most of the cement on the structure was left in a rough, textured form.

Corbusier left his mark on cities around the world. In the United States, he created the Cubist Carpenter Center for the Visual Arts (1964) at Harvard University (Cambridge, Massachusetts) and collaborated on the United Nations Headquarters in New York City. In South America, he contributed to the design of the Ministry of Education and Health (1945) in Rio de Janeiro, Brazil. And, in India, he designed the government complex (1952–1956) at

Le Corbusier. Villa Savoye. *1929. Poissy-sur-Seine, France* MIT COLLECTION (F. PASSANTI)/ CORBIS

Chandigarh, the capital of Punjab state. Corbusier was also involved in city-planning projects. He developed urban schemes that featured elaborate traffic patterns and clusters of skyscrapers set in parks. Famous among these were his plan for the north African capital of Algiers (1930) and his *Ville Radieuse* (French for "Radiant City") [1935]. A continuous presence in modern architecture, he was also a talented painter in the Cubist mode.

Mies van der Rohe The International style began in Europe, where its practitioners were influenced by such developments as the Bauhaus in Germany and de Stijl in Holland. But with the threat and eventual eruption of war (World War II, 1939–1945), many architects immigrated to the United States, where they continued to explore their design theories. Among the newcomers was German architect and former Bauhaus Director Ludwig Mies van der Rohe, who arrived in 1937. More than any other single architect, he helped define the modern American skyline. The International style was clearly stated in Mies's elegant apartment and office towers, characterized by exposed support pillars, glass walls, and simplified forms.

His best-known structures include the Farnsworth House (1950), a glass-walled private home in Plano, Illinois, built as a retreat for Dr. Edith Farnsworth and inspired by the work of Frank Lloyd Wright; Chicago's 860 Lakeshore Drive apartments (1951), two twenty-six story steel-framed glass towers, built on stilts and connected on the ground floor by a steel canopy; and New York City's stunning Seagram Building (1958), a thirty-eight story bronze- and gray-glass skyscraper he designed with Philip Johnson and which is set back from

the street by one hundred feet so that passers-by can fully appreciate its soaring height.

Walls of Glass The wall of glass became an emblem of the International style. A non-supporting "curtain wall," it is made of expanses of horizontal or vertical windows. Exemplified by Mies's 860 Lakeshore Drive, the technique was also successfully implemented in the design of the Lever House (1952), an office tower on Park Avenue in New York City. The steel structure is wrapped in so much glass that neighboring buildings are clearly reflected in its expanses. Designed by the architectural firm Skidmore, Owings, and Merrill (founded in the 1930s), the Lever's simple yet highly sophisticated aesthetic soon became the symbol of corporate America. By the 1960s, Manhattan was dotted with rectangular expanses of glass, including the Tishman Building (1957); Steuben Glass Building (1959); Time-Life Building (1959); Union Carbide Building (1960); Chase Manhattan Bank (1961); Met Life Building (1963); and the New York Hilton (1963). The form was copied in urban centers the world over.

In such innovative designs as the Kaufmann House (1946) in Palm Springs, California, and the Corona Avenue School (1935) in Los Angeles, architect Richard Neutra (1892–1970) used walls of glass and open floor plans that proved functional, yet achieved his goal of blending living space with the landscape. Born and educated in Austria, he immigrated to the United States in 1923. After working with Frank Lloyd Wright in 1925, Neutra opened his own firm in Los Angeles (1926). He concerned himself with the private home, which, like Wright, he believed should be integrated with its natural environment. Neutra wrote, "Place Man in relationship to Nature; that's where he developed and where he feels most at home!" Glass expanses played an important role in his human-centered designs.

Experiments in Wood, Brick, Concrete Noted for his smooth, bent-wood chairs, Finnish architect and designer Alvar Aalto (1898–1976) blended the International style with the vernacular of his native Scandinavia. Aalto applied his design precepts to create curving and unembellished wood walls as well as more rustic-looking structures of timber and patterned bricks. His House of Culture in Helsinki, Finland (1958), with its undulating brick walls, stands at one end of the spectrum, while his textured-brick Villa Mairea (1938) is at the other. His worldwide reputation grew as a result of his designs for the Finnish pavilions at the Paris Exposition of 1937 and the New York World Fair of 1939.

While materials and particular settings inspired Aalto to create flowing and harmonious spaces, Italian Pier Luigi Nervi (1891–1979) pushed the limits of engineering to design and build immense structures in a variety of new shapes. Concrete was his favorite material and he experimented with methods to mold, lighten, and strengthen it to suit the needs of a project. An engineer as well as an architect, Nervi was adept at solving problems. For example, in the late 1940s, when Turin, Italy, needed an exhibition hall built very quickly, he devised a construction method that used prefabricated segments, which were then assembled on site. (He created molds to cast concrete into the needed forms for construction.) His other innovations include the Berta Stadium in Florence (1932), which features a cantilevered roof (supported by large brackets, attached to the walls). Known for his experiments with ferroconcrete*, Nervi used the

*ferroconcrete concrete reinforced with a metal framework, usually steel mesh

material in such buildings as Rome's vast Sports Palace (1957–1960), constructed for the Olympic Games.

Hungarian-born and Bauhaus-bred Marcel Breuer (1902–1981), known for his tubular-steel furniture as well as his gruff New England houses of natural materials like timber and stone, also falls under the International style umbrella. But his severe-looking Whitney Museum of American Art (1966) in New York City, with its gloomy interior of slate floors, rough concrete walls, and unexpected trapezoidal windows, combines geometric abstraction with Brutalism. An architectural style, pioneered by Corbusier in his Marseilles apartments, Brutalism relies on "raw" architectural components, usually concrete; the resulting structures are often massive and plain.

American Paul Rudolph (1918–1997) also applied the principles of Brutalism in works such as the Government Services Center in Boston (1962). His handsome concrete and stone buildings were known to scrape inattentive passers-by. Rudolph's controversial Art and Architecture Building (1963) at Yale University (New Haven, Connecticut) so infuriated students that it was set on fire.

Reactions to the International Style

Although the International style continued to have its practitioners, by the 1950s, architects and the public began to tire of a style many considered cold and impersonal. Perhaps what offended them was not the work of the master architects, but, rather, the cheap copies that began to dominate urban landscapes, as well as the apparent anonymity of Modernist buildings that tended to ignore regional traditions.

The responses to the style were many and varied. American architect, engineer, and inventor Buckminster Fuller (1895–1983) was a tireless experimenter, whose innovations were credited with challenging the viewer's imagination. His most well-known invention was the geodesic dome—a dome with a curve like that of the earth. Developed in the early 1950s, Fuller used *tetrahedrons* (geometric forms having four triangular faces) to create the lightweight but strong dome with no internal supports; the structure is supported by the framework of the triangular segments.

An enduring testimony to Fuller's belief that all human needs can be met through technology and planning, the geodesic dome proved remarkably versatile. For example, for a time, the geodesic dome of the Union Tank Car Plant (1958), in Alsen, Louisiana, enclosed the largest clear span in the world. So light that they can be transported by helicopter (typical building materials are aluminum and fiberglass), the structures were also used as radar shelters by the U.S. military. Perhaps the most recognizable dome is that (called Spaceship Earth) at EPCOT Center, Disneyworld, in Florida.

Estonian-born Louis Kahn (1901–1974) derived his own answers to Modernism's austerity. He tried various approaches in different parts of the world, creating bold and often monumental buildings. His Center for British Art (1977) at Yale University features slate panels on the exterior, cast concrete and warm wood inside, and an atrium that allows visitors to view galleries on various levels. The museum retains the elegance of the International style but adds warmth and complexity.

Like Kahn, the works of Finnish-born Eero Saarinen (1910–1961) undermined the International style's severity. He designed Yale University's Morse and Stiles colleges (1962) complex in a Mediterranean style, with courtyards and wide stairways; he also created Yale's whale-shaped Ingalls Hockey Rink (1959). His other modern structures include the TWA Terminal at John F. Kennedy International Airport (New York, 1956–1962), the exterior of which is shaped like a bird spreading its wings; and Dulles International Airport (Virginia, 1963), with its expansive roofline arcing skyward.

Brazilian architect Oscar Niemeyer (born 1907) designed futuristic-looking buildings in Brasilia and towers in Rio de Janeiro that took the landscape and surroundings into account. Mexican architect Luis Barragán (1902–1988) retained Modernism's minimal, unadorned surfaces, but added rich color, echoing that of the natural surroundings. His buildings, mostly homes and other low-profile structures, possess a warmth yet also have an otherworldly simplicity. At Barragán's structures, such as the Folke Egerstrom house and stable (1968) in Mexico City, the visitor loses a sense of place amid the boldly lit surfaces.

Postmodernism

Among those reacting against the International style was Robert Venturi (born 1925), considered the father of the movement known as Postmodernism. In its broadest sense, the term refers to the mixing of elements from different historical periods, cultural and architectural movements, as well as from

Eero Saarinen. **Trans World Airlines Terminal at Kennedy International Airport.** *1956–1962. New York City*
Angelo Homak/Corbis

***perspective** a painting technique in which three-dimensional objects and figures depicted on a flat surface appear in correct proportion and relation

***pediment** in architecture, a triangular section over the entrance into a building

popular culture and high art. With these many influences, Venturi produced a remarkably varied yet coherent body of work. In the Vanna Venturi House (1962) in Chestnut Hill, Pennsylvania, he employed such Postmodern devices as distortions in perspective* (*see also* sidebar, BRUNELLESCHI) and created, for example, a stairway that widens as it recedes into the distance. In his design for the Sainsbury Wing, his 1991 addition to the National Gallery in London, he presented a stripped-down version of the original, Neoclassical structure, both celebrating and parodying it. Stark, unembellished, and cream-colored, it resembles a building waiting to be colored in.

Whereas Venturi's brand of Postmodernism was a minimalist one, the architecture of Michael Graves (born 1934), which also links popular and high culture, is maximalist. Graves's buildings are busy and characteristically colorful. They often resemble the objects he designed, including teakettles and toasters. In creating hotels for Walt Disney World, he used everything from colorful Egyptian motifs to sculpted cartoon characters and stripped-down and painted classical columns and pediments*. But, once an element is removed from its conventional context, as in POP ART, the viewer must re-examine its appearance and meaning.

Several notable architects designed works similar to Graves: Ettore Sottsass (born 1917), whose accomplishments include the Rome Airport; Mario Botta (born 1943), designer of the San Francisco Museum of Modern Art; and Aldo Rossi (born 1931), who created the Aurora House in Turin, Italy. All three made object-like buildings in primary colors with elements combined as they might be in a set of children's playing blocks.

American designer Richard Meier (born 1934) worked in a different vein. He looked to art and the architecture of Corbusier, creating what one critic described as "twenties revivalism." Meier's Getty Center (1997) in Malibu, California, and High Museum (1983) in Atlanta capture a distinctive geometric style that has much in common with the works of Conceptual artists such as Minimalist sculptor Sol LeWitt (born 1928).

Toward the Twenty-first Century

By the 1980s, a bewildering array of styles, trends, new materials, and academic and social concerns, as well as technological innovations and globalization, had transformed the international architectural landscape. Many architects found themselves working in several genres or none at all. Some Postmodernists segued into a movement called Deconstruction, in which buildings or objects are broken down into their component parts. Inside and outside merge and appear to be in constant flux, much like a Cubist painting.

Star players in this rebellious contingent were Americans Frank Gehry (born 1929) and Peter Eisenman (born 1932), German Daniel Libeskind (born 1946), and Iraqi-born, London-educated Zaha Hadid (born 1950). Although they all worked in other movements, these architects evolved stylistically and shared a preoccupation with theory—the philosophical questions upon which architecture is based. They sought to answer fundamental questions: Why build? . . . Which is more important, the building or the ideas on which it is derived? . . . Whom does it—and should it—serve? . . . and, Should architects make buildings that draw attention to their own genius, or should functionality and economy be the motivating factors? But they did not draw conclusions. Instead,

they built structures that engage the users and observers as much as they might confound them.

For example, Eisenman's design for the Wexner Center (1989) at Ohio State University, in Columbus, offers a disorienting range of intersecting angles and levels. Libeskind's multilevel, dizzying Jewish Museum in Berlin (1999) is so dramatic and sculptural that it was difficult to determine what kind of collection could fill it without undermining its effect.

Hadid's work depends on extensive use of computer design programming; her finished product gives the impression of zooming through space and time, with a building's colored and darting angles suggesting continual motion. The first woman to design an American museum, Hadid's style was exemplified in Cincinnati's Contemporary Arts Center (1998), which blurs the distinction between the building interior and the streetscape. She also built a firehouse at the Vitra Design Museum complex in Weil-am-Rhein, Germany, where Gehry, too, practiced wild building antics.

Gehry, above all, achieved a fantasy-driven personal style. In his modest Gehry House (1978) in Santa Monica, California, he seemed to work haphazardly with corrugated metal, chain-link fencing, cinder blocks, and exposed nails. In dazzling public commissions, he moved on to high-tech, flamboyant elegance and a free-form sculptural style. For his highly acclaimed design for the Guggenheim Museum (1997) in Bilbao, Spain, considered one of the major works of the late twentieth century, Gehry employed odd-shaped pieces of titanium sheathing, which wing up, out, and into one another.

Others staking out an original style were Italian architect Renzo Piano (born 1937), whose projects include mixed-use buildings (1992 and 1997) in Berlin's Potsdamer Platz, where he used courtyard-like atriums and louvers to control light and his slick structures mix Mediterranean devices with traditional solidity. Richard Rogers (born 1933) created the playful Beaubourg Center and

Frank Gehry. Guggenheim Museum. *1997. Bilbao, Spain* ISLAND IMAGES (BEN WOOD)/CORBIS

Museum in Paris (1978), which wears its inner workings—pipes and escalators—on the exterior. He and Piano were considered mavericks for their high-tech design for the Centre Pompidou (1976) in Paris, which brought them wide fame. Their architectural firms received coveted commissions from around the globe.

English architect Norman Foster (born 1935) created the groundbreaking Hong Kong and Shanghai Bank (1985) in Hong Kong; it plays with large expanses of glass. For Spanish architect Santiago Calatrava (born 1951), "the language of geometry is as important as the language of structure." Sculpture also played an important role in his creations, which were often animal-inspired steel structures, following in the footsteps of Eero Saarinen. Among Calatrava's works is the Palace of the Arts in Valencia, Spain (unveiled 2001).

By the twenty-first century, order prevailed in modern architecture and ornamentation enjoyed a new vogue. Asian, African, and Latin American influences, from the decorative and handmade to the high-tech and minimal, were increasingly integrated into contemporary building. For example, in his design for the Institut du Monde Arabe in Paris (1988), French architect Jean Nouvel (born 1945) incorporated a lacy Moroccan pattern in concrete, allowing for a continual play of natural light in an East-meets-West design.

But to others, Modernism remained synonymous with the International style. The style's legacy was seen in the work of German-born architect Helmut Jahn (born 1940), a student of Mies van der Rohe. Jahn's Sony complex at Potsdamer Platz (2000) in Berlin, featuring a tall, slender, and angular steel-and-glass office tower, shows his commitment to a pure Modernist philosophy.

(*See also* ABSTRACT ART; CONCEPTUAL ART; MINIMALISM.)

MODERSOHN-BECKER, PAULA

German, 1876–1907

In her brief life, Paula Modersohn-Becker produced groundbreaking paintings of great power that foreshadowed the Expressionist movement in Germany. She studied at the Berlin School of Art for Women, where the course work focused on thoroughly traditional academic training. However, in 1898, at age twenty-two, she joined an artists' colony at Worpswede, a village near Bremen, in northern Germany. Worpswede was one of several artists' colonies that sprang up in Germany around the turn of the twentieth century, in revolt against both academic ideals and the growing industrialization of Europe. The Worpswede painters followed the example of the BARBIZON SCHOOL in France and often worked directly from nature.

Becker met her future husband, a painter named Carl Modersohn, at Worpswede and married him in 1901. She also became friendly with the German poet Rainer Maria Rilke (1875–1926), who later worked as a secretary for the French sculptor Auguste RODIN and kept her abreast of some of the more advanced artistic ideas of the day.

Eventually, Modersohn-Becker became dissatisfied with the Worpswede group's rather sentimental approach to painting. In 1903, she made a long visit to Paris, determined to free herself from the constraints on her life and art in Germany. Under the influence of the French painters Paul CÉZANNE and Paul GAU-

GUIN, as well as the NABIS, Modersohn-Becker worked to simplify her pictures, using broad, flat areas of color and patterned backgrounds. It was in Paris that she also began to attach a deep, symbolic importance to the naked human body.

In the last few years of her life, the artist divided her time between Paris and Worpswede, producing a number of remarkable nude self-portraits. Her *Self-Portrait* (1906) recalls Gauguin in its simplified shapes and broad brushwork, but its intense color seems to anticipate the French painter Henri MATISSE and the other Fauvist painters. The portrait eerily gives visible form to a diary entry she made in 1900, when she had a premonition of her own early death. "If I have painted three good pictures," she wrote, "I shall leave gladly with flowers in my hair."

Although she was physically weak, Modersohn-Becker produced an astonishing 650 pictures in a career that lasted only a decade. She died at age thirty-one after the birth of her only child. Although she was little known at the time of her death, in the years since, art historians have come to see her as the most important woman painter of the early modern era.

(***See also*** ACADEMIC ART; EXPRESSIONISM; FAUVISM.)

MODIGLIANI, AMEDEO

Italian, 1884–1920

Amedeo Modigliani's fame as a tormented genius doomed to an early death is almost as great as that of the Dutch painter Vincent VAN GOGH. Addicted

Amedeo Modigliani. *Reclining Nude. c. 1919. Oil on canvas. Museum of Modern Art, New York City* MRS. SIMON GUGGENHEIM FUND. THE ART ARCHIVE/ALBUM/JOSEPH MARTIN

to drugs and drink, he was renowned even among the unconventional circle of the Spanish painter Pablo PICASSO for outrageous behavior. Nonetheless, in his short lifetime he produced a significant body of painting and sculpture that is a stylistic oddity for its time. Although a contemporary of the Cubists, Modigliani never participated in their experiments with form and space, choosing to remain dedicated to a figural art uniquely his own.

Modigliani was born in Livorno, Italy, to a prosperous family of Sephardic Jews. Childhood illnesses kept him from following a normal course of education, but in 1898 he studied with a follower of the Italian Impressionist school. In 1902, he left home to study at the Scuola Libera di Nudo (Free School of the Nude) in Florence, but less than a year later he moved to Venice, where he stayed until 1906.

With a small allowance from his mother, Modigliani moved to Paris, to the neighborhood of Montmartre, then the hub of the avant-garde* art world. Because of strong anti-Semitic feeling in France, Modigliani found his closest friends among other French Jewish artists, such as the painter Chaim SOUTINE and the sculptor Jacques LIPCHITZ. Apart from visits to his family and a brief stay in the French cities of Cannes and Nice in 1918 and 1919, Paris would remain Modigliani's home for the rest of his life. He was a familiar figure at Montmartre cafés, and his excesses earned him the nickname "Modi," a pun on *maudit,* the French word for "cursed."

Modigliani's early works in France show the influence of many sources, among them the French painters Paul CÉZANNE and Paul GAUGUIN and the Fauves. After returning from a visit to Livorno, however, Modigliani decided to change direction and dedicate himself to stone sculpture. He fell under the spell of the Romanian sculptor Constantin BRANCUSI, whose radically simplified forms made a deep impression. Modigliani's caryatids* and, in particular, his sculpted heads from this period also show the influence of the art of Oceania (the Central and South Pacific islands) and Africa, which Modigliani studied in the Musée de l'Homme (Museum of Mankind) in Paris. Still living in extreme poverty, the artist used stone stolen from building sites, which was easy enough to find because the city was then in a construction boom. However, ill health and the outbreak of World War I (1914–1918) put a stop to his efforts in sculpture; the dust irritated his lungs, and materials became harder to find.

In the early years of the war, Modigliani turned to portraiture. He painted his friends—such as the Spanish artist Juan GRIS, Lipchitz, and Soutine—and later his mistress, Jeanne Hébuterne, a fragile woman fourteen years younger than the artist. In their elongated, simplified forms, these paintings show the influence of both Modigliani's own sculptures and his study of AFRICAN ART.

Modigliani also became a master of gloriously sensual nudes, many of which recall the reclining Venuses of RENAISSANCE ART. Like the Italian painters TITIAN and GIORGIONE, he delighted in the contrast of softly glowing flesh and light draperies against a deep Venetian red.

In 1918, Modigliani escaped war-torn Paris to live briefly in the south of France; but he was unmoved by the beauty of the Mediterranean landscape and spent most of his time indoors, painting shopkeepers and their children. He was soon back in Paris and enjoying a growing reputation. Buoyed by financial success, he moved into his first real home, an apartment above one once occupied by Gauguin.

***avant-garde** literally, the "advanced guard"; a term describing innovators or innovation in a particular field

***caryatid** in sculpture, a usually draped female figure that serves as a supporting column

Modigliani's health continued to deteriorate, however, aggravated by his alcoholism. In late January 1920, he fell into a coma and died from tubercular meningitis. Two days after his death, Jeanne Hébuterne, pregnant with her second child, committed suicide by leaping from a window.

(*See also* CUBISM; FAUVISM; IMPRESSIONISM.)

MONDRIAN, PIET

Dutch, 1872–1944

Often called "one of the great lawgivers of modern art," Piet Mondrian had an influence on the art and design of the twentieth century that cannot be overestimated. Along with the Russian painters Wassily KANDINSKY and Kazimir MALEVICH, Mondrian was a pioneer of pure ABSTRACT ART. His road toward that goal was as lonely as it was daring. "He . . . pushed reduction almost to the limit," critic Robert Hughes once noted, until nothing was left but "right angles and primary color."

Early Influences and Works

Born Pieter Cornelius Mondriaan in the town of Amersfoort, the Netherlands, Mondrian was the son of a domineering religious father who was described by a family friend as being "frankly disagreeable." However, the young

Piet Mondrian. *Composition 2. 1922.*
Oil on canvas. BURSTEIN COLLECTION/CORBIS

Mondrian gained some early guidance from his father, who was an academic draftsman, and from an uncle who was a professional painter. Between 1892 and 1897, he studied at the Amsterdam Academy, and in 1889 he passed an examination that allowed him to teach drawing in secondary schools. His progress as an artist was slow, however, and at one point he considered becoming a minister. Mondrian's earliest works were unremarkable landscapes and still lifes, but they show an inclination toward a controlled and abstract organization of space.

Between 1907 and 1910, Mondrian's work took on qualities of SYMBOLISM under the influence of a circle of experimental artists that included the Dutch painter Jan Toorop (1858–1928), who was a leading figure in both the Symbolist and ART NOUVEAU movements. Mondrian also became an enthusiastic convert to Theosophy (*see* sidebar, KANDINSKY). One of the devotees of this mystical belief system, the Austrian social philosopher Rudolf Steiner (1861–1925), maintained that "occult influences . . . can be awakened by devotional religious feelings, true art, music."

In 1909, the same year that he discovered Theosophy, Mondrian had his first exhibition at the Stedelijk Museum in Amsterdam. His works of that time—paintings of flowers, churches, dunes, and trees—pulsate with broken color and often emphasize a close-up, severely frontal view.

Develops Neoplasticism

In November 1911, Mondrian saw works by the Spanish painter Pablo PICASSO and the French painter Georges BRAQUE for the first time. A year later, he moved to Paris, where he changed his life and his art. Strongly influenced by CUBISM, he made a series of paintings on the theme of the tree, in which the image becomes progressively more fragmented and abstract. Mondrian's vision of Cubism shows that he was struggling to keep the geometric pattern while eliminating any hint of solid forms. Therefore, in a work like *Flowering Apple Tree* (1912), the artist preserves the delicate arabesque* of lines, but the work remains as flat as STAINED GLASS.

By 1914, Mondrian had virtually eliminated both curved lines and references to the natural world. He later wrote that he rejected Cubism because "it was not developing abstraction toward its ultimate goal: the expression of pure reality." Pure reality, for Mondrian, would come to mean a fully abstract dance of lines and patches of color, in which the only "reality" was that of the spare geometry of his mature works. He called this style Neoplasticism. Mondrian believed that works stripped to a simple black grid enlivened by three colors—blue, red, and yellow—reflected the laws of the universe. The world outside the canvas, for him, did not exist at all. All in all, he wrote, "nature is a damned wretched affair. I can hardly stand it."

Compositions

By the early 1920s, Mondrian had arrived at the formula that was to occupy him for the rest of his life. Even the titles of his works, such as *Composition 2* (1922), reveal his desire to produce a stripped-down art reduced to its sparest essentials. By carefully calculating the placement of a few elements, Mondrian sought to achieve what he called "a balance of unequal but equivalent oppositions." Although his grid paintings all bear a resemblance, each is dif-

***arabesque** linear decoration that involves intricately interlaced floral or geometrical designs; used since classical times

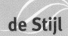

de Stijl

In 1917, Mondrian joined forces with another Dutch painter, Theo van Doesburg (1883–1931), to found an association known as *de Stijl* (Dutch for "the Style"). Their aim was to find laws of balance and harmony that could be applied to life and society as well as to art. The kind of painting and design these artists produced was one of severe abstraction, reducing art to its most fundamental geometries. Mondrian called his version of this painting Neoplasticism and outlined its principles in the journal *De Stijl*, which was published irregularly between 1917 and 1931. Like the Arts and Crafts movement (*see* Art Nouveau) and the *Wiener Werkstätte* (*see* sidebar, Kokoschka), de Stijl sought to create a style appropriate for every facet of contemporary life, erasing distinctions between fine and applied art and even extending to town planning.

Mondrian broke with the group around 1924 because of differences with van Doesburg. However, both de Stijl the movement and *De Stijl* the publication had an enormous influence, especially in architecture and design. The group's emphasis on clean lines and simple geometries would have an impact on the Bauhaus, for example, and modern architecture owes much to its basic principles.

ferently composed to effect a sense of taut balance and poise. "His compositions," noted the art historian George Heard Hamilton, "have no centre, no focus, and their tensions are so distributed across the entire surface that each square inch is essential to the whole."

Mondrian spent the years of World War I (1914–1918) in Holland, but by 1919 he was back in Paris. For many years, he struggled to earn a living and sometimes produced pleasing watercolors of flowers as a sideline to make ends meet. Gradually, his work became known to a wider circle of admirers. Beginning in 1922, exhibitions in Amsterdam, Paris, Germany, and the United States brought his work to the attention of influential collectors such as Katherine Dreier, founder of the Société Anonyme, the forerunner of New York's Museum of Modern Art.

Spare, Eccentric Lifestyle

Mondrian's studio in Paris was as notoriously spare and impersonal as his paintings. The English painter Ben Nicholson (1894–1981) compared it to a hermit's cave. Mondrian kept few personal possessions, even few books, and destroyed all letters. His single concession to "decoration" was an artificial tulip painted white. The artist's eccentricities included changing his seat in restaurants so that he would not have to gaze at the trees outside (he hated the color green), and he became so obsessed with preserving his anonymity that he would change grocers at regular intervals so as not to become a recognized patron. Mondrian's only indulgences were a gramophone and lessons in fashionable dances of the day. As his biographer John Milner noted, "He had no wife, no children, to enrich and complicate the simplicity of his daily life, to impose upon him or upset the stillness of the studio where he lived and found the real measure of his world."

London and New York

Mondrian became one of the first artists to leave Paris when World War II (1939–1945) threatened. He settled in a studio in London in 1938, close to Nicholson and the Russian-born sculptor Naum Gabo. When the house next to his was bombed, Mondrian made up his mind to move to New York.

Although he was nearly seventy, he eagerly adapted to his new home, becoming a great fan of jazz music. Under the influence of its syncopated rhythms, he created his last masterpiece, *Broadway Boogie-Woogie* (1943). In this tribute to the city and its music, he eliminated the black lines that had been his trademark for years, using pure color—blips of red, yellow, and blue—shuttling along gridded avenues to express the dynamism of urban life.

Mondrian's impact on the history of art to the present day has been profound. His ideas and example were felt during the 1970s among Minimalist artists and others, and his influence continues to the present day. Even more significant, perhaps, has been his influence on industrial and interior design and on advertising, from the 1930s on. The familiar Mondrian grid has found its way onto everyday objects, from fabrics to floor coverings to architecture.

(*See also* MINIMALISM.)

MONET, CLAUDE

French, 1840–1926

More than any other nineteenth-century painter, the works of Claude Monet represent the true goals of IMPRESSIONISM. He was devoted to the ideals of the movement throughout his long career. Virtually all of Monet's canvases were painted out-of-doors, with the kind of flickering brushstrokes that gave the movement its name. In fact, the word was coined in 1874 when a hostile critic, after viewing Monet's *Impression: Sunrise,* condemned the artist and his circle as nothing more than a bunch of "Impressionists."

Early Years

Monet spent his early years in the French seaside town of Le Havre, where he began his career as a caricaturist*. He switched to landscape painting under the influence of his early teacher, Eugène Boudin (1824–1898), who did seascapes and beach scenes of the region. Boudin was one of the first artists to work out-of-doors, painting directly from nature. Prior to the BARBIZON SCHOOL of landscape painting in the mid-nineteenth century, most artists worked only in the studio; landscapes were painted from memory or from sketches made out-of-doors.

In 1859, Monet went to Paris to study and became good friends with Camille PISSARRO, another member of the Impressionist group. He did two years of military service (1860–1861) in Algiers and then returned to Le Havre, where he met an older Dutch landscape painter, Johan Jongkind (1819–1891). Monet credited the older man, whose seascapes and views of ports captured the effects of air and light, with "the definitive education of my eye." After returning to Paris, Monet befriended other painters who were to make up the nucleus of the Impressionist group, in particular, Pierre-Auguste RENOIR.

Monet's dedication to *plein air** painting sometimes led him to take extreme measures. In 1866, while working on his eight-foot-high *Women in the Garden,* he had a trench dug to hold the bottom of the painting. The canvas was raised and lowered on pulleys so that the artist could work on different sections. When Gustave COURBET visited him, he was astonished that Monet

*caricaturist an artist who makes images that are distorted or exaggerated for comic effect

*plein air (French for "open air") pictures, usually landscapes, painted out-of-doors to capture effects of light and atmosphere

would not paint even the leaves in the background of a canvas unless the light was exactly right. A few years later, Monet converted a flat-bottomed boat into a floating studio, fitted with grooves to hold his canvases.

A typical work from Monet's early Impressionist years is *On the Seine at Bennecourt* (1868). The scene is flooded with sunlight; Monet has built it through applying patches of color, almost like the tesserae* of MOSAICS. The paint is applied evenly across the surface to give the painting its uniform texture and also to blur the lines between illusion and reality. Both the reflections in the water and the "real" trees and flowers along the shoreline are treated in the same way. As the art historian H. W. Janson has pointed out, "Were it not for the woman and the boat in the foreground, the picture would be just as effective upside-down."

***tesserae** small pieces of colored glass or marble used in mosaics

"Would-be Artists" and Hard Times

During the Franco-Prussian War (1870–1871), Monet fled to England. There, he studied works by John CONSTABLE and J. M. W. TURNER and met the art dealer Paul Durand-Ruel, the first great champion of the Impressionists. Turner's paintings, in particular, confirmed Monet's ambitions to capture the magical effects of light. On his return to France, he settled in the village of Argenteuil, along the river Seine near Paris. Friends often visited, and the artist frequently worked side by side with Renoir at easels set up next to each other.

It was during the 1870s that Impressionism developed into a fully mature style, and some of the most joyous works of the movement belong to this period. The artists painted boating parties, picnics, dancers at outdoor cafés, horse races, and other scenes of middle-class amusements. In 1874, however, the group's first exhibition provoked outrage among the critics. One wrote of the show: "Five or six lunatics, among them a woman, have joined together and

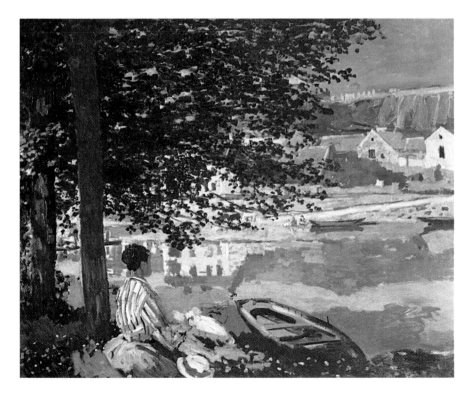

Claude Monet. *On the Seine at Bennecourt.* 1868. *Oil on canvas. Art Institute of Chicago, Illinois* POTTER PALMER COLLECTION. FRANCIS G. MAYER/CORBIS

exhibited their works. I have seen people roar with laughter in front of these pictures. . . . These would-be artists call themselves revolutionaries, 'Impressionists.' They take a piece of canvas, color and brush, daub a few patches of paint on it at random, and sign the whole thing with their name. It is a decision of the same kind as if the lunatics at Bedlam [the London insane asylum] picked up stones from the wayside and imagined they had found diamonds."

The technique Monet developed did, indeed, consist of applying to canvas small dabs of pigment to record his immediate visual observations. Earlier painters counted on gradual variations in tone to give an illusion of three dimensions. Monet placed spots of different color side by side so that the surface of the painting almost vibrates. In an effect called "optical mixing," the colors often seem to blend together at a distance and dissolve into a shimmering surface. The Impressionist painters usually avoided black and other dark tones; to represent shadows, they used violets, blues, and greens.

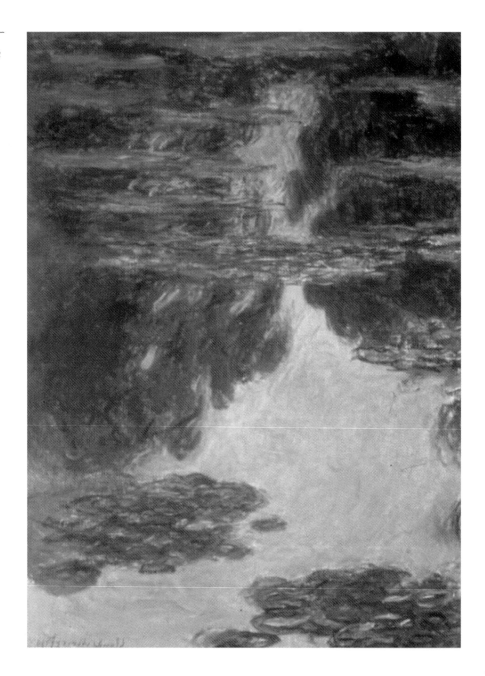

Claude Monet. *Waterlilies.* *1907. Oil on canvas. Walters Art Gallery* AP/WIDE WORLD PHOTOS

Although Monet painted bright and cheerful scenes, his life at this time was plagued by poverty. He pawned his possessions for paint, and in 1875 was begging friends for assistance. To the novelist Émile Zola (1840–1902), he wrote, "We haven't a single [coin] in the house, not even anything to keep the pot boiling today." In 1879, his first wife, Camille, died. Such was Monet's obsession with his art, however, that while sitting at her deathbed, he continued to paint, recording the blue and gray pallor of her face as her life slipped away.

Later Years

In the 1880s, the fortunes of the Impressionist group began to improve as collectors in both Europe and the United States took note of their work. Their technique attracted imitators worldwide. Yet, the original Impressionists suffered a kind of "identity crisis." The group held its last show in 1886. Pissarro, under the influence of Georges SEURAT, abandoned the approach for several years. Renoir turned away from his dappled canvases toward a more severe style. Monet alone remained faithful to the notion of recording his observations on the spot, although many of his later works were completed in the studio.

By 1890, Monet was able to buy the house he was renting at Giverny, a village forty miles outside Paris. In the decade following, he fixed on the idea of painting the same subject at different times of day, in different light, or during changing seasons. His series *Haystacks* (1890–1891) and views of Rouen Cathedral are the best-known examples of this idea. The cathedral series is a sequence of more than thirty canvases recording the facade of the church in the town of Rouen from dawn to dusk. In the bright light of midday, the cathedral is a bleached shimmer of stones; at twilight, Monet captures the change of day in glowing yellows and cool blues.

In his last years, the artist increasingly focused his attention on the grounds surrounding his home at Giverny, where he created lush gardens and lily ponds for his personal pleasure and artistic pursuits. The grounds themselves were a living canvas, which he described as "my most beautiful masterpiece." After 1911, the grounds became his sole subject, and he had a special studio built to house his huge canvases, some as large as six feet high and fourteen feet long.

In these late paintings of water lilies and pond flora, his brushwork became increasingly loose, but with greater variety and rhythm. Typically, surface and reflections blur and merge, creating a kind of all-over surface. In their grand size and freedom of handling, the works foreshadow the abstractions of Jackson POLLOCK and the American Color Field painters. As Monet aged, cataracts blurred his vision, but he painted until the end of his life. "Monet is only an eye," his friend Paul CÉZANNE once remarked. "But what an eye."

(*See also* COLOR FIELD PAINTING.)

The Rise of the Art Dealer

Until the seventeenth century, the church, private patrons, and official institutions commissioned works directly from artists. Gradually, the middleman known as the art dealer (sometimes called a gallerist) became indispensable to selling art, so much so that, it is said, the French painter Antoine WATTEAU died in the arms of his dealer.

Although the Impressionists held their own exhibitions and occasionally had works accepted by the Salon, France's official art exhibition, they still depended on a handful of enthusiastic dealers to sell their works. Among these were Père Tanguy, Ambroise Vollard (*see* sidebar, ROUAULT), and Paul Durand-Ruel. In 1865, Durand-Ruel took over his family's business and became the main dealer for the Barbizon School of landscape painters. He became acquainted with the Impressionists Camille PISSARRO and Monet when the artists took refuge in England during the Franco-Prussian War. Durand-Ruel was unflagging in his support of the young group of painters, coming close to bankruptcy in trying to sell the works of these "outcasts."

In 1886, Durand-Ruel staged a groundbreaking exhibition of Impressionist works in New York. The show was such a success that he decided to open a branch of his business there. In the late nineteenth and early twentieth centuries, Durand-Ruel was instrumental in helping build some of the outstanding collections of Impressionism in the United States.

MOORE, HENRY

English, 1898–1986

Henry Moore is considered one of the greatest sculptors of the twentieth century. He was born in the county of Yorkshire in northeastern England. He started his career as an elementary school teacher, but at age seventeen he joined

the army. At the end of World War I (1914–1918), Moore returned to teaching briefly, before attending Leeds College of Art on an ex-serviceman's grant.

Early Influences

In 1921, Moore won a scholarship to the Royal College of Art in London. He later recalled his first days in the British capital as "a dream of excitement." Like many young art students, he haunted the museums, developing a special fascination for pre-Columbian and African sculpture. Trips to France and Italy broadened his knowledge of avant-garde* trends and deepened his appreciation for artists of the Italian Renaissance.

Moore's first one-man show, held in 1926, was an immediate success. Members of England's artistic establishment, including the Welsh painter and sculptor Augustus John (1878-1961) and the American-born sculptor Jacob Epstein (1880-1959), purchased his work. Moore's sculptures of the late 1920s show the influence of pre-Columbian art and his indebtedness in particular to the *chacmool* figures in Mayan art. The chacmool is a reclining figure representing the Mayan rain god; it holds a container used for sacrifice. In these early sculptures, Moore was developing an aesthetic of "truth to materials," which means that the shape a work of art eventually takes should be closely related to the material from which it is made: stone should look like stone, wood like wood.

The 1930s and 1940s

In the early 1930s, Moore came under the influence of SURREALISM, particularly the sculptures of the French artist Jean ARP and the Spanish painter and sculptor Pablo PICASSO. He showed at the International Exhibition of Surrealist Art in London in 1936. Moore began to gain a following in the United States when his work was included in an exhibition at the Museum of Modern Art in New York. By the mid-1930s, his sculptures had begun to make greater use of hollowed-out spaces. Although he produced a few completely abstract pieces, his work almost always refers to the human body and the natural world. A handful of themes, such as reclining figures and mother-and-child groups, would occupy him throughout his life.

By the end of the 1930s, Moore was considered the leading modern sculptor in Great Britain. During the bombing of London in World War II (1939–1945), he sketched the people who took shelter in underground (subway) stations. He made thousands of these drawings, generally in black and white, and the figural groupings of huddled figures suggested more ideas for his sculptures. They also gained Moore wider public attention when they were exhibited; Londoners could identify with the cramped, eerie subterranean world so many had experienced.

After the war, Moore returned to sculpture, often working in a more traditional and conservative idiom, such as *Madonna and Child* (1943), commissioned for the Church of St. Matthew in Northampton, England. Bronze gradually replaced wood as his preferred material, and the mother-and-child theme took on renewed significance after the birth of his daughter in 1946. That same year marked the huge critical and popular success of his retrospective exhibition at the Museum of Modern Art in New York. Two years later, he won the International Sculpture Prize at the Venice Biennale, one of the most prestigious international art exhibitions.

*avant-garde literally, the "advanced guard"; a term describing innovators or innovation in a particular field

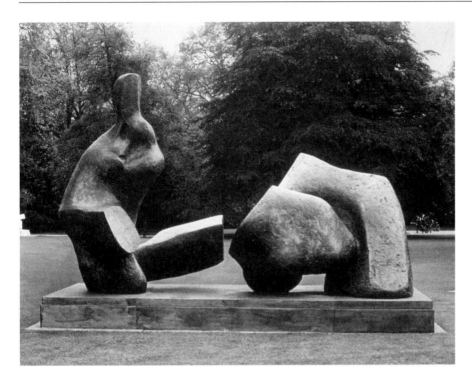

Henry Moore. *Reclining Figure No. 5.*
1966. Stone sculpture. London, England
ARCHIVE PHOTOS

Later Years

In the last decades of his life, Moore received numerous commissions for large "architectural" sculptures—works placed on museum and university grounds, and the plazas of public buildings, such as those at Lincoln Center in New York and at the UNESCO headquarters in Paris. Most of these were executed in bronze and explored familiar themes, often in the most abstract terms. As he worked on a larger scale, Moore turned to help from assistants, among them the English sculptor Anthony CARO and other young British artists.

Late in his career, Moore also turned to PRINTMAKING, showing a talent for etching in series such as the *Sheep Portfolios* (1970s). Although his output was immense—some six thousand works in sculpture alone—and his stature enormous, Moore seemed to mark the end of a period rather than the beginning of a significant new trend. Late-twentieth-century sculptors turned away from the traditional materials of bronze, wood, and stone to a host of new technologies and mediums, from aluminum to plastic to neon.

(*See also* ABSTRACT ART.)

MORAN, THOMAS

English-born American, 1837–1926

The paintings and sketches of Thomas Moran offered Europeans and Americans their first glimpses of the spectacular sites of the American West. Moran is best remembered for his vistas of the Grand Canyon in Arizona, the Yellowstone region in Wyoming, and the Teton Range, a chain of the Rocky Mountains, in Wyoming and Idaho.

Born in England to a family of weavers, Moran grew up in Philadelphia and was largely self-taught. He started his career as an engraver* but spent

*engraver one who makes prints by using a sharp instrument to render a pattern, design, or letters on a hard surface (usually wood, stone, or copper plate)

most of his free time painting. On a trip to England in 1861, he was particularly impressed by the works of J. M. W. TURNER and afterward kept in his studio a full-size copy of the English artist's *Ulysses Deriding Polyphemus* (1829).

Moran's career did not take off until the early 1870s when he was invited to join a surveying expedition to the American West. Until this time, the bubbling geysers and hot springs of the Yellowstone region, "the place where Hell bubbled up," were known only through verbal and written accounts. Moran's watercolor images brought home the reality of this thrilling and alien place; he later used his sketches to create a fourteen-foot-long canvas, *The Grand Canyon of the Yellowstone.* In part, Moran's visual record, together with the photographs of a companion on the expedition, William Henry Jackson (1843–1942), helped persuade President Ulysses S. Grant (1822–1885; president 1868–1876) to set aside thirty-five hundred square miles of the Yellowstone area as national parkland.

In the six decades of his career, Moran did hundreds of open-air studies and landscape paintings of Pennsylvania; Long Island, New York; Mexico; and Venice, Italy, among other places. He is still best known, however, for his images of a vast frontier that had yet to be tamed.

MORISOT, BERTHE

French, 1841–1895

The great-granddaughter of the Rococo painter Jean-Honoré FRAGONARD, Berthe Morisot grew up in a highly cultured, upper-middle-class household. For a time, Camille COROT was her teacher, but the more important influence on her work was Édouard MANET, whose brother she married in 1874.

Morisot was twenty-six when she first met the thirty-five-year-old Manet at the Louvre Museum, where she was copying a painting by Peter Paul RUBENS. The attraction between the two probably never developed into a romance, but their strong friendship lasted for sixteen years, until Manet's death. The older artist influenced her early paintings, but over time Morisot developed a style distinctly her own. She, in turn, convinced Manet to try *plein air** painting and to experiment with the Impressionist palette of bright colors.

*plein air** (French for "open air") pictures, usually landscapes, painted out-of-doors to capture effects of light and atmosphere

Through Manet, Morisot made the acquaintance of Edgar DEGAS and other artists and writers of the day, including the poet Charles Baudelaire (*see* sidebar, COURBET) and the novelist Émile Zola (1840–1902). Considered cultured and charming, she became a regular at social gatherings where literature, music, and art were topics of discussion. She posed for several of Manet's works, and he encouraged her to pursue her own path. Unlike those of some of her male colleagues, Morisot's paintings were regularly accepted by the Salon*. It is also interesting to note that although she was not commercially successful in her lifetime, Morisot outsold fellow Impressionists Pierre-Auguste RENOIR and Claude MONET.

*Salon** France's official art exhibition; established in 1667

Exposed to some of the most advanced ideas of the day, Morisot was nonetheless excluded from the cafés and other haunts that became favorite

Berthe Morisot. *Sur la Falaise aux Petites Dalles. 1873.* Francis G. Mayer/Corbis

subjects of her male peers. She seldom went out without the company of a chaperone, and even then her movements were restricted. Like Mary Cassatt, she eventually settled on the sheltered world of motherhood and family as her subject matter, but she was also an expert painter of harbors and seaside scenes.

After the marriage of her sister Edma in 1869, with whom she was extremely close, Morisot suffered several years of depression and self-doubt. Thanks to Manet's encouragement and her own will to succeed, she began to produce more and more work in the years after 1872. The eighteen paintings she completed in 1875 firmly launched her career, and the birth of her daughter in 1878 signaled a decisive change in her style. In her own words, she wished to "capture something transient."

La Lecture (Reading), a work from 1888, reveals Morisot's approach to Impressionism and also her debt to Renoir. Hers is a light-filled vision of a little girl reading, surrounded by explosive greenery. Morisot's style tends to be sketchier than that of many of her peers, and she has a delicate, feathery technique all her own. She was also accomplished at watercolors, a difficult medium but one that responded to her lightness of touch and search for ever freer execution. In choosing to focus on her immediate surroundings, the poet Paul Valéry (1871–1945) noted, her works became "like the diary of a woman who uses color and line as her means of expression."

(*See also* Rococo Art.)

MOSAICS

The art of producing surface designs by arranging pieces of stone, marble, or glass in plaster probably began in ancient Sumeria, perhaps as early as the third century B.C. In ROMAN ART, floors were decorated with mosaics made with small marble cubes, known as *tesserae*. These mosaics were often geometrical patterns or large pictures. But it was the Early Christian and Byzantine artists who perfected the art of wall mosaics on a grand scale to decorate the interiors of churches. Some of the world's most glorious mosaics are in the churches of St. Mark's in Venice, San Vitale in Ravenna, and Hagia Sophia in Constantinople (Istanbul), Turkey.

To make a mosaic, the artist or his assistant first applied a rough coat of cement to a bare wall. A second layer was then added, studded with nails to help hold the two coats together. A design was drawn on the upper layer, with markings to indicate different colors. The tesserae—which can be cut from marble, glass, semiprecious stones, tile, or alabaster*—were embedded in a third layer of cement. For the most dazzling effects, the artist placed thin sheets of gold or silver inside cubes of glass. A large mosaic called for thousands of tesserae, graded by size and color. The artist deliberately placed them unevenly on the surface, so that sunlight or the candles carried in church processionals would reflect off the surface, creating an otherworldly, flickering effect.

In the earliest churches, white backgrounds were used; later, blue became the predominant color; and finally, in the sixth century, gold grounds came into use and were preferred above all others. The skilled mosaicist could employ different colored stones to indicate shading, subtle flesh tones and facial features, and even the folds of drapery.

Because of the expense of the materials and the months of skilled labor required to complete a mosaic, only the wealthiest churches and cities could afford to commission them. The artform reached its pinnacle in Byzantium. The Byzantine emperor was considered to be God's representative on earth; therefore, the lavish decoration of churches was underwritten by the government. The artists who made mosaics trained in special workshops, which became well known and admired throughout Europe and the Islamic world. Byzantine artists and craftsmen often traveled to other countries to create these shimmering works for wealthy patrons.

(*See also* BYZANTINE ART; CHRISTIAN ICONOGRAPHY; EARLY CHRISTIAN ART; SUMERIAN ART.)

***alabaster** a variety of gypsum or calcite that is of a dense, fine texture; usually white, but may be gray, yellow, or red; sometimes banded

MUNCH, EDVARD

Norwegian, 1863–1944

Norway's most famous artist, Edvard Munch opened up new paths for artists in the twentieth century with his anguished and memorable explorations of his own mental torment. His childhood was an unhappy one: he lost both his mother and eldest sister to tuberculosis; another sister developed mental illness. Munch was so terrified by his fanatically religious father that he ordered his first painting of a nude, *Puberty* (1895), to be covered up before the senior Munch attended an exhibition at which it was displayed. Munch once remarked,

"Illness, madness, and death were the black angels that kept watch over my cradle." Obsessions with sex, violence, and death would continue throughout his life, and he painted extreme psychological states with a conviction and turbulence that sometimes borders on frenzy.

Develops Mature Style

Munch first began to study painting seriously in 1880 at the School of Art and Handicraft in Oslo, but his teachers were rooted in academic traditions and in the realism of the French BARBIZON SCHOOL of landscape painting. On Munch's first visit to Paris in 1885, he discovered the works of Édouard MANET, Paul GAUGUIN, and others and began to develop his own singular approach to painting. From the Impressionists, he learned how to use a palette of divided color; the Postimpressionist Gaugin taught him how to use flat areas of non-naturalistic color. Yet, even his earliest works show a mood of melancholy that is far removed from the Impressionist world of sunlight and bustling urban gaiety.

By 1892, Munch's reputation was sufficiently impressive that he was invited to participate in an exhibition at the Artists' Union (*Kunstlerverein*) in Berlin. His work caused such an uproar because of its violent emotionalism and unconventional imagery that the show was closed. Sympathetic leaders of the union resigned to form the Berlin Secession (*see* sidebar, KLIMT), an avant-garde* group dedicated to new art. Both the controversy and recognition persuaded Munch to move to Germany, where he came to maturity as an artist and spent most of his time until 1908.

*avant-garde literally, the "advanced guard"; a term describing innovators or innovation in a particular field

Munch's Dark Themes

Throughout much of the 1890s, Munch devoted himself to producing an ambitious series of paintings called *The Frieze of Life,* which he subtitled *A poem of life, love, and death*. The best-known work from the series is *The Scream* (1893), a work that has been reproduced so often that it is now a cliché. Munch did many variations on the theme in different mediums, of which both his black-and-white and colored woodcuts are particularly impressive. All of the lines seem to converge on the skeletal head in the center of the print, so that even the bridge and landscape participate in the sheer terror conveyed by the screaming face. Something terrible has obviously happened—or else the figure has been gripped by some unknown hysteria—but part of the work's power is that it does not reveal exactly what has taken place.

Although Munch is often seen as a forerunner of German EXPRESSIONISM, his painting generally has an intensely literary and even mystical aura that is distinctively Scandinavian. Historians and critics have often drawn parallels between his painting and the plays of his friend and countryman Henrik Ibsen (1828–1906), for whom he designed theater posters and stage sets. Both were strong opponents of conventional bourgeois morality, and both focused on darkly passionate themes. A painting like *The Dance of Life* (1900), with its mirthless frozen characters, could almost be a scene from an Ibsen play.

In 1908, after a bout of nonstop work and heavy drinking, Munch suffered a mental breakdown. After recovering, he returned to Norway permanently. His works became even more freely painted and optimistic, but for the most part they did not exude the power of Munch's earlier paintings. The artist

Edvard Munch. *The Dance of Life.*
1900. Nasionalgalleriet, Oslo, Norway

himself recognized that his genius lay in his mental instability: "I would not cast off my illness," he wrote, "for there is much in my art that I owe to it." In his last self-portrait, however, he rekindled the anguish that had made his earlier works so compelling. *Between the Clock and the Bed* (1942) shows an old man, frail and afraid, hovering at the edge of the unknown.

Legacy

Together with Vincent VAN GOGH, Munch was one of the most influential artists on twentieth-century Expressionism, particularly in Germany and Scandinavia. The deliberate distortions, dizzying vantage points, and sinuous use of line opened up new possibilities that have continued to be mined right up to the present day. In front of his pictures, viewers still experience the reaction Munch had hoped for when he stated, "I want to paint pictures that will make people take off their hats in awe, the way they do in church."

(*See also* POSTIMPRESSIONISM.)

MURILLO, BARTOLOMÉ

Spanish, 1617–1682

A follower of Francisco de ZURBARÁN, Bartolomé Esteban Murillo eventually surpassed the older painter, becoming the most popular artist in seventeenth-century Seville. Little is known about his early career, but he made his reputation in the 1640s with a series of paintings on the lives of the saints for the

Franciscan monastery in Seville. His favorite subjects were the Virgin and Christ child—shown together, with saints, or in Holy Family groups. He made something of a specialty of scenes of the Immaculate Conception*, and the sweetness and delicacy of his style have made his paintings extremely successful as devotional images for prayer and meditation.

*Immaculate Conception in Christian art, a scene depicting the belief that the Virgin Mary was conceived without original sin

In Murillo's many versions of the Immaculate Conception, the Virgin, with clasped hands and flowing robes, stands on a globe or crescent moon. Other images show the standard formula of the Madonna with the Christ child on her lap, an image that had been popular in Europe since the Early Renaissance. Murillo, however, brings to his visions a soft, delicate coloring and haunting expressiveness that show the influence of northern European artists, including Peter Paul RUBENS and REMBRANDT. The term *estilo vaporoso,* Spanish for "vaporous style," is often used to describe Murillo's work.

Besides religious subjects, Murillo was also a splendid portraitist; here his approach became much more somber and reflective. Perhaps the best known of his works are genre paintings* of beggar children, which have been reproduced countless times over the centuries. His *Young Beggar* from 1645, is typical of his treatment of street urchins, who must have been a common sight on the streets of Seville. The pale boy sprawls in a corner, a basket of fruit at his feet. The strong, slanting light shows the influence of CARAVAGGIO, and the homeliness of the scene—the absence of religious overtones—recalls *The Water Seller of Seville* by Diego VELÁZQUEZ, from about twenty-five years earlier. The tenderness that Murillo brings to his scenes, however, distinguishes him from the many other talented Spanish painters of his day.

*genre painting painting that focuses on everyday subjects

Murillo spent most of his life in Seville, where he founded an academy for painters and became its first president. His style was enormously influential; he was one of only two or three Spanish artists who became well known outside their native country.

(*See also* BAROQUE ART.)

MURRAY, ELIZABETH

American, born 1940

One of the most inventive abstract artists of her generation, Elizabeth Murray is noted for irregularly shaped canvases and paintings that often draw on exaggerated and cartoonish images. Born in Chicago, she studied at the Art Institute of Chicago and received a master of fine arts degree from Mills College in Oakland, California, in 1964. She moved to New York in 1967, and within a few years her paintings became totally abstract. In the mid-1970s, Murray began making shaped canvases, sometimes composed of overlapping forms or pieced together like the elements of a puzzle.

Titles are important to her work. *More Than You Know* (1983), *Can You Hear Me?* (1984), and *Not Good-bye* are about the small dramas of everyday domestic life. Murray explains that *Just in Time,* a fractured image of a steaming cup of coffee, was made the summer she fell in love with her husband; the cup seems to be a cozy and romantic image of warmth and intimacy. Cups are also a signature theme in Murray's work.

As critics have noted, there is a specifically female slant to Murray's imagery; she often uses egglike shapes, gently bulging and curving forms, and familiar objects from the home. Her works are generally large and exuberant, with heavily scrawled surfaces, and Murray plans each one carefully through full-scale preparatory drawings. Although her vision seems to be buoyant and even comic, many of her works have a darker side. The artist herself has stated, "I think making art is trying to respond to being alive, to learning about death and how those things mingle."

(*See also* ABSTRACT ART.)

MUSEUMS

The word *museum* was derived from the Greek term *mouseion,* the name for the temple dedicated to the muses of the arts and sciences. The site of competitions held by literary societies, these rooms or buildings were often filled with statues, paintings, vases, and other ornaments. The first *mouseion* that resembled the modern idea of a museum was founded in 290 B.C. in Alexandria, Egypt, as an adjunct to the famous Alexandrian Library, which housed some 400,000 scrolls. Intended as a resource for a community of scholars, the museum displayed statues and portrait busts, as well as animal hides, biological samples, surgical and astronomical instruments, and other items intended for study and teaching.

Europe's Private Collections

In the Middle Ages (c. 500–c. 1500), churches and monasteries throughout Europe displayed statues, paintings, the relics of saints, and objects brought back as spoils from the Crusades (1099–1291). But it was not until the Renaissance (c. 1350–c. 1600) that princes and the privileged class revived the Alexandrian ideal of the *mouseion.* In the sixteenth century, voyagers to the New World and other far-flung lands returned to Europe with strange objects—natural specimens and human artifacts—from exotic cultures. These were displayed in *Wunderkammern* or *cabinets de curiosité,* "cabinets of wonder" or "curiosity." At first, only their owners and illustrious visitors had access to these private collections.

It was also during the Renaissance that princely patrons began displaying their personal collections of paintings and sculptures, from their time as well as from earlier ages. The long rooms where works were exhibited, called *gallerie* in Italian, were the forerunners of the museum galleries. One of the most famous, and the only one to have survived in its original quarters, was Florence's Gallerie degli Uffizi, designed in 1560 by Renaissance biographer and painter Giorgio VASARI for Cosimo de' Medici (*see* sidebar, RENAISSANCE ART). Over the years, the collection was expanded. In the twenty-first century it continued to house outstanding examples of quattrocento* and High Renaissance (early 1490s to 1527) art, as well as works by famous Flemish masters, such as the Portinari altarpiece (c. 1476) by Hugo van der GOES.

The Museum as National Treasure

In the seventeenth century, many of the great collections assembled by aristocrats, royalty, and churches opened to the public, although during this time

*quattrocento** in Italian art, the fifteenth century

"public" generally meant only connoisseurs, artists, students, and privileged visitors. In England in 1753, an act of Parliament established the British Museum in London after the government purchased the private collection of the eminent English physician and naturalist Sir Hans Sloane (1660–1753). But until the dawn of the nineteenth century, entry was extremely limited; visitors often had to wait two weeks for tickets and stays were limited to two hours.

In 1750, the Palais de Luxembourg in Paris opened an eclectic display of paintings that had been assembled beginning in the sixteenth century. Eventually, the collection was transferred to the Louvre, formerly the residence of the royal court. After the French Revolution (1789), the Louvre and its contents—the royal art collection—were seized by the government, which established it as a public art museum. More than any other, the Louvre spurred the idea of the museum as a national treasure, a symbol of a nation's social and cultural sophistication. By 1801, the French government had established fifteen other museums to manage the overflow of objects from the Louvre as well as to display works confiscated from the church and aristocracy during the revolution. These museums were generally situated near regional art schools and were intended for educational purposes.

Museums for the Benefit of the Public

The idea of the museum as a place where broad sectors of the public can find enlightenment and education through the study of fine and applied arts did not take shape until the opening of the South Kensington Museum, later

Richelieu Pavilion and Glass Pyramid of the Louvre. *1667–1670 (east facade).* *Paris, France* OWEN FRANKEN/CORBIS

the Victoria and Albert Museum, in London in the 1850s. In part founded by Prince Albert (1819–1861), consort of Queen Victoria (1819–1901; ruled 1837–1901), the goal of the museum was to improve standards by putting on display "the most perfect illustrations and models" of art and design.

Elevating public taste and educating ordinary citizens were also the goals behind the founding of most museums in the United States. In the 1800s, a few wealthy American capitalists (derisively called "robber barons"), who had amassed great fortunes in the industrial boom, began collecting European art at a furious pace. These wealthy leaders and their wives, concerned about the nation's cultural inferiority (as compared to Europe), established museums around the nation, including the Metropolitan Museum of Art (1870) and Brooklyn Museum (1823) in New York, the Boston Museum of Fine Arts (1870), the Philadelphia Museum of Art (1876), and the Art Institute of Chicago (1879). Among the goals expressed by the boards of trustees of these young institutions were the training of artists; the exposure of new immigrant populations to a unified culture; and an almost religious objective—the belief that great works of art could give ordinary citizens a spiritual experience. Original works of art were displayed alongside reproductions and casts of famous sculptures.

Collections Broaden to Include Contemporary Art

At first limited to European art, museum collections in the West began expanding their collections in the late nineteenth and early twentieth centuries. The expansion of trade to Asia resulted in an import of items from the Far East. The Impressionists were among the first to fall under the spell of Asian (especially Japanese) art. Museums responded to the craze by acquiring or borrowing works for display. After the Fauves demonstrated their regard for the tribal art of Africa and Oceania (the Central and South Pacific islands), art museums began exhibiting the works of cultures that had previously been shown only in institutions dedicated to natural history. And, with the growth of avant-garde* movements early in the twentieth century, the time had finally arrived for museums to promote the works of living artists.

*avant-garde literally, the "advanced guard"; a term describing innovators or innovation in a particular field

Metropolitan Museum of Art. *New York City* GAIL MOONEY/CORBIS

Privately founded in 1929, the Museum of Modern Art (MoMA) in New York was the first museum in the United States devoted entirely to modern art; it sponsored lectures, publications, traveling exhibitions, and the nucleus of a permanent collection. Serious bequests led to an expansion of the collection, and eventually, the move to its quarters on West 53rd Street, a site that was being enlarged in the early twenty-first century.

Other modern art museums followed, including the Solomon R. Guggenheim Museum in New York, the Musée National d'Art Moderne in Paris, and the Museum Ludwig in Cologne, Germany. Most are dedicated to showing the works of contemporary artists as well as to arranging exhibitions of the art of the recent past. The Guggenheim, in particular, proved to be an aggressive advocate for spreading the gospel of new art, establishing outposts in Venice and Bilbao, Spain.

Museums in the Early Twenty-first Century

In the early twenty-first century, major museums resemble corporations in their structure and activities. Most are staffed by curators and scholars with impressive credentials, as well as directors and support personnel charged with development (fund-raising), membership, education, publications, publicity, and outreach. The buildings themselves house galleries (public exhibit spaces) as well as auditoriums for lectures, theaters for screening films, and museum shops that sell books and reproductions.

But the modern-day museum is criticized for some of its practices. Beginning in the late twentieth century, many came under fire for staging expensive "blockbuster" exhibitions that seemed to value the box office take more than artistic merit, for selling off valuable parts of their permanent collections, and for not doing enough community outreach to underprivileged and minority groups. Despite these problems, the museum remains the most welcoming and accessible place for studying the art of the past and understanding the art of the present.

(*See also* AFRICAN ART; FAUVISM; IMPRESSIONISM; JAPONISME; OCEANIC ART.)

MYCENAEAN ART

See AEGEAN ART.

NABIS

During his stay in Brittany (a province in northwest France) during the late 1880s, Paul GAUGUIN attracted a following among younger painters who settled in the region to study with the master. They hoped to learn from his use of color and rhythmic pattern and his interest in capturing the emotional life of the world around him. One of Gauguin's disciples, Paul Sérusier (1863–1927), was particularly influenced by the older artist, who urged him to look for the "essence" of an object rather than its outward appearance. In 1888, Sérusier completed the first Nabis-style painting, called *Landscape of the Bois d'Amour,* also known as *The Talisman.* In color and form, it is almost a purely abstract work.

The Nabis is Formed

Sérusier returned to Paris where he shared both his painting and what he learned from Gaugin with other artists, including Maurice Denis (1870–1943), Pierre Bonnard (1867–1947), and Édourd Vuillard (1868–1940). Together, they formed a group called the Nabis, after the Hebrew word for "prophet." The Nabis were fascinated by the supernatural power of all things, which led to an interest in rituals and magic. They were also inspired by Japanese woodcuts and French Symbolist painting. They painted imaginary and mythological subjects using rhythmic brushstrokes to create decorative patterns of color. It was Maurice Denis, the theorist of the group (but, regrettably, not the most memorable of painters), who came up with a rallying cry that underlies so much of modern art: "Remember that a picture—before being a warhorse, a nude woman, or some anecdote—is essentially a flat surface covered in colors assembled in a particular order."

In turning away from the Impressionist emphasis on the natural world, the Nabis pointed the way to a breakdown between the decorative and "fine" arts at the end of the nineteenth century. They believed that the decorative arts were as important as painting, and devoted much of their time to illustration, STAINED GLASS, and stage and poster design. Some members worked in collaboration with outstanding writers of the day, such as André Gide (1869–1951), Jules Renard (1864–1910), and Paul Verlaine (1844–1896).

Henri de Toulouse-Lautrec. Poster for *La Revue Blanche.* CORBIS

*caricature an image that is distorted or exaggerated for comic effect

*avant-garde literally, the "advanced guard"; a term describing innovators or innovation in a particular field

From 1891, a magazine called *La Revue Blanche* published writings, illustrations, and caricatures* aimed toward the advancement of "modern art" of the day. It helped spread Postimpressionist theories, and included frequent contributions from Henri de TOULOUSE-LAUTREC (an unofficial member of the Nabis). The review's headquarters in Paris became a popular gathering place for members of the Paris avant-garde*; it was also the site where the Nabis held its exhibitions. By the time *La Revue Blanche* ceased publication in 1903, most of the Nabis had gone their separate ways, mostly due to dissension among the artists. The group's last exhibition was held in 1899.

Vuillard and Bonnard

Two of the most talented members of the group, Vuillard and Bonnard, moved away from the original aims of the Nabis and developed highly individual styles focused, for the most part, on domestic interiors. From Gauguin, Vuillard learned to use flat planes of color and strong outlines. To this he added a shimmering technique, reminiscent of the works of Georges SEURAT, in which he applied splotches of color across the surface of a work. In a painting from 1899, called *Woman in Blue with Child,* Vuillard depicts the apartment of Thadée Natanson, cofounder of *La Revue Blanche,* and features Natanson's wife, Misia, playing with her niece. Vuillard places his subjects against a richly patterned surface incorporating textures and prints in a way that makes the figures seem almost incidental. But the work has a sense of intimacy and quiet enchantment that recalls earlier masters of middle-class life, including Jan VERMEER and Jean-Baptiste-Siméon CHARDIN.

Vuillard's lifelong friend, Pierre Bonnard, also led a quiet and outwardly uneventful life and became known for peaceful domestic scenes. Bonnard, however, brought to his paintings a greater sense of light and color. His broken brushwork and general sense of middle-class well-being make him the natural heir of the Impressionist tradition. His favorite model was his wife, Marthe, who had an obsession for cleanliness and spent many hours in the bath. Over the course of their marriage, Bonnard painted her many times, either in the tub or at her toilette. In these works, the artist both lovingly catalogs her pink and white flesh and offers a rich surface of flickering light and color. He also made numerous self-portraits, which show his anguish after Marthe's death in 1940.

(*See also* FAUVISM; IMPRESSIONISM; SYMBOLISM.)

NANNI DI BANCO

Italian, c. 1380–1421

Although he completed only a few major works, Nanni di Banco was an important figure in the transition from GOTHIC ART to RENAISSANCE ART. Working during the Early Renaissance, he is remembered for two great projects: the group of *Four Crowned Martyrs* at Or San Michele in Florence, and the reliefs* for the Porta della Mandorla (door) to the Florence Cathedral.

*relief sculptural figures or decorations that project from a flat background

Originally a granary (grain storage facility), Or San Michele was transformed into a church in 1336. It was named for the vegetable garden of a Benedictine monastery dedicated to Saint Michael, which once stood on the site. In

the fourteenth century, each of Florence's major artists' guilds was asked to provide a sculpture to fill the fourteen niches on the exterior of the church, but the commissions were often not carried out until years later. Eventually, Italy's best sculptors contributed works: DONATELLO created figures of *St. Mark* (1411–1413) and *St. George* (1415–1417); VERROCCHIO completed *Christ and Doubting Thomas* (1476–1483); and Nanni di Banco sculpted the *Four Crowned Martyrs* (c. 1408–1414).

Based on a story of early Christianity, the *Four Crowned Martyrs* is also known by its Italian name, *Quattro Santi Coronati.* According to tradition, four Christian sculptors were asked by the Roman Emperor Diocletian (c. 245–c. 316; ruled 284–305) to carve a statue of a pagan god; because of their beliefs, they refused to do so and were put to death. Nanni portrayed the four martyrs, huddled together in an ornately carved Gothic niche. But the figures are based on classical* Roman figures, particularly in the rendering of their togas and their dignified poses. The heads recall Roman portraiture, which the artist probably studied. Some historians believe that two of the figures are likenesses of Nanni and his brother Antonio, also a sculptor.

*classical pertaining to Greek or Roman culture

The four standing figures, grouped in a semicircle, are an innovation in Italian art. The movement in the graceful folds of drapery visually ties the figures together, but the variation of the folds makes each figure distinct. Nanni's artistry makes the four life-size figures seem nearly capable of movement. This work had a great impact on other artists of the quattrocento*, in particular the painters MASACCIO and Andrea del Castagno (c. 1421–1457).

*quattrocento in Italian art, the fifteenth century

After completing the *Four Crowned Martyrs,* Nanni began working on an Assumption* for the Porta della Mandorla. But art historians do not believe that he finished it. Theories suggest the relief was completed by Lucca DELLA ROBBIA.

*Assumption in Christian art, a scene in which a holy figure, such as the Virgin Mary or a saint, is taken up into heaven

(*See also* ROMAN ART.)

NATIVE AMERICAN ART

Scholars estimate that before the first Europeans arrived in the Western Hemisphere, North and South America were inhabited by more than ninety million native peoples, including ten million in the areas north of present-day Mexico. The Native Americans of today and the recent past are descended from groups that crossed the Bering land bridge between Asia and North America during the Ice Age some thirty thousand years ago. Over thousands of years, these peoples scattered across the continent, settling in different geographical regions and developing distinct ways of life based on the terrain, weather, and flora and fauna of the area.

Anthropologists and archaeologists divide the present-day United States into the following native culture areas: Arctic, Subarctic, Pacific Northwest, California Inter-Mountain region, Southwest, Plateaus, Plains, Eastern Woodlands, and Southeast. Within each of these areas, many tribes or groups flourished at different points in history, and each developed art forms according to their beliefs and traditions. There are outstanding examples of artworks from all these cultures, and certain crafts and forms of expression (weaving, carving, mask-making) are virtually common to all. But some cultures valued some forms

more than others, and the objects that were made were the products of distinctive visions, talents, and spiritual beliefs.

Traditional Native American art was not created as art per se, but usually had a purpose. Aesthetic principles were applied to crafting useful everyday objects, such as baskets, ceramic vessels, dolls, and pipes; decorative designs were applied to ceremonial and warfare objects, such as headdresses, masks, and shields. When many of these objects were first seen and collected by Europeans, they were not considered art as much as they were anthropological relics. Thus, many ended up on display in museums of natural history rather than in art museums. But the cultures that produced these useful objects also prized them for their beauty—their color, design, and materials. Further, the artwork often represented spiritual beliefs.

A look at the traditional art produced by some of the groups of the Pacific Northwest, Southwest, Plains, and Eastern Woodlands provides a basic understanding of the rich and varied traditions within the broad spectrum of Native American arts.

Pacific Northwest

The Native Americans of the Pacific Northwest occupied the west coast of North America, from northern California to southern Alaska. The northernmost people included the Tlingit, the Haida, and the Tsimshian. In the middle part of this vast region, around the Douglas Channel and Gardner Canal (in British Columbia, Canada), the Haisla, Haihais, and Kwakiutl settled. To the south were the Coast Salish and the Chinook. There are differences among the groups, but most share certain customs and ceremonies.

The Native Americans of the Pacific Northwest lived in large villages, occupying long wooden houses that included an extended family headed by a chief. The houses belonging to families of high standing were elaborately decorated with representations of mythological creatures, "spirit helpers," and the images of human and animal ancestors. The entranceway to such a dwelling was often the belly of a carved or painted creature, considered a symbol of rebirth. Virtually every object in the household—from bowls to fish hooks—was elaborately carved and painted. Most of these Native American groups made traditional totem poles and traveled in large dugout canoes. The Haida were particularly renowned for their skill at carving oceangoing canoes.

Virtually all the Pacific Northwest tribes observed a ceremony known as the *potlatch*, a ritual exchange of gifts, often held on the occasion of weddings and deaths, and accompanied by feasting and dancing. These represented opportunities for different families to make conspicuous displays of wealth. The host would hand out costly gifts, usually food and blankets, and sometimes even destroyed his property or threw riches into the sea to indicate his clan's financial superiority.

***motif** a favorite symbol or subject in an artist's work

The most commonly seen motif* in Pacific Northwest art is the family crest, usually in the form of flattened, highly stylized faces or parts of animal and human faces. These adorned totem poles, house posts, wooden boxes, baskets, pots, and robes. Masks were worn during religious and healing ceremonies. For example, a mask representing Hamatsa, a personification of a man-eating spirit, was worn by the Kwakiutl during the winter ceremony known as Tseyka.

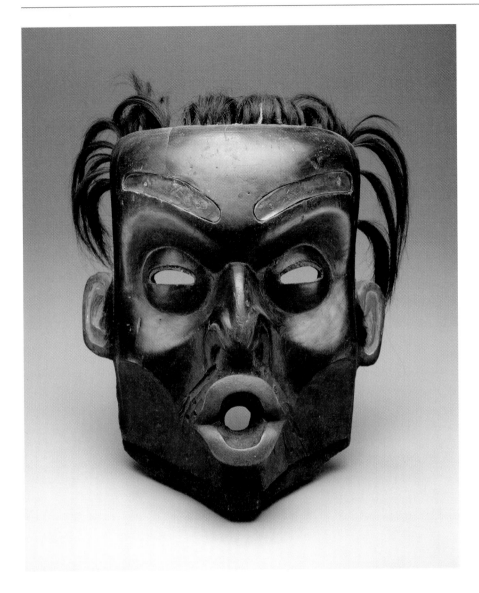

Kwakiutl mask of Dz'onokwa. *Nineteenth century. From British Columbia. Wood, copper, hair, and paint. Detroit Institute of Arts, Michigan* FOUNDERS SOCIETY PURCHASE, HENRY FORD II FUND. PHOTOGRAPH © 1994. COURTESY OF THE MUSEUM

The Southwest

The area that encompasses Arizona, New Mexico, southern Colorado, and northern Mexico has been home to many different peoples, including the Anasazi, Mogollon, Apache, and Navajo. Among these groups were cliff dwellers who carved homes, and entire communities, out of the rock walls of canyons or on the summits of mesas. Most cliff dwellings were built by ancestors of the modern Pueblo people, who made these communal habitats for protection from the elements and from nomadic Navajo and Apache tribes. Art historians identified two broad styles in the art of the Southwest desert cultures: carefully composed geometric designs on baskets, textiles, pots, and other domestic objects; and more casually designed art made for ritual use—feathered sticks, dolls, and cave paintings.

Some of the finest pottery in North American was made by the Pueblo groups that descended from the early Anasazi. A red-on-buff ware dates to A.D. 600 to 900. The Mogollon made a distinctive pottery known as Mimbres, which dates to about A.D. 1000, and features delightful black-on-white renderings of animals and ceremonial scenes.

Ancient Anasazi pottery. *c. 1100. Pecos National Historical Park, New Mexico*

Perhaps the most powerful works from the desert cultures are the Navajo sand paintings, which some art historians believed were an inspiration to modern painters such as Jackson POLLOCK. The sand paintings were usually made as part of a healing ritual performed by priests who sprinkled ground pigments on a base of smooth sand to produce symbolic designs. The different colors signified the four corners of the world: white for east, blue for south, yellow for west, and black for north. During the healing ceremony, the patient was positioned on top of the drawing, and sand from the painting was later rubbed over parts of his or her body. When the purpose of the drawing was fulfilled, it was erased with a sweep of the hand, since the design's "medicine" was considered so strong it had to be eliminated.

The Plains

The North American Plains extend from the eastern front of the Rocky Mountains to the Mississippi River Valley, and from southern Canada to Texas and northern Mexico. Within this vast area are the arid High Plains, the foothills of the Rocky Mountains, and the prairies east of the Missouri River. The rest of the region is grassland, once inhabited by large herds of bison. These herds, along with abundant deer and antelope, provided sustenance for the migrant Plains peoples, who traveled in small nomadic bands, moving when the animals moved.

About A.D. 900, farming people came into the region, building semipermanent settlements of earth-covered lodges. The early Plains peoples included the Blackfoot and Hidatsa; from west of the Rockies, beginning around 1450, came the Shoshone and Comanche. As Europeans colonized North America's Atlantic seaboard regions in the seventeenth through the nineteenth centuries, they displaced Eastern Woodlands and Southeastern tribes, pushing the Native American tribes west onto the Plains. Thus, the Plains became home to many different tribes, with varying traditions.

A pottery tradition among the Plains Indians dates to as early as A.D. 200. Later, the more settled societies produced basketry and small stone sculptures.

But the arts and artifacts most closely associated with the Plains people are those made familiar from movie westerns: elaborately feathered headdresses, painted teepees, rawhide shields, peace pipes, beaded moccasins, and fine garments made from tanned deerskins.

Many artistic objects were emblems of bravery and courage, displayed either during the hunt or in times of warfare. For example, the Comanche war helmet was especially fearsome: it was made from a bison scalp, with the horns still intact. The most common designs for paintings on hides or in delicate beadwork were geometric—triangles, crosses, circles, and parallel lines. But, in what is called the female style, floral emblems were also used. Bison-skin robes and garments were decorated with designs, often symbolic, celebrating great deeds in war. Colors, too, had a profound spiritual meaning for the Plains tribes, with yellow symbolizing the sun, blue for sky or water, and red for the earth.

The Eastern Woodlands

The Eastern Woodlands culture encompassed the area from Minnesota and Ontario, Canada, east to the Atlantic Ocean and south to North Carolina. Much of this area was once densely forested, and the lakes, rivers, and coastline offered abundant fish and shellfish. Copper, mined in the Great Lakes region, was fashioned into weapons and ornaments. Among the better-known tribes were the Delaware, Powhatan, Iroquois, Cahokia, Illinois, and the Sauk and Fox.

The most spectacular artworks from this region were made by the ancestors of these Native Americans, a prehistoric group known as the Mound Builders. Over a period that ranges from about 2000 B.C. to the arrival of the first Europeans in the sixteenth century, the Mound Builders constructed tremendous shapes from the earth, in the form of cones, pyramids, and animals. Some, known as *midden* mounds, were the result of an accumulation of garbage and other debris over hundreds of years. Others were used as funerary monuments, with a central chamber serving as a burial site for important people.

One of the most awe-inspiring, the Serpent Mound still survives in Adams County, Ohio. This spiraling monument, measuring some 1,400 feet in length, winds its way along the crest of a ridge near a river in the southern part of the state. The mound is about twenty feet wide at the base and stands as tall as five feet in some places. A pile of stones that may once have been an altar marks the head of the twisting serpent. Its original meaning and use are unknown, but the Serpent Mound is as impressive as European megaliths such as Stonehenge (England).

"Nontraditional" Arts

Many Native American traditions were lost, falling victim to the sweeping changes that resulted after the arrival of the Europeans in North America. Threatened during the colonial period, the Native American way of life was forever altered and diminished as pioneering Americans pushed steadily westward during the early decades of the new republic. To make way for the white settlers, tribes were relocated by order of the federal government. Those that rebelled were forcibly moved, as in the Trail of Tears (1838–1839), or suppressed, as in the Sioux Wars (1854–1890). Some customs and artistic practices vanished. But, by the mid-twentieth century, a renewed appreciation of

Navajo sand painting with theme of abundant crops. *Twentieth century.* GEOFFREY CLEMENTS/CORBIS

the beauty and importance of Native American art led to a revival of interest in preserving and perpetuating those traditions that did survive the white man's incursion.

At the same time, a debate was underway about what constituted Native American art. Beginning in the late 1800s, Native American artists who had come into contact with Europeans began using new materials. Wood, rawhide, rock, and pottery were replaced by paper as a medium on which to paint. By the early 1900s, Native American artists in the Southwest were encouraged to use watercolors. Beginning in the 1930s, artists began to be trained at newly established studios and art schools, typically run by non-Indians. Many artists created paintings that documented the struggles faced by their tribes and the problems of life on the reservation. Others depicted scenes of everyday life. Critics labeled such art nontraditional; some even called it derivative. But, advocates argued that Native American art must be considered an ongoing tradition; art produced under the new circumstances was a valid artistic expression.

By the post-World War II (1939–1945) era, Native Americas, like other American artists, had been exposed to modern art. Elements of POSTIMPRESSIONISM, ABSTRACT EXPRESSIONISM, and CUBISM began to be seen in their canvases and sculptures. Also like their non-native counterparts, Native Americans used their artwork to communicate their views on society, government,

politics, and popular culture. New developments in the art world affected their output; multimedia and PERFORMANCE ART were produced.

The progression of Native American art was similar to that seen in Latin America. There, too, native peoples had been exposed, at about the same time, to European traditions, techniques, and materials. And, there, too, indigenous artists struggled to perpetuate their rich cultural heritages, express their distinct points of view, and, yet, embrace and be embraced by an increasingly international art world.

Among the first Native American artists to be welcomed into the mainstream was Kay WalkingStick (born 1935), a Cherokee Indian and professor at Cornell University (Ithaca, New York). She is known for her dual panels, which she paints with her hands. In works such as 1995's *The Four Directions/Vision,* WalkingStick addresses "who we are and our conditions on the planet." Her art has been the subject of more than twenty solo exhibitions and was included in some thirty permanent collections, including that of the Metropolitan Museum of Art, New York City.

(*See also* LATIN AMERICAN ART; PREHISTORIC ART.)

NAUMAN, BRUCE

American, born 1941

Described as CONCEPTUAL ART and PERFORMANCE ART, Bruce Nauman's work defies categorization. He works in a broad range of media—from neon to video. Known for his nihilism (a belief that there is no meaning to life) and a provocative attitude, he exerts a great influence on younger artists.

Nauman was born in Fort Wayne, Indiana, and studied at the University of Wisconsin and the University of California, Davis. His earliest works were wax casts of his own body, as well as photographs of inane and puzzling activities. *Self-Portrait as a Fountain* (1966–1970), a photograph showing the artist squirting water out of his mouth, is a reference to the *Fountain* (1917) by Marcel DUCHAMP as well as to grand public statues that gush great sprays of water.

Nauman's works in neon, a medium he frequently turns to, often feature disturbing images, such as a hanged man or sexual acts. These works are realized in bright, gaudy colors. Nauman is also fond of puns, videos that show annoyingly repetitive activities, and scatological content (excrement). Art historian Robert Hughes noted that Nauman exploited "whatever can turn you off . . . tension, repetition, torpor, and bad jokes."

Among Nauman's bigger efforts is a kinetic sculpture called *Carousel* (1988). In this work, four arms swing from a central pivot; a cast of an animal's body, painted dull gray, is suspended at the end of each arm. A motor drags these carcasses in sweeps around the floor, producing an irritating, scraping noise. Critics noted that *Carousel* is a grotesque distortion of the friendly animals seen at an amusement-park carousel—a deeply unpleasant "glimpse of hell."

Although many critics and viewers are put off by his work, Nauman is generally recognized as an "evil genius," whose talent lays in his ability to shock, even at a time when sophisticated art audiences had been deemed unshockable.

(*See also* VIDEO ART.)

NAZARENES

In 1809, a group of young German painters who were students at the Vienna Academy banded together to form the Brotherhood of St. Luke, named after the patron saint of painting. The idealistic band believed that art should serve a religious or moral purpose, much as it had in the Middle Ages (c. 500–c. 1500). A year later, the group's leaders—Johann Friederich Overbeck (1789–1869) and Franz Pforr (1788–1812)—along with two other members moved to Rome and took up residence in the abandoned monastery of Santa Isidoro. Their goal was to revive the working environment and spiritual aims of medieval artists, and their long hair and biblical dress earned them the name Nazarenes. This is in reference to Jesus Christ, the founder of Christianity, who was sometimes called Jesus the Nazarene after his home in Nazareth (now in Israel).

Their early works showed a striking purity of color and line, which came from many sources of inspiration, including the Renaissance masters Fra ANGELICO, PERUGINO, and RAPHAEL. Overbeck's painting *Italia and Germania* (1811–1828), a symbolic representation of the union of Italy and Germany, shows the kind of background landscape popular in Italian portraiture of the Renaissance. The dress and figures of the two women do indeed recall Raphael, but there are also echoes of NEOCLASSICAL ART in the smooth finish and strong emphasis on line.

One of the goals of the Nazarenes was to revive the art of fresco* (*see also* sidebar, GIOTTO) painting, the preferred technique of so many Renaissance artists. They obtained two important commissions for paintings to decorate the home of the German consul and the Villa Massimo; these works made them internationally known. For the most part, however, the paintings produced by the Nazarenes have been judged lifeless by succeeding generations, and modern taste tends to prefer the landscape and portrait drawings produced by members of the group over the more ambitious figure compositions.

The group disbanded in the 1820s. Some of the original members, including Pforr, died young, while others returned to Germany, where they laid the groundwork for ROMANTICISM in that country. One member who worked on the Villa Mossimo, Julius Schnorr Von Carolsfeld (1794–1872), later painted for King Ludwig I of Bavaria (ruled 1825–1848) and enjoyed popular success with his drawings of the Bible in Pictures (1851–1860).

(*See also* GOTHIC ART; RENAISSANCE ART.)

*fresco (Italian for "fresh") a method of painting in which powdered pigments mixed with water are applied directly to wet plaster

NEEL, ALICE

American, 1900–1984

A painter who worked outside the mainstream of American art for most of her career, Alice Neel gained fame late in life for her stark and searching portraiture. Born in Merion Square, Pennsylvania, she graduated from the Philadelphia School of Design for women in 1925 and moved to New York City. Later that year, she married Cuban painter Carlos Enriquez (1900–1957) and lived with him in Havana until 1927, when she returned to New York.

The next few years brought a series of hardships for Neel—the end of her marriage, a nervous breakdown, and a suicide attempt. In the early 1930s, her career began to take off. From 1935 until the early 1940s, she worked for the Works Progress Administration (WPA), the government agency set up to help artists and others during the severe economic downturn of the Great Depression (1929–1939). Neel became a passionate advocate for radical social reform, painting scenes of city streets and people—the impoverished and the homeless. This period also marked the beginning of her commitment to portraiture. "I love to paint people torn by all the things that they are torn by today in the rat race in New York," she said.

Neel's style changed little throughout her life. Typically she worked directly on canvas, using vivid color and expressive distortion to convey a sense of the sitter's state of mind. One of her best-known portraits is of Andy WARHOL, a painting finished in 1970, two years after Warhol had suffered a near-fatal shooting. In the portrait, Neel shows not the self-promoting party animal of the 1960s, but a vulnerable character who seems almost saintly in his suffering. "One of the qualities that makes Neel's works so powerful and difficult," noted art historian Margaret Walters, "is the combination of a deep physical empathy with her sitters . . . and a vision so unsentimental that it verges on brutality."

In the 1960s and 1970s, Neel painted many portraits of artist-celebrities and became somewhat famous herself. She appeared on talk shows and was a forceful public speaker. Nevertheless, she remained something of an outsider, never gaining full acceptance from the art world she so vividly portrayed in her paintings.

(*See also* REALISM.)

NEO-BABYLONIAN ART

See ASSYRIAN ART.

NEOCLASSICAL ART

Many historians date the birth of the modern era to the last quarter of the eighteenth century, the age of democratic expansion and the great American and French revolutions. In the half-century before these two historic political events, a new outlook called the Enlightenment emerged that emphasized a spirit of skepticism. The writers and philosophers of the Enlightenment believed that human affairs should be ruled by reason and a desire for the common good, rather than by traditional religious faith or royal decree. This rationalist approach wrought significant changes in government and economics, and it had an impact on the visual arts as well.

Painters and sculptors in this period reacted against the frivolity and light-heartedness of ROCOCO ART, as exemplified by French painters François BOUCHER and Jean-Honoré FRAGONARD. Just as artists in the Renaissance looked to the ancient worlds of Greece and Rome for inspiration, those of the

***antiquity** the period of history before the Middle Ages; Greek and Roman times

***relief** sculptural figures or decorations that project from a flat background

Neoclassical period—between roughly 1750 and 1830—favored a return to the grand themes and heroic simplicity of antiquity*.

The chief characteristics of Neoclassical art are precise drawing and brushwork so smooth the surface of the painting seems polished. Figures are usually set in a shallow space with little illusion of depth, much like Roman relief* sculptures. Backgrounds often include classical shapes such as columns and arches. There are, however, many stylistic variations. For example, the delicate and sweet manner of painter Angelica KAUFFMANN is far removed from the hard-edged paintings of French artist Jacques-Louis DAVID. Nor is there a firm dividing line between Neoclassicism and ROMANTICISM, a movement of the same time period that emphasized emotion over reason and sentimentality over rationality. French painter Jean-Auguste-Dominique INGRES and Italian sculptor Antonio CANOVA seem to straddle both worlds.

The Legacy of Greece and Rome

One of the most influential figures of Neoclassical art was not a painter or a sculptor but a German art historian and theorist named Johann Joachim Winckelmann (1717–1768). In two immensely influential books published in 1755 and 1764, he proclaimed the superiority of Greek art and culture, praising its "noble simplicity and calm grandeur." His ideas made a deep impression on painters in Rome, including Anton Raphael Mengs (1728–1779) and Gavin Hamilton (1723–1798), who became pioneers of international Neoclassicism. Both had limited talents as artists but were extremely successful in spreading the gospel according to Winckelmann.

Jacques-Louis David. *Napoleon in His Study.* 1812. *Oil on canvas. National Gallery of Art, Washington, D.C.* SAMUEL H. KRESS COLLECTION. BETTMANN ARCHIVE/CORBIS

The Neoclassical impulse in art was also fueled by discoveries in archaeology made in the mid-eighteenth century. Extensive excavations begun in 1738 and 1748 at the Roman cities of Herculaneum and Pompeii offered a remarkable glimpse of well-preserved ancient art, and other finds in and around Rome attracted a steady flow of visitors to Italy. The discovery of ancient Greek vases in Italy inspired expeditions to Greece. At the beginning of the nineteenth century, British diplomat Thomas Bruce (1766–1841), the seventh earl of Elgin, brought the so-called Elgin marbles to England. This collection of ancient sculptures and architectural details from the Acropolis in Athens, the principal temple of the Greek world, further aroused the public's curiosity about the ancient world. The eighteenth century also saw an increase in the publication of illustrated books on classical art, architecture, and antiquities, which helped spread the movement's ideals.

Neoclassicism and the French Revolution

The leaders of the French Revolution (1789) looked to the republic of ancient Rome as a political model. Critics of the aristocracy desired to replace the perceived decadence of the Rococo with simple classical styles. The Neoclassical style in France found its purest expression in the paintings of David, who believed that art should "contribute forcefully to the education of the public." David intended his severe compositions and dramatic historical scenes to arouse in the viewer the noble sentiments of ancient Rome. Later in his career, he headed the artistic program of the French Emperor Napoléon Bonaparte (1769–1821; ruled 1799–1814), who, as Caesar's self-styled successor, found it useful to promote his image as the heroic general and benevolent ruler.

Johann Winckelmann: Father of Modern Art History

Born the son of a cobbler, Johann Joachim Winckelmann (1717–1768) developed a passion for ancient Greek civilization early in life. He held positions as a schoolteacher and tutor while he taught himself Greek and learned as much as he could about ancient culture. In 1755, he made his way to Rome and became librarian to the leading art collector of the day, Cardinal Alessandro Albani (1692–1779). It was at Albani's villa that German artist Anton Mengs (1728–1779) painted his famous fresco *Parnassus* (1761); the work is one of the first in the Neoclassical style.

In Rome, Winckelmann soon established a reputation for near-fanatical scholarship. His books *Thoughts on the Imitation of Greek Art in Painting and Sculpture* (1755) and *History of Ancient Art* (1764) discuss the ideal beauty of Greek art, which seemed to him superior to nature. "The only way for us

to become great," he maintained, "or even inimitable if possible, is to imitate the Greeks." His writings combine historical analysis with ecstatic descriptions of ancient works of art, despite the fact that he based many of his observations on Roman copies of Greek works. On the famous *Apollo Belvedere*, a Roman nude based on a Greek original, he wrote: "At first glance, you may see no more than a lump of marble, but if you know how to penetrate the secrets of art, you will see a marvel."

Winckelmann's writings were a milestone; they established the foundations of modern art history. He believed that when a society was healthy and thriving, the art it produced was equally vigorous. Winckelmann also proposed the novel idea that works of art are an index to the spirit of their times.

The eighteenth century also saw dramatic changes in the way art was taught and displayed. Since the time of the CARRACCI family in the late sixteenth century, academies had begun to replace the apprentice system in the teaching of artistic theory and practice. By the time of the French Revolution, more than a hundred academies flourished in Europe, all of which were dedicated to Neoclassical ideals. For the first time, too, museums made art widely available to the public. The Louvre Museum, long the private picture gallery of royalty, opened to the public in Paris in 1793.

American Neoclassicism: Painting and Sculpture

In the eighteenth century, the wealthy classes in Britain's American colonies commissioned likenesses of themselves based on English portraiture. These tended to be stiff but reasonably lifelike, showing the sitters dressed in Old World finery. Many early portraits were painted by artists known as *limners,* who traveled around the colonies in search of customers. Talented American painters, such as Benjamin WEST and John Singleton COPLEY, studied in Europe and remained in England to pursue their careers. Others, like Charles Willson PEALE and Gilbert STUART, trained in England but eventually settled in the colonies. Neoclassical art was then the prevailing style taught in the academies, and American works echoed the grand linear manner found in David's paintings.

Sculpture in the colonies and, later, the United States also aped the Neoclassical style popular in Europe. In the late 1700s, French sculptor Jean-Antoine HOUDON was invited to make a likeness of George Washington (1732–1799; president 1789–1797). He produced a noble figure of the founding father in a classical pose but in contemporary dress. Later American sculptors followed his lead, with less successful results. Horatio Greenough (1805–1852) created a colossal and controversial statue of Washington in the manner of the Greek god Zeus, now in the Smithsonian Institution. One of the most acclaimed works of its time was the *Greek Slave* (1843), a marble statue of a naked girl in chains by Hiram Powers (1805–1873).

Neoclassical Architecture

Like Neoclassical painting and sculpture, Neoclassical architecture arose in reaction to the excesses of the Baroque period and the frivolity of the Rococo style. Unlike Baroque architecture, which was used to glorify the Catholic Church, Neoclassicism was a secular movement. In opposition to the sweeping curves of the Baroque, Neoclassical architecture was earnest, featuring austere forms and a focus on the solid and geometric. Generally, it favored plain columns and broad, simplified domes. The Neoclassical style was not entirely homogeneous, and it often overlapped with the earlier Palladian* style of architecture. There were also variations on the style from country to country.

England In England, the Neoclassical style, particularly in country houses, often used landscaping as a factor in the design. Some architects chose to pursue geometric perfection as a means to pure architecture, following in the tradition of Sir Christopher Wren (1632–1723), who was a mathematician as well as an architect. He believed in the beauty of perfect, regular forms.

Richard Boyle, the earl of Burlington (1695–1753), and William Kent (c. 1686–1748), who together designed Chiswick House near London, drew on the designs of Italian architect Andrea PALLADIO. Palladio had based his theory of architecture on classical principles, so Boyle and Kent were thus one degree removed from pure classical forms. Later architects went straight to the source after excavations revealed the interiors as well as the exteriors of ancient buildings. James Stuart (1713–1788), William Chambers (1723–1796), and Robert Adam (1728–1792) were all involved in these excavations. Exemplifying the British style of international Neoclassicism is Adam's Syon House (1761), on the outskirts of London. Adam remodeled the interior of a Jacobean* house using geometric shapes based on classical structures. The entrance hall, for example, is modeled after a basilica*—a rectangular room divided by two rows of columns, with one end shaped like an apse*.

France In France, many architects were influenced by the priest and author Marc-Antoine Laugier (1713–1769), whose writings on architectural theory focused on the rational and geometric. The design for the Panthéon in Paris (1755–1792) by Jacques-Germain Soufflot (1713–1780) was an exemplar of Neoclassicism after Laugier's theories. Its facade* used elaborate Corinthian* columns—unlike the purists who insisted on the severe Doric* style—and a triangular pediment*. Claude-Nicolas Ledoux (1736–1806) designed buildings with a basically geometric approach, seeking to blend traditional French architecture with Neoclassicism. Most notable are his Château de Benouville, Calvados (1768–1775) and the Hôtel de Montmorency in Paris (c. 1770–1772). The buildings both have Ionic* colonnades* with straight entablatures*.

Germany German Neoclassicism was based on the same principles as French and British architecture, but it looked quite different. The Greek revival in Germany was linked with the rising spirit of nationalism in that country and supposedly represented the moral righteousness of ancient Greece. Characteristic of the style in Germany is the Brandenburg Gate (1788–1791) in Berlin, designed by Carl Gotthard Langhans (1732–1808). It was based on the Propylaia, the entryway into the Acropolis in Athens, and was the first of a number of Doric ceremonial gateways built in Europe. The facade of Berlin's Altes Museum (1822–1830) by Karl Friedrich Schinkel (1781–1841), one of

***Palladian** relating to the style and tradition of the High Renaissance architect and theorist Andrea Palladio

***Jacobean** relating to the reign and times of James I of England (1566–1625; ruled 1603–1625)

***basilica** in Roman architecture, a long public hall usually flanked by aisles; the same ground plan was often followed in early Christian churches

***apse** a recessed part of a building, especially the east end of a church; may be semi-circular or polygonal in shape and is usually topped by a dome

***facade** the exterior face of a building, usually the front

***Corinthian** an ornate style of Greek column featuring a decorative top carved with vines and flowers

***Doric** the least ornate style of Greek column, featuring a fluted column with no base

***pediment** in architecture, a triangular section over the entrance into a building

***Ionic** a style of Greek column featuring a fluted shaft and a top with carved scrollwork

***colonnade** a series of columns set at regular intervals

***entablature** in architecture, the part of a building between the supporting columns and the roof

Thomas Jefferson. Monticello.
1770–1806. Charlottesville, Virginia DAVID
MUENCH/CORBIS

the great German architects of the nineteenth century, has been described as a triumph of rationalism.

The United States In the United States, that man of infinite talents, Thomas Jefferson (1743–1826; president 1801–1809), was the first to put into practice an architectural style that articulated the ideals of the new republic by echoing the ancient republic of Rome. Jefferson modeled his home, Monticello, near Charlottesville, Virginia, on Palladian architecture and the Maison Carrée, a well-preserved Roman temple in Nîmes, France. Here, geometry and simplicity prevail. Monticello has porticos* on the front and back and octagonal pavilions on either side. British-born architect Benjamin Latrobe (1764–1820) moved to the United States in the late eighteenth century and helped Jefferson design a number of buildings. He was especially noted for his elegant and quiet Baltimore Cathedral (1806–1821), the first Roman Catholic cathedral in the country. The Neoclassical style can also be seen in a number of other public buildings in the United States, including the Capitol building in Washington, D.C., and the main chamber of the Supreme Court. —ANN LANDI, BARBARA M. MACADAM

(*See also* ACADEMIC ART; BAROQUE ART; GREEK ART; MUSEUMS; RENAISSANCE ART; ROMAN ART.)

***portico** a roofed porch supported by columns

NEOEXPRESSIONISM

In the late 1970s, many artists rebelled against the "cool" style of MINI-MALISM and other recent developments, such as PERFORMANCE ART and VIDEO ART. Once declared a dead end, painting came back with a vengeance, as younger artists turned to the heroic scale, explosive brushwork, and charged

content that had characterized American art in the 1950s and European art from earlier in the century. Critics dubbed the style Neoexpressionism because it revived the distortions and emotional subject matter of EXPRESSIONISM. Like the earlier movement, it, too, was spearheaded in Germany, where its key figures were sometimes called *Neue Wilden* (New Wild Ones). At the same time, painters in the United States and Italy revived the art of painting as high drama. However, they achieved varying degrees of critical success.

German Painters Achieve Startling Effects

Anselm Kiefer (born 1945) was considered one of the leaders of German Neoexpressionism. His works deal with German and Jewish history, in particular the aftershocks of the Holocaust, the systematic murder of millions of Jews by the Nazis during World War II (1939–1945). In his paintings, Kiefer tries to come to terms with the terrifying history of his homeland. Using sand and straw mixed with thick dark paint, he created grandiose landscapes that evoke the devastation of battle and mass destruction.

Like Kiefer, Georg Baselitz (born 1938) dwelled on Germany's violent past, but his works recall the country's great legacy of figure painting. His earliest canvases, from the 1960s, show huge, crudely drawn men towering over scorched and barren landscapes. Later he developed a signature style that features figures turned upside down—perhaps, as one critic suggested, "to take the focus off the subject matter and redirect it toward the expressive surface."

The art of Sigmar Polke (born 1941) was also marked by a dark and brooding strain, although his works contain pointed responses to American art from the same period. Like Roy Lichtenstein (1923–1997), he borrowed printing dots developed by newspaperman Ben Day (1810–1889) to print color in illustrations. Polke, however, simply hand-copied the dots onto canvas, emphasizing not their comic-strip character (as did Lichtenstein), but their cheap look and subject matter. For example, his *Bunnies* (1966) shows a blurred quartet of Playboy bunnies as nearly grotesque objects of desire. Polke also rendered horrifying subjects on mass-produced fabrics; the juxtaposition of images of brooding terror with the cheery patterns produces a jarring effect on the viewer.

Italy's "Three Cs"

Enzo Cucchi (born 1949), Francesco Clemente (born 1952), and Sandro Chia (born 1946), the Italian members of Neoexpressionism were sometimes referred to as "the three Cs." Cucchi shared Kiefer's doomsday vision and affinity for thickly crusted surfaces, but he brought to his works remembrances of Italy's great tradition of religious painting. Crosses, skulls, and emblems of martyrdom found their way into a deeply personal but often baffling iconography*.

Clemente's imagery is also charged with personal history, and he often used his own body as a subject. The most prolific of the three Cs, he maintained residences in Rome, Madras (India), and New York, and drew on the emblems and history of each locale in his works. His paintings on Indian themes, for example, recall the Hindu tradition of jewel-like miniatures; those from his stays in Rome are made in the RENAISSANCE ART technique of fresco* (*see also* sidebar, GIOTTO). Many of his works used the body to convey hallucinatory states of mind: Clemente said that he was "interested in the body as a conductor between what we show on the outside and what we feel within."

***iconography** the symbols, signs, and images that are associated with a work of art, an artist, or a body of art

***fresco** (Italian for "fresh") a method of painting in which powdered pigments mixed with water are applied directly to wet plaster

Sandro Chia's work is also largely figurative. But his muscle-bound figures, which recall the works of MICHELANGELO and Giorgio de CHIRICO, are painted in mock heroic poses.

American Painters Get Mixed Reviews

In the United States, Neoexpressionism received a decidedly mixed critical response, at least in part because a handful of its practitioners achieved almost instant fame and their works commanded high prices in the 1980s. Among its most visible figures was Julian Schnabel (born 1951), who incorporated broken crockery into his heavily impastoed* pictures and gained some renown as a filmmaker.

David Salle (born 1952), like all the Neoexpressionists, favored a huge scale, but he usually worked in many panels, which are layered with different meanings and are seemingly unrelated to one another. For example, in *Muscular Paper* (1985), the central panel shows two heads painted in the style of Batman comics, superimposed on a pair of rope-skipping nudes. To the right, affixed to a swatch of cheap, plaid fabric, is a skeletal copy of a painting by Max BECKMANN; at left is a painted photograph of a Pablo PICASSO sculpture turned into a pegboard. As curator Robert Storr noted, "Salle is neither celebrating tradition nor mocking it," but, rather, he is displaying "his alienation from the legacy of his medium."

The most straightforward American Neoexpressionist was Eric Fischl (born 1948), whose scenes of suburban discontent reminded critics of Edward HOPPER. However, Fischl's clumsy skills as a painter and draftsman earned him harsh criticism and even ridicule.

Although Neoexpressionism provoked a fair amount of controversy among curators and critics, the "movement," which was never unified as a group with common aims, did bring painting back to the limelight after two decades when the art form was considered passé. In the various strains of Neoexpressionism, critics identified a tendency called Postmodernism, which often involved mining the art of the past for different ideas and approaches. That tendency continued to prove fruitful for artists into the twenty-first century.

***impasto** thickly applied pigment, often showing the marks of a brush or palette knife

NEOLITHIC ART

See PREHISTORIC ART.

NEVELSON, LOUISE

American, 1900–1988

Acclaimed for her innovative wall sculptures, Louise Nevelson became recognized as an artist relatively late in life. Slow to develop her own style, some historians believe her ambitions were thwarted by a prejudice toward women artists and a lack of an American sculptural tradition from which to draw support and inspiration. Like her fellow Abstract Expressionists, Nevelson's mature work depended on her gift for improvisation.

Born Leah Berliawsky near Kiev, Russia (now Ukraine), she immigrated with her family to the United States in 1906. They settled in Rockland, Maine, where her father worked first as a junk dealer and later became a prosperous real estate developer. In 1920, she married businessman Charles Nevelson, and the couple moved to New York City. Restless in conventional middle-class life, she began taking classes at the Art Students League in 1929, seven years after the birth of her only child.

In 1931, Nevelson traveled to Munich to study with Hans HOFMANN, but soon dropped out to travel around Europe. In Berlin, and later in Vienna, she played small roles in movies, developing the dramatic flair that came to characterize her life and her art. After returning to the United States in 1932, Nevelson separated from her husband and plunged into a bohemian existence, living in poverty as she struggled to support herself and her son.

The 1930s were a time of both personal and professional change for Nevelson. Like many other artists during the Great Depression (1929–1939), she received support from the Federal Art Project (FAP). She also worked as an art teacher and as an assistant to Diego RIVERA, who was then painting his mu-

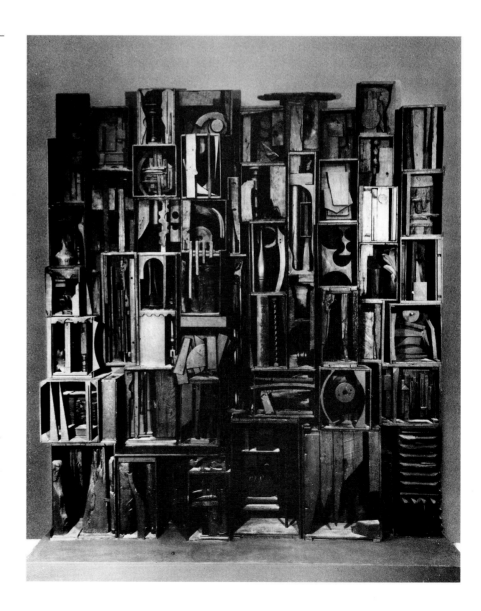

Louise Nevelson. *Sky Cathedral.* *1958.*
Painted wooden assemblage. Museum of
Modern Art, New York City GIFT OF MR. AND
MRS. BEN MEDWOFF. COURTESY OF THE MUSEUM

rals for Rockefeller Center in New York City. The decade also saw her make the transition from painting to sculpture.

In 1941, Nevelson had her first solo show; she was forty-two. By the mid-1940s, she was making figurative assemblages* from pieces of wood and other found materials. Lacking storage space and reportedly frustrated when the assemblages failed to sell, the artist destroyed many of these early sculptures. She began working in terra cotta*, exhibiting wherever and whenever she could.

Nevelson settled in a neighborhood on the East Side of Manhattan, where old houses were regularly demolished. From the architectural rubble, she scavenged objects—often heading out with a wheelbarrow at four in the morning, before garbage trucks made their rounds. By 1958, the artist had begun creating her signature works—large wall sculptures constructed of shallow wooden boxes joined together, the compartments filled with scraps of molding, dowels, finials, chair legs, tool handles, and other found objects.

Nevelson painted her wall sculptures a uniform black, which she felt represented mystery and the dark forces of the unconscious mind. The works are plays of light and shadow, and so are considered among the first "environmental sculptures," in which the artist attempts to control the space in which the object is viewed. The works, such as 1958's *Gate of Eternity,* brought her international fame.

For the last thirty years of her life, Nevelson made numerous variations on the theme, painting the walls of her sculptures all-white or all-gold and working in different materials (metal, plastic, acrylic). During the 1970s, she received several commissions for open-air sculptures of aluminum or steel. The art world revered her as a "sacred monster," an artist of extraordinary talent and possessing a distinctive personal style, characterized by eccentric clothing and dramatic makeup.

(*See also* ABSTRACT EXPRESSIONISM.)

NEWMAN, BARNETT

American, 1905–1970

With Mark ROTHKO, Barnett Newman initiated American COLOR FIELD PAINTING. Although he was a contemporary of Willem DE KOONING and Jackson POLLOCK, Newman developed a visual language that was the polar opposite of the highly charged canvases of ABSTRACT EXPRESSIONISM.

Of Polish Jewish heritage, Newman was born in New York City and grew up in the Bronx. He showed an interest in art at a young age, spending entire days in the Metropolitan Museum. After studying at the Art Students League and the City College of New York, he did not turn to painting full-time until he was nearly forty. Before launching his career as an artist, Newman worked in his father's clothing business, taught art in high schools, and even ran for mayor, losing to Fiorello La Guardia (1882–1947; mayor 1934–1945). Newman was also a student of ornithology (the study of birds) and botany (the science of plants), and, in 1944, finished a series of drawings based on plant motifs*.

assemblage a type of sculpture in which a group of objects is put together to form a work of art

terra cotta a brown-red clay used for sculpture, pottery, and architectural purposes

motif a favorite symbol or subject in an artist's work

In the winter of 1945–1946, Newman rented a small studio and became determined to try his hand as a painter. After struggling with it for a few years, he announced his mature style as an artist with *Onement I* (1948), a small canvas featuring a single, light-orange stripe running down the middle of a dark red field. Newman called these stripes "zips," and they became characteristic of the large works that followed. The zip was interpreted as the upright human figure.

By the mid-1940s, Newman was active in the avant-garde*, writing catalogue essays and articles and organizing exhibitions for the Betty Parsons Gallery (New York City). Parsons, herself an artist, was one of the first women dealers and a devoted champion of Abstract Expressionism. By the time of Newman's first solo show at Parsons, he was painting wall-sized pictures, such as *Vir Heroicus Sublimis* (Latin for "Heroic Sublime Man") [1950–1951]. But such works were coolly received by his fellow artists and critics. Newman's spare canvases were at odds with the energetic, gestural works then in favor with collectors.

The negative reaction his work provoked caused Newman great distress. By 1956, he stopped painting altogether and, a year later, suffered a heart attack. But by the end of the 1950s, some critics, including Clement Greenberg (*see* sidebar, COLOR FIELD PAINTING), had begun to champion Newman's works, securing him a wider and more sympathetic audience. He began a series of black-and-white paintings and tried his hand at sculpture, producing slender steel shafts that recall the zips in his paintings. In 1966, *Stations of the Cross,* Newman's series of fourteen paintings on the theme of the Passion* of Jesus Christ, was shown at the Guggenheim Museum. The exhibit was the high point of Newman's career and the works were later installed at the National Gallery of Art, Washington, D.C.

Newman made somewhat grandiose claims for his paintings, saying they were a window on the "sublime in art and nature." Nevertheless, during later decades, he became highly regarded as a pivotal figure in modern art, an artist who paved the way for the MINIMALISM of the 1960s and 1970s.

NOLAN, SIDNEY

Australian, 1917–1992

Australia's most acclaimed twentieth-century painter, Sidney Nolan was best known for his large body of work inspired by Australian themes. Nolan's wide range was evidenced by his many series on his homeland's history, folklore, and landscape—all explored in a singularly modernist vocabulary.

Although Nolan studied off and on at the National Gallery of Art School in Melbourne, he was primarily self-taught. Some art historians suggested that French artist Henri ROUSSEAU, who was also self-taught and whose works found favor with the avant-garde* of the early 1900s, provided Nolan with the confidence and the example to paint.

In 1942, during World War II (1939–1945), Nolan was drafted into the army and served in Victoria, Australia. Intrigued by the region's plains, cliffs, and trees, in the late 1940s, he returned there to explore the distinctive terrain. The experience inspired Nolan to paint a successful series of landscapes.

avant-garde literally, the "advanced guard"; a term describing innovators or innovation in a particular field

Passion in Christian art, scenes depicting Jesus Christ in the events between the Last Supper and the Crucifixion

avant-garde literally, the "advanced guard"; a term describing innovators or innovation in a particular field

Nolan's best-known series is based on episodes in the life of outlaw and bush ranger, Ned Kelly (1855–1880), an Australian legend. *Glenrowan* (1956–1957), painted in oil on hardboard, is Nolan's most famous single abstract treatment of the Ned Kelly story. *Pretty Polly Mine* (1949), a collage-like* fantasy in brilliant colors, was executed in a guileless and somewhat primitive style. It treats the quintessentially Australian themes of exploration and rugged individualism in Queensland, the expansive northeastern state.

Nolan also painted non-Australian subjects. His *Leda and the Swan* (1960) series illustrates the Greek myth explaining the birth of Helen of Troy, who, according to legend, was the most beautiful woman in the world. He also devoted series to the lives of French poet Arthur Rimbaud (1854–1891) and artist Paul CÉZANNE.

After 1950, Nolan made his home in England, where, in 1981, he was knighted by Queen Elizabeth (born 1926). In 1987, the artist was the subject of a retrospective exhibition at the National Gallery of Victoria; the exhibit later toured Australia's state capitals. In addition to painting, Nolan designed illustrations for books as well as sets for ballets and operas.

***collage** a method of picture making in which pieces of photographs, torn paper, news clippings, and other objects are assembled on a flat surface

NOLDE, EMIL

German, 1867–1956

One of the pioneers of German EXPRESSIONISM, Emil Nolde grew up in a farm in the northwestern part of the country, near Denmark. As a child, he painted and drew, sometimes covering barn doors and loose boards with chalk drawings. Raised in a devoutly religious family, Nolde's childhood study of the Bible was so thorough that images from the life of Jesus Christ became the subjects of his vividly colored paintings. At the age of eighteen, Nolde became an apprentice in a furniture factory. A few years later, he moved to Berlin, where he designed furniture. Working in the German capital, Nolde found himself increasingly drawn to the art world. He took classes and studied the paintings of the old masters on display in Berlin's museums.

In 1893, Nolde made a series of paintings in which he transformed the Swiss mountains into giants and hideous trolls. Two of these works were reproduced as postcards, becoming so popular that a hundred thousand copies sold within ten days. The money he earned from the postcards enabled him to return to school in Germany (Munich) and, later, to travel to Paris. In France, he studied the great artists of the nineteenth century, especially Eugène DELACROIX, Honoré DAUMIER, and Édouard MANET. Although Nolde was not a fan of IMPRESSIONISM, the works did influence him to use brighter and more varied colors in his paintings.

Develops Mature Style

In 1900, Nolde returned to Germany and began searching for his own artistic style. He was a visionary—deeply moved by nature and compelled to paint the scenes from his fertile imagination. For Nolde, even the calls of animals during the night had the power to suggest colors. Certain cries, he wrote, "appeared as shrill yellows, the hooting of owls in deep violet tones."

Degenerate Art Exhibition

The term "degenerate," meaning corrupt or perverted, was used in the 1930s by Germany's Nazi government to describe all contemporary art that was not consistent with its goals and ideals. Denouncing most modern art as "political and cultural anarchy," Nazi leader Adolf Hitler (1889–1945) approved only a narrow range of subjects for German art. These subjects usually exalted Hitler or otherwise promoted his objective of Aryan supremacy.

To publicly condemn artists who did not comply with Nazi objectives, the government sponsored a series of exhibits. The Degenerate Art Exhibition (*Entarte Kunst* in German) of 1937 was the most famous, or infamous, of these. Works by masters of modernism—including Emil Nolde, Max BECKMANN, Wassily KANDINSKY, Pablo PICASSO, and Piet MONDRIAN, were confiscated from German museums and displayed alongside paintings by institutionalized mental patients. The authorities intended to demonstrate to audiences that the "acclaimed" artists were, in their opinion, depraved.

As an exercise to glorify Nazism, the show was a tremendous success, drawing millions of visitors on its tour around Germany. When the exhibit was dismantled, Nazi party officials helped themselves to some of the seized art, which also included outstanding POSTIMPRESSIONISM works, including paintings by Paul GAUGUIN and Vincent VAN GOGH. Other works were sold to foreign museums and collections, raising money for Nazi causes. Still others were burned, as a warning to the public, which destroyed many early modern masterpieces.

Until the Nazi government was toppled at the end of World War II (1939–1945), German artists were forced to work in a tradition-bound REALISM that was little more than propaganda—or they would not work at all. Artists condemned as "degenerate" were forbidden to work; even those who were sympathetic to modern art lost their jobs in museums and schools.

lithography the process of printing from a smooth, flat surface (such as a stone or metal plate)

Known for his solitary nature, Nolde lived long stretches of his life in isolation. In 1906 and 1907, he exhibited with the artists' alliance *Die Brücke* (The Bridge). But he soon withdrew from the group, devoting himself to his own highly personal visions. However, his brief association with Die Brücke encouraged him to experiment with woodcut prints and lithography*.

Around 1909, Nolde's art became much freer and he used ever more forceful color to express his emotions, especially his religious feelings. He allowed himself to create works "without any prototype or model, without any well-defined idea . . . a vague idea of glow and color was enough." One of his finest paintings from this time is *The Last Supper* (1909), an image that recalls the famous interpretation of the same subject by LEONARDO DA VINCI.

In contrast to Leonardo's supremely balanced composition, Nolde used a deliberately clumsy drawing style, thickly encrusted paint, and tightly compressed space to heighten the intensity of the tragic moment when Jesus Christ tells his followers of his impending crucifixion. The mask-like faces recall the works of the early Expressionist artist James ENSOR. The unnatural color and the intense spirituality of *The Last Supper* bring to mind the works of Paul GAUGUIN, which Nolde may have seen on his visit to Paris.

The Era of the World Wars

Between 1910 to 1913, Nolde's work was becoming increasingly well known. At the invitation of the government, he visited German territories in the South Pacific. His travels broadened his knowledge of primitive art, a form that was becoming popular with avant-garde* artists, such as Pablo PICASSO. But the central elements of Nolde's style were established before his exposure to the works of untrained artists in the South Pacific. When critics described

avant-garde literally, the "advanced guard"; a term describing innovators or innovation in a particular field

Nolde's work as "primitive," they referred to its brutal force, not to the use of exotic motifs*.

In the years after World War I (1914–1918), Nolde continued to travel widely, even as he became increasingly popular in his native Germany. In 1927, Dresden mounted an official exhibition of his work in honor of his sixtieth birthday; five years later, he was offered the presidency of the State Academy of Arts in Berlin. With honors and acclaim, Nolde assumed he would be safe from the Nazi government's campaign against modern art, which began around 1934 and culminated in the Degenerate Art Exhibition of 1937. However, the Nazis attacked Nolde's works just as they did those of other modern artists. More than a thousand of his works were eventually removed from German museums, and, in 1941, the German government prohibited him from painting.

Nolde survived World War II (1939–1945) to see his fame restored as "the grand old man" of German art. He continued to work with tremendous energy through his eighties. A late self-portrait, painted with forceful brushstrokes, shows him looking out on the world with a candid and even amused directness. Although his religious works were his most famous, Nolde was also an outstanding painter of landscapes (such as *Friscan Landscape* from the 1930s) and brilliantly colored flowers (including *Still Life, Tulips*, c. 1930).

NORTHERN RENAISSANCE ART

In Renaissance Italy (c. 1350–c. 1600), artists made discoveries that would mark a distinct break with the artistic styles of the past and ultimately revolutionize European culture. The architect Filippo BRUNELLESCHI and the artists of the early fifteenth century, including DONATELLO, MASACCIO, and Lorenzo GHIBERTI, found ways of representing three dimensions on a flat surface so that painted figures and objects appeared to occupy real space. They and others also began to study the art and architecture of ancient Greece and Rome, absorbing and reinterpreting the achievements of antiquity*. At the same time, artists developed an ever greater interest in studying human anatomy, drawing directly from models, and showing human beings as they actually looked rather than according to the idealized formulas followed by Gothic and Romanesque artists.

In the countries to the north, no such distinct revolution took place. Unlike their contemporaries in Italy, Flemish artists did not reject the elegant INTERNATIONAL GOTHIC STYLE of the late fourteenth century. Artists in Flanders—part of present-day Belgium—still favored that style's elongated forms, wealth of sumptuous detail, and depiction of often unrealistic spaces.

However, there was still a Northern Renaissance, although some art historians view it as a continuation of the previous era in art, calling it the "Late Gothic" period. Works by northern painters such as Jan van EYCK, the MASTER OF FLÉMALLE, Hugo van der GOES, and Rogier van der WEYDEN displayed a new sophistication in painting techniques, a painstaking accumulation of detail, and careful attention to surfaces. These artists are usually credited with introducing the practice of painting in oils on wooden panels, which offered painters a rich range of colors and an ability to create both fine detail and a supple blending of colors. Painters such as Hans Memling (c. 1430–1494)

*motif a favorite symbol or subject in an artist's work

*antiquity the period of history before the Middle Ages; Greek and Roman times

and Petrus Christus (c. 1420–1472), believed to be pupils of van Eyck and van der Weyden, continued to build on the traditions established by their teachers, bringing new vigor to the art of portraiture.

Their achievements were admired not just in their homeland but also by the Italian masters of the day. In the fifteenth century, travel between northern and southern Europe became much more common due to the rise of a new economy based largely on trading and banking. Artists, too, traveled between Italy and Flanders, showing their works and exchanging ideas about style and technique. This growth of trade, cities, and a new merchant class also meant that the emphasis in art began to shift from purely religious subjects to portraits of individuals and a greater focus on everyday clothing and furniture.

Just as painters in the north continued to use many Gothic elements, architects in that region drew on the innovations the Gothic style had introduced in buildings, such as the pointed arch and the flying buttress*. They also maintained the Gothic taste for rich ornamentation and graceful lacework, often taking it to such extremes that it is referred to as the Flamboyant style. One example is the Palace of Justice in Rouen, France, built in the late fifteenth century. Its spindly turrets and elaborate designs above the top-story windows serve no real purpose other than decorative. During these same years, by way of contrast, Italian architects were striving instead for a kind of classical* harmony and regularity.

(*See also* GOTHIC ART; GREEK ART; RENAISSANCE ART; ROMAN ART; ROMANESQUE ART.)

***flying buttress** an exterior structure of thin half-arches, attached to the walls of a Gothic cathedral to give them extra support and help them bear the roof's weight

***classical** pertaining to Greek or Roman culture

Palace of Justice. *Late fifteenth century. Rouen, France* FRANZ-MARC FREI/CORBIS

OCEANIC ART

The vast area known as Oceania encompasses the thousands of islands of the Pacific Ocean, usually divided into three subregions—Melanesia, Micronesia, and Polynesia—and sometimes including New Zealand and the Malay Archipelago. Since the native people of these cultures have markedly different languages and customs, it is difficult to describe a single artistic style or outlook.

Nevertheless, the arts of Oceania do have certain traits in common. The forces of nature, for example, are believed by these cultures to hold great powers. Therefore, many art objects were created so that humans could negotiate with the realm of the supernatural. Representations of the human face and figure, generally having exaggerated features, are common in all Oceanic cultures. Throughout the region, the principal tools for making art are stone, supplemented by bone and shell; metalworking techniques were unknown before contact with the West, about 1800. Still, Melanesia, Micronesia, and Polynesia each possess certain features unique to its cultures and each region's physical nature. The art of the Maori of New Zealand is also distinctive.

Melanesia

The group of islands northeast of Australia and south of the equator is called Melanesia (the prefix *mela* means "dark" or "black" and refers to the complexion of many of the native peoples). The region includes the Solomon Islands, Vanuatu, Fiji, and others. Its westernmost island, New Guinea, is the largest of all the Pacific islands and is the most important center of Melanesian art. Throughout the region, the most ordinary objects are adorned with elaborate and delicate decorations—carved, woven, or engraved—but their meaning is somewhat mysterious.

The central highlands of New Guinea are notable for having perhaps the most colorful forms of self-decoration in the world, including feather headdresses and face painting. Farther east, around the Gulf of Papua, local artists concentrate their talents on mask making and woodcarving. The people in the small Torros Strait islands construct complicated human and animal masks from plates of turtle shell; these are used primarily during male initiation ceremonies and funeral rites. In the area known as the Massim, in the extreme southeastern tip of New Guinea, artists enjoy especially high social prestige, and the region is noted for its intricately carved ceremonial canoes, decorated in a curvilinear style (composed of curved lines).

But the richest and most important area of artistic production in New Guinea lies in the central part of the island, along the basin of the Sepik River and its tributaries. The different people along the Sepik create sculptures and paintings representing human and animal figures (especially snakes and crocodiles). These renderings range from fairly realistic to highly stylized. An example is a carved and painted figure from a ceremonial house post, which was once part of a column that supported the structure. Made by one of the Kamboi people along a tributary of the Sepik, it represents one of two brothers who are associated with the tribe's myth of creation. There is a double image in the head, where the eyes and nose of the central face also form the arms and flute of a second, smaller figure.

The focal point of the Kamboi's social and religious life are the ceremonial "houses of men," in which the shape of the crocodile, believed to be the great creator, often figures prominently. These houses are often raised off the ground and feature towering steeples at each end. In 1929, one Western explorer described his first encounter with a ceremonial house in Papua, New Guinea: "It was inland from the river about a mile and full of mosquitoes. From small openings in each gable protruded four grinning skulls. . . . Inside the clubhouse were beautifully carved drums with crocodile heads and tails."

Micronesia and Polynesia

North of New Guinea lies the area called Micronesia, consisting of the tiny islands and a number of archipelagos of the west Pacific and lying east of the Philippines. Among the region's many islands are the Northern Mariana (including Guam) and the Marshall Islands. Compared with the art of Melanesia, Micronesian sculptures and masks are streamlined, highly finished, and functional.

The nearly abstract figures from the Caroline Islands bear a striking resemblance to simple and elegant Cycladic sculptures from early GREEK ART, although the examples from Micronesia often feature elaborate carved decorations. The only masks produced in this region come from the Mortlock Islands; these show friendly spirits with elongated features. Micronesian peoples are also noted for their pottery and for weaving on simple looms.

Much of the art of Polynesia, the central Pacific islands that include Hawaii and the Marquesas, did not survive the influx of Christian missionaries in the 1800s. The new arrivals destroyed art they considered idolatrous or erotic, thus wiping out much of the islands' sculpture. But the missionaries did return to Europe with many fine examples of Polynesian basketry, weaving, and jewelry. The other artwork that remained shows a high degree of artistry; the objects reflect the strict hierarchies found in Polynesian societies. Throughout the region, the various cultures organized themselves according to hereditary classes of rulers, priests, workers, and slaves. Certain objects were associated with each class. For example, special ceremonial clubs and elaborate feathered headdresses belonged to persons of high rank.

Among the Polynesian sculptures that remained intact through the twentieth century were the well-known stone heads carved from the soft rock on Easter Island. Weighing as much as twenty tons, these mysterious colossi, called *moai,* were probably carved in the quarries and then were moved by pushing a pile of stones underneath them. But, according to the beliefs of islanders, the enormous stone heads got where they are by walking, having been commanded by one of the chiefs to do so: "Hearing his words, all the statues set out and picked the places which were most convenient to them."

New Zealand

Perhaps the most distinctive works of all Oceanic cultures are those made by the Maori people, who live on the islands of New Zealand, off southeastern Australia. Carvings in wood of animals and people are done in an intricate curvilinear style. A typical figure is the *manaia,* a stylized human form with the head of a bird. The great war canoes of the Maori have similarly complicated carvings at the prow and stern. The Maori also created stone jewelry, called *hei*

Sculpted heads on Easter Island. *Seventeenth century or earlier. Stone.* SUSAN D. ROCK

tiki. These pieces show embryonic birds and humans with their heads bent to one side. Like other Polynesian cultures, many traditional Maori art forms were destroyed and the traditions collapsed with the arrival of the Europeans at the end of the nineteenth century.

(*See also* ABORIGINAL ART.)

O'KEEFFE, GEORGIA

American, 1887–1986

One of the pioneers of American modern art, Georgia O'Keeffe was born on a farm outside Madison, Wisconsin. At age ten, she decided to become an artist and took drawing lessons in a convent school run by Dominican nuns. At age fifteen, in 1902, her family moved to Virginia, but a few years later she was back in the Midwest studying at the Art Institute of Chicago.

Perhaps the most influential art training that O'Keeffe received was in 1912, during a brief stint studying at Columbia University, New York. There she learned the theories of Professor Arthur Dow, who taught elements of composition derived from the NABIS—a school of French painting emphasizing flat color and rhythmic patterns. Dow's teachings were radical for their time and place, and they laid the foundation for O'Keeffe's later style.

In 1912, O'Keeffe's long romance with the American West began when she accepted a job teaching art in Amarillo, Texas. Three years later, she accepted another teaching post in South Carolina. There she decided to begin anew on her art, reducing her materials to charcoal and paper. By these simple means, she made a series of abstract drawings that evoke the natural world in the gently rounded forms and curving shapes that became the basics of her visual language.

At the end of 1915, O'Keeffe wrapped up the charcoal drawings and sent them to a friend in New York, who, in turn, showed them to the remarkable

photographer and art dealer Alfred STIEGLITZ. Stieglitz was so impressed with O'Keeffe's works that he included them in a show at his tiny gallery, 291, in 1916. A year later, he gave O'Keeffe her first solo exhibition. The two became involved in a passionate relationship and married in 1924.

In 1918, O'Keeffe was forced to give up teaching due to illness. Devoting herself entirely to her painting, she was soon producing her first mature oils, bold abstractions such as *Blue and Green Music* (1919). During the next decade, the artist abandoned that innovative approach to make paintings of greatly enlarged flowers and soaring skyscrapers.

In their hard-edged shapes and celebration of urban life, O'Keeffe's cityscapes, such as *Radiator Building—Night, New York* (1927), drew comparisons to works by the proponents of American PRECISIONISM, such as Charles Demuth (1883–1935) and Charles Sheeler (1883–1965). But O'Keeffe's flowers, like *Black Iris* (1926), invited an entirely different reading; they were immediately perceived as expressions of female sexuality, or what critic Robert Hughes described as "a sense of the body externalized on canvas that could not have been a man's."

After a visit to Taos, New Mexico, in 1929, O'Keeffe fell in love with the landscape of the Southwest. It was a return that she had longed to make since 1917, when, upon first sighting the state's Sangre de Cristo Mountains from a train, she was inspired to write, "from then on I was always on my way back." O'Keeffe began dividing her time between the desert and Stieglitz's family home in Lake George, New York. In 1940, she bought property near New Mexico's Abiquiu Reservoir, not far from Santa Fe. After Stieglitz's death in 1946, she settled permanently in the Southwest. Regional motifs*—such as bleached cow skulls and adobe houses—showed up in her works, as did the curves of her beloved desert and mountains.

Thoroughly American, O'Keeffe did not make her first visit to Europe until 1953. Over the next two decades, she became a tireless traveler. As a result,

***motif** a favorite symbol or subject in an artist's work

Georgia O'Keeffe. *Yellow Hickory Leaves with Daisy. 1928.* ART RESOURCE

many of her later paintings were inspired by aerial views of sky, clouds, and earth. In 1963, she was elected to the American Academy of Arts and Letters. Six years later, the Whitney Museum of American Art in New York mounted a major retrospective of her work. After becoming partially blind in 1971, O'Keeffe completed few new canvases. A museum devoted exclusively to O'Keeffe's work opened in Santa Fe in 1997.

OLMEC ART

See MAYAN ART.

OROZCO, JOSÉ CLEMENTE

Mexican, 1883–1949

The celebrated painter José Clemente Orozco was one of the pioneers of the Mexican muralist movement. Like his contemporaries, David SIQUEIROS and Diego RIVERA, Orozco created vast paintings asserting powerful social statements. Less concerned with politics than with expressing his humanitarian view of the world, he was influenced by Renaissance frescoes* (*see also* sidebar, GIOTTO) German EXPRESSIONISM, and Mexican popular art, including the lurid social and political cartoons of José Guadalupe POSADA.

***fresco** (Italian for "fresh") a method of painting in which powdered pigments mixed with water are applied directly to wet plaster

Born in Ciudad Guzmán, Mexico, Orozco suffered a terrible accident in his youth: an explosion claimed his left hand and impaired his hearing and sight. Nevertheless, he went on to study in Mexico City and was trained as an agronomist (farmland production analyst) and cartographer (map-maker). Turning his attention to painting, from 1906 to 1914, he studied with the influential artist Gerardo Murillo (1875–1964), better known as Dr. Atl. A strict proponent of the traditions of the Renaissance fresco artists, Atl admired their style—simplified forms, dramatic lighting, and formal compositions—as well as their intellectual substance. The teacher exerted a tremendous influence on Orozco. Atl was also a leading proponent of Mexico's nationalist art movement, a response to the political upheaval of the Mexican Revolution (1910–1920).

In 1914, Orozco found work as a political cartoonist for the revolutionary newspaper *La Vanguardia* (The Vanguard). His first series of paintings, *House of Tears* (1917), portrayed human degradation and poverty. The works outraged the authorities and Orozco was forced to leave the country in 1917. Seeking refuge in the United States, he remained there until 1920.

When Mexico's political scene stabilized during the administration of President Álvaro Obregón (1880–1928; in power 1920–1928), Orozco returned home. Painting nationalistic subjects, he completed his first murals, *Cortés, Malinche,* and *The Trench* (1923–1927), at the Escuela Nacional Preparatoria (National Preparatory School). The works stirred a controversy, as would many of Orozco's paintings, and were among those that were destroyed or altered in response to public outcry. In 1927, the artist was again exiled from his homeland.

Fleeing to the United States, the muralist received important commissions at Pomona College (Claremont, California), where he completed the mural *Prometheus* (1930) and Dartmouth College (Hanover, New Hampshire), where he painted *The Epic of American Civilization: Modern Migration of the Spirit* (1932–1934). His American works won the artist international acclaim. In 1934, with a new political regime installed in Mexico, Orozco was free to return home. He painted murals on public buildings in Guadalajara (in his native state of Jalisco) and Mexico City, the site of his famous *National Allegory* (1947–1948). After his death, Orozco's Guadalajara studio was made into a museum. —BARBARA M. MACADAM

(*See also* LATIN AMERICAN ART.)

OUTSIDER ART

The French painter Jean DUBUFFET was the first to discover the aesthetic value in works of art made by children, the inmates of insane asylums, and other self-taught painters and sculptors who worked outside the mainstream art world of galleries and museums. When he first discovered such works, he saw them as a critique of the emptiness and snobbery of "official" postwar French art. Calling them *Art Brut* (French for "raw art"), Dubuffet eventually assembled a private collection numbering in the thousands.

By the late twentieth century in the United States, the term *Outsider art* was used to describe a broad range of works—from children's drawings to traditional FOLK ART, from prisoners' paintings to the obsessive records that isolated loners kept of their private worlds. Outsider art became big business for dealers, without the benefit of a substantial body of critical appraisal or historical study. An annual Outsider Art Fair is held at New York City's Museum of American Folk Art; the event attracts thousands of collectors, dealers, and curious visitors.

In the early years of the twenty-first century, no Outsider artist had yet attained the fame of, for example, Jasper JOHNS or Frank STELLA. But a handful were becoming steadily better known. One of the earliest masters in the Art Brut category was Adolf Wölfli (1864–1930), who produced thousands of works from a small cell in a Swiss asylum. His mosaic-like drawings are a dizzying mix of landscape and personal symbols, recalling the imagery of Hiberno-Saxon manuscripts made one thousand years earlier. Henry Darger (1892–1972), a Chicago recluse who saw himself as an ardent protector of children, left a sizeable trove of paintings and drawings, which, after he died, were discovered by his landlord. Completely untutored, he produced several hundred works in collage* and watercolor that showed "The Story of the Vivian Girls," seven little heroines who battled all manner of monstrous evils. Aside from their highly imaginative content, the works are remarkable for a sumptuous feeling for color and landscape.

A former slave who turned to art late in life, Bill Traylor (1856–1947) began drawing at the age of eighty-three, working on the streets of Montgomery, Alabama. His subjects were mainly animals and African Americans, and although crudely depicted, his compositions show a sure balance of shapes and busy patterns. The best-known architect/sculptor among Outsider artists was Simon

*collage a method of picture making in which pieces of photographs, torn paper, news clippings, and other objects are assembled on a flat surface

Henry Darger. Untitled (Blengin-Child-Headed Whiplash-tail Blengins). *Mixed media and watercolor on paper. Collection of the American Folk Art Museum, New York* PROMISED GIFT OF SAM AND BETSEY FARBER. PHOTOGRAPH BY KIYOKO LERNER

Rodia (1879–1965), who built a complex of towers over one thousand feet in height in an abandoned lot in downtown Los Angeles. Constructed between 1921 and 1955, the Watts Tower is composed of structural steel rods and circular hoops connected by spokes. Rodia affixed bits of found materials—seashells, glass, and pottery—so that the fantastic spires appear to glitter in the sunlight.

Although its various categories later became blurred, Dubuffet maintained that true Outsider art could be distinguished from naive art* or many kinds of folk art because it was produced solely as a private compulsion, never intended for public display or appreciation.

(*See also* HIBERNO-SAXON ART.)

*naive art fresh, childlike painting characteristically employing bright colors and strong, rhythmic designs; usually the work of untrained artists

PALEOLITHIC ART

See PREHISTORIC ART.

PALLADIO, ANDREA

Italian, 1508–1580

Born Andrea di Pietro della Gondola in Padua, Andrea Palladio began as a humble stonemason and emerged as the most important and influential architect in Italy. His fame is based not only on his distinctive structures but also on his books about architecture, notably, *I quattro libri dell' architettura* (The Four Books of Architecture) [1570], which are devoted to the theory and practice of his own work. Palladio's buildings, remarkable for their symmetry, simplicity, elegance, and airiness, are based on Greek and Roman styles with touches of MANNERISM and even Byzantine architecture.

Under the guidance of the scholar and poet Gian Giorgio Trissino (1478–1550), Palladio took up the study of archaeology, Latin, and mathematics, traveling to Rome in 1545 to study ancient ruins. He then went to Vicenza, Italy, where he won an award for his remodeling of the Palazzo della Ragione, a formal Early Renaissance building, which he surrounded with a two-story screen of arches.

Well versed in Roman architecture, with its emphasis on symmetry and harmonic proportions, Palladio went on to build mostly secular buildings. He made his mark in designing palazzi (town houses) and villas (country houses) rather than churches. The Villa Rotonda (begun 1550) in Vicenza is considered his finest villa. However, Palladio did design some famous churches, mostly in Venice, including the Church of San Giorgio Maggiore (designed 1565) and Il Redentore (begun 1576), both in the Mannerist style.

In his designs, Palladio often used the pillars and columns conventionally found in courtyards and moved them to the exterior of his structures, lending a buoyancy to the often stolid facade*. Palladio's villas, which were often farm

***facade** the exterior face of a building, usually the front

***portico** a roofed porch supported by columns

***colonnade** a series of columns set at regular intervals

***relief** sculptural figures or decorations that project from a flat background

buildings, followed a general plan: a symmetrical structure with a portico* and wings. He built the villas to blend in with the surrounding landscape.

Around 1550, Palladio designed the famous Palazzo Chiericati in Vicenza in northeastern Italy, which was uncompleted at his death but finished in the late seventeenth century. Built in a large square, the palazzo featured one of his two-story colonnades* to support the base of the building's roof, which was unprecedented at that time. He also began the never-completed Palazzo Thiene, noted for its rectangular rooms and octagons.

The Loggia del Capitanio (1571), a roofed open gallery in Vicenza, became Palladio's most distinctive and elaborate creation; it is filled with relief* sculptures. "Palladio is never dry or demonstratively scholarly," the architecture historian Nikolaus Pevsner wrote. "He combines the gravity of Rome with the sunny breadth of Northern Italy and an entirely personal ease not achieved by any of his contemporaries."

Palladio left his mark through the centuries, but most notably in English country houses and in the buildings of the U.S. president and architect Thomas Jefferson (1743–1826; president 1801–1809), who studied Palladio's *Four Books of Architecture.* Jefferson's regal yet intimate home, Monticello, in Charlottesville, Virginia, with its porticos and octagonal pavilions, is an eloquent homage to Palladio. —BARBARA M. MACADAM

(*See also* NEOCLASSICAL ART; RENAISSANCE ART.)

PARMIGIANINO

Italian, 1503–1540

From the beginning of his career, the Italian Mannerist painter Girolamo Francesco Maria Mazzola, known as Parmigianino for his birthplace of Parma, Italy, showed unusual talent and sophistication. At age twenty-one, he painted his *Self-Portrait in a Convex Mirror* (1524), hoping to impress Pope Clement VII (1478–1534; pope 1523–1534) with his skill. The sixteenth-century biographer Giorgio VASARI claimed that Parmigianino was inspired by seeing his own reflection in a barbershop mirror and commented that he seemed to have "the face of an angel rather than a man."

The artist used a specially prepared convex panel for the self-portrait. Although his face and shoulders are recorded in normal proportions, his left hand is distorted, as are the window and the ceiling behind him. Parmigianino's reason for portraying himself that way is unknown and has perplexed art historians for centuries. Some have suggested that the enlarged hand represents a barrier between himself and the outside world or that it is a symbol of the importance an artist attaches to his hand in making pictures. According to the historian Arnold Hauser, the hands in portraits by Italian Mannerist painters such as BRONZINO and Parmigianino "are part of the 'armour' behind which all feeling, directness, and intimacy are shut off." The convex mirror may be an important symbol as well. Such mirrors were valued during the Renaissance because people believed they could reveal hidden aspects of the past and the future.

In 1524, Parmigianino moved to Rome. He was influenced by the Italian masters CORREGGIO, RAPHAEL, and MICHELANGELO, and his paintings became more grand and graceful. Vasari claimed his audience and numerous patrons were so impressed that they believed "the spirit of Raphael had passed into him." After the looting of Rome in 1527 by Holy Roman Emperor Charles V (1500–1558; ruled 1519–1556), Parmigianino moved to Bologna, where he painted a portrait of Charles. During this period, he also painted the *Madonna of the Rose* (c. 1530), which shows the young painter's talent for giving religious subjects a sensuous, almost erotic charge.

By 1531, Parmigianino was back home, and almost immediately he was in trouble with the law. On failing to complete an important commission, he was jailed for breach of contract. Vasari claimed he had become obsessed with alchemy, the "science" of converting base metal into gold, and that he "wasted his days in manipulating coal, wood, furnaces and other things . . . and neglected himself and grew melancholy and eccentric."

Nonetheless, Parmigianino's later paintings show no decline in quality. His most famous work, *Madonna with the Long Neck* (c. 1535), dates from the last five years of his life. The work, which is more than seven feet tall, shows the odd distortions and strange spaces that were typical of many Mannerist paintings. The painting is puzzling in many ways. It is impossible to tell whether the Madonna is sitting or standing. The child on her lap appears to be sliding from her grasp. The other figures in the painting have never been accurately identified: the group to the left may be angels; the tiny man on the right, a prophet. It is not clear whether the scene is taking place inside or outdoors. Parmigianino seems to be deliberately baffling the viewer, while at the same time presenting an image of cold and elegant beauty.

The artist's strange personality was no more evident than in this painting and in the request he made on his deathbed. According to Vasari, at his request Parmigianino was buried "naked with a cypress cross standing on his breast."

(*See also* MANNERISM; RENAISSANCE ART.)

PEALE, CHARLES WILLSON

American, 1741–1827

Known in his time as America's "homegrown Leonardo" (referring to the great Italian artist and scientist LEONARDO DA VINCI), Charles Willson Peale was a man of many talents. He was a scientist, silversmith, soldier, and inventor, as well as an artist. He founded the first art gallery, the first museum, and the first art school in the American colonies. He also became the nation's most fashionable portraitist. His other firsts include the invention of porcelain false teeth, a new type of spectacles, and a steam bath.

Early Studies

Peale's father was a thief who escaped the gallows in London and was sent to Maryland, where he found work as a schoolmaster. He died when Peale was eight, and the boy went to work learning different trades, including watch

repair and metalwork. He briefly served as an assistant in the studio of the famous American portraitist John Singleton COPLEY in Boston. In 1766, Peale sailed to London. Over the next two years, he studied with the American expatriate artist Benjamin WEST.

Peale's main effort during his stay in London was a full-length portrait (1768) of William Pitt, earl of Chatham (1708–1778). The painting was commissioned by a group of Virginia planters in honor of Pitt's helping to repeal the Stamp Act, which had taxed printed papers and hampered American business. Peale borrowed from the Neoclassical style of the day and showed the English statesman dressed in a Roman toga and gesturing.

The American Revolution

After returning to Maryland to paint for a few years, Peale eventually settled in Philadelphia, then the largest and richest city in the thirteen colonies. He quickly became popular as a portraitist, but the American Revolution (1775–1783) interrupted his career. He served at Valley Forge, Pennsylvania, General George Washington's winter headquarters in 1777–1778, achieving the rank of colonel.

Peale continued to paint while serving his country. He once used a spare bedsheet as a canvas on which to paint a likeness of George Washington (1732–1799; president 1789–1797), commander of the Continental armies. Unlike Copley, who fled the colonies at the first signs of rebellion, Peale was an ardent patriot. He also became one of the nation's first artists to do history painting*, completing a canvas showing Washington and French Major General Marie-Joseph Lafayette (1757–1834) and their troops after the Battle of Yorktown (1781). For Princeton College, in New Jersey, Peale painted a full-length portrait of Washington, showing the portly general holding a drawn sword.

Turns to Natural Science

Peale usually worked in a solid, often formal style. One of his most celebrated works, *The Staircase Group* (1795), however, is a witty piece of trompe l'oeil*. The work also served as an announcement that the fifty-four-year-old head of the family was turning over the family business to his sons so that he could devote more time to natural science.

The Staircase Group shows two of Peale's sons, Raphaelle (1774–1825) and Titian Ramsay (1799–1885), on the steps of a curving stairway. It is painted in the Superrealistic style that would become popular in the United States in the nineteenth century. To reinforce the illusion, Peale enclosed the canvas in a door frame and nailed on an extra, real step. Raphaelle holds a palette and a maulstick (a stick with a padded knob on one end, used by artists to steady their brush hand), emblems of his profession. Washington, then president of the United States, is said to have been so fooled by the painting that he tipped his hat to the two boys when he first saw it.

In 1782, Peale opened a gallery next to his studio, where he displayed his own portraits of the heroes from the American Revolution. The project expanded over time to become perhaps his most ambitious "invention," the first American museum. Peale's hope was to "bring into one view a world in miniature." To do so, he taught himself taxidermy and displayed animals in their

***history painting** a picture that depicts an important historical occasion

***trompe l'oeil** (French for "fool the eye") a style of painting in which an object is rendered so realistically that the viewer will mistake it for the real thing

Charles Willson Peale. *The Staircase Group.* 1795. *Oil on canvas. Philadelphia Museum of Art, Pennsylvania* FRANCIS G. MAYER/CORBIS

"natural" habitats, such as snakes entwined around tree branches and gophers poking up from the ground.

His most spectacular exhibit was the skeleton of a giant mastodon unearthed near Newburgh, New York. Peale, at age sixty, oversaw the excavation of the giant skeleton, bone by bone. He recorded the dig in a painting, *Disinterment of the Mastodon* (1808), showing the workers digging in the watery pit while Peale and his children hold a drawing of the animal's leg. After the mastodon skeleton was assembled inside the museum, Peale's son Rembrandt (1778–1860) gave a dinner party under the massive rib cage.

A Family of Artists

Peale was the head of the first American artistic dynasty. Eight of his ten children, named after famous European painters, became artists. Raphaelle became one of the most distinguished American still-life painters and was capable of his own brand of visual wit. His *Venus Rising from the Sea—A Deception (After the Bath)* (c. 1822) shows only the hands and feet of the goddess, hidden behind a realistic "towel." The towel is actually a handkerchief pinned to a ribbon hiding a *picture* of Venus. The younger Peale thus makes fun of the puritanical nature of American painting. Images of nude women, although common in European painting since the Renaissance, were rare in the young nation and were usually discouraged. Two other of Peale's sons also earned a small place in art history: Rembrandt as a portraitist and Titian Ramsay as an artist and a naturalist, like his father.

(**See also** NEOCLASSICAL ART; RENAISSANCE ART.)

PERFORMANCE ART

Performance art covers a broad spectrum of activities, often incorporating mediums from the visual arts as well as music, theater, and dance. Its origins lie in the early twentieth century, when DADA and Futurist groups staged noisy and provocative performances to draw attention to their art. In the 1960s, the antic Happenings of American Pop artists (*see* sidebar, POP ART) were an adjunct to the playful nature of their paintings and sculptures. In Europe, French artist Yves Klein (1928–1962) hoped to break down barriers between art and life by smearing nude models with paint and directing them to roll around on canvases.

Performance Art Comes of Age

The Performance artists who came of age in the 1970s, however, often had a more serious goal in mind. Dismayed by a gallery system that viewed art largely as a commodity, they wanted to make direct contact with their audiences—without the intervention of dealers or curators. As art historian H. H. Arnason said, "Performance appeared to offer the maximum possibility for converting art from an object of consumption to a vehicle for ideas and action, a new form of communication."

In Europe, German artist Joseph BEUYS was among the first to explore the boundaries of Performance art. He hoped to show how the concept of art making could be "extended to the invisible materials used by everyone." He was a

*avant-garde literally, the "advanced guard"; a term describing innovators or innovation in a particular field

member of an international group of avant-garde* artists known as Fluxus, which flourished until the early 1970s. Recalling the spirit of Dada, the Fluxus artists hoped to "purge the world of bourgeois sickness . . . of dead art . . . to promote a revolutionary flood and tide in art, to promote living art, anti-art."

Fluxus Happenings (called *Aktions* in Germany) took place in major cities around the world. Among the better known artists associated with the group were the Korean Nam June Paik (born 1932), the father of VIDEO ART, and Yoko Ono (born 1933). Ono's work revolved around experimental films and the spare use of words to create an image in the viewer's imagination. One of her most famous performances was the *Bed-in for peace,* which she staged with rock musician John Lennon (1940–1980) on their honeymoon in 1969.

Joseph Beuys. *How to Explain Pictures to a Dead Hare.* 1965. *Performed at the Schmela Gallery, Düsseldorf, Germany* PHOTOGRAPH BY WALTER VOGEL

In England, a pair who called themselves Gilbert (born 1943) and George (born 1942) became the best-known British Performance artists. In the late 1960s, they transformed themselves into self-styled "living sculptures." In their most famous performance, *Underneath the Arches* (1969), Gilbert and George dressed in neat suits, painted their hands and faces gold, and imitated old-fashioned English music hall performers. Their later works, often homoerotic in content, consisted of photographs documenting their performances, their bodies, and images of street life in London's East End.

One of the most famous American Performance artists was Laurie Anderson (born 1947), a poet and musician who used inventive audio and visual effects. She brought a sense of humor and great craftsmanship to her art, winning a devoted international following for her "talking songs." After 1974, she even made her own instruments. Her best-known performance was *United States,* described as "an eight-hour opus of song, narrative and sleights of hand." This epic, divided into four parts, drew on Anderson's many accomplishments—including drawing and sculpture—to present half-hour segments dealing with such themes as politics and psychology.

Body Art

Most Performance art in the United States took the form of what critics called Body art. One practitioner was Vito Acconci (born 1940), whose best-known performance was *Seedbed* (1972). In this "piece," the artist, who was concealed beneath a ramp inside a gallery, spent hours each day engaged in autoerotic activity, while loudspeakers broadcast his sounds to visitors.

The most extreme Body artist was Chris Burden (born 1946), who attracted worldwide attention in 1971 when he had a friend shoot him in the arm during a Los Angeles performance. He also invited spectators to push pins into his body and had himself crucified on the roof of a Volkswagen. In Burden's later works, however, the artist distanced himself from physical violence, preferring instead to make works that demonstrated the threat of nuclear war.

Another artist who pushed the body to extremes in the name of art was a Frenchwoman who called herself Orlan (born 1947). Beginning in the early 1990s, she had parts of her body surgically altered to conform to the ideals of beauty represented in certain "Old Master" paintings. For example, she had her forehead reshaped to resemble that of LEONARDO DA VINCI's *Mona Lisa* (c. 1503–1505) and her chin "sculpted" after Sandro BOTTICELLI's *Birth of Venus* (c. 1482). Orlan explained her so called "theater of the self," saying, "My work is not against cosmetic surgery, but against the dictates of beauty standards which are imposed more and more on feminine flesh."

(*See also* FUTURISM; POP ART.)

PERSIAN ART

The area that is now modern-day Iran was once known as Persia. It is situated atop a high plateau rimmed by mountains. To the west is the ancient Mesopotamian region that the Sumerians called home. For nearly five thousand years before the birth of Christ, the region served as a gateway for nomadic tribes who entered the ancient Near East (present-day Egypt, Israel, Syria,

Iraq, Iran, and Turkey) from the Russian steppes to the north as well as from India to the east. Each new wave of people would settle down for a time, either ruling or mixing with the local population. They were then forced to leave by the next wave of migrants.

The Animal Style

There is little knowledge about these early nomadic tribes. They left no written records and no permanent monuments. Historians and archaeologists trace their movements through the objects they buried with their dead. Known as "nomad's gear," these are generally portable and practical items—weapons, buckles, bridles for horses, and pots and bowls—and are made from whatever materials were available, usually bone, wood, or metal. These items have been found over a vast area. They are well designed, and generally incorporate animal subjects in their decoration or form. Therefore, art historians have grouped this nomadic art under a category known as the "animal style."

As early as 5000 B.C., the animal style made its appearance on a distinctive group of pottery from Susa in ancient Iran. One beaker shows an abstract image of an ibex, a kind of wild mountain goat. The body is made up of two triangles, representing the animal's forelegs and hindquarters. Its horns are formed by a great sweeping circle. In the band above the ibex is a series of racing hounds, shown as little more than horizontal streaks for legs. The band above that, which looks like a group of vertical stripes, actually depicts a row of long-necked birds. Thousands of years later, modern artists like the Spanish sculptor and painter Pablo PICASSO, the Swiss-born German painter Paul KLEE, and the Romanian sculptor Constantin BRANCUSI admired this highly abstract way of drawing natural subjects, incorporating similar techniques into their own art.

The influence of the animal style of ancient Iran can be seen in the art of the Luristan region in western Persia, and in objects made by the Scythians, a nomadic people from southern Russia. An ornament made of bronze, designed to fit on the top of a pole, again shows two ibexes with long necks and curving horns; below them, a pair of lion heads with gaping jaws are depicted. From about the same period comes a chased* gold stag. Its body is rendered in more realistic fashion, except for the folded legs—which are really long-billed birds—and the antlers, which are stretched out in repeating curves. The fanciful distortions that are typical of the animal style crop up again and again in the history of art, most notably in EARLY CHRISTIAN, ROMANESQUE, and HIBERNO-SAXON ART.

The Persian Empire

Around 1000 B.C., a group of nomadic tribes, including the Medes and the Persians, began to drift into the areas that are now Iran and Iraq. By the sixth century B.C., the Medes had united with the Babylonians to crush the Assyrian Empire. At the time, the Persians were vassals of the Medes. However, with the rise of a leader known as Cyrus the Great (c. 585–c. 529 B.C.), the Persians became the greatest power in the Near East, creating an empire even larger than that of the Assyrians. Cyrus became king of Babylon, and the dynasty he founded endured for more than two centuries.

Within a single generation, this obscure tribe of Persian nomads developed a sophisticated government and a grand, monumental artistic style. Although

*chased ornamented by making grooves and indentations

Bull capital. *c. 500 B.C. Marble. Persepolis, Iran* CHARLES HEMPHILL/PHOTOVAULT.COM

they borrowed much from the Assyrians who had ruled previously, the religious beliefs of the Persians and their generally humane government were entirely different. The Persians believed in the teachings of a prophet called Zoroaster, and their faith was based on the clash between two central forces of good and evil, embodied in light and darkness. Religious rituals were held outdoors, where fires were built on open altars. For this reason, the Persians left no religious architecture.

The most elaborate structures built by the Persians were their palaces, especially the one begun by Darius I (550–486 B.C.; ruled 522–486 B.C.) at Persepolis c. 521 B.C. and continued over many years by his successors. Built on a raised stone platform, the palace at Persepolis contained a huge number of rooms, hallways, and courtyards. The most impressive structure was the audience hall, a room where the king received foreign emissaries. The 250-square-foot chamber had a wooden ceiling supported by columns forty feet tall. At the top of the columns were capitals* in the shape of double bulls, sharing one body but with two heads. The animals themselves recall the massive guardian figures from ASSYRIAN ART, but the way they are positioned also recalls the double bronze figures from Luristan in western Iran. The choice of a bull, a symbol of fertility and power, is another example of the important role this animal played in the art of other cultures, most notably the Sumerians and the peoples of the Aegean (the arm of the Mediterranean Sea between Greece and Turkey).

*capital in architecture, the top part of a column

Inside the palace were relief* sculptures revealing Assyrian influence. These were generally stiff and ceremonial in nature, emphasizing the importance and grandeur of the king. A scene from the stairway to the audience hall at Persepolis shows rows of subjects bringing gifts to the king. In contrast to the violent nature of so many Assyrian reliefs, the Persians preferred more peaceful themes. The passionate energy seen in Assyrian works has been replaced by a stately but rather monotonous emphasis on order and dignity. What is new in the Persepolis sculptures, however, is the depiction of overlapping layers of garments; no earlier Near Eastern art showed folds of fabric that seem to lie on top of each other. This innovation indicates that Persian artists were probably aware of the revolutionary changes taking place in GREEK ART around the same time.

*relief a sculpture that projects from a background surface instead of standing freely

Nearly two hundred years after Darius began building Persepolis, Persian rule of the Near East came to an end. In 331 B.C., Alexander the Great (356–323 B.C.; ruled 336–323 B.C.) added Persia to his many conquests, destroyed the palace at Persepolis, and forever changed the course of both art and history.

(*See also* AEGEAN ART; BABYLONIAN ART; ISLAMIC ART; SUMERIAN ART.)

PERUGINO

Italian, c. 1450–1523

As the teacher of the great Italian master RAPHAEL, Perugino can be said to have had a hand in shaping the art of the High Renaissance. He was born Pietro di Cristoforo Vannucci in Perugia, in the central Italian region of Umbria. He took his name, Perugino ("the Perugian"), from that city. Almost

nothing is known of his early life and training, but he is thought to have formed his style in Florence.

According to the Italian painter and art historian Giorgio VASARI, Perugino studied with the sculptor and painter Andrea del VERROCCHIO. In 1472, Perugino was a member of Florence's fraternity of St. Luke, the patron saint of painters. Three years later, he returned to Perugia. Having absorbed some of the great advances of the day—he mastered the new concept of perspective* (*see also* sidebar, BRUNELLESCHI) and developed a figurative style influenced by Verrocchio's sculpture—Perugino helped make his hometown an important artistic center.

Summoned to Rome

Along with several of the leading Florentine painters, including Sandro BOTTICELLI and Domenico GHIRLANDAIO, Perugino was summoned to Rome in 1481 to paint frescoes* (*see also* sidebar, GIOTTO) for the newly built Sistine Chapel at the Vatican. His best-known painting there, *The Delivery of the Keys* (1482), shows Christ handing over the keys to the kingdom of heaven to Saint Peter, who became the leader of the Christian community after the Crucifixion. Perugino set the scene in a vast plaza, with a church in the background. The open structures to either side are modeled on late Roman triumphal arches and are typical of the classical* structures often found in paintings of the Early and High Renaissance. The figures lined up in the foreground are portraits of contemporary Florentines; they witness the scene with great seriousness and solemnity. The draperies and sculptural solidity of the figures recall earlier Florentine masters, from MASACCIO to Verrocchio. Perugino brings to the drama an open and airy feel, however, allowing the eye to wander freely among buildings and people in a way that is very unlike the Florentine masters. One art historian has suggested that he might have been influenced by the perspective drawing made by the Italian master LEONARDO DA VINCI for *The Adoration of the Magi,* which was made in 1481, only a year earlier.

An Artist in Demand

Perugino traveled throughout central Italy in the 1480s, and by the 1490s he had established workshops in both Florence and Perugia. He was much in demand for his altarpieces, which tended to be sweet and rather sentimental, but he was also an excellent portraitist. Some scholars have suggested that he was influenced by the highly finished, cool style of the Flemish painters, such as Jan van EYCK.

Indeed, Perugino's portrait of Francesco delle Opere, from 1494, uses a device favored by fifteenth-century painters in northern Europe: the subject is shown with hands resting on a ledge. This convention became increasingly popular in Italy and can be seen many times in portraits by Leonardo da Vinci, TITIAN, and Raphael. Like van Eyck and other Late Gothic painters, Perugino pays meticulous attention to the details of the sitter's face and clothing. This is especially apparent in the carefully painted frizz of hair that escapes from under Francesco's close-fitting cap. The many different textures of cloth, skin, and hair are all rendered in a lifelike way, giving the portrait great richness. A little painted scroll in Francesco's hand says *Timete Deum* (Fear God), a sign to the viewer that the sitter wants to be seen as a deeply religious man.

perspective a painting technique in which three-dimensional objects and figures depicted on a flat surface appear in correct proportion and relation

fresco (Italian for "fresh") a method of painting in which powdered pigments mixed with water are applied directly to wet plaster

classical pertaining to Greek or Roman culture

The Sistine Chapel

In 1481, long before MICHELANGELO painted his astonishing frescoes for the ceiling of the Sistine Chapel, a remarkable group of painters was summoned to Rome to decorate other parts of the chapel. The building had been commissioned by Pope Sixtus IV (1414–1484; pope 1471–1484), whose nephew, Julius II (1443–1513; pope 1503–1513), later became Michelangelo's patron. The chapel looks more like a long hall than a church, and it was intended both for the pope's private worship and for gatherings of cardinals.

The art historian Giorgio VASARI believed that Sandro BOTTICELLI was in charge of the paintings for the walls below the windows. Later scholars, however, have argued that Perugino, who painted the altarpiece and the important fresco *The Delivery of the Keys* (1482), was more likely responsible for the overall scheme. Still others believe the pope played an important part in deciding the subjects and giving out general guidelines.

The artists who participated, besides Perugino and Botticelli, included Domenico GHIRLANDAIO and Cosimo Rosselli (1439–1507). The left wall contained scenes from the life of Moses, the biblical Old Testament prophet; on the right were scenes from the life of Christ as recorded in the New Testament. For reasons that have never been discovered, the original group of painters abruptly quit around 1483 (it has been suggested that they laid down their brushes because of slow payment), and new artists were brought in to complete the project. Among these was Luca SIGNORELLI, whose paintings for the San Brizio Chapel of the Orvieto Cathedral in central Italy made a deep impression on Michelangelo.

Falls Out of Favor

By 1505, Perugino's work had come to be regarded as old-fashioned. He left the competitive climate of Florence and retreated to Perugia for the rest of his life. As the art historian Frederick Hartt noted, "Like all Central Italian painters who made their reputations in the 1470s, save only Leonardo da Vinci, Perugino arrived at the threshold of the High Renaissance and was temperamentally unable to cross it." The idealized physical types in Perugino's frescoes and altarpieces and his carefully observed portraits were to have a profound influence on his student Raphael, however, whom the older painter outlived by three years.

(*See also* CHRISTIAN ICONOGRAPHY; NORTHERN RENAISSANCE ART; RENAISSANCE ART; ROMAN ART.)

PEVSNER, ANTOINE

Russian-born French, 1886–1962

Together with his brother, the sculptor Naum GABO, Antoine Pevsner was one of the leading Russian figures in the spread of CONSTRUCTIVISM in the early 1920s. He was born in Orël, Russia, and by age fifteen had decided to become an artist. Between 1902 and 1909, Pevsner studied at the School of Fine Arts in Kiev and then for a short time at the Academy in St. Petersburg, Russia.

Like many adventurous artists of his day, Pevsner was drawn to Paris. He arrived there in 1911, in time to see the first major exhibition of Cubist artists. He made lengthy visits over the next three years, becoming friends with the Russian-born sculptor Aleksandr ARCHIPENKO and the Italian painter and sculptor Amedeo MODIGLIANI.

During World War I (1914–1918), Pevsner took refuge in Denmark and then made his way to Oslo, Norway, where he was joined by his brother. When they returned to Russia in 1917, Pevsner and Gabo came into contact with the painter Kazimir MALEVICH and his ideas about Suprematism, as well as with the Constructivist theories of the painter and sculptor Vladimir TATLIN. Suprematism called for an art stripped of all references to nature; Tatlin proclaimed that art should be useful.

As Gabo later said, "Tatlin's group called . . . on those artists who were doing constructions in space to drop this 'occupation' and start doing things useful to the human being in his material surroundings—to make chairs and tables, to build ovens, houses, etc. We were opposed to those materialistic and political ideas on art. . . . "

In 1920, Gabo and Pevsner issued their *Realistic Manifesto,* a document containing ideas and statements about the creation of a new reality in art that did not imitate nature and did not serve as utilitarian art. In it, they declared that art had an independent value and a function to perform in society, no

**Antoine Pevsner. *Le Monde (The World). Musée d'art Moderne, Paris* THE ART ARCHIVE/DAGLI ORTI

matter what the society's form of government. "Art will always be alive as one of the indispensable expressions of human experience," they wrote.

By 1922, the differences between the Suprematists and the Constructivists had become decisive, but neither camp would over time be tolerated by the Russian state, which soon decreed that Socialist Realism (*see* sidebar, MALE-VICH) was the only acceptable style for artists. Gabo moved to Berlin, and Pevsner returned to Paris in 1923. He was to live there for the rest of his life.

Up to this time, Pevsner had worked mainly as a painter, but after settling in Paris he turned to sculpture, using both plastic and metal in new and ingenious ways. His early sculptures still contained traces of representation, as in his witty *Portrait of Marcel Duchamp* (1926). Soon, however, he turned to total abstraction, forging a technique that gives an illusion of movement even though the design is essentially static. His *Developable Column* (1942), constructed to appear almost like an hourglass, seems to be composed of tightly wedged slender reeds spinning in space.

In the 1950s, Pevsner received several commissions to carry out his ideas in monumental sculptures, and he remained until his death one of the most important voices in abstract sculpture. By the end of his career, he was honored with major retrospective exhibitions, and in 1961 he was awarded one of France's highest honors, the Legion of Honor.

(*See also* ABSTRACT ART; CUBISM.)

PHOTOGRAPHY

Photographs are so commonplace today that it is hard to imagine how miraculous they seemed not too long ago. The first official photographic technique, the daguerreotype*, named after Louis J. M. DAGUERRE, was announced to the world by the French government in 1839. Yet, there is no one inventor of photography. Many others had been experimenting for years, to varying success, with the whimsical idea of capturing and recording an image.

The First Cameras

As early as the fifth century B.C., a phenomenon of light was recognized. If light passes through a hole the size of a pin into a dark room, the outside scene will be reflected upside down on the back wall of the room. In the seventeenth century, portable tents and boxes called *camera obscura* were constructed to produce this effect. By the eighteenth century, these devices were commonly used by artists to help them draw nature with correct perspective* (*see also* sidebar, BRUNELLESCI).

The Englishman Thomas Wedgwood (1771–1805) was the first person who tried to link the camera obscura with chemistry to make a lasting picture. Around 1800, he made prints of leaves and insects by letting sunlight pass through them onto paper brushed with silver salts, which were known to darken when exposed to light. He created ghostly impressions, but Wedgwood did not know how to stop the chemical reaction, and eventually the whole paper turned black. He failed completely when he tried putting treated paper inside the camera obscura, because both the reflected image and the chemicals were too weak.

***daguerreotype** an early photographic process, invented by Louis Daguerre in 1838, in which the photograph was produced on a silver or silver-covered copper plate

***perspective** a painting technique in which three-dimensional objects and figures depicted on a flat surface appear in correct proportion and relation

Julia Margaret Cameron. *Alfred Lord Tennyson.* *1865. Albumen print.*

Far more successful was the French physicist Joseph-Nicéphore Niepce (1765–1833). In the 1820s, he experimented with putting inside his camera obscura metal plates that were coated with chemicals. When exposed to light, the plates were bleached instead of darkened, thereby creating positive images rather than ones in reverse. Although successful, his process was time-consuming; the exposures took an entire day to develop. In 1829, he teamed up with Daguerre, who had done similar research, and together they tried to find faster-working chemicals to make picture-taking more practical. Niepce died in 1833, but Daguerre carried on their work. He eventually found that silver iodide in combination with mercury vapor was extremely sensitive and produced delicate white images on his shiny copper plates. Daguerre sold the process to the French government, which released it publicly in 1839.

This vexed the English physicist William Henry Fox Talbot (1800–1877), who had been inventing a form of photography at the same time. Talbot moved quickly to publish and patent his research. In his process, called the *calotype,* chemically treated paper was put in a camera that produced an inverted image. From that paper negative, an unlimited number of positive prints could be made, which is still the basic premise of photography today. Initially, the pub-

lic viewed this two-step process as cumbersome and was more charmed with the precious one-of-a-kind daguerreotypes. By the 1850s, however, daguerreotypes were outdated. Calotypes were simply more portable—paper could be stored indefinitely inside the camera—and could be reproduced in books or sold as loose prints.

The calotype process flowered in England starting in the late 1840s. Photographers like Roger Fenton (1816–1869) took off with their cameras in search of picturesque scenes and exciting drama. Fenton's pictures of the Crimean War (1853–1856) offered the first extensive photographic coverage of a war. In France, the government employed Edouard-Denis Baldus (1813–1889) and Gustave Le Gray (1820–1882), among others, to photograph works of architecture in need of restoration—beginning the documentary history of photography.

The Business of Photography

The new technology of photography attracted entrepreneurs, including Mathew Brady (c. 1823–1896) in New York, who were quick to set up portrait studios. Whereas painted portraits had been accessible only to the wealthy, photographic portraits were far more affordable and attractive to the middle class. Brady, whose famous 1860 portrait of Abraham Lincoln (1809–1865; president 1861–1865) is said to have helped Lincoln win the presidency, worked first with daguerreotypes, and then the *wet collodion* process after its invention in 1851. This technique involved applying wet chemicals to a large glass negative and yielded far greater detail than either the daguerreotype or the calotype.

The big drawback of the collodion process was that it required a lot of messy darkroom manipulations on the spot. Wet plates had to be used within ten minutes of being prepared and then quickly developed after the exposure was taken. The Englishman Samuel Bourne (1834–1912), who made a fortune in the 1860s selling his breathtaking views of the Himalayas to a public that craved exotic pictures, used teams of up to fifty porters to drag his heavy equipment and chemicals through the mountains.

In the 1870s, great headway was made with preparing dry plates that would eliminate the need for instant developing. George Eastman (1854–1932), a brilliant businessman and technician, advanced this study of extremely sensitive dry silver-gelatin emulsions in the 1880s. He realized that if he could make picture-taking easier, then anyone could be a photographer.

Eastman got rid of both the tripod, which kept the camera stationary and the photographer grounded to one spot, and the individual plates, which had to be reloaded in the camera for each picture. Because of the constant reloading, a professional photographer made only about six exposures per day. In 1888, Eastman introduced a hand-held camera loaded with flexible rolling film for one hundred exposures that would then be returned to the factory for processing and reloading. He invented the name *Kodak* and marketed it with the slogan "You press the button; We do the rest." The modern age of snapshot photography had begun.

Photography as Art

The revolutionary impact of the new photographic technology cannot be underestimated. Suddenly, pictures were not so precious and deliberate.

Photographers were free to experiment and snap off shots from all different angles. The results were more casual and often surprising.

With the speed and sensitivity of the emulsions, movement could be captured in a new way, even before the hand-held camera was released. In the late 1870s and 1880s, Eadweard Muybridge (1830–1904) studied split-second motion in his consecutive pictures of horses running and men vaulting. These not only anticipated the idea of motion pictures invented a few decades later but also greatly influenced modern painters of the day, such as Edgar DEGAS.

Early on, artists had embraced photography as a valuable tool for painting, eliminating the need for long sessions with models. And some photographers, such as Julia Margaret CAMERON, who made lush pictures of literary figures and themes in England in the 1860s, created photographs that were truly artistic. Yet, as the twentieth century approached, photography fought an uphill battle in being accepted as a valid art form comparable to painting or sculpture.

As long as photography was difficult technically, there was a built-in prestige for those who could master it. With the arrival of the point-and-shoot Kodak, which became a huge fad, especially in the United States, what was there to distinguish between a novice playing around with a camera and the dedicated photographer trying to make art? Out of this tension, photographic societies in places like Vienna, London, and Paris began springing up in the 1890s. They pursued *Pictorialist* photography—pictures that expressed beauty and emotion with no commercial or documentary function.

More than any other individual, Alfred STIEGLITZ advanced the cause of pure-art photography. In 1896, Stieglitz, who had exhibited his own photographs in Europe, helped set up the Camera Club of New York, which included leading Pictorialists such as Alvin Langdon Coburn (1882–1966) and Clarence White (1871–1925). In 1902, he split off to form his own, more daring group, called the Photo-Secession. Through his magazine *Camera Work* and the 291 Gallery, which he opened in 1905, he promoted the achievements of photographers like Edward STEICHEN and Gertrude Kasebier (1852–1934). They suppressed sharp details in favor of gauzy effects achieved by both smearing things on the lens and painting or wiping the negative during the printing process.

The Pictorialists were interested in photographs that resembled traditional paintings, and they kept their subjects largely confined to portraits, figure studies, and romantic landscapes. Yet, avant-garde* European painting, more concerned with the small, unheroic incidents of everyday life, was beginning to infiltrate New York. Stieglitz showed works by Pablo PICASSO and Henri MATISSE at his gallery alongside photography. In 1913, the Armory Show in New York exhibited the radically abstract paintings of artists like Marcel DUCHAMP and Wassily KANDINSKY, which had tremendous influence on the American art world.

Steichen was an early defector to a crisp, modern approach to photography. Even Stieglitz, the original champion of Pictorialism, guided his younger protégé Paul STRAND away from sentimental pictures toward "straight photography" and shut down his gallery and magazine in 1917 to pursue his own photography. Strand went on to be a leading Modernist photographer who explored the rhythms and patterns of urban life and the gritty realism of people on the street.

*avant-garde literally, the "advanced guard"; a term describing innovators or innovation in a particular field

Alfred Steiglitz. *The Steerage. 1907. Art Institute of Chicago, Illinois* THE STIEGLITZ COLLECTION, 1949. 847. COURTESY OF THE MUSEUM

In the 1920s and 1930s, Strand, as well as cutting-edge photographers like Edward WESTON in the United States, Manuel ALVAREZ BRAVO in Mexico, Man RAY in France, and László Moholy-Nagy (1895–1946) in Germany, experimented with making common objects, buildings, the human body, and industrial machinery look unfamiliar or abstract. They used various abilities of the camera, including extreme close-up, stark contrast between light and dark tones, and unusual cropping to make the viewer see the world in a different way.

Documentary Photography

At the same time that art photography was on the rise, technological advances in the publishing industry sparked documentary photography. From its invention, photography had been valued for its ability to record visual information. With the perfection of the halftone block in the 1880s—which could reproduce photographs using tiny pinpoints of ink—the same printing presses, ink, and paper could be used to print type and image. Books and magazines increasingly used photographs alongside text to help tell a story.

The news journalist Jacob Riis (1849–1914) took photographs of the miserable living conditions of immigrants in New York, published in his 1890

Walker Evans. *Signs and Billboards in Atlanta, Georgia.* 1936. *Metropolitan Museum of Art, New York City* CORBIS

book *How the Other Half Lives.* Lewis Hine (1874–1940), who called himself a "social photographer," concentrated on the plight of industrial workers in the United States early in the twentieth century. In France at the same time, Eugène ATGET was taking unembellished pictures of old buildings and streets in Paris, which he sold to artists as drawing aids. None of these photographers considered their factual pictures as art, even though these images were to become influential to future artists—such as Berenice Abbott (1898–1991) in the case of Atget—and later collected and exhibited by museums.

In the 1920s and 1930s, news photography flourished. Newspapers all used photographs now, and a new format of magazine called the picture weekly—narrated with sequences of photos accompanied by captions and text—was popular. Photojournalists, often employed by picture agencies that supplied images to these publications, were sent all over the world to cover breaking stories. One of the great news photographers in the 1930s was Arthur Fellig (1899–1968), known as "Weegee" (after the board game Ouija) for his skill at divining where crime would strike.

In the 1930s, during the Great Depression, a department of the U.S. government called the Farm Security Administration (FSA) hired photographers to document how poverty affected the nation's farmers. Operating much like the picture agencies, the FSA distributed stark, unadorned pictures by Walker EVANS and Dorothea Lange (1895–1965), among others, to newspapers with the idea that they could promote public understanding. The belief that photographs told the truth and could improve the world had never been stronger.

The glossy magazines were also huge employers of photographers in the second quarter of the twentieth century. Steichen was the reigning fashion and celebrity photographer in the 1920s and 1930s, followed in the 1940s by Irving Penn (born 1917), who said in 1950, "For the modern photographer the end product of his efforts is the printed page, not the photographic print." *Life* magazine, which was started in 1936 and soared in popularity over the next two decades, chronicled American life through the pictures of photographers like Alfred Eisenstadt (1898–1995) and Margaret Bourke-White (1906–1971). They produced some of their most important images during World War II (1939–1945), bringing the grim reality of the battlefield to American homes before the invention of television.

Postwar Photography

Although many photographers enjoyed the rewards of working in publishing—both financial benefits and the ability to reach a huge audience—not all were interested in bowing to the will of an editor or art director. Aaron Siskind (1903–1991) and Harry Callahan (1912–1999) were among those who worked independently in the 1950s. Their pictures were personal statements rather than politically or commercially motivated. They also helped introduce the study of photography to the academic curriculum in the United States.

Henri Cartier-Bresson (born 1908) in France was another who pursued photography for art's sake. His 1952 book *The Decisive Moment* illustrates his intuitive approach to composing beautiful pictures charged with psychological power. Robert Frank's (born 1924) book *The Americans* (1959) was equally influential but opposite in tone. Frank studied the American psyche through seemingly offhand photos he shot while driving across the country.

Strongly affected by the "artless" style of Walker Evans, Frank's work challenged what a picture should look like and in turn inspired younger photographers such as Garry Winogrand (1928–1984) and Diane ARBUS. In the 1960s and 1970s, Winogrand shot the humor and drama of street life in New York. Arbus sought out people with physical or mental deformities who were marginalized by society.

Increasingly, such "useless" pictures found an audience. First to collect and exhibit photography was the Museum of Modern Art in New York, which started its groundbreaking photography department in 1940. Between the 1950s and 1970s, more museums, galleries, and individuals became interested in pictures for their artistic and historic power. Photographs taken for documentary or utilitarian functions, such as Eugène Atget's, were reassessed for their aesthetic structure. As the popularity of television diminished the importance of the printed page, serious photographers turned more to the art world as the place to practice their craft.

Cindy Sherman. *Untitled, No. 96.* 1981.
*Color photograph. Saatchi Collection,
London, England* COURTESY OF THE ARTIST AND
METRO PICTURES

Contemporary Photography

One almost universal shift in the look of photographs over the last decades of the twentieth century was color. Used earlier in advertising and by snapshot photographers, color technology had evolved enough by the 1970s to start attracting artists. The younger ones, who had grown up with color movies, did not find it gaudy and were the quickest to accept it. Another change was the increased size of photographs. When photographs came to be distributed more through galleries than the magazine page, they tended to be readable on the wall from a distance.

A predominant theme in contemporary photography is the challenge to the presumption that photographs tell the truth. A photographer's decision about what to include in the frame and what to omit has always shaped the facts of the picture. Also, with advances in computer and digital technology, pictures can be manipulated without the viewer's knowledge.

Many artists working today have made fiction the subject of their work. Cindy SHERMAN, Yasumasa Morimura (born 1951), and the team of Gilbert and George (Gilbert Proesch, born 1943; George Passmore, born 1944) all dress themselves up to impersonate other types of people and question identity. William Wegman (born 1943) costumes his very cooperative dogs, rather than himself, for his humorous portraits. Jeff Wall (born 1946) constructs elaborate environments and uses live models to act out the drama in his wall-sized pictures. Others use dioramas or dolls to narrate the story.

The distinctions between different kinds of photography—art, documentary, commercial, amateur—no longer seem relevant. All are practiced and valued. Photographs that could not fetch ten dollars a print in the 1930s routinely

sell for hundreds of thousands of dollars today. The battle for acceptance that Alfred Stieglitz fought a century ago is over. Photography is now a universal means of communication and expression. —HILARIE M. SHEETS

PHOTOREALISM

Also called Superrealism or photographic REALISM, Photorealism emerged in the late 1960s, in part growing out of Pop artists' fascination with commonplace images and large scale. Painters working in the style often take visual information directly from photographs and transfer it to canvas, using color slide projections or grids. The result is a sharp-focus realism, faithfully recording details but on a greatly enlarged scale and with a cool detachment not found in earlier Realist art.

Audrey Flack (born 1931) is often credited with making the first Photorealist painting. Her earliest series of pictures in this vein are on the time-honored theme of worldly vanity. The canvases mix traditional reminders of time's passing—skulls, calendars, burning candles, and the like—with contemporary emblems of female vanity, such as lipsticks and other cosmetics. Richard Estes (born 1936) uses more than one photograph to compose hyper-real visions of the modern-day cityscape. His paintings typically incorporate multiple reflecting surfaces and a wealth of detail, so that the viewer is presented with objects up close as well as from a great distance.

Another aspect of the cityscape is captured in the paintings of Robert Cottingham (born 1935), who finds his subjects in advertising signs and movie marquees, especially those from the bygone eras of the 1920s and 1930s. In evoking the world of Edward HOPPER through a sharp-focus lens, Cottingham achieves a curious blend of nostalgia and hip aloofness.

Several painters and sculptors have used a Photorealist approach to make figurative works. Philip Pearlstein (born 1924) takes the nude as his subject, but he uses cropping, ungainly poses, and, often, claustrophobic spaces to give it, in his words, "its own dignity as a form among other forms in nature." John de Andrea (born 1941), a sculptor, makes lifelike nudes in a more voluptuous and conventionally beautiful form. Cast from polyester resin, a kind of plastic, his "statues" of reclining and seated women come close to the vapid beauty of calendar girls. The late Duane Hanson (1925–1996) also made figures cast from synthetic plastic, with real clothing and props. His garishly dressed tourists, exhausted shoppers, and weary museum guards represent some of the fringe elements of American life.

Loosely associated with the Photorealists are the still-life painters Janet Fish (born 1938) and William Bailey (born 1930). Fish's dazzling compositions of reflective glass dishes, vases, fruits, and flowers recall the technical mastery of seventeenth-century Dutch still-life painters. Bailey works in a quieter vein, focusing on the sensuous shapes of mugs, pitchers, bowls, and other crockery, usually arranged on tabletops against stark backgrounds.

What all of these artists have in common is a dedication to a Realist tradition, brought up to date through the use of cameras, airbrushes, and a dispassionate way of seeing the world around them. The late 1960s and early 1970s was a time when American art was branching in many different directions—

toward CONCEPTUAL ART, EARTH ART, MINIMALISM, and feminist art. Photorealism offered one strategy, however remote and seemingly mechanical, for keeping alive the centuries-old traditions of painting and figuration.

(*See also* FEMINIST ART AND ICONOGRAPHY; PHOTOGRAPHY; POP ART.)

PICASSO, PABLO

Spanish, 1881–1973

The most versatile and the most influential artist of the twentieth century, Pablo Picasso possessed a restless nature that spurred him to explore every available medium and to move easily through different styles. He worked in painting, PRINTMAKING, and PHOTOGRAPHY, in ceramics, monumental murals, and public sculpture. Almost as celebrated for his long and stormy life as for his legendary output, Picasso had two wives, several mistresses, and four children. With boundless energy, he worked almost up to the day of his death.

Childhood and Earliest Works

Picasso was born in Malaga, in southern Spain, to Maria Picasso López and José Ruiz Blasco. It is said that his first word as a baby was *lapis*, Spanish for "pencil." As a child, he hated schoolwork and spent much of his time drawing. His father, a teacher at the local art school, recognized his son's remarkable talent and encouraged him in every way possible. Picasso was never really a "child artist"; his earliest drawings and paintings show remarkable skill. Important themes that would preoccupy him throughout his long life—self-portraits, bullfight scenes, and doves—have their origins in the artist's earliest years.

In 1895, the family moved to Barcelona, where his father was appointed professor of drawing at the Academy of Fine Arts. Picasso studied there and at the Royal Academy of San Fernando in Madrid. He quickly mastered the approved academic style, producing portraits of his family in oil and watercolor. He painted his first major figure composition, a lifelike scene (*The First Communion,* 1896), when he was only fifteen; it was included in an important art exhibition in Barcelona.

By the time he was sixteen, Picasso had his own studio, and he soon became part of a circle of Barcelona's young bohemians and intellectuals. The young artist's output—compelling portraits and decorative menu covers—shows the love of sinuous line that characterizes so much of ART NOUVEAU. Many of his works are moody and dark, a possible response to the death of a beloved sister (in 1895) and to the poverty he saw around him.

The Blue Period

Picasso first arrived in Paris in the fall of 1900 at the age of nineteen, accompanied by his friend and fellow artist Carlos Casagemas. The sights and rhythms of the French capital entranced him, and he made drawings and paintings reflecting its lively nightlife. Following Casagemas's suicide over an unhappy love affair in 1901, Picasso created a pictorial world entirely in shades of blue, showing the sadness and misery around him. His subjects were poor

Pablo Picasso. *Self-Portrait.* *1901. Oil on canvas. Musée Picasso, Paris* B. HATALA. RÉUNION DES MUSÉES NATIONAUX/ART RESOURCE, NY

people and social outcasts suffering hunger and cold—hardships the young artist himself was experiencing at the time.

Known as the Blue Period paintings, these were created between 1901 and 1904, in both Paris and Barcelona. One of the best known and most enigmatic is *La Vie* (Life)[1903], an image of Casagemas and his lover on the left and a woman holding a baby on the right. The literal meaning of the picture is not entirely clear. X rays have revealed that the young man's face was originally a portrait of Picasso, and the artist's studies show the setting to be a studio. The heavily cloaked woman resembles traditional figures of the Christian Madonna, and the naked figures seem to refer to a shamed Adam and Eve.

In 1904, Picasso settled permanently in Paris and quickly established himself at the center of a group of avant-garde* writers and artists, including the painter Juan GRIS, the poet and critic Guillaume Apollinaire (1880–1917), and the writer Max Jacob (1876–1944), a devoted friend until Jacob's retirement

*avant-garde literally, the "advanced guard"; a term describing innovators or innovation in a particular field

into seclusion. Picasso also found a mistress, Fernande Olivier. It was during this time that his work began to attract the attention of important collectors, including the American writer Gertrude Stein (1874–1946) and her brother Leo.

The Rose Period

Over time, the somber mood of the Blue Period gave way to the less melancholy, but still far from lighthearted, phase of Picasso's career called the Rose Period. He and his friends often attended performances of the Cirque Medrano several times a week, and harlequins and acrobats replaced the poor people and beggars of his earlier paintings. The artist chose not to show them as brilliant figures on a stage in the manner of Edgar DEGAS and the Impressionists, however. Rather, he portrayed them as family groups or as isolated figures, lost in thought or during moments of rest.

Picasso's masterpiece from this time is a huge canvas more than seven feet high. *The Family of Saltimbanques* (The Family of Traveling Entertainers) [1905] shows a group of clowns and acrobats, both children and adults, gathered in a strangely barren landscape. The colors are mainly earth tones, shades of rose and ochre, and the mood is one of muted stillness. This and other works from the period show the artist varying the expressive power of his lines, introducing brighter color, and exploring a new intimacy and tenderness.

Les Demoiselles d'Avignon

By 1906, Picasso had begun to take a serious interest in African sculpture and in the art of other so-called primitive cultures. He was also influenced by the large retrospective of works by the Postimpressionist Paul GAUGIN and the late works of Paul CÉZANNE. These various influences combined to spur Picasso to break with traditional picture making. The result was the creation of what has been hailed as the single most important painting of the twentieth century, *Les Demoiselles d'Avignon*. Picasso worked on the picture over many months in 1907, producing some eight hundred sketches and studies in preparation for the final work. The painting shows five naked women who look out at the viewer and display their fragmented bodies in a shamelessly provocative manner. Its title, loosely translated as "The Young Ladies of Avignon," suggests a resemblance between the subjects and the prostitutes of Avignon Street in Barcelona.

When comparing *Les Demoiselles* with paintings of the Rose Period, it is difficult to believe the work was made by the same artist who painted such gentle acrobats two years earlier. The women's bodies are simplified into fragmented, interlocking shapes. The faces on the left are wide-eyed and staring; on the right, they are grotesquely distorted masks. The scene is riddled with different points of view, in a manner that foreshadows the "exploded" scenes of CUBISM.

At the time of its creation, the picture baffled even the most advanced of Picasso's circle of artist friends. It was not shown in public until 1916 or reproduced until 1925. Art historians agree, however, that *Les Demoiselles* marked a profound break with Western traditions of picture making. The fractured forms, the lack of a single unifying perspective, and the emphasis on raw sexuality would all have an influence on art almost to the present day.

Pablo Picasso. **Les Demoiselles d'Avignon.** *1907. Oil on canvas. Museum of Modern Art, New York City* LILLIE P. BLISS BEQUEST. THE ART ARCHIVE/ALBUM/JOSEPH MARTIN

Picasso and Braque

Of all the artists in Picasso's circle, the one who was most deeply affected by *Les Demoiselles* was Georges BRAQUE. Together the two embarked on the development of Cubism, in a remarkable artistic partnership that was to last until the beginning of World War I (1914–1918). In 1909, Braque produced a series of canvases that showed landscapes as fragmented as Picasso's "young ladies." During the years following, the two painters visited each other's studio and exchanged ideas in such close collaboration that it is sometimes difficult to tell their works apart.

In the first, or Analytical, stage of Cubism, Picasso and Braque took traditional subjects—such as portraiture and still life—and shattered the surface appearances into multifaceted images. At the same time, the artists often incorporated bits and pieces from their everyday world into their paintings. For example, Picasso's *The Scallop Shell* includes a painted fragment from a newspaper, a pipe, and a book of matches. Before long, the artists began to use other materials, such as scraps of wood and metal. In fact, Picasso is usually credited with the invention of collage* with his *Still Life with Chair Caning* (1912).

In the years before World War I, Picasso's fortunes grew. He moved into a new and more spacious studio on the Boulevard de Clichy and was building a powerful reputation among a small circle of influential dealers and collectors. He parted company with Fernande Olivier in 1911 after he fell in love with Eva Gouel at the house of Leo and Gertrude Stein. A fragile woman who died of tuberculosis in 1915, Eva was the only one of Picasso's companions who did not inspire a series of portraits, although her name—or references to her—appear in numerous Cubist paintings.

World War I marked the end of Picasso's collaboration with Braque, who was sent to the front and seriously wounded in 1915. As a citizen of neutral Spain, Picasso was not required to serve. He continued working in Paris, a gray and depressing city during the war years. In 1917, Picasso went to Rome with his friend the writer Jean Cocteau (1889–1963) and became involved in designing costumes and scenery for the ballet *Parade*, choreographed by Sergey Diaghilev (1872–1929). There, he met and fell in love with one of the dancers, Olga Koklova, the daughter of a Russian general, and he entered a new phase in his life and art.

From Neoclassicism to Surrealism

Picasso and Olga returned to Paris and married in July 1918. Now in his late thirties, the artist decisively left the bohemian days of his youth behind when he moved into a grand apartment in the rue de la Boetié. In 1921, he became a family man with the birth of his first child, a son named Paolo.

The period from 1916 to 1925 was marked by significant changes in Picasso's style. The 1917 visit to Italy had been an important factor in introducing him to the world of classical antiquity, and he now directly confronted some of the masters of earlier eras. As early as 1915, he was making realistic portrait drawings notable for their delicate and economical line. The exposure to Greek vase painting and sculpture a few years later unleashed a whole new strain in his artistic vocabulary. In his so-called Neoclassical phase, Picasso drew and painted monumental nudes whose volume and draperies recall art from ancient Greece and Rome, but on a much coarser scale.

Picasso's *Seated Nude Drying her Foot* (1921) is not conventionally beautiful in the manner of Greek statues. It shows a figure with a gigantic body and unnaturally large hands and feet but nonetheless a figure of great calm and serenity in comparison with the nudes in *Les Demoiselles*. Scholars have suggested that the happy domestic life Picasso shared with Olga and Paolo accounts for the often ecstatic or blissful mood of much of his output in this period.

Astonishingly, Picasso continued to work in a bold and confident Cubist vein. "If the subjects I have wanted to express have suggested different ways of

*collage a method of picture making in which pieces of photographs, torn paper, news clippings, and other objects are assembled on a flat surface

Sergey Diaghilev: Impresario and Critic

Born in Russia, Sergey Pavlovich Diaghilev (1872–1929) became famous as the founder of the Ballets Russes (Russian Ballet), one of the most inventive and spectacular ballet troupes of all time. While studying law in St. Petersburg, he became part of a circle of writers and artists that included the painter and stage designer Léon Bakst (1866–1924). In the first few years of the twentieth century, he started a magazine, *World of Art,* and organized exhibitions of paintings, including one of Russian works at the 1905 Salon d'Automne—the largest seen in the West up to that time.

Diaghilev bought the ballet company that became the Ballets Russes in 1909, and it blossomed into a sensational success soon after. In place of traditional backdrops and costumes, he encouraged his designers to indulge in flights of imaginative fancy, believing the visual spectacle was as important as the music or choreography. The inclusion of works by avant-garde composers provoked the occasional scandal. For example, a riot broke out in the audience on the opening night of *The Rite of Spring* by Igor Stravinsky (1882–1971). Diaghilev's celebrated dancers included Anna Pavlova (1882–1931) and Vaslav Nijinsky (1890–1950). For set designs and costumes, he preferred using painters rather than artists trained for the theater, and among the notable contributors to his productions were Pablo Picasso, Georges BRAQUE, Henri MATISSE, and Georgio de CHIRICO.

expression," he explained in 1923, "I have never hesitated to adopt them." *Three Musicians* (1921), made in the same year as the *Seated Nude Drying her Foot,* is a masterpiece of synthetic Cubist composition on a monumental scale. Art historians have identified the three figures as disguised portraits of the artist's poet friends Max Jacob on the right, and Guillaume Apollinaire at left, with Picasso himself in the middle. Because Jacob withdrew to a monastery the same year that Picasso completed the painting and Apollinaire had died in 1918, the work has been interpreted as a memorial to the artist's lost friends.

In the later 1920s, life with Olga became increasingly strained. Picasso recoiled from both her fashionable friends and her obsessive jealousy. At the same time, he became involved with SURREALISM, which encouraged artists to draw upon the power of dreams and the unconscious. The result was a series of works remarkable for both their misogyny (hatred of women) and violently expressive distortions. The images of anguished women screaming in pain from this period have sometimes been interpreted as metaphors for the crisis in his marriage to Olga.

After Picasso met his next mistress, seventeen-year-old Marie-Thérèse Walter, in 1932, his relationship with Olga ended, and his work reflects a new period of calm. Marie-Thérèse, who bore him a daughter in 1936, became the model for some of the artist's most sensual portraits. Picasso often showed her sleeping or sitting, her figure and face expressed in gently rounded forms and warm colors.

War and International Fame

During the early 1930s, Picasso renewed his ties with Spain, visiting his family in Barcelona. When the Spanish Civil War broke out in 1936, the artist came down firmly on the side of the Loyalists against the Nationalists under General Francisco Franco (1892–1975). The twenty-six-foot-long canvas *Guernica* (1937) was a response to the destruction of a Basque (a region in northern Spain and southwestern France) town by German bombers in Franco's service. The central figure in *Guernica* is a screaming horse surrounded by symbols of death and anguish. A grief-stricken woman holds the body of her dead child

Picasso and Sculpture

Although Picasso's activity as a sculptor was more sporadic than his work in two-dimensional mediums, here too he nonetheless ranks as one of the twentieth century's greatest. His 1912 *Guitar,* as art historian H. H. Arnason pointed out, resulted in "a quality of transparency heretofore alien to sculpture." He was the first to incorporate things from the real world—so-called found materials—into sculpture, a practice that artists have been using ever since. Picasso, together with fellow Barcelonan Julio Gonzalez (1876–1942), also pioneered welded steel as one of the major artistic innovations of the century. Sculpture also offered Picasso a chance to display his tremendous visual wit. In his hands, the simplest of objects could be transformed into something completely different—a bicycle seat and handlebars, for instance, became a bull's head.

Many of Picasso's most moving conceptions, however, were done in the traditional medium of bronze. His *Man with a Sheep* (1943) exerts a powerful symbolic presence. The figure might refer to early Christian representations of Jesus Christ as the Good Shepherd. It also calls to mind ancient rites of animal sacrifice. Because the sculpture was in the artist's studio at the time of France's liberation by Allied forces at the end of World War II (1939–1945), one scholar claimed it represented "an act of faith in humanity." Typically, Picasso insisted, "It is just something beautiful."

at far left; a soldier lies fallen at the bottom, a broken sword in his right hand. To the right is a figure with a lamp, perhaps bringing light into the darkness, and another with upraised arms inside a burning building. In the upper portion of the painting is a lightbulb inside a jagged "sun," whose meaning is unclear. Ultimately, the painting's power lies in the anguished faces and contorted forms that express the horror of war.

Except for the animals and fallen soldier, all of the figures in *Guernica* are female, and critics have seen in this painting and in other works from around the same time echoes of Picasso's personal life. He officially separated from Olga in 1935. Soon after Marie-Thérèse gave birth to their daughter, Maya, Picasso began an affair with Dora Maar, a talented photographer who spoke fluent Spanish and kept a photographic record of his progress on *Guernica.*

After the Second World War began in Europe in 1939, Picasso spent most of his time in his studio in Paris. The German forces occupying France banned him from exhibiting but left him alone. Most of his friends and associates were forced into exile or arrested, and the artist turned to increasingly dark subject matter—animals devouring each other, still-life paintings with skulls and candles, and gloomy studio interiors.

At war's end, Picasso suddenly found himself a celebrated figure of international stature. His life and work became the subject of popular magazine articles. Yet, some critics disapproved of his membership in the Communist Party, and much of his politically inspired work proved sterile. Several of his most ambitious works from the postwar years, such as *Massacre in Korea* (1951), are particularly weak paintings; nothing he executed in this vein conveys the power and originality of *Guernica.* Still, his drawing of a dove, made for a party peace congress, soon became an international symbol.

From the Postwar Years to Final Days

Beginning in 1946, Picasso spent most of his time in the south of France, where he set up a second residence and rented a pottery workshop in the little town of Vallauris. Just after the liberation of Paris in 1944, he had met a beau-

tiful and talented painter, Françoise Gilot, who became his companion, displacing Dora Maar. Gilot bore him two children, Claude and Paloma, and both she and their offspring became favorite subjects for the next several years. With a pottery studio at his disposal, the artist also turned his attention to ceramics. With the same flair and energy he brought to other mediums, Picasso created painted plates, cups, and vases.

In 1953, fed up with the tensions of life with Picasso, Gilot left the artist—the only woman to have parted company with him of her own accord. Picasso soon found a new love, Jaqueline Roque, whom he married in 1961. By this time, he was world-famous, the subject of large exhibitions and almost universal acclaim. He moved several times, in part to escape the many people who clamored to meet him, spending the final years of his life in a manor house in the village of Mougins.

Picasso's creative powers remained strong to the end—he was still driven enough to create between three and five paintings a day. Following an operation for prostate cancer in 1965, his subject became a commentary on the process of physical decay: a favorite theme was an old man who gazes in wonder at a beautiful young woman. Picasso's final exhibition was in 1970. The harsh and brutal style of the works alienated many critics, but over time they have come to be seen as forerunners of the NEOEXPRESSIONISM of the 1980s. Picasso died in 1973, at the age of ninety-one, leaving an estate that was valued at $260 million.

(*See also* ABSTRACT ART; NEOCLASSICAL ART.)

PIERO DELLA FRANCESCA

Italian, c. 1420–1492

Largely forgotten until the twentieth century, Piero della Francesca is now considered one of the most original artists of the Early Renaissance. He was born in the province of Umbria in central Italy. As a young man, Piero worked as an assistant to the Italian painter DOMENICO VENEZIANO in Florence. He spent little time in that city, however, and historians have speculated that patrons and other painters of the day considered his work somewhat old-fashioned.

Nonetheless, Piero's paintings show that he absorbed the discoveries of great Florentine artists such as MASACCIO, DONATELLO, Fra Filippo LIPPI, and Veneziano. He found a way to apply the principles of perspective* (*see also* sidebar, BRUNELLESCHI) to portrayals of the human form. The timelessness and monumental dignity of his subjects has made him popular with abstract artists of recent times.

***perspective** a painting technique in which three-dimensional objects and figures depicted on a flat surface appear in correct proportion and relation

Piero's most famous work is a series of frescoes* (*see also* sidebar, GIOTTO) painted between 1452 and 1465, entitled *The Legend of the True Cross.* They were painted for the choir of the Church of San Francesco in Arezzo. The story of the finding of the cross on which Christ was crucified is based on medieval legends containing many different episodes. In one such story depicted in Piero's frescoes, the Roman Emperor Constantine the Great (died 337; ruled 306–337) is asleep in his tent before a crucial battle. While soldiers stand guard, the quiet night is suddenly interrupted by an angel descending toward Constantine. The

***fresco** (Italian for "fresh") a method of painting in which powdered pigments mixed with water are applied directly to wet plaster

State Medals and Portraits

Along with the revival of interest in classical learning during the Renaissance came an interest in certain artistic styles that were popular in ancient Greece and Rome. One of these was the portrait bust. Important noblemen and political officials wanted to see themselves commemorated in paintings and sculptures or on large medals made of non-precious metals, usually bronze or lead. The medals had no value as money and were in imitation of ancient Roman coins, which were eagerly collected during the fifteenth century. Usually, such medals showed a portrait on one side, and the reverse recorded a historical event associated with the subject.

Another type of commemoration was the official, or state, portrait of an individual ruler. These, too, were often inspired by ancient coins. Two such portraits were created in 1465 by Piero della Francesca and show the duke Federigo da Montefeltro (1422–1482) and his wife, Battista Sforza. Federigo was a successful *condottiere* (captain) who increased the family's wealth by acting as a hired military leader, fighting for the highest bidder. He was also a great patron of artists and was an extremely learned man who established an outstanding library.

In keeping with classical models, Piero painted Federigo and his wife in strict profile, a choice that also hides the right eye the duke lost in battle. The subjects and their background landscapes are bathed in the chilly white light Piero favored in his paintings. As in other works, the artist reduced his sitters' heads and upper bodies to simple geometric shapes. At the same time, Piero did not hesitate to depict Battista's rather bland face, prominent nose and all. This was in imitation of the blunt honesty of Roman portraits.

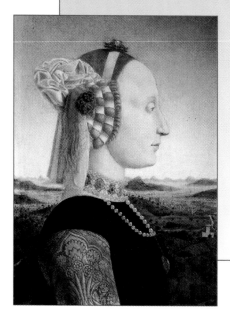

Piero della Francesca. *Portrait of Battista Sforza, Duchess of Urbino.* c. 1465. Oil on panel. Galleria degli Uffizi, Florence, Italy THE ART ARCHIVE/DAGLI ORTI

angel shows him the cross and tells him that under this sign he will be victorious.

The frescoes show that Piero, like other painters in Florence, had completely mastered the technique of perspective. He also uses careful lighting to heighten the drama of the scene. A soldier to the near left is almost completely in shadow, and one to the right is in semidarkness. Almost as if directing the lights for a scene from a play, Piero reserves the brightest spots for the central players: the sleeping emperor, his watchful bodyguard, and the angel who darts into view from above. Light not only helps the artist make his figures seem more real but also increases the illusion of depth, drawing the eye from foreground to background.

The static, monumental quality of Piero's figures is reminiscent of both Giotto and Masaccio. His people generally cast no shadows and seem to exist in a world of their own. In recreating the human form, Piero greatly simplifies many details, focusing instead on the overall shapes created by the body. This gives his work a sculptural quality.

In another episode from the cycle of paintings in Arezzo, *The Discovery and Proving of the True Cross* (c. 1455), the figures are almost as clearly drawn as the architectural shapes in the background. Although this is an event of great importance in the story—to the right, the True Cross brings a dead youth back to life—the participants show little emotion. Piero allows the low, glancing light and the interplay among the different shapes to carry the drama.

After about 1475, Piero stopped painting. The Renaissance painter and art historian Giorgio VASARI claims that Piero was blind at the time of his death and that the reason he gave up painting was because of his growing infirmity. During his final years, Piero devoted himself to the study of mathematics and perspective, writing two books on the subject. In one treatise, he showed that, by means of careful plotting, one could apply the rules of perspective as easily to a human head as to a cube or to the capital* of a column. Although Piero was underappreciated in his lifetime, his work had a deep impact on later Italian painters, such as Pietro PERUGINO and Luca SIGNORELLI.

(*See also* CHRISTIAN ICONOGRAPHY; RENAISSANCE ART.)

***capital** in architecture, the top part of a column

PIRANESI, GIOVANNI BATTISTA

Italian, 1720–1778

After studying architecture and stage design in Venice, Giovanni Battista Piranesi settled in Rome and achieved great popularity at the age of twenty-five with the publication of forty-eight small works called *Varie Vedute de Roma Antica e Maderna* (Various Views of Ancient and Modern Rome) [1745]. These etchings* showed scenes of the ancient and modern city, often with the buildings altered to exaggerate their already impressive scale. Piranesi's poetic images of Italian ruins made a big impact on other Europeans and did much to mold a romantic ideal of Rome that would influence artists and writers for the next 150 years.

***etching** a method of printmaking in which a design is made on a plate using acid and wax

The *Vedute* was followed by prints of Roman antiquities and architectural details, published in 1756 and designed to promote Piranesi's theory that the glories of Rome were far superior to any produced by Greek artists. Around this time, the German archaeologist and art historian Johann Joachim Winckelmann (*see* sidebar, NEOCLASSICAL ART) was writing enormously popular books praising the art and culture of Greek civilization.

Piranesi's most original works, however, were part of the series *Carceri d'Invenzione* (Imaginary Prisons), begun in 1745. These masterful etchings, intended as original works of art, evoke a nightmarish world of confinement and confusion. Staircases lead to nowhere; mysterious instruments dangle from pulleys; and small figures are engaged in puzzling activities. Piranesi's hallucinatory visions were to have a great impact on both the twentieth-century Surrealists and set designs for horror movies.

(*See also* SURREALISM.)

PISANELLO, ANTONIO

Italian, c. 1395–1455

The most celebrated court artist of the early Italian Renaissance, Pisanello takes his name from Pisa, the town where he was presumably born. He was renowned as the greatest portrait medallist of his day, perhaps of the entire Renaissance, and his medals were in great demand among the princes of the Early and High Renaissance (early 1490s to c. 1527). His medals remain unsurpassed in their delicacy, clarity, and precision. Along with GENTILE DA FABRIANO,

Pisanello is also considered a major exponent of the International style of Gothic painting.

Pisanello spent his early years in Verona, but his career also took him to Venice and Rome. Unlike many prominent painters of the day, Pisanello seems never to have spent time in Florence. He worked with Gentile da Fabriano on frescoes* (*see also* sidebar, GIOTTO) in Venice and Rome, but most of his major works have perished. The few paintings that still exist, along with a sizable number of drawings, show that he had a remarkable feel for the portrayal of animals, giving them personalities that were even more compelling than his human subjects. (Nobles in the northern Italian courts of the day took great delight in hunting and also collected rare animals from Africa and the Near East.)

Pisanello's *Vision of St. Eustace* (c. 1440) shows his mastery in painting wild and domesticated beasts. Sitting astride a magnificently decorated horse, Eustace comes upon a fine stag that bears a figure of Christ on the cross between his antlers. In the foreground, a greyhound chases a rabbit, while other hunting dogs mill around Eustace's horse (one even sniffs at the hindquarters of an offended greyhound). Other deer, a bear, and swans fill the murky upper reaches of the tiny painting, seeming to glow in jewel-like colors.

The artist's love for his subject is nowhere more apparent than in his sketches. One pen drawing of a horse shows the beast head-on. Its nostrils and mane seem as stylized as other International Gothic depictions, but the horse is tenderly and carefully observed, right down to his delicate eyelashes and velvety ears.

(*See also* GOTHIC ART; INTERNATIONAL GOTHIC STYLE; RENAISSANCE ART.)

PISANO FAMILY

Italian, active thirteenth and early fourteenth centuries

Father and son, architects and sculptors, Nicola (c. 1220–1278) and Giovanni Pisano (c. 1250–c. 1314) stand at the beginning of a tradition of Italian sculpture in much the same way that their contemporary GIOTTO marks the start of modern Western painting. The Pisanos are credited with reviving sculpture as a distinct art form. Although they often worked together, Giovanni eventually developed his own unique style.

Nicola moved to Tuscany from southern Italy, where the emperor Frederick the Great (1194–1250) had fostered a strongly classical* style. Frederick saw himself as the heir to the caesars of antiquity and insisted that artists follow Roman models. Nicola's most famous work is the pulpit in the baptistry* of Pisa (1259–1260). The relief* sculptures carved around its top tell stories from the life of Christ. They are based heavily on classical forms and conventions.

In the baptistry's *Nativity,* the figure of Mary could be that of a Roman matron, so close are the similarities in her robes and hair to such depictions in antique portrayals of women. The crowded scenes favored by Nicola show that he had been looking closely at ancient sarcophagi, or coffins. This led him to depart from earlier European conventions by squeezing several episodes into a single unit. Thus, the relief shows the Annunciation* in the upper left and the shepherds receiving the news of Christ's birth in the upper right.

*fresco (Italian for "fresh") a method of painting in which powdered pigments mixed with water are applied directly to wet plaster

*classical pertaining to Greek or Roman culture

*baptistry a sacred place where the rite of baptism is performed; often a building separate from the church or cathedral

*relief sculptural figures or decorations that project from a flat background

*Annunciation in Christian art, a scene in which the angel Gabriel tells the Virgin Mary that she will give birth to the Christ child

Nicola Pisano. *Annunciation and Nativity* (detail) from pulpit of the baptistry. *1259–1260. Marble. Pisa Cathedral, Italy* DENNIS MARSICO/CORBIS

By the time he fashioned a similar pulpit for the cathedral in Siena (1265–1268), Nicola was head of a large workshop whose assistants included his son. Both father and son worked on a large fountain for the public square in Perugia (1278), which includes a typical mix of biblical scenes, imaginary beasts, and representations of the seasons. From 1284 onward, Giovanni concentrated on creating the facade* of Siena's cathedral, showing his own talent for giving statuary tremendous vigor and inner life. One of his last great works included a pulpit for the same cathedral his father had decorated some fifty years earlier, the cathedral at Pisa.

A comparison of the son's rendition of the *Nativity* (1302–1310) to his father's earlier work shows a more elegant, flowing style. Giovanni was probably influenced by the art of the French court during this period. His slender figures no longer exhibit the traits of classical sculpture. He also leaves large pockets of space around the principal figures, giving them more room to "breathe." Yet another of Giovanni's works, a figure of the Madonna and Child for the Arena Chapel in Padua (1305), recalls his father's love of solid, substantial forms.

Giovanni is often considered the most powerful sculptor of his time, with his exuberant works marking a distinct break with the serene forms of classical sculpture. It would be nearly a century before another Tuscan sculptor, DO-NATELLO, would create sculptures that more vividly depicted real people existing in three-dimensional space.

(*See also* ROMAN ART.)

***facade** the exterior face of a building, usually the front

PISSARRO, CAMILLE

French, 1830–1903

Born in the West Indies to a Jewish father and a Creole mother, Camille Pissarro moved to Paris in 1855 and soon became a central figure in IMPRESSIONISM. Older than the other members of the Paris Impressionist group,

Pissarro was a respected teacher and occasionally served as a peacemaker when squabbles broke out among the members.

Pissarro first studied with the French painter Camille COROT and was associated with the BARBIZON SCHOOL, but a meeting in 1859 with the French Impressionist painter Claude MONET led to a change in his approach. Pissarro was the only Impressionist to show works in all eight of the group's exhibitions, held between 1874 and 1886.

During the Franco-Prussian War (1870–1871), Pissarro joined Monet in London and briefly came under the spell of the English landscape painters J. M. W. TURNER and John CONSTABLE. Back in France, many of Pissarro's early works were destroyed by Prussian soldiers who occupied his house and studio—and stabled their horses there—for four months.

Eventually, Pissarro settled in southern France and painted in close friendship with his neighbor, the painter Paul CÉZANNE, who would later speak glowingly of Pissarro's qualities as a teacher. Cézanne called him "humble and colossal." Over a ten-year period, between 1872 and 1882, the two made numerous landscape paintings, working side by side, as well as portraits of each other. Pissarro learned from Cézanne's strong sense of composition, and the younger Cézanne was encouraged to experiment with Impressionist light and bright color.

Pissarro's favorite subjects from the 1870s through the early 1890s were sun-drenched landscapes, rustic vistas with peasants and laborers, and snowy winter scenes. *Vegetable Garden and Trees in Flower, Spring, Pontoise* (1877) is typical of his rural views. He worked with bright colors and often used light brushstrokes over dark, a technique that gives his works a shimmering quality.

***pointillism** a technique in which dots of complementary colors are applied to a canvas; the result is a unified image

Of all the Impressionists, Pissarro was the most open to change. In the 1880s, he experimented with the pointillist* technique of the Postimpressionist painter Georges SEURAT. After 1895, Pissarro's eyesight began to fail, and he gave up painting outdoors. He spent his last years in Paris, recording views of the city from the windows of his apartment. Throughout his long life, he was renowned for his gentle temperament and for sharing his hard-won knowledge with others. "The first thing that struck one in Pissarro was his air of kindness, of delicacy and at the same time of serenity that joyous work brings forth," said one of his admirers.

Several of his descendants became painters, including his son Lucien Pissarro (1863–1944) and a granddaughter, Orovida Camille Pissarro (1893–1968). His great-great-granddaughter, Lélia Pissarro (born 1963), paints in an Impressionist vein and shows her works in Paris and London.

(*See also* POSTIMPRESSIONISM.)

POLLAIUOLO BROTHERS

Italian, active fifteenth century

The Pollaiuolo brothers, Piero and Antonio, jointly ran a flourishing workshop in Florence, producing paintings, sculptures, and works in precious metals for wealthy patrons of the time. Over the years, scholars have sometimes had difficulty distinguishing the works of one brother from another. The paint-

ings that can be positively documented as those of Piero Pollaiuolo (c. 1443–c. 1496) are largely mediocre in quality. Art historians generally agree that the paintings from the brothers' studio that are so superior to Piero's independent work were created by Antonio (c. 1431–1498).

Trained as a goldsmith, probably in the workshop of the Florentine sculptor Lorenzo GHIBERTI, Antonio Pollaiuolo was deeply influenced by the works of the sculptor DONATELLO, who was active during the first half of the quattrocento*. Antonio was also a student of ancient art, like many other painters and sculptors of the Early and High Renaissance (early 1490s to c. 1527), and he sometimes looked to the Greek and Roman myths for his subject matter.

*quattrocento in Italian art, the fifteenth century

Antonio's small bronze statuette *Hercules and Antaeus* (1475) shows the great hero Hercules, with both feet on the ground, locked in a violent struggle with his enemy Antaeus. Even though it gives an impression of strenuous movement, the sculpture is perfectly balanced. The arms and legs of the two opponents appear to radiate from the central axis formed by the point at which the two men's torsos meet. Antonio's composition was new for its time; no earlier model for it survives from either ancient or Renaissance sources.

Several years earlier, Antonio made a large picture of the same subject for the Medici Palace in Florence. The Medici were a powerful family in Florence and Tuscany from the fourteenth through the sixteenth centuries (*see* sidebar, RENAISSANCE ART). The painting is now lost, but its character survives in an engraving* he made around the same time. Scholars have not yet identified the subject of the work, which probably comes from a classical* legend, so the engraving is called simply *Battle of the Ten Naked Men* (c. 1470). What makes this work important for its time is Pollaiuolo's mastery at depicting the human body in motion. It has been suggested that he was the first artist of the Renaissance to have gained a detailed knowledge of anatomy by dissecting cadavers to study how bones and muscles appear on a real human being. The violent facial expressions, which underscore the physical tension of the battling men, were also new to fifteenth-century Florence. The pairing of emotion with motion—occasionally achieved in earlier works by the Italian painter MASACCIO and by Donatello—would become increasingly important to artists of the future.

*engraving the process of making a design or drawing by cutting lines into a hard surface; or, an impression made by that process

*classical pertaining to Greek or Roman culture

A later painting by Antonio, *The Martyrdom of St. Sebastian* (1475), also shows the artist's interest in both human anatomy and balanced composition. In the center is Saint Sebastian, eyes turned toward heaven. He is surrounded by his executioners: six archers in various stages of loading or drawing their bows and arrows. Their arrangement is carefully calculated. The two pairs of men in the foreground are almost mirror images of each other. Some art historians have proposed that Pollaiuolo may have used the same model for all six men, simply drawing him from different angles.

As can be seen from this work, Antonio was also something of a pioneer in painting landscapes. He has applied the new laws of perspective*, developed by the Florentine architect Filippo BRUNELLESCHI, to the wonderfully detailed background view of the Tuscan hills in Italy. The mountains become smaller and less distinct as they lead the eye away from the buildings, trees, and horsemen in the middle ground of the picture. Nonetheless, the artist has not been entirely successful in combining his main scene with the background view. There is still the sense that the landscape is a kind of curtain or backdrop. It

*perspective a painting technique in which three-dimensional objects and figures depicted on a flat surface appear in correct proportion and relation

would remain for later artists like LEONARDO DA VINCI and GIORGIONE to successfully integrate a subject with its outdoor surroundings.

(*See also* CHRISTIAN ICONOGRAPHY.)

POLLOCK, JACKSON

American, 1912–1956

A major figure of ABSTRACT EXPRESSIONISM, Jackson Pollock led a difficult and stormy life that occasionally overshadowed his accomplishments as an artist. He died in a car crash at age forty-four, leaving behind a substantial body of work that helped change the course of American painting.

Early Influences

Born Paul Jackson Pollock on a sheep ranch in Cody, Wyoming, Pollock moved to California with his parents and five older brothers when he was still a baby. The family divided its time between California and Arizona, and critics have speculated that Pollock was influenced by Native American cultures in the southwestern United States. He may have witnessed certain religious tribal artists making sand paintings on the ground.

In 1929, Pollock headed east to New York City, where he studied at the Art Students League with the American Regionalist painter Thomas Hart Benton (1889–1975). Although he later called Benton's work "something against which to react very strongly," Pollock's early paintings were heavily indebted to Benton's energetic, twisting compositions. Pollock was also attracted to Benton's hard-drinking macho style and alcoholism.

Like many artists, Pollock survived the Great Depression of the 1930s by working in the Federal Art Project, a government program that employed artists to produce art for public buildings and places. He came into contact with Mexican muralists such as Diego RIVERA and José Clemente OROZCO and was moved not so much by the political content of their work as by the large scale of their paintings and their impatience with accepted techniques. Another influence was the Mexican painter David SIQUEIROS, who ran an experimental workshop in New York. Siqueiros introduced Pollock to unconventional materials such as Duco (an industrial paint used on automobiles) and to new techniques, like spattering and spraying.

After suffering a nervous breakdown in 1938, Pollock underwent psychological therapy with Jungian analysts. They discussed theories about the "collective unconscious" as a repository for ancient myths, an idea developed by the Swiss psychologist and psychiatrist Carl Jung (1875–1961). Jung's theories were widely discussed by Abstract Expressionists of the day. For Pollock, this resulted in works like *Guardians of the Secret* (1943), *Male and Female* (1942), and *The She-Wolf* (1943). The paintings show sketchy and schematic figures in murky colors, with an energetic surface that would later become the artist's trademark.

Success for Pollock, as for others of his generation, was slow in coming. In 1942, he met his future wife, the painter Lee Krasner (1908–1984), who introduced him to a wider circle of artists and collectors. Among them was Peggy Guggenheim (1898–1979), who became his chief patron and supporter.

"Jack the Dripper"

By the mid-1940s, Pollock was painting in a completely abstract style, and two years later he made the breakthrough to the "drip and splash" style that would catapult him to fame. By then, he was living on the eastern end of Long Island, New York, and working on canvases spread across the floor. Using a brush or stick, he threw paint into the air so that it landed on the canvas in delicate webs and traces of lines. As he worked, he moved around the painting, almost in a kind of dance, a process that led the critic Harold Rosenberg to coin the term *action painting*.

Critics have seen in his best works from this period, such as *Autumn Rhythm* (1950) and *Number 1, 1950 (Lavender Mist)*, echoes of the nineteenth-century landscape tradition. They seem to be filled with weather—with mists and wind and shifting light. These paintings also introduced a new art style known as all-over painting, in which Pollock completely covered the picture plane, with no single part of the painting more important than another.

As the art historian H. H. Arnason pointed out, the lines "are divorced from any descriptive function and range from stringlike thinness to coagulated puddles, all merging into a hazy, luminous whole that seems to hover above the picture plane rather than illusionistically behind it." An article published in a popular magazine dubbed Pollock "Jack the Dripper," and he became the best-known American abstract painter. This "all-over" compositional phase, for which he is famous, lasted only four years, from 1947 to 1951.

Final Years

Pollock's last years were deeply troubled. Many of his fellow artists regarded him as a freak, "part of the entertainment," as one recalled. His alcoholism resurfaced, and by 1954 he had stopped painting. Two years later, drunk at the wheel, Pollock crashed his car near his home in East Hampton, Long Is-

Jackson Pollock. *Documents II.* *1954.*

Francis G. Mayer/Corbis

land. The artist and one of his two passengers lost their lives. Pollock's fame has remained, however, and he is credited with revitalizing American abstraction, giving younger painters the freedom to take risks and explore unconventional means and methods.

(*See also* COLOR FIELD PAINTING.)

PONTORMO, JACOPO DA

Italian, 1494–1557

The Mannerist painter known as Jacopo da Pontormo takes his name from the Italian hill town in Tuscany where he was born. Also known as Jacopo Carrucci, he was the son of a painter. Praised by the Italian master MICHELANGELO when he was still a very young man, Pontormo entered the workshop of the Florentine artist Andrea del Sarto (1486–1530) in 1512. By 1515, he had already created a style of his own. His early works show that he was already breaking away from the classical tendencies of the High Renaissance (early 1490s to c. 1527) masters.

Pontormo's painting *Joseph in Egypt* (1518) illustrates a scene from the life of the Virgin Mary's husband, Joseph. *The Visitation* (1516) is a scene in which the Virgin Mary greets her cousin Elizabeth when both women are pregnant. These paintings are filled with restless movement, tense relationships among the figures, and strange architecture.

Pontormo's two greatest masterpieces are a second *Visitation* (1529) and the *The Deposition* (c. 1528), which shows Christ being placed in his tomb after his body has been taken down from the cross. The ghostly, dreamlike *Deposition* is painted in intense colors. The figures seem to be lost in a trance of grief. It is impossible to tell where the event is taking place; there is no architecture or landscape, except for a simple platform at the bottom of the painting and one wispy cloud. The figures seem to be piled on top of one another, with little relationship among them. This would become one of the key characteristics of MANNERISM.

Pontormo's *Visitation* of 1529 uses the same vivid color, and the four figures have a similar dreamlike feeling. However, there seems to be a real sense of communication between Mary, on the left, and her older cousin, Elizabeth. The two background figures seem to be mirror images of Mary and Elizabeth but are seen full face. There is more of a sense of a setting, perhaps a town street, than in *The Deposition*, but the tiny figures on the far left look grossly out of proportion with both the architecture and the central group. This odd juxtaposition seems to foreshadow by about ten years the strange relationship between the Virgin and the little prophet in *Madonna with the Long Neck* (c. 1535) by the Italian painter PARMIGIANINO.

Pontormo was also a renowned portrait painter and had a great influence on his adopted son, Agnolo di Cosimo, known as BRONZINO. Pontormo's later works show that he had spent much time studying the Italian painter and sculptor Michelangelo and the German painter and engraver Albrecht DÜRER.

Mannerist Eccentrics

The Mannerist painters of the sixteenth century were often as odd in their personalities as they were in their art. The Florentine painter ROSSO FIORENTINO kept a pet baboon that jumped from roof to roof, much to the annoyance of his neighbors. Jacopo da Pontormo, according to the painter and art historian Giorgio VASARI, was "so fearful of death that he never allowed it to be mentioned. . . . He never went to feasts or other places where crowds collected for fear of being crushed, and he was solitary beyond belief."

Pontormo is one of the few sixteenth-century artists whose diaries, from the years 1554 to 1556, have survived. His writings reveal that he was an introspective man who suffered from fits of melancholy and self-doubt.

(*See also* CHRISTIAN ICONOGRAPHY; RENAISSANCE ART.)

POP ART

The Pop art movement emerged in the late 1950s and spread rapidly, particularly in the United States and England. A reaction to the often solemn and "arty" attitudes of ABSTRACT EXPRESSIONISM, the movement embraced popular culture. As its most visible artist, Andy WARHOL remarked, Pop art was "about liking things"—advertisements, comic books, movies and television, packaging, and all the other familiar symbols of the prosperous economy that followed World War II (1939–1945). Pop rejected distinctions between good and bad taste, and sought to debunk the seriousness of the art world. It also became the first truly international Modernist style, spreading to many countries and eventually being welcomed by museums and galleries around the world.

Origins

Although the origins of Pop art can be traced to the European DADA movement and to the ready-mades* of French artist Marcel DUCHAMP, the more immediate influences in the United States were the works of Robert RAUSCHENBERG and Jasper JOHNS. In their assemblages* and collages* from the mid-1950s, both artists incorporated into their compositions commonplace objects—targets, a rubber tire, beer cans, and images from the mass media.

In England, at about the same time, a disciple of Duchamp named Richard Hamilton (born 1922) launched Pop with a work titled *Just What Is It That Makes Today's Homes So Different, So Appealing?* (1956). The tongue-in-cheek collage shows a muscleman and a pinup girl surrounded by a miscellany of consumer goods, including a canister vacuum, a canned ham, and a television set. After 1957, American R. B. Kitaj (born 1932) became an important figure in the English Pop art scene; his paintings of everyday life, rendered in broad and flat areas of color, look back to IMPRESSIONISM and ahead to artists such as Alex KATZ.

Advertising, Mass Media Inform American Pop Art

Pop enjoyed its fullest flowering in the United States. Since most of the major figures of American Pop art had backgrounds in commercial art (as illustrators or billboard painters), they looked to the world of advertising and the mass media for their images. Warhol was the first to mine comic books for their simple figures and shiny colors, but Roy Lichtenstein (1923–1997) based his paintings and sculptures on the comics throughout his long career. Beginning in 1962, when one of his young children challenged him to make a painting as appealing as those in comic books, Lichtenstein used printing dots (called Ben Day dots, after their nineteenth-century developer), primary colors, and blunt outlines to construct powerful works, such as 1963's *Whaam!* Blown up to huge proportions, his paintings have a clarity, force, and humor that transcend the

*ready-made an ordinary object isolated from its familiar context and elevated to the status of a work of art; term was coined by artist Marcel Duchamp

*assemblage a type of sculpture in which a group of objects is put together to form a work of art

*collage a method of picture making in which pieces of photographs, torn paper, news clippings, and other objects are assembled on a flat surface

source of their inspiration. Lichtenstein also produced paintings based on the works of modern masters such as Henri MATISSE and Paul CÉZANNE.

Like Lichtenstein, Claes Oldenburg (born 1929) discovered that magnified scale could give new meaning to the commonplace. Soon after moving to New York City from Chicago, he became involved in Happenings staged with other young artists. Making props for this early form of PERFORMANCE ART led him to create environments and sculptures based on everyday objects. His larger-than-life versions of French fries, hamburgers, sandwiches, and ice cream sodas were made out of plaster or of canvas stuffed with foam rubber. He was also known for his soft sculptures of hard and durable objects such as typewriters, electric fans, and toilets, which he fashioned from shiny vinyl. In Oldenburg's visions, the viewer's expectations are turned upside down and the ridiculous or trivial becomes monumental. This is especially true in his plans for large-scale monuments, some of which were actually carried out, such as the forty-five-foot *Clothespin* erected in Philadelphia, in 1976.

James Rosenquist (born 1933), who trained as a billboard painter, based most of his work on the large scale of the advertising images seen along American highways and on the sides of city buildings. He was one of the few in the Pop generation whose works express social protest. His most famous work, *F-111* (1965), is a multi-paneled mural that stretches across eighty-six feet and contains images of wholesale destruction (a fighter plane, a nuclear explosion) juxtaposed with the normal everyday reality of canned spaghetti, an automobile tire, and a little girl's smiling face under a cone-shaped hair dryer. Rosenquist commented on his painting, saying, "How insignificant it is to be an artist in this day and age when all that power is zipping by for defense."

The Movement's Variations and Impact

Other artists who came of age during the heyday of Pop found more poetic or gently humorous strains in the movement's emphasis on the ordinary. The Venezuelan sculptor Marisol (born 1930) made block-like figures that can be both lyrical and satirical in their depiction of famous people and middle-

Roy Lichtenstein. *Whaam!* 1963. *Magna on two canvas panels. Tate Gallery, London, England* ART RESOURCE

Happenings

Central to the idea of Pop art was "mixing it up"—using different media and finding a way to integrate real life into the work of art. In the 1960s, Happenings brought an element of theater into the art world, although these spontaneous events seldom included rehearsals or scripts. The term was coined by American artist and theorist Allan Kaprow (born 1927), who wrote that a "Happening, unlike a stage play, may occur at a supermarket, driving along a highway, under a pile of rags, and in a friend's kitchen, either at once or sequentially." Although art historians claimed Happenings picked up on the antics of the early twentieth-century DADA group, Kaprow traced their origins to Jackson POLLOCK, an Abstract Expressionist who used the canvas as an "arena" in which to paint. Kaprow said that Pollock "left us at the point where we must become preoccupied with and even dazzled by the space and objects of our everyday life."

Happenings often included bizarre elements and behavior. In one of Kaprow's Happenings, participants licked strawberry jam from the hood of a car soon before it was set on fire. Other events featured a greater sense of theater, with props and costumes, or spontaneous musical performances that might include the destruction of the instrument the artist had chosen to "play." Spur-of-the-moment and often childlike, Happenings anticipated the advent of PERFORMANCE ART in the following decades.

class life. Wayne Thiebaud (born 1920) used a thick and creamy impasto* to create luscious still lifes of cafeteria foods—cakes, pies, ice cream cones, and pastries. And sculptor George Segal (1924–2000), whose style was often compared with that of painter Edward HOPPER, made plaster casts of real people, creating ghostly monuments to the frustrations and small pleasures of ordinary men and women.

*impasto thickly applied pigment, often showing the marks of a brush or palette knife

The legacy of Pop art was to elevate the otherwise annoying blitz of visual information in the world to the status of art. "What Pop art has done for me is to make the world a pleasanter place to live in," said architect and collector Philip Johnson. "I look at things with a totally different eye—at Coney Island, at billboards, at Coca Cola bottles. One of the duties of art is to make you look at the world with pleasure. Pop art is the only movement in this century that has tried to do it."

POPOVA, LIUBOV

Russian, 1889–1924

Liubov Popova was one of the leading figures of the Russian avant-garde* during the years of the Bolshevik revolution. The Bolsheviks were members of the extremist wing of the Russian Social Democratic Party who seized power after overthrowing the government of Czar Nicholas II (1868–1918; czar 1894–1917) in the Russian Revolution of 1917.

*avant-garde literally, the "advanced guard"; a term describing innovators or innovation in a particular field

Popova was born near Moscow, the daughter of a wealthy and cultured textile merchant. She studied painting there in 1907 and 1908, in the studio of the Russian Impressionist artist Stanislav Shukovski. In the years following her studies, Popova traveled widely in Russia and Italy, where she especially admired the painters of the Early Renaissance. Through visits to a notable collector of French art in Moscow, she became acquainted with the works of the Cubist painters. In 1912 and 1913, she spent several months in Paris, gaining

a firsthand acquaintance with advanced art in the studios of Russian artists then living in the city and studying with French Cubists.

When World War I (1914–1918) broke out, Popova returned to Moscow by way of Italy. She worked in the studio of the Russian artist Vladimir TATLIN, perhaps the most innovative sculptor of CONSTRUCTIVISM. She became politically active in the developing Bolshevik movement, helping to organize other artists and contributing to a groundbreaking exhibition of Russian artists in Petrograd (later St. Petersburg) in 1915. Influenced by the example of the Russian painter Kazimir MALEVICH, who reduced painting's complexity to no more than one square placed atop another, Popova was creating completely abstract work by 1916.

Between 1916 and 1920, she completed a series of pictures she called *Painterly Architectonics,* which show her distinctive take on CUBISM. Popova generally favored angular forms in strong greens, blues, and reds, painted on a rough board. The colors, as critic Camilla Gray has noted, "are brushed on this crude, raw surface, leaving the impression of lightning-swift movements, a darting, breathless meeting of forces. . . . "

After the outbreak of the Russian Revolution, Popova, like most of the avant-garde, threw herself into projects on behalf of the Bolshevik cause, designing posters and painting buildings. In 1918, she married an art historian, Boris von Eding, and soon afterward gave birth to a son. A year later, Popova lost her husband to typhoid fever. In 1920, unhappy with conditions in Russia, she moved to Germany, where she became a teacher at the Institute of Artistic Culture, founded by her countryman Wassily KANDINSKY.

In 1921 and 1922, Popova produced her last series of pictures, the rigorously abstract *Space-Force Constructions.* Along with other artists dissatisfied with the aims of "fine" art and attracted to the utilitarian emphasis of Constructivism, Popova renounced easel painting in favor of more "useful" products, such as textile designs, ceramics, and stage sets. Seeing fabrics of her own design worn by ordinary people, she once said, gave her more satisfaction than her efforts as a painter.

Popova's brief but astonishingly vital career was cut short at age thirty-five, when she died after contracting scarlet fever from her son.

(*See also* ABSTRACT ART.)

POSADA, JOSÉ GUADALUPE

Mexican, 1851–1913

The printmaker and wildly influential political cartoonist José Posada was born in the state of Aguascalientes in central Mexico. His images agitated the upper classes and political elites and fired the imagination of the lower classes and many of Latin America's literary giants.

Posada began his career as a teacher of lithography*. In 1887, he moved to Mexico City, where he became a newspaper illustrator, and from 1890 on, he ran a storefront printer's shop. It was there that he produced and distributed his savage and sensational illustrations, depicting in graphic images the kinds of subjects that appear in newspaper tabloids—murders, scandals, per-

*lithography the process of printing from a smooth, flat surface (such as a stone or metal plate)

verse sexual acts—as well as works addressing politics and social conditions such as poverty. The cartoonish format was one that illiterate immigrants from the countryside could understand. Posada frequently satirized the upper classes and politicians, showing, for example, images of women in long black dresses shooting each other.

Posada is most famous for the numerous propagandist broadsheets he produced, especially those showing his *calaveras*, or skeletons, created for Mexico's Day of the Dead celebrations. These drawings took elements from folk culture and used them to dramatize social conditions. Highlighting the Mexican fascination with death, they are clever, funny, and very frightening—the truest form of popular art. Posada's drawing *A Fashionable Lady* is a characteristic masterpiece of grotesquerie, showing a skeletal head all decked out in finery.

A big influence on the Mexican painters José Clemente OROZCO and Diego RIVERA, as well as Frida KAHLO, Posada's enterprise can also be considered a precursor of GRAFFITI ART. "Posada was the rare kind of artist who is clearly linked to a universal form of culture," wrote the Mexican novelist Carlos Fuentes (born 1928) in his book *The Buried Mirror* (1992), "the culture of danger, of the bizarre, of extremes, of informality." —BARBARA M. MACADAM

(*See also* LATIN AMERICAN ART.)

POSTIMPRESSIONISM

By the 1880s the revolution started by the Impressionist painters was no longer considered revolutionary. In 1882, the year before his death, the unofficial leader of the movement, Édouard MANET, was recognized by the French government and made a member of the prestigious Legion of Honor. Collectors eagerly sought to purchase the works by the group's original members, and the triumph of IMPRESSIONISM over ACADEMIC ART seemed complete.

A younger generation of painters, whose careers spanned the years 1880 to 1905, sought to build on the achievements of Impressionism or to react against the movement in pursuit of different aims. These artists included Georges SEURAT, Henri de TOULOUSE-LAUTREC, Paul GAUGUIN, Vincent VAN GOGH, and Paul CÉZANNE. The British art critic Roger Fry coined the termed *Postimpressionism* to describe their work. It was Fry who organized a landmark exhibition, "Manet and the Post-Impressionists," in London in 1910–1911. The paintings of the three central figures in the movement—Gauguin, Van Gogh, and Cézanne—dominated the show.

Unlike the Impressionists, who were united in rebellion against the establishment and who held many exhibitions together, the Postimpressionists embarked on different and distinct paths. Cézanne wanted a more substantial art than that of his forebears; he wished, he said, "to make of Impressionism something solid and durable, like the art of the museums." Gauguin moved away from the focus on the everyday to explore the symbolic use of color and line. And Van Gogh brought to his painting a deep emotional intensity and almost religious feeling.

In some ways, the art of the Postimpressionists echoed the split in ambitions between the Romantic and Neoclassical painters of one hundred years

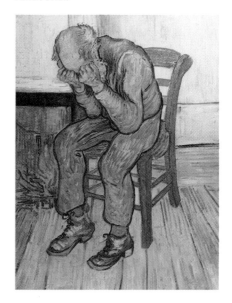

Vincent Van Gogh. *Old Man with His Head in His Hands.* 1890. *Kröller-Müller Museum, Otterlo, Netherlands* FRANCIS G. MAYER/CORBIS

earlier. Seurat and Cézanne concentrated on formal, near-scientific principles of design. Lautrec, Van Gogh, and Gauguin looked to color and light to express inner emotions and sensations. Although they did not share one common goal, the achievements of these different artists point toward the series of avant-garde* movements, such as CUBISM and FAUVISM, that would form the foundations of twentieth-century art.

(*See also* NEOCLASSICAL ART; ROMANTICISM.)

POUSSIN, NICOLAS

French, 1594–1665

Nicolas Poussin, considered by many to be the greatest French painter of the seventeenth century, spent most of his career in Rome. He did not arrive there until the relatively late age of thirty, but once he did, he became passionately interested in Greek and Roman antiquity*. Poussin was never at home with the Baroque style that was fashionable in Italy in the 1620s and 1630s. For several years, his work showed the influence of TITIAN, the great Venetian master of the Renaissance.

Greek and Roman Subjects

Poussin's *Cephalus and Aurora* (c. 1630) was inspired by Titian's warm color and by his approach to classical* mythology. Like Titian's *Bacchanal* (1519), this is a dreamy and poetic world, but Poussin's vision strikes a mournful note. Aurora, goddess of the dawn, is trying to keep Cephalus, the man she loves, from leaving. A little putto* commands her lover's attention, holding up a portrait of Cephalus's wife to remind him of his vows to be faithful. On the left is a sleeping river god, a symbol of the night, and in the background, Apollo, the god of divine distance and associated with the sun, waits by his winged horse for daybreak.

About five years later, Poussin produced quite a different vision of a story from antiquity. *The Rape of the Sabine Women* (c. 1635) tells of an incident in the life of Romulus, one of the legendary founders of Rome. The Sabines were an ancient people who were defeated by the Romans about 290 B.C. After the men had been lured out of the city, Romulus told his troops to capture the Sabine women. In Poussin's painting, the figures are like statues, frozen in action, with many derived from Greek sculpture. The painting signals Poussin's growing interest in what he called *la maniera magnifica* (the grand manner). Painting, he believed, should represent noble and serious human actions: "The first requirement, fundamental to all others, is that the subject and narrative be grandiose, such as battles, heroic actions, and religious themes." The artist should avoid "low" and common subjects, he said, like those favored by the Italian artist CARAVAGGIO in the generation before his.

Returns to France

By the end of the 1630s, Poussin's reputation was so great that King Louis XIII (1601–1643; ruled 1610–1643) summoned him to Paris to paint a ceiling fresco* (*see also* sidebar, GIOTTO) for the Louvre. Artistically, the trip was a disaster. Believing that artists should strive for rational portrayals of emotion,

***avant-garde** literally, the "advanced guard"; a term describing innovators or innovation in a particular field

***antiquity** the period of history before the Middle Ages; Greek and Roman times

***classical** pertaining to Greek or Roman culture

***putto** (plural, putti) a cherub (small angel) rendered as a chubby male baby, often with wings; especially popular in Renaissance art

***fresco** (Italian for "fresh") a method of painting in which powdered pigments mixed with water are applied directly to wet plaster

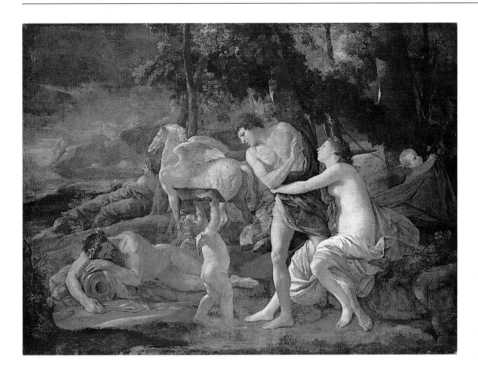

Nicolas Poussin. *Cephalus and Aurora.* *c. 1630. Oil on canvas. National Gallery, London, England* NATIONAL GALLERY COLLECTION, BY KIND PERMISSION OF THE TRUSTEES/CORBIS

Poussin could not conform to the king's taste for flying figures and overblown ornament. In France, Poussin came into contact with the ideas of the philosopher René Descartes (1596–1650) and the dramatist Pierre Corneille (1606–1684). Their own desire for classical order reinforced Poussin's quest for unity of mood in his paintings. According to his theories, the subject of the painting and its treatment could be worked out through specific principles. The painting should appeal to the mind rather than to the senses, he believed, and "trivial" aspects, such as color, should be subdued in favor of design and composition.

Landscape Painting

Poussin also had formulaic notions about how to portray landscapes. After returning to Rome in 1642, he spent time exploring the countryside. Many sketches he made on the spot are remarkably fresh and spontaneous, but his finished works have a much more ponderous quality. His *Landscape with the Funeral of Phocion* (1648) shows the influence of the Italian painter Annibale CARRACCI, who had specific rules for creating the "ideal landscape." According to this formula, the elements of a landscape should be arranged as a grand and highly formal setting for small figures. The spaces between the buildings, clumps of trees, and people are almost mathematically precise.

Poussin's approach was to become enormously influential over the course of the next two centuries. Citing the master's example, teachers at the French Academy, founded by King Louis XIV (1638–1715; ruled 1643–1715), for years instructed students that everything to do with art could be reduced to logical formulas. It was an idea that would lead to the term *academic,* meaning stiff, formal, and excessively grandiose. Yet, even as late as the 1870s, Poussin continued to have an impact. The French painter Paul CÉZANNE, one of the most adventurous of the Postimpressionist painters, once declared that he wanted to "do Poussin again, from Nature."

(*See also* ACADEMIC ART; BAROQUE ART; POSTIMPRESSIONISM.)

PRECISIONISM

Neither an organized group nor a movement, Precisionism is the name given to the works of several painters who, after World War I (1914–1918), took as their subject matter American architecture and machinery. Their scenes glorified the barns, bridges, skyscrapers, and factories that sprang up across the landscape in the prosperous decade before the Depression of the 1930s, and their approach tended toward REALISM and geometric clarity. The Precisionists favored crisp lines, smooth brushwork, and scenes in which the human presence is minimal or lacking altogether. The paintings of skyscrapers by Georgia O'KEEFFE are considered Precisionist, as are some of the works of the Futurist painter Joseph Stella (1877–1946) from the 1920s. The two most famous Precisionists, however, are Charles Demuth (1883–1935) and Charles Sheeler (1883–1965); Sheeler is credited with coining the term.

Charles Sheeler

Born in Philadelphia, Sheeler studied with William Merritt CHASE and became close friends with Morton Schamberg (1881–1918), a promising painter whose career was cut short when he died in the influenza epidemic of 1918. Between 1904 and 1909, Sheeler made several trips to Europe, where he came into contact with works by the most advanced French artists of the day, including Paul CÉZANNE and Pablo PICASSO. Back in the United States, Sheeler started his career as a professional photographer in 1910, and showed a talent for high-definition images of stark, anonymous buildings.

After moving to New York in 1919, Scheeler became part of the circle that surrounded the collectors Louise and Walter Arensberg (*see* sidebar, DUCHAMP). A year later, he collaborated with the photographer Paul STRAND on one of the first American "art" films, *Manahatta,* which is based on a poem by Walt Whitman (1819–1892). The six-minute movie used kaleidoscopic effects to portray the city as a dizzying place of soaring skyscrapers and nearly empty streets.

Sheeler's paintings were greatly influenced by his film and photographic work. He gradually abandoned his Cubist compositions for highly detailed paintings that prefigure PHOTOREALISM. In 1925, he was hired by the Ford Motor Company to take photographs of its Rouge River plant near Detroit, Michigan. The images from this assignment—factories as pristine temples of industry—brought Sheeler international acclaim. His paintings continued in the same Realist vein until the mid–1940s, when his style changed to encompass multiple points of view realized in brash colors.

Charles Demuth

Born in 1883, the same year as Sheeler, Charles Demuth also made several visits to Europe between 1904 and 1921 and became friendly with the Arensbergs and their artistic crowd. He was a great admirer of French painter Marcel DUCHAMP, calling his *Large Glass* (1915–1923) "the greatest picture of our time." Like that landmark work, Demuth's own paintings were often riddled with sexual references. He was exceptionally skilled as a watercolorist, producing delicate Cubist-inspired landscapes along with more conventional still lifes and figure paintings.

In the 1920s, the artist produced a series of "symbolic portraits" made up of numbers and images associated with the person being depicted. The most famous of these was *I Saw the Figure 5 in Gold* (1928), dedicated to his friend the poet William Carlos Williams (1883–1963). Emblazoned with a huge numeral 5 against a backdrop of splintered red and blue planes, the work was inspired by a poem by Williams called "The Great Figure," that begins: "Among the rain/and lights/I saw the figure 5/in gold/on a red/fire truck. . . . "

Demuth's last important works took the industrial landscape around his hometown of Lancaster, Pennsylvania, as their subject. Lame from childhood, the artist was afflicted with diabetes toward the end of his life and spent his final years in the home of his parents. From this period dates *My Egypt* (1927), an imposing frontal view of a grain elevator. The title refers to the mania for all things Egyptian following the discovery of Tutankhamen's tomb by English archaeologist Howard Carter (1873–1939) in 1922. The critic Robert Hughes has suggested a secondary meaning, connecting the painting to the exile of the Jews to Egypt as told in the Book of Exodus. For Demuth, Lancaster was a kind of Egypt, a barren desert, remote from the intellectual excitement of Paris or New York.

Charles Demuth. *My Egypt.* *1927. Oil on board. Whitney Museum of American Art, New York City* FRANCIS G. MAYER/CORBIS

The Precisionist Vision

Many American artists besides Sheeler and Demuth worked in a Precisionist vein during the 1920s and 1930s. These included the photographers Paul Strand and Imogen Cunningham (1883–1976), and the painters Elsie Driggs (1898–1992), Ralston Crawford (1906–1978), Preston Dickinson (1889–1930), and Niles Spencer (1893–1952). In the era before pollution and industrial sprawl became serious environmental issues, they saw the clean geometries of barns, skyscrapers, machines, and factories as a source of beauty and grandeur. Where Europeans such as Duchamp and architect Le Corbusier (Charles-Édouard Jeanneret; 1887–1965) reacted to the machine aesthetic with a certain irony or playfulness, the Americans found intrinsic worth in the hard, clean lines of the landscape emerging around them.

(*See also* CUBISM; MODERN ARCHITECTURE.)

PRE-COLUMBIAN ART

See AZTEC ART; INCAN ART; MAYAN ART.

PREHISTORIC ART

Archaeologists and anthropologists divide man's early history into three periods—the Paleolithic (from the Greek words meaning "old" and "stone"; hence the Old Stone Age), the Mesolithic (Middle Stone Age), and the Neolithic (New Stone Age). To study the artistic endeavors of the earliest peoples is to understand the very nature of the beginnings of modern civilization.

Paleolithic Art

By the time of the Upper Paleolithic era (30,000–10,000 B.C.), the category of modern man known as *Homo sapiens* had evolved. These early people

were hunters and gatherers. They had not yet settled into stable villages or learned to live off the land through farming, and they had not yet discovered metal. They made their weapons and implements from stone, and although the invention of writing would not happen for thousands of years, they evidently made marks that kept track of time. The men and women of the Paleolithic era were not conscious of creating "art" in the modern sense of the term, but they did sculpt images, apparently as objects of worship, and they left behind some of the most breathtaking paintings of all time.

Cave Paintings Scenes of animals—bison, reindeer, bears, and horses—found on the walls of caves in Europe are among the earliest known works of art. The artists of the Paleolithic era and even earlier incised, painted, or sculpted images in the darkest recesses, where they presumably worked by firelight. Protected from the elements, the works were startlingly intact and vivid when they were discovered in the twentieth century. The most famous cave paintings date from 15,000 to 10,000 B.C., and are located at Altamira, in northern Spain, and Lascaux, in the Dordogne region of southwest France.

Most historians speculate that these vivid images, which often show a sophisticated knowledge of anatomy and the use of shading to produce lifelike creatures, served as more than decoration. They may have been part of magic rituals performed to ensure successful hunting. Sometimes lines representing spears or arrows point to the animals, and in some cases the walls seem to have been gouged, as if by spear points. Historians speculate that by making a picture of his prey, the hunter-artist believed he could bring the animal within his grasp: "killing" the image would mean destroying the animal's life spirit.

Generally, the artist drew an outline of his subject, and then filled in the image with colors—usually red, brown, yellow, black, and red. The pigments were ground from minerals, such as ochre and manganese; when applied to the natural white limestone walls, the effect could be exceptionally intense. These

Chinese horse cave painting. *c. 15,000–13,000 B.C. Axial Gallery, Lascaux, France*
CORBIS

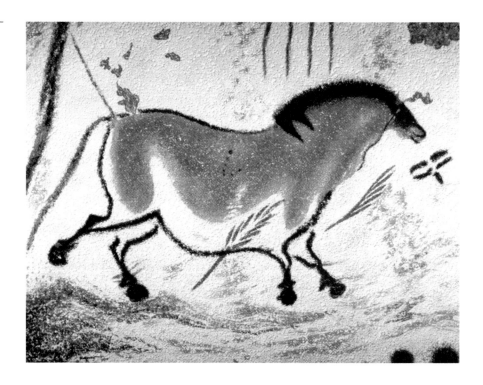

early artists were also adept at making the natural rock formations found in the caves—bumps, mounds, and hollows—part of their pictures. Some of these works may have been intended as part of a fertility ritual. One of the few human figures in Paleolithic art is the "Nude Woman" (c. 12,000 B.C.) from La Magdeleine Cave in southwestern France, in which the natural ledges of the rock have been used to form the woman's legs and torso.

The more recent discovery of cave paintings in Chauvet, France, in 1994, sets back the dates of the earliest cave art to about 30,000 B.C. Because some of the animals depicted, including rhinos and hyenas, were probably not hunted for food or hides, some experts on Prehistoric art speculate that they indicate the very early beginnings of religious rituals. But the nature of the religion that produced these striking beasts, perhaps as complex as any in the modern world, may forever remain a mystery.

Sculpture and Portable Objects The most famous sculpture of the Paleolithic period is a little statue, not even five inches high, of a faceless female with enormous breasts, no arms, and stumpy legs. Known as the *Venus of Willendorf* (c. 28,000–25,000 B.C.), after the town where she was found, the statue is one of many such figures from this era. These were most often carved from rocks whose shapes suggested a human figure, and they represent women in all stages of life—from adolescence through pregnancy to the heaviness of later life.

Most of these prehistoric Venuses are sculptures in the round, but early artists also carved figures in relief* bearing colored traces that suggest they were once painted. These figures are generally faceless, with exaggerated hips and breasts. Because the sexual aspects of these figures are so prominent, archaeologists speculate that they were worshiped as fertility figures. Just as a modern-day believer might pray to a patron saint for some desired end, so early ancestors evidently hoped these female figures would guarantee pregnancy and safe childbirth.

Paleolithic carvers from southern Europe to the former Soviet Union also made deftly sculpted images of animals. Again, a slab of stone or shapely rock probably suggested the final form of these sculptures. The animals most frequently represented include bison, horses, and oxen. In contrast to the exaggerated sexuality of the Venus figures, these works are often surprisingly naturalistic, with delicately incised details that show great skill and sharp powers of observation.

Neolithic Art

Sometime around 8000 B.C., in the area of the ancient Near East (present-day Egypt, Israel, Syria, Iraq, Iran, and Turkey), there occurred a momentous revolution in the history of humankind: man first began to plant crops and keep domesticated animals. Once people could assure their own food supply, they settled into permanent communities and began to produce the first efforts at architecture and crafts. Long before the appearance of metals, the inhabitants of Neolithic settlements learned how to make pottery, to weave baskets and clothing, and to make primitive buildings from brick, stone, and wood.

New forms of worship accompanied the huge change from a hunting-and-gathering society to settled villages. Agricultural rituals were developed to

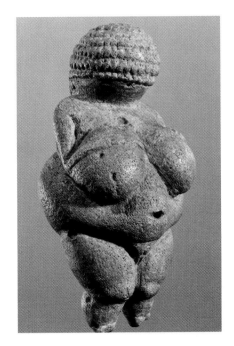

Venus of Willendorf. c. 28,000–25,000 B.C. *Limestone. Naturhistorisches Museum. Vienna, Austria* ARCHIVO ICONOGRAFICO, S.A./CORBIS

***relief** sculptural figures or decorations that project from a flat background

celebrate the seasons and the cycles of birth, death, and rebirth. Burial practices indicate that there was a concern with an afterlife. And archaeologists have found evidence of worship of mother-goddesses, descendants of the *Venus of Willendorf,* and of the earliest attempts at building places of worship.

The Mysterious Portrait Heads of Jericho One of the world's oldest fortified settlements, dating from 8000 B.C., the city of Jericho was located on the West Bank of the River Jordan in modern-day Israel. Jericho was enclosed by walls some five to twelve feet thick and protected by lookout towers of rough masonry. The nearly two thousand inhabitants lived in rectangular mud-brick buildings with plaster floors and walls painted with patterned designs. Corpses buried beneath the floor have led historians to speculate that the residents of Jericho worshiped an "ancestor cult"—that is, they revered the spirits of those who came before them and wanted to assure their continued good will from beyond the grave.

Further evidence of ancestor worship lies in the remarkable sculpted heads found in Jericho, dating to between 7000 and 6000 B.C. These are not actual sculptures in the traditional sense of carving or modeling, but rather human skulls with a tinted plaster covering that reconstructed the surface and features of the face. Painted hair and shells embedded in the eye sockets further added to the realistic look of these "portraits," whose subtle modeling is comparable to the more sophisticated works from later eras. The purpose of these heads is still unknown, but they suggest that Neolithic people believed in a spirit or soul, which may have resided in the head and lived beyond the death of the body. Whatever their meaning, the Jericho heads are the first in a line of portraits that would continue until the collapse of the Roman Empire several thousand years later.

Çatal Hüyük North of Jericho, across the Mediterranean Sea in the southern part of modern-day Turkey, another group of people also left evidence of ancestor worship. The Neolithic site of Çatal Hüyük, dating from around 7000 to 5000 B.C., is the largest in the ancient Near East and one of the most advanced. Because the inhabitants had no form of writing, little is known about their beliefs and customs. But the ruins discovered by archaeologists show that these early inhabitants carefully planned their settlement, which consisted of one-story houses built of mud brick reinforced by timber frames. Inside the houses, built-in benches served as beds and seats, and an airshaft provided ventilation for smoke. The most curious aspect of the town planning at this site is the absence of streets. Instead, the houses were connected to each other with access provided by ladders that stretched across the rooftops.

Like the cave painters of thousands of years earlier, the residents of Çatal Hüyük made images of the hunt on the interior walls of their shrines. In these, however, archaeologists have found evidence of worship of specific symbols, namely bulls and stags, which were honored as male deities. One shrine includes a wall painting, which depicts the town of Çatal Hüyük in the foreground and a mountain with two peaks in the distance; lines and dots indicate that a volcanic eruption is taking place. Dating from c. 6000 B.C., it is considered to be the world's first landscape. Statues of "mother goddesses" have also been found—heavy women with large thighs and drooping breasts who were possibly worshiped as fertility figures.

Human plastered skull from Jericho.
c. 7000–6000 B.C. Painted and inlaid with shell. Archaeological Museum, Amman, Jordan ARCHIVO ICONOGRAFICO, S.A./CORBIS

The Neolithic Era in Europe

While the ancient Near East became the cradle of civilization, giving rise to the diverse and sophisticated cultures of Egypt, Greece, and Mesopotamia*, the sparse populations to the west continued to live as simple tribes in small villages, even after the discoveries of bronze and iron. Neolithic peoples in Europe, in the period between 7000 and 2000 B.C., never reached the level of organization that produced the houses and portrait heads of Jericho. In their religious monuments, however, they left behind some of the most memorable structures of all time.

Megaliths The religious monuments of the western Neolithic people consist of huge blocks or boulders placed upright or supporting each other without mortar. Known as *megaliths* (from the Greek word *mega,* meaning "big"), the most impressive are found in modern-day Great Britain, France, and Italy. Given their great weight and size, the megaliths obviously required a superhuman effort to assemble. They are still capable, thousands of years later, of inspiring a sense of awe and mystery in the beholder.

Three distinctive kinds of megaliths have been found in Europe. Their names are Celtic in origin, after the group of peoples called Celts who began to migrate throughout western Europe at the beginning of the ninth century B.C. *Menhirs* are uncarved, roughly shaped single stones placed upright in the ground. They were erected individually, or arranged in clusters or rows. The best known are in Carnac, in northern France, which was probably an important place of worship for an unknown Neolithic tribe.

The megaliths known as *dolmens* were built as tombs, or "houses for the dead." They consisted of upright stones for walls and a giant, single-stone slab "roof." Sometimes interior walls were decorated with crude sculptures or a pillar was placed in the center of the burial chamber. Like menhirs, the dolmens were believed to have sacred powers, the exact nature of which remains unknown. What seems certain, however, is that the durability of the stones was somehow linked to Celtic ideas about eternity.

A third group of megaliths, known as *cromlechs,* formed a kind of circular or semi-circular setting for religious worship. Great Britain has by far the greatest number of cromlechs. Of these, the most famous is Stonehenge in southern England. Built in several stages between c. 2550 and 1600 B.C., Stonehenge is a great circle of evenly spaced upright stones supporting horizontal slabs called *lintels.* There were originally two inner circles, similarly spaced, and a central altar inside a U-shape made of giant stones set in pairs.

As early as 3000 B.C., Stonehenge was a burial site made up of individual mounds of earth and bones surrounded by a ditch. Running in an east-west direction from this circular arrangement was an avenue hollowed out of the ground. Later, the other stone elements were added, some of them carted from as far away as present-day Wales, a distance of more than one hundred miles.

Final construction of Stonehenge is generally credited to the Beaker People, a group whose origins are still uncertain. They are named for their beaker-shaped pottery, and it is known that they discovered new building techniques and had some knowledge of metalwork. The Beaker People are credited with building Stonehenge's outer circle and inner U-shape from large sarsen, or sandstone, blocks carted from Marlborough Downs twenty miles away.

Early Body Painters?

In 1999, British archaeologists found evidence that our ancestors were producing paint as early as 350,000 to 400,000 years ago, long before the species had evolved into the modern human beings known as *Homo sapiens.* A team from the University of Bristol discovered pigments and paint-grinding equipment in a cave in southern Africa near Lusaka, Zambia. The fragments of pigment included a dark red, sparkling purple, yellow, brown, and pink. The evidence suggests that these early people may have been painting their bodies for rituals and ceremonies around the same time that humans were developing more efficient hunting equipment, such as wooden handles to make spears. If the pigments were being used for body painting, as indeed seems likely, it would imply that ritual behavior was evolving at a very early period, hundreds of thousands of years before man turned from painting his body to painting on walls.

*Mesopotamia an ancient region of Southwest Asia, between the Tigris and Euphrates Rivers, in modern-day Iraq; Mesopotamia means "land between the rivers"

Stonehenge. *c. 2550–1600* B.C. *Salisbury Plain, Wiltshire, England* SUSAN D. ROCK

The exact meaning and use of Stonehenge and other cromlechs is still open to interpretation. Some historians think that they must have been the sites of sacred rites and dances. Others believe they were used as early observatories, places from which to predict lunar eclipses and seasonal changes. Because Stonehenge is aligned toward the exact point where the sun rises on the day of the summer solstice, it may have been the site of sun-worshiping rituals. Yet other stones are oriented toward the northernmost and southernmost points of the rising moon.

The great megaliths of Western Europe may never be completely understood. It is clear, however, that they were intended for rituals held in the open air. As the use of metal increased and the climate changed from temperate to damp and cloudy, between 2000 and 1500 B.C., building of these mysterious stone monuments declined.

(*See also* CELTIC ART.)

PRENDERGAST, MAURICE

Canadian-born American, 1859–1924

Born in Newfoundland, Canada, Maurice Brazil Prendergast grew up in Boston, which was his home base until the last ten years of his life. He occupies a curious position in American art history, a kind of bridge between the IMPRESSIONISM of William Merritt CHASE and Childe HASSAM and the gritty REALISM of the later ASHCAN SCHOOL of painters.

Prendergast first visited Paris in 1886 and returned again in 1890 to study there for three years. By then, Impressionism was an established style, and younger painters were coming under the influence of SYMBOLISM and the theories of the French painters Georges SEURAT, Paul GAUGUIN, and others. Prendergast enthusiastically embraced the NABIS dictate that a painting, before it was anything else, was essentially a surface to be filled with patches of color. He also responded to their emphasis on flat, decorative pattern instead of the illusionism favored by artists since the Renaissance.

In Prendergast's splendid watercolor views of Venice (he traveled widely in Europe), he uses clear, direct color; the pattern he uses for buildings suggests a glimpse into deep space. Over the next two decades, his compositions became more like friezes* and more abstract, and by the time his work was exhibited at the 1913 Armory Show in New York (*see* sidebar, DUCHAMP), he was considered one of the most advanced American artists.

In 1914, Prendergast moved to New York, where his specialty became scenes of outdoor leisure, such as *The Holiday* (1909). The subject matter, middle-class people enjoying a day free from work, recalls the Impressionist tradition, but the artist evolved a technique all his own. He often began with quick sketches painted outdoors and then produced a larger work in the studio. The color is generally pearly and subtle, the paint laid on so thickly that it almost resembles a tapestry.

Later in his career, Prendergast joined a subgroup of Ashcan painters known as "The Eight." The group, which included the American painters Robert Henri (1865–1929) and John Sloan (1871–1951), celebrated the seamy side of city life, painting scenes from the ghettos, the music halls, and the streets. Prendergast's buoyant views of untroubled enjoyment seem to have had little in common with the harsh Realism of his colleagues. All of them, however, shared a desire to rescue American painting from the lifeless academic formulas that were dominant at the time.

(*See also* ABSTRACT ART; POSTIMPRESSIONISM.)

*frieze a horizontal band along the side of a building, tomb, or other structure; usually decorated with paintings or relief sculptures

PRE-RAPHAELITES

Founded in London in 1848, the Pre-Raphaelite Brotherhood was established by a group of artists who were profoundly dissatisfied with what they considered the frivolous art of the day. They took the name "Pre-Raphaelite" to signify their sympathies with the masters of fifteenth-century Italian art: that is, with the artists who preceded the High Renaissance painter RAPHAEL. At the core of the group were three students at the Royal Academy, Great Britain's official art school: John Everett Millais (1829–1896), William Holman Hunt (1827–1910), and Dante Gabriel Rossetti (1828–1882). Their aim was to reform the standards of British painting, which they believed had sunk to lifeless history paintings* and trivial genre* scenes. The Pre-Raphaelites sought to produce art that had "genuine ideas to express"; they chose religious and morally uplifting themes, hoping to reform the ills of modern civilization through their painting.

Although their works differed in choice of subjects and style, the group shared a devotion to detailed settings, costumes, and plant life, and to the use of a clear, sharp-focus technique. Their works achieved a particular brilliance through the application of a thin base of wet, white oil paint to the surface of the canvas, on top of which layers of color were applied with a watercolor brush. The method, which Millais hoped to keep secret, allows the white paint to shine through rather than mix with the pigments.

From the beginning, the movement had a strong literary flavor. Like the nineteenth-century Romantic painters, Pre-Raphaelite artists often chose themes from William Shakespeare (1564–1616), Dante (1261–1321), and

*history painting a picture that depicts an important historical occasion

*genre painting painting that focuses on everyday subjects

other writers. Millais's *Ophelia* (1852) is taken from Shakespeare's *Hamlet*. The subject is the drowning of Ophelia, which Millais depicts in vivid detail. It is a somber, yet beautiful scene. The pale face of Ophelia rising from the water is in stark contrast to the red flower that floats from her right hand and the murky, green water that envelops her. The painstaking attention to detail and the sumptuous garments recall earlier art, although the modeling of the figure places the painting squarely in a post-Renaissance tradition.

The work that is often cited as the one most faithful to Pre-Raphaelite aims is William Holman Hunt's *The Awakening Conscience* (1853). In Hunt's work, a young woman rises from the lap of her lover, stirred by the music she sings to the realization that she has been living in sin. For subject, Hunt was inspired by the eighteenth-century painter and engraver William HOGARTH, who was looked to by many of the artists in the movement. In his paintings and etchings, Hogarth also attempted to convey a moral. In its style, *The Awakening Conscience* can be compared to the *Arnolfini Wedding Portrait* (1434) by Jan van EYCK, which had just been acquired by England's National Gallery. Like the Flemish painter, Hunt includes many details that reinforce the message of the scene. The radiant sunlight in the window is a reference to a religious "awakening"; the cat under the table, about to pounce on a bird, signifies the young woman's plight; and the glove cast off in front of the hem of her dress is a symbol of her possible fate.

John Everett Millais. *Ophelia. 1852. Oil on canvas. Tate Gallery, London, England*
ART RESOURCE

When the group became known to a wider public in 1850, critics were quick to attack their ambitions. The novelist Charles Dickens (1812–1870) was outraged by the rejection of Raphael, who at that time was held to be the greatest artist who ever lived. The group's fortunes improved when critic John Ruskin (1819–1900) came to their defense in 1851 in a series of letters written to the London *Times.* He avoided any identification with the brotherhood's religious themes, but praised their truthfulness to nature and suggested that they would establish a nobler school of art than anything seen in the last three hundred years. Their works were, he wrote, "more earnest and complete in their aspirations than anything painted since the time of DÜRER."

By 1854, the group had all but dissolved. They were earlier united by a youthful commitment to high ideals, but in reality, as artists, they had little in common. Of the founding members, only Hunt remained true to Pre-Raphaelite aims. In his later works, Rossetti concentrated on themes from Dante and became known for the depiction of pale, languid women with flowing hair. A younger member of the group, Edward Burne-Jones (1833–1898), concentrated on strong, muscular nudes modeled after the figures by MICHELANGELO found in the ceiling of the Sistine Chapel. By far the most successful member of the group was Millais, who also gained great fame as a portraitist and book illustrator. Ironically, the movement that started in rebellion against the artificial and the sentimental is today strongly identified with those same qualities by art historians.

(*See also* ROMANTICISM.)

PRINTMAKING

A print is a picture or design that is usually made on paper by spreading ink onto another surface, such as a metal plate or woodblock, and pressing paper against that surface. There are a number of processes by which prints can be made, many of which continued to be used by artists into the twenty-first century.

Woodcuts

Woodcuts are the oldest form of prints, and the process is a simple one. The artist draws a design on a smooth block of medium-soft wood, such as beech or sycamore. The parts that are to be left blank (the non-printing part of the block) are cut away with sharp tools, leaving a drawing in relief* on the block. The woodblock image is then spread with ink and pressed to paper. A single woodblock can yield thousands of copies.

***relief** sculptural figures or decorations that project from a flat background

Woodcuts were probably first used in China in the fifth century to apply patterns to fabric. The first European woodcuts date from the early fifteenth century, and were mostly crudely rendered religious images. An easy and inexpensive process, woodcut prints were available to all, including those of modest means. In the hands of a skilled artist, such as Martin SCHONGAUER in the 1400s or Albrecht DÜRER in the 1500s, woodcuts achieved great sophistication, both as individual prints and as book illustrations. In Europe, woodcuts reached the height of popularity in the first thirty years of the sixteenth century, eventually losing ground to engravings, which offer subtler effects.

Beginning in the seventeenth century, woodcut prints known as UKIYO-E became extremely popular in Japan. The late nineteenth and early twentieth centuries saw a revival of interest in woodcuts in Europe, when artists such as Paul GAUGUIN and Edvard MUNCH used the grain of the wood to create bold, expressive images.

Engravings

Engraving grew out of the European goldsmith's art during the middle of the fifteenth century. In this method of printmaking, a design is cut directly into the surface of a metal plate (usually copper), using a cutting instrument known as a *graver* or *burin*. The plate is then inked, and the excess ink wiped away from the surface, leaving ink in the grooves. An impression is made when paper is pressed against the plate in a printing press.

Skilled engravers made cross-hatches* or closely spaced parallel strokes in the surface of the metal to suggest depth and shadows in the resulting print.

***cross-hatch** a pattern of parallel lines imposed on top of each other, in a weave; used to suggest shadows or three-dimensional shapes

Martin Schongauer. *St. Anthony Tormented by Demons. c. 1480–1490. Engraving. Rosenwald Collection, National Gallery of Art, Washington, D.C.* LIBRARY OF CONGRESS

The sixteenth-century master Dürer was perhaps the most outstanding engraver of all time; he used the medium to achieve its full range of effects. At the same time, in Italy, Marcantonio Raimondi (c. 1480–c. 1534) began using engraving to reproduce the works of other artists, especially RAPHAEL. Images produced in this way were cheaper than paintings and allowed the works of the masters to be widely circulated.

Etchings

Etching is another way to produce multiple images from a single metal plate. To make an etching, the artist covers the plate with a waxy substance that resists acid, thus creating an etching ground. He or she then uses a *stylus* (a sharp metal instrument) to make a drawing on the ground. When the plate is placed in a bath of acid, the acid eats away only the exposed lines (not the wax), creating grooves where the ground was scratched through by the stylus.

The darkness of the print is determined by the amount of time the plate is immersed in acid. An artist can achieve subtle effects by "stopping out" part of the drawing, covering it with a varnish, and returning the plate to the bath so that other areas of the image are "bitten" (rendered) more deeply (than those protected by the varnish). After the plate is inked, an impression is made, just as in the engraving process. But etchings allow for more spontaneity than engravings because a stylus moves as easily over the ground as a pencil or pen over paper. Thus, etching allows for a greater freedom of the hand as well as a more delicate line.

Etching was developed during the early sixteenth century as a shortcut to the engraving method, but it soon became a popular technique. REMBRANDT was probably the greatest etcher of all time, using the technique for landscape, portraiture, and religious scenes.

Related Techniques Drypoint, a variation of etching and engraving, is a method of drawing directly on a copper plate. The artist scratches the image with a sharp tool held like a pen, instead of using the clumsier engraver's burin, which requires greater pressure. One unique feature of this method is the *burr,* or rough edge, along the line made by the cutting tool. When the plate is inked, the burr collects the ink and produces a soft, rich quality in the darker areas of the image. Because the burr wears down during printing, only a limited number of "good" prints can be made from a plate produced by this method.

Aquatints are made by a process similar to etchings but allow for finely textured tonal areas rather than lines. The artist covers the spaces between etched lines with an acid-resistant varnish, called *rosin,* which is fused to the plate surface by heating. Then, when the plate is dipped in an acid bath, the acid penetrates to the metal but produces a grainy surface. The artist can control the range of graininess (and thereby the range of tones in the resulting printed image) by repeating the process of immersing the plate in acid and varnishing. Color can also be added by hand or by using several plates with different colored inks. Aquatints can be used to reproduce watercolors. Beginning in the nineteenth century, the technique was used by many artists, including Francisco GOYA, Edgar DEGAS, and Pablo PICASSO.

Lithographs

Lithography is a method of printing from designs drawn on a stone slab, such as limestone. To make a lithograph, the artist draws directly on the stone using a grease crayon or an ink mixed with grease. The porous surface of the stone "holds" the image. The stone is then wetted and rolled with an oily ink, which sticks only to the greasy drawing. Since the rest of the surface is damp, those areas repel the ink. A layer of damp paper is then pressed against the stone, and the image is transferred from the stone to the paper. In a variation called transfer lithography, the artist draws a picture on paper and it is then fixed to the stone. Color lithographs are made by using a different stone for each ink color. Because the stone does not wear out during the printing process, an almost infinite number of impressions can be made from it.

Lithography became especially popular among artists in the nineteenth and twentieth centuries. Honoré DAUMIER was the first to make it a major part of his artistic output, and Henri de TOULOUSE-LAUTREC used color lithography to create his striking posters of Parisian nightlife.

Related Techniques Monotypes are made by painting (usually in oil colors) on a flat sheet of metal or glass and then transferring the image directly to paper. With a glass plate, the artist uses the back of his or her hand to press the image onto the ground (surface of the glass plate). A design painted on metal can be printed with a press. Usually, only one image can be "pulled" using this method (hence the prefix mono, meaning "one").

Silkscreen prints are made by forcing pigments through the mesh of a screen. The process is similar to stenciling, in which paint is forced through a perforated sheet onto fabric or paper, but, in silkscreening, several stencils can be used to obtain different colors. The stencil is attached to a screen of nylon or silk, and color is forced through the unmasked areas using a squeegee. The process became especially popular with late-twentieth-century artists, who often combined silkscreening with photographic processes.

Impact

Beginning in the sixteenth century, printmaking became an important method for circulating images to a large audience. Artists who could not travel abroad to see the paintings and drawings of foreign artists firsthand could know of them through prints, which in the right hands became works of art in themselves. Moreover, multiple images can be made from the same plate or lithographic stone. A set of such images is called an edition, and the number of the print is often marked on the image. For example, the numbers 12/300 in the lower corner of a print mean that the print was the twelfth image in an edition, or printing, of three hundred.

For collectors, affordable prints became a way to own images by "name" artists. But some prints were highly sought after and earned high prices. For example, in the early twenty-first century, a Rembrandt etching at auction would fetch as much as or even more than an original painting or drawing by a lesser artist.

(See also JAPONISME.)

Henri de Toulouse-Lautrec. *Moulin Rouge—La Goulue.* 1891. Poster. Musée de l'Affiche, Paris THE ART ARCHIVE/DAGLI ORTI

PUGET, PIERRE

French, 1620–1694

The greatest French sculptor of the seventeenth century, Pierre Puget formed his style in Italy between 1640 and 1643. He worked with the Italian painter and architect Pietro da Cortona (1596–1669), who was second only to Giovanni Lorenzo BERNINI as a genius in the Italian Baroque style. Puget made several visits to Genoa, Italy, before returning to France, where he found commissions in the cities of Toulon and his native Marseilles.

In 1656, at age thirty-six, Puget made his first major sculptures for the town hall of Toulon. These were a pair of figures of Atlas, the Greek mythological giant who supported the earth on his shoulders. Puget portrays them as two anguished and muscular giants rising from groups of seashells. The highly realistic style—one art historian compared them to burly dockworkers—was at odds with the idealized anatomy then popular in French sculpture.

Like other ambitious artists in seventeenth-century France, Puget sought out the patronage of the royal court at Versailles. His style, however, like Bernini's, was too robust and passionate to fit in with the aims of Charles Lebrun (1619–1690), artistic overseer for King Louis XIV (1638–1715; ruled 1643–1715). Lebrun favored the classical* tendencies of artists like the French painter Nicolas POUSSIN. When Lebrun's influence began to wane, Puget succeeded in having a few sculptures accepted for the palace at Versailles, among them the statue *Milo of Crotona* (1683). The sculpture tells the story of the Greek hero Milo, who boasts that he is so strong that he can split a tree trunk with his bare hand. When Milo's hand becomes stuck when he chops at the trunk, a lion attacks him from behind. The story was interpreted from the Renaissance onward as a warning against excessive pride. Puget's statue became a symbol for the beliefs of certain French writers of the day, who warned that physical strength should be moderated by reason and understanding.

Puget's *Milo of Crotona* has been compared with Bernini's *David* (1623) for its sheer emotional force: Milo's agony is apparent all the way from his screaming mouth down to his clenched toes. Puget's composition, however, with its diagonal lines, seems filled with a greater internal tension. The detailed realism of the work also put it at odds with other works in Versailles, where more superficial themes of pleasure and glory were the norm under Lebrun's direction.

Puget's artistic talents included painting and architecture, but it was his sculptural works that were to have the greatest impact on future generations. Eighteenth-century writers on art compared him with the Italian master MICHELANGELO and Bernini. To nineteenth-century Romantics, such as the French painter Eugène DELACROIX and the French sculptor François Rude (1784–1855), Puget was an example of a genius torn by inner conflicts. Even the French painter Paul CÉZANNE, one of the fathers of modern art, admired the solidity of his sculptures and made many drawings based on his works.

(See also BAROQUE ART.)

*classical pertaining to Greek or Roman culture

Index

This index is specific to volume 3
of Schirmer Encyclopedia of Art; a
cumulative index is found in
volume 4. Numbers in boldface
indicate a main entry for the
subject. Page numbers in italics
indicate an illustration.